These Ruins Are Inhabited

Muriel Beadle

THESE RUINS ARE INHABITED

These Ruins
Are Inhabited

MURIEL BEADLE

DOUBLEDAY & COMPANY, INC., GARDEN CITY, NEW YORK, 1961

LIBRARY OF CONGRESS CATALOG CARD NUMBER 61–8874
PRINTED IN THE UNITED STATES OF AMERICA

TO GEORGE AND REDMOND

For many reasons, not the least of
which is gratitude for their patience
while the book was being written

ACKNOWLEDGMENTS

THE author expresses her thanks for permission to reprint "Tourist's Round," from *Culex's Guide to Oxford* (The Abbey Press, Abingdon, England) ; and to quote from the following: George Mikes's delightful guidebook, *How to Be an Alien* (Andre Deutsch, Ltd., London, 1946); *Britain's Homage to 28,000 American Dead:* The Times Publishing Company Limited, 1952. All Rights Reserved. Reprinted, by permission, from "Britain's Homage to 28,000 American Dead", "Oxford Letter," by Glen W. Bowersock, in *The American Oxonian,* July 1960; and *Other Schools and Ours,* Edmund J. King's excellent study in comparative education (Rinehart & Co , New York, 1958).

It should also be mentioned that some of the material in this book has appeared in different form in the Los Angeles *Mirror-News,* in *The Saturday Evening Post,* and in *The American Oxonian.*

THESE RUINS ARE INHABITED

I

NOW that the train was slowing and the rain was no longer slashing so fiercely at the windows, it was possible to see something of the countryside through which we were passing. The scene was drab, small farms and pastureland beginning to give way to clusters of brick buildings and back-yard cabbage patches. Ahead I could see some metal sheds and a storage tank. *It looks like the outskirts of Peoria,* I thought. *And it mustn't.* This was the place that Dryden had likened to Athens, and Hazlitt to Rome; this was Max Beerbohm's lotus-land, Logan Smith's "taste of Paradise." *Please don't let it look like Peoria.*

There was a little stir outside our compartment as disembarking passengers began to form a line in the corridor. My son, Redmond—a lanky near-fifteen, and by his own measure as good as grown up—unfolded from his seat, stretched and said, "Well, I'd better be getting the suitcases down. This *is* Oxford, isn't it, Mom?"

"I guess so," I replied, my eyes still searching the landscape ahead. "It's silly of me, I suppose, but I was hoping . . ." And then I saw them. The towers of Oxford. Square, rounded, tapered, like fingers lifted to heaven. Blurry in the mist, but there; and we were going *toward* them. It was only a glimpse. They speedily vanished behind a chain of trackside buildings. But it was enough. "Yes, Red," I said—and now my voice was

confident and cheerful—"this is Oxford. What are you going to carry, and what shall I take?"

As we dragged our luggage out into the corridor, I said, "I wish Pop were here, don't you?" George was in London, touring a lab, and would drive out later in the day. I was sorry that we weren't sharing the moment of arrival.

Red shot me an indulgent glance; my menfolk know that I am sentimental about beginnings. "It isn't Plymouth Rock, Mom."

"I know, but even so . . ."

To an American academic family, coming to Oxford was like coming to Olympus—exciting but scary. We were there because my husband, a geneticist and professor of biology at Caltech in Pasadena, had accepted a year's appointment as a visiting professor at the university. I had without regret quit my own job as a newspaper reporter in order to accompany him to England; and Red had beat his brains out for nine months in preparation for the school that awaited him here. Those spires up ahead symbolized the grace and beauty and intellectual richness of England's oldest university—some of which we hoped would rub off on us.

The Oxford station was a dark and smoky bedlam. We followed the crowd, sucked along as if by a giant syphon, toward a slotted gate. As we neared this bottleneck, staggering slightly under the weight of our luggage, a brawny young man with a knapsack on his shoulders tried to wriggle past us. He whacked his shin against the suitcase Red was carrying and spun us both into the path of a tall, lean man whose sandy mustache seemed to quiver as he checked his own forward motion.

Even as I apologized, I was cataloguing him: bowler, dark jacket, striped trousers, leather gloves, neatly furled umbrella carried canelike in his right hand. *Ah, an English gentleman!*

He acknowledged my "so sorry" with a faint inclination of the head and a dilation of the nostrils. Then he squared his shoulders against the pressure of the crowd behind us and moved off again, this time lifting out of harm's way the burden he had been carrying in his left hand: a brace of pheasants. *Probably bagged them at his shooting lodge,* I decided, pleased by this early encounter with the landed gentry. As I think about him now, the probability is that he was a college porter doing an errand for the chef.

I remain grateful to him, however, for the romantic touch he added to our arrival in Oxford. It was the only one. Where were the quaint old inns with cobbled courtyards and window boxes full of flowers? The gray-walled colleges with coats of arms above their fretwork gates? The dons strolling in the groves of Académe? This was a city of dirty, no-period buildings, of narrow streets choked with traffic, of store fronts like those in small towns in Nebraska. Nothing appeared as in the Come-to-Britain ads except the big red busses chugging along the same route our taxi took from the station to the suburb of Headington.

Nor did our new house (supplied by the college with which George would be affiliated) look quite as much like Anne Hathaway's as I had thought it might. It had been described in correspondence as a stone cottage, but no gate bowered by roses awaited my hand, no patch of lawn or border of fragrant pinks met my eye. In fact all that separated the house from the street was a lean strip of sidewalk, decorated at that moment by a couple of candy-bar wrappers. Nothing separated the house from its two neighbors; they shared common walls, ours rising higher because it had a second story. Aside from the fact that it had recently been painted Bermuda pink, it was a no-nonsense stone box, devoid of frills.

The frills were inside. The living room was, at first glance, so

overwhelming that what the landlady looked like and what she was saying failed to register. The room was so *little*. So full of *things*. Samplers under glass. Della Robbia plaques. Venetian water colors in heavy gilt frames. Corner cupboards stuffed with porcelain. A wall of books. Lamps with lace shades and velvet bows. A ship's clock. Ceiling lights with crystal drops. Red brocade draperies, red damask chair seats, red and white pillows, red chintz slipcovers. Oriental rugs. Striped wallpaper. Pattern rampant everywhere.

But even as despair mounted, I recognized the effort that had been expended to make us welcome. Everything was spotless. The woodwork was freshly painted. The brasswork gleamed. Table tops were mirror-bright. A glorious bouquet of Michaelmas daisies stood in front of the fireplace. Shame overwhelmed me, and with a contrite heart I turned to our landlady. Maybe if I concentrated on *her* instead of her house . . .

She was a tall woman, bigger-boned than the English women I'd previously met, and so regal of manner that Lady Headington seemed a much better name than her own. She was saying, "The clock should be wound once a week, you open the crystal with this key and wind with *this* one; and that's really all that needs looking after in this room. Except for the barometer. It must be kept upright"—she was talking now to Red—"at all times. Is that clear?"

"Yes, *ma'am*," he said.

We followed her then into a tiny enclosure that served to link the house with a shedlike wing projecting to the rear. "This is the solarium," she said proudly. "I'm leaving my plants for you to enjoy." The room had a corrugated plastic roof and one glass wall, and on the others there were pots of geraniums, ivy, and other pendant vines; a jungle of them. A two-foot lemon seedling and some ferns occupied pots at our feet. My thumbs,

never too green, paled further, but I murmured, "How nice!"

She led us upstairs next—the risers were so high and the treads were so narrow our heels hung over when we climbed—to the two bedrooms and the bathroom. None of these was rectangular. The wall facing the bathroom door was so sharply angled the door barely cleared it. The bedrooms had bays and setbacks, filled-in fireplaces, and remnants of beams: evidence upon evidence that various owners had done a lot of tinkering.

"How old is this place?" I asked, noting a frayed sash cord in Red's bedroom.

Lady Headington shrugged. "Oh, a hundred fifty years, I dare say. Maybe two hundred. Your son will be careful with this chest, won't he? It's a Chippendale I'm rather fond of."

The doorbell rang.

In a minute she called me down. There, with a bouquet of flowers in his arms, a worried look on his face, and a desire to know whether the house was satisfactory, stood Mr. Bennett, the domestic bursar (that is, the business manager) of Balliol College, who had rented it for us. I had never been presented in person with a sheaf of flowers; in my experience this sort of thing is a prerogative of prima ballerinas. So I was too effusive as I thanked him, which made him even more nervous.

His jumpiness was understandable. Oxford had recently had in residence some rather difficult—and vocal—American wives, and for all the bursar knew I might be another. Signs pointed in that direction: among the spirited letters we had exchanged was one from me saying that I would not accept a house without central heating, and one from him saying that the best house he could find—this one—didn't *have* central heating. So here we were.

"Have you had a chance yet to check the silver?" he inquired. I hadn't, so we did it together. What a table I was going to set!

The college had sent up a complete service for twelve: luncheon forks, luncheon knives, dinner forks, dinner knives, teaspoons, dessert spoons, serving spoons, coffee spoons, fish knives, fruit knives, cheese knives, carving knives, teapots, coffeepots, water pots, mustard pots, jam pots, cruets, sugar shakers, salt cellars, serving dishes, big pitchers, little pitchers, trays, toast racks, and —whee!—a bucket for icing champagne.

It was only after Mr. Bennett had bowed himself out—allowing himself a frosty smile on departure—that I realized that the dining-room table would seat, at most, six people. And that the dining room was so located that guests would have to pass through the kitchen to get to it. The possibility of our giving formal dinner parties suddenly grew very remote.

The kitchen and dining room were housed in the wing that the "solarium" linked to the house. Both rooms had casement windows along their entire length, and were light and open and inviting. Under the kitchen window was a six-foot table—the biggest unobstructed expanse of surface I'd seen in the house—and my eye lit on it with joy. But what my gaze lingered on was a large, buff-colored, enamel range, its back guard and black flue pipe towering ominously over an iron cook-top. Surely this was the "solid fuel cooker" about which Mr. Bennett had written me. " 'Solid fuel cooker,' indeed!" I had said to George. "I'll bet it's a plain old coal stove." And so it was, as one glance at the scuttles standing beside it confirmed, except that the cooking surface on the top was a metal plate with a hinged enamel cover.

Lady Headington called it "the Rayburn," and proceeded to instruct me in its care and feeding. It was not only a cooker but also the source of our hot water, she said. She showed me where the water pipes left the firebox, arching up the wall and traveling behind the shelf over the sink, finally to disappear in the greenery

of the solarium; they emptied, she said, into a tank in a closet off the living room.

Flinging open the Rayburn's upper right-hand door—"Jolly little fire in there now, you see"—she armed herself with a pronged metal handle, hooked it into a rod, and shook down the fire, thus releasing a cascade of sparks and glowing coals into the ashpan. Then she opened the lower right-hand door, gave the tool in her hand a twist, and hooked it into the ashpan. "Empty this twice a day," she ordered. "Like this." She trotted outside, pan full of glowing embers outthrust like a fish impaled on a spear, and dumped it into a sieve over a bucket. The ashes sifted through, and the coals were thriftily returned to the fire pit.

Then, kneeling by the Rayburn's ashpan door, she pointed to a slotted circle at its base. "See this vent? Keep it open just a bit, the fire won't burn without air from below. And the *other* damper"—she suddenly stood up and withdrew a plate at the base of the flue pipe—"must come way out if you want a hot fire. There's an indicator here"—pointing to the upper of the two left-hand doors—"that tells you how hot the oven is, and *here*"—flinging open the other left-hand door, which brought her down to her knees again—"is the warming oven. It's fine for making Melba toast and drying shoes."

A city girl all my life, without even camping experience behind me, I must have looked as frightened as I felt. Lady Headington sought to reassure me. "It's quite simple, really; you'll get the knack in no time. And if by chance the fire should go out, don't worry. I've had an electric coil installed in the water tank. It's useful in hot weather, when you won't want a fire in the kitchen, and you'll be grateful for it when you let the Rayburn go cold to clean the flue. . . ."

"Clean the flue?" I quavered.

"That's right, I *did* neglect to mention that little odd job, didn't I? Once a month, if you don't mind. Soot fires can be rather messy. The brush is on a peg in the corner. And there's stove blacking in the cupboard."

I noted with relief that the kitchen also contained a tiny gas range. There was a small refrigerator, too, comparable to those of the 1930's in the United States, with no back on the freezing compartment; and a pantry. Behind the door was a shallow cul-de-sac in whose shadowy depths I glimpsed an ancient Hoover. An electric iron and household cleaning supplies were on a shelf. (Regrettably, I never used the stove blacking. Nor the lavender-scented bowl cleanser.)

Throughout the house I had noted an odd assortment of heaters: one or two to a room, in addition to the living-room fireplace and the two ranges in the kitchen. From Lady Headington's manner as she pointed them out, I had gathered that this was a colossal amount of equipment. It pleased her to have me recognize the fact. She had assembled so much, she said, because Americans like their rooms boiling hot.

(And don't try to tell the English anything to the contrary. You can convince them—maybe—that the streets of Chicago are moderately free of gangsters these days, or that *some* American children obey their parents, but you can never, never convince an Englishman that Americans like their rooms other than boiling hot.)

The electric heaters—I soon learned to call them electric fires—were self-explanatory, but the others baffled me. They were of enameled steel, approximately three feet square, with neither flue nor cord. "Oh, those are paraffin heaters," my mentor said. "I believe your word for the fuel they burn is kerosene. They're efficient and economical—and easy to manage, too.

"One lifts the lid . . . See? There's the reservoir. Holds a

16

gallon. The drum is outside, the ironmonger will keep it full for you. . . . Now, to light it, you raise this wire guard, remove the cylinder, turn up the wheel on the right—it releases paraffin to the wick, you know—and set a match to the wick . . . So!" The wick was a strip of stiff webbing, and I watched in fascination as the fire crawled around it. Lady Headington continued, replacing the cylinder as she spoke, "Now, when the dome on the cylinder glows red, the wheel should be turned down again. That's all there is to it; very simple, once you get the knack. . . . Flames? Oh, so there are. A bit too much paraffin, I dare say." She spun the wheel lower, then, as an afterthought, remarked, "By the way, watch the wicks. If they aren't trimmed properly or replaced as needed, you'll be bothered by smoke."

Well, I told myself, *at least the paraffin heaters are smaller than the Rayburn. Perhaps they'll be easier to subdue.*

Lady Headington gave us lunch, but hurried us through. "Thursday is early closing," she said, "and if you wish to lay on supplies we must get to the shops before one." The butcher shops shut their doors on Monday and Saturday afternoons, in addition, she told us; and the wine merchant was open (for the purchase of spirits) only during "hours," which I later found out meant during the same hours the pubs were open.

The rain had stopped, but the air was heavy with moisture and the sky was still gray. Umbrellas in hand, we set out—skirting puddles, hopping over curbside rivulets, and dodging the chestnut trees that hung dripping heads over garden walls. First we went to Mrs. Bond's shop at the bottom—I would have said, "at the end"—of the street, for the few staple groceries I knew I'd need immediately. At Berry's, the bakery, I bought a small round loaf of bread, receiving it with a piece of thin paper loosely wrapped around part of it. At Murchison's the Headington Greengrocer, I added newspaper-wrapped pota-

toes, carrots, and a limp head of lettuce to the bundles in Red's arms.

Our final stop was H. E. Weaver's Quality Meats, and there I made a mistake. Walking along, I had made a quick calculation as to what might be the simplest menu to prepare, and I had answered myself: a good Irish stew. So I asked Mr. Weaver for "a pound of beef for stew," expecting the succulent squares of chuck that the same request would have produced at home. I don't know what he gave me, because I never ordered it again. . . . But I'm getting ahead of my story.

I had finished unpacking our suitcases when, in the late afternoon, George arrived. He had picked up the car we had ordered before we left home, and had driven down from London. (Oxford is actually north of London, but since in England one always goes up to the capital, travel in the reverse direction *has* to be down.) I had not noticed upon arrival that there was a pub across the street, and now the curb in front of it was solid with parked cars. Consequently George had to back and fill for ten minutes before he was able to get our car into the narrow garage. Later on he refined his system of garaging so the car slid in like a sausage into a casing; sometimes, in fact, he positioned it so smoothly that one could open the doors on *either* side. But that accomplishment was still in the future, and he therefore entered his new English home for the first time tired and cross.

Determined not to burden him further, I turned Pollyanna as I showed him around the house, Red drifting silently behind us. But George reads me clearly; he kept saying, "Well, now, isn't that nice?" in much too hearty a manner as I called his attention to the bouquets, and to the ship's clock; to the big kitchen table, and to the door that opened off the dining room into the garden; to the simplicity of the decoration in our bedroom, and

the fine big closet Lady Headington had had newly built into a corner there. His only reference to the living room was oblique: "I guess we're going to have to learn to keep our elbows in, eh?"

Meanwhile, renewed rain pattered gently onto the plastic roof of the solarium and gurgled down the spout just outside the kitchen door, and the stew bubbled along on the top of the Rayburn. While I set the table with my gleaming college silver, George essayed a fire in the living-room fireplace. He's a master fire builder at home, but in California one burns wood; and now he was using coal. He tried paper spills, then live embers from the Rayburn, much pumping of the bellows, and finally a dollop of paraffin. (*George*, who normally considers the application of fire-lighting fluid to be as shocking a practice as dousing a steak with catsup!) But the fire wouldn't catch. He cursed it while I cursed the stew. After four hours of cooking a fork still wouldn't penetrate the meat.

At 8:30 I said, "Let's eat it. If we cut it into small enough pieces, we won't even have to chew it." I *did* chew one piece of mine, to see what it tasted like, and it didn't have any taste.

Red, sensing my distress and doing his best to relieve it, said, "The potatoes are awfully good, Mom."

"I'm glad you like them," I said with savage politeness, and burst into tears.

I lay awake for quite a time that night, listening to the rain on the roof and looking at the pattern thrown on the bedroom ceiling by the lamp across the street. I thought about the stew. *Tomorrow's dinner will be good,* I promised myself, and wondered whether I'd be satisfied to be just a housewife, after having had a paying job for all those years. I said a little prayer for Redmond's happiness in his new school, and for the success of George's lectures. *They say that Oxford undergraduates refuse to attend lectures. What if no one at all comes?* I let my thoughts

drift back to the electric range in my California kitchen, and to the furnace we lit by pressing a button, and to the big living room in our Spanish-style house, with its unadorned white plaster walls and its wide open spaces of rug and its quietness of shape and color. *Now, that's enough of that,* I told myself. *You're not going to be homesick, ever again.* The ship's clock downstairs struck eight bells, and the street lamp across the way dimmed out, and before long I fell asleep.

2

WE awakened to a blue and gold world. The air was so clear it made us blink, even looking at it from indoors—and who could stay indoors on a morning like this one? Breakfast could wait; out we went.

There ahead of us was a pretty little gray and white bird splashing about in the bird bath in the center of the graveled side yard; whenever he flickered his wings, he stirred up a tea-cup-sized tempest of droplets and set them flying in shining parabolas into space. Atop the handsome old stone wall that bordered the yard sat a mammoth black cat with topaz eyes, staring gravely at the bird. And in front of the gate that opened into the garden there was a turtle that seemed to be smiling and wagging his tail. This was not such a silly notion, as it turned out, for the turtle was a neighbor's house pet, was very fond of paying social calls in the neighborhood, and in due course became rather a nuisance. But on that first morning in Oxford the turtle and the cat and the bird gave us the feeling that Peter Rabbit and his friends had turned out to welcome us.

The garden behind the gate was over a hundred feet deep, with lush turf; there was a bed bright with dahlias and daisies in the foreground and a vegetable garden in the rear. There, too, were five apple trees, one as gnarled and twisted as a Monterey cypress, and at their feet some rosy windfalls glimmered.

George, reared on a Nebraska farm, estimated the coming

harvest. "Gee, honey, there must be three or four bushels on those trees. Think of the apple pies you can make."

This was a gibe, for my failures with pie crust were family legend, but I let it pass. "Heavens," I said, "even if we get 'em picked, wherever are we going to *keep* them?"

"Over there," George replied, pointing to a storage shed he had spotted at one side of the garden, half hidden in a tangle of vines. Lady Headington must have used it for the same purpose, for it contained paper-covered shelves that gave off a faint fruity odor. Over the door we noted a fading stenciled name, "BLAZE"; the next day, when we met our part-time gardener, he told us that Blaze was an 'orse the previous hoccupants of the 'ouse 'ad 'ad.

The fire in the Rayburn had gone out—we had forgotten to stoke and bank it the night before—but in this morning's mood we didn't care. While George rebuilt it, I set about frying bacon and eggs on the little gas range. It was like those one sometimes sees in American Pullman kitchenettes, except that its oven was not equipped with jets for broiling. Instead, they lay in two rows directly below the top burners, in a six-inch cavity between the burners and the drip tray. Into this cavity one could insert a grill pan just big enough for three chops or four slices of bread. I never had any trouble broiling chops, because I could hear them sputtering, but since I couldn't see the bread and forgot about it, the toast we ate in England was usually burned. (Unless we ate it away from home; then it was pale tan and cold. English housewives toast it before they start the coffee, then carefully set it off to one side to cool to proper temperature for eating.)

The reason I burned the toast that first morning was that the mailman and the milkman arrived together—the mailman on a bicycle, which he parked at the curb as he peeled two

letters off the bundle in his hand, and the milkman in a gleaming white truck labeled "Job's Dairy." Would we be wanting him to serve us regularly?

"Oh yes," I said. "We'll need a quart of homogenized milk . . ."

"It doesn't come homogenized, madam. The Guernsey is very nice."

"Fine. A quart of Guernsey, then . . ."

"It doesn't come in quarts, madam. Just pints."

"Fine. Two pints, then. And perhaps some half 'n' half, or the equivalent? In the States, we like it for cereal. It's half milk and half cream, homogen—oh! Well, perhaps you'd better leave another pint, then. We'll use the top milk."

British immigration officials had been pleasant but firm, and our passports were clearly stamped: "Permitted to land at Liverpool on 16th September on condition that the holder does not remain in the United Kingdom longer than twelve months, and registers at once with the police." The "at once" had been stressed, so as soon as the fire in the Rayburn was crackling away again, and the breakfast dishes were dried, we gathered up a street map and the photos of ourselves that we had been told to bring, and set out for the Oxford police station.

Headington is two miles from the city center, and on higher ground. The street we followed descends the hill through a deep cut over which the tree tops join; at that time of year driving through it is like tunneling through a green cavern. At the bottom lies a flat plain that is called The Plain, and on the left we noted a sweep of incredibly green meadow in which several placid horses were grazing. I thought, *How lovely. And how strange I didn't see this yesterday when the taxi brought us up from the station.* The meadow was particularly restful

to the eyes because it was bordered on all sides by ugly row houses of red brick.

The street, wide up to this point, suddenly narrowed; and as suddenly filled. Cars and busses seemed to spew into it from a series of side streets, and we inched along until a bend brought us face to face with a roundabout (a traffic circle; the British prefer them to intersections controlled by traffic lights). It resembled a runaway carousel, and I caught my breath. But George, thanks to his drive from London on the previous day, was a veteran, and he tackled the maelstrom ahead of us with cheer and confidence.

"There's no right of way at these," he explained, his head swiveling and his foot ready on the gas pedal. "The trick is to cut in front of the first driver who hesitates. A good time to catch 'em is when they're shifting gears . . . So!" He shot into the stream like a salmon in springtime. I would have congratulated him, and he would have congratulated himself, had we not just then found ourselves facing one of Oxford's most beautiful landmarks—the stone bridge that spans the Cherwell River, Magdalen (pronounced "Maudlin") College, and its magnificent fifteenth-century tower.

Solidly set, strong and simple, the tower's lower windows are narrow and unornamented, and its tawny stones are rough in texture. But slenderness gives it a vigorous upward thrust, and heaven touches it as it rises. The upper windows are high and elegantly arched, the stone is smooth, there is ornamental fretwork and gallery around the belfry, and at the summit a series of feathery pinnacles fling themselves into the sky. In its frame of trees, sky, and water, and despite the vitality of the tower itself, the view across Magdalen Bridge is a tranquil one. There is a soothing spaciousness about it that we came to appreciate even more fully as we discovered its rarity in modern Oxford.

After we had crossed the bridge, the city closed in. Oh, High Street curved on sweetly enough—past the classic cupola of Queens College, the lace-frilled church of St. Mary the Virgin Church, and the austere spire of All Saints—but on that day we couldn't see the beauties that lie beyond the curbs because we didn't dare lengthen our focus beyond a car's length. There is a chronic traffic tangle on this street, since it leads to the Carfax, the only real intersection in Oxford, the one place where north-south and east-west traffic meet; but on the day of our baptism we had made the mistake of tackling the town during the morning rush hour, and vehicles were approaching this intersection in a spirit of no quarter given, none expected. The street was raucous with the roar of motors, and a bluish haze born of exhaust smoke eddied about the patient queues of people at the bus stops. No sleepy university town, this; it was like traveling on a cross-town street in Manhattan at high noon. When George finally managed the necessary left turn at the Carfax and a short run south on St. Aldate's Street brought us to the police station, we felt as if we'd found sanctuary.

Incidentally, it's an odd feeling to be registered as an alien, if up to that moment in your experience *other* people have always been the aliens.

That formality completed, George proposed that we go to see Balliol. To get there seemed simple enough: we'd retrace our route on St. Aldate's, but instead of turning toward Headington at the Carfax we'd go straight ahead to Broad Street. We noted a puzzling detail, however: although the street we'd be following on the other side of the Carfax appeared to be a direct continuation of the one we were on, it had a different name—Cornmarket Street.

Red, looking at the map over George's shoulder, made a related discovery. "High Street quits at the Carfax too," he said.

"On the other side it's called Queen Street. And look: it forks almost right away, but one fork is called New Road and the other is Castle Street."

"Yes, that's right," George said, having scanned the entire map. "Street names change at each intersection. Now I understand why Peters"—an Englishman recently in residence in California—"thought it worth mentioning that he drove west on Sunset Boulevard for twenty miles and it was *still* Sunset Boulevard."

"I remember too that he was shocked by the house numbers in five figures," I recalled. "Now I see why."

We crawled north on Cornmarket Street, past the musty Victorian façades of food stores and bakeries, a bank and some dress shops, and then found ourselves stalled between the twentieth century and the tenth. The twentieth, on the left, was an enormous, shiny, glass-fronted, fluorescent-lit Woolworth's that people were entering and leaving like bees at a hive. The tenth century, ahead on the right, was a rubble tower of modest height, as rough as Woolworth's was slick. Red checked the guidebook: "One of the few remaining examples of Saxon architecture in the city . . . Gaunt, unadorned, with round-headed windows, good for shooting from with the bow. . . . It was here that the North Gate, which included a prison called the Bocardo, spanned the street. . . . The inmates used to let down a greasy old hat and cry to passers-by, 'Pity the Bocardo birds!'"

I tried to visualize the street as it might have looked with a gate and watch tower from which archers showered foes with arrows, and where tenderhearted townsmen tossed a few pence to the poor birds in the Bocardo, but Woolworth's and the autos all around us kept getting in the way. Nor, as we passed the tower, was it easy to banish the packed-tight buildings on its other side and replace them with either the earth embank-

ment of William the Conqueror's day or with the stone wall that enclosed the city about the time King John had signed the Magna Carta at Runnymede. However, it *was* easy to locate the broad ditch that had protected both of these walls. We parked in the middle of it. It had been filled in, becoming a broad street. Balliol College fronted on Broad Street.

Our first view of Balliol was disappointing. It was just a chain of dirty, gray stone buildings with a Scottish baronial tower on one end, at the base of which was a door that looked as little as a mousehole. No matter; we had been told that the Oxford colleges hide their beauties, and we started across the street toward it.

That's when I noticed a brick cross set into the cobbled street, flush with its surface. "I wonder what it means?" I mused.

"That's easy," Red said. "Something religious happened here."

"Let's be sure to look it up in the guidebook later," I told him.

Stepping through the little door of the college, we found ourselves in a stone foyer. The walls on one side were hidden by stacks of trunks and boxes, heralding the return of undergraduates who would soon be arriving for the fall term. A doorway on the right led into what could only be the porter's lodge. There were pigeonholes for mail, a telephone booth, a counter, and behind it a tidy little man in sober black.

But we barely glanced at him, because standing there too was a man with bushy iron-gray eyebrows and a wild mane of hair that almost reached the collar of his tweed jacket. There were leather patches on the elbows of his jacket; his trousers had gentle bags that were quite independent of the current position of his own knees; and an umbrella as formidable in size as a medieval broadsword hung over one forearm. I thought, *A don at last!* He shuffled through the mail in one of the pigeonholes,

27

withdrew a notice, shifted the umbrella to his right hand, and walked past us as unseeingly as if there had been no one there. Surely this had to be a don. I was enchanted.

Then George heard his name called. Stepping through the mousehole was a man whose appearance and manner were so commonplace that I didn't peg him as a don, too—although he was in fact equally one with the other. Romantic notions die hard, and I felt cheated when I finally got it through my head that don is simply a contraction of "dominus" and is the Oxford title for anyone who teaches at the university. A don may or—more likely—may not look as if he's gotten up for a fancy-dress ball.

"Why, it's Roger Mackenzie!" George exclaimed, pumping the newcomer's hand. "Honey, I first knew Roger at Harvard. He's visited the United States often, and gave a fine seminar at Caltech just last spring. Roger, are you a Fellow of Balliol?" Roger was; and I could see George relax. How pleasant to know already one of his future associates.

"Have you been here long?" Roger inquired, and we told him that this was our initial visit to the college, and that we had arrived just before he had. "Well, let me show you round," he said, and we gratefully followed him.

Beyond the entry lay a grassy quadrangle, its four sides formed by stern, stone buildings that Roger identified as the library, the chapel, undergraduates' rooms, and offices. The windows had an icy stare. We ducked through a narrow passageway and into the chapel, a walnut-paneled room with lots of stained glass, a silver altar, and a gleaming brass lectern. Somehow it looked more like an authentic copy of something than the real McCoy; and I found out later why this was so. It was so heavily restored in the nineteenth century that nothing remains of the original

28

chapel except a few bits of fourteenth- and seventeenth-century glass that have been preserved in the modern windows.

But through another narrow passageway a little jewel awaited us: the Fellows' Garden, a low-walled enclosure with benches and flowers and turf so well tended it had the unreal look of stage grass. As I took a step forward into it, Roger hastily said, "I'm sorry. It's the *Fellows'* Garden." He paused discreetly, but I still looked blank. "For their exclusive use," he continued. "Others don't—er—enter."

However, others do enter the big quadrangle behind it, and it was a lovely sight. Fleecy puffs of cloud now speckled the brilliant blue of the sky, the smooth lawns sparkled in sun, and there was enough wind to set the branches of the lofty elms and chestnuts dancing. At the far end of this garden was the dining hall, and Roger led us up the stairs to look in.

Almost three stories high, the huge room was dusky even on this bright day. The stone walls and Jacobean oak paneling blotted up the small amount of light admitted by the Gothic windows, and the heavy beams arching across the ceiling were swallowed in shadow. Small sections of each window were open, but each was masked by a wide-grid screen—a modern touch that struck me as odd, and I said so.

"Oh, but they're necessary to keep the birds out," Roger said. "Great numbers of sparrows used to perch on those beams, and it was sometimes unpleasant for the diners at table below . . ."

I could imagine.

". . . because the birds liked to take dust baths up there, and they did dislodge rather a lot of debris."

The tables were long and narrow, three columns of them, each with benches, and they were set at right angles to a dais that spanned one end of the hall.

"That's High Table," Roger explained. "Where the Fellows

sit." Then, speaking directly to George, "I hope you will join us often; we've a good chef and a fine cellar."

George grinned at me. "Men only, honey."

I said, "All the time? Don't you even have Ladies' Night, or something of the sort?"

Roger smiled. "No, I'm afraid it's an unbreakable rule that women may not dine in Hall during term. We were never a college for the clergy, like Merton, nor supported by a religious order, like Worcester, but there is a monkish residuum at *all* the colleges. There was a time, you know, when Fellows were supposed to be in orders, and it wasn't until late in the nineteenth century that we were allowed to marry."

As he talked, we had been sauntering around the hall, glancing at the portraits that studded the oak wainscot, and at this point Roger broke off his discourse and pointed to one. "John Wycliffe. He was Master here."

"Wycliffe the Bible translator?" I asked.

"Yes, but that was afterwards. He was Master of Balliol around 1360." (How easily he said, "1360"; as if it were just last week.)

"And up there is the Founder, John de Balliol, and his wife," Roger continued, gesturing toward a pair of portraits hidden in the gloom. "He was a North Country baron who started the college for the support of sixteen poor scholars. It was a penance laid on him in 1260 or so by the Bishop of Durham. I don't know what he had done to deserve it."

"But what I don't understand," I said as we left the hall and stood gazing down at the big quadrangle and the multicolored brick tower beside the chapel, "is why, if the college is so old, it looks so, well, *Victorian*."

Roger chuckled. "Most of the buildings *are* Victorian. They replaced old ones or were given during our great period of growth in the nineteenth century. People like Southey and

30

Swinburne and Matthew Arnold—and the great Master, Jowett—made us famous. Now we're said to have the best brains and the worst food in Oxford."

"I thought you said the chef is good," George reminded him.

"He is," Roger replied. "There's a twenty-year time lag on this sort of thing."

We were proceeding along a stone-flagged passageway when I stumbled and steadied myself by reaching out toward the wall. My hand came to rest on wood, and I turned to look. Hung against the wall was a very heavy and seemingly ancient door, so black it appeared to be charred.

"That used to be one of the college gates, and it *is* charred," Roger responded to my query. "It got scorched when Archbishop Cranmer was burned at the stake in the ditch that used to run along in front of the college; it's Broad Street now."

"The cross in the street!" Red exclaimed.

"Oh, you noticed it?" Roger replied. "Yes, there. Did you also notice the Saxon tower on Cornmarket before you turned into the Broad? In the sixteenth century it was used as a prison. They say that when Latimer and Ridley—they died a year before Cranmer, in 1555—were put to the stake, the archbishop was brought to the top of the tower so he could see what was in store for him. Rather gruesome, what?"

"But the cross is quite some distance from the present entrance," I demurred.

"Well, it was quite a fire," Roger answered. "I don't know how true this story is, but I've been told that the wood was characteristically so damp that condemned heretics didn't so much burn at the stake as slowly roast to death."

I swallowed painfully.

"So it was the humane custom in those pre-Elizabethan days to allow the victim to buy gunpowder and secrete it on his body.

But Cranmer is said to have refused the comfort, if one could call it that, of death by explosion; and he died so slowly and so agonizingly that someone finally took pity on him and tossed a bucket of pitch on the fire. That's why it blazed up fiercely enough to scorch the gates of the college."

"The good old days," George murmured.

"A hard lot, our forbears," Roger agreed.

Then he took us to the west door of the college and pointed out, on St. Giles' Street, a slim gray stone spire as richly embellished as a wedding cake and approximately twenty-five feet high.

"The Martyrs' Memorial," Roger explained. "It was put up in the 1840's. Read the inscription sometime, it's rather nice. 'To the glory of God, and in grateful commemoration of His servants, Thomas Cranmer, Nicholas Ridley, and Hugh Latimer, Prelates of the Church of England, who near this spot yielded their bodies to be burned.' Splendid rolling rhythm, don't you agree?

"Until quite recently, to climb the Martyrs' Memorial was a favorite undergraduate sport, but they can be sent down—you'd say 'expelled'—for it now, so they save their strength for weekend visits to Cambridge, or for holidays on Snowdon."

3

"WHAT makes Oxford so confusing," I said at breakfast the next morning, "is that the chronology is so mixed up. You have to keep hopping from the Reformation to the Norman Conquest to the industrial revolution, and at the same time you're signing an application for a telephone or buying some frozen peas for dinner."

George grinned. "What did you expect? Another Williamsburg, with people all dressed up in hoop skirts?"

"Well, it would certainly be easier on a tourist," I rejoined.

"You're the one who kept talking about living history," Red reminded me.

"And how being here would deepen 'our understanding of our own culture," George added.

"Oh, quit needling me." But they were right: I'd had a worse case of nostalgia for the homeland than either of them. Not that Britain was in any physical sense a homeland to any of us, except way back, when the Bothwells and Joneses and McClures on my family tree, and the Albros and Spaldings on George's, had emigrated to the United States from their various corners of the British Isles. But there was French and German blood in us, too, and we had no family ties to anybody outside of the United States, so the only explanation for my feeling that we were coming home to England was sentiment.

A good many Americans feel so, even if their names are

Martinez or Stepanek; I dare say it's because we hear about the Pilgrim Fathers so often and from such a tender age that by the time we find out that there were Dutchmen in New York and Spaniards in St. Augustine we think of them as foreign interlopers. Through school, almost the only non-native literature to which we are exposed is English, and almost the only history we study, after our own, is Western European. And somehow the names and scenes that linger, hazy with romance and bright with derring-do, are Robin Hood and Sherlock Holmes and Nelson dying on the quarterdeck. Good Queen Bess was on the throne in . . . 1066? 1215? 1588? Anyway, *she's* the one for whom Raleigh spread his cape. Eliza's rain stays mainly on the plain. And Burma is . . . ? Oh yes, Burma is where the dawn comes up like thunder out of China 'cross the bay. God bless us, every one!

Out of such stuff—if it has turned one into an Anglophile— has evolved an expectation that the modern Englishman will be a paragon of the civilized virtues, his character as stout as Churchill's, his manner as suave as the Schweppesman's. Since the English themselves rather agree with this view, it is no wonder that so many Americans go to England feeling like raw colonials —even Americans as basically sensible as the three of us.

We knew, because we already knew some Englishmen, that they come in assorted sizes, shapes, and casts of mind, and that stereotypes are treacherous. But emotional attitudes lie deep. It was at this time, too, that our own and other periodicals were leveling a drumfire of criticism at Americans abroad. We are boastful, loud, and arrogant, they told us. We equate a high degree of civilization with how well the plumbing works. American women are immodest. American men are Milquetoasts. And our young are savages. This is no more true than that all Englishmen like well-done beef, ride to hounds, or have stiff upper lips, but it had its impact on George and Red and me.

34

Just below the surface of my mind was a resolve not to be bossy in public or shrill in speech. George, despite the fact that he is a distinguished scientist and teacher, was awed by the reputation of Oxford, and fearful that he wouldn't measure up. Red doesn't wear his heart on his sleeve, but I had noticed a tightening of the mouth and a squaring of the jaw whenever his new school was mentioned, and I think he expected the boys to have parade-ground bearing and tea-party manners, and the teachers to be as cold as fish.

It's hard now to recapture the feeling of timidity with which we three set out that morning to meet the headmaster of Magdalen College School, to which Red had been provisionally (we *thought;* it had never been said in so many words) accepted. Although we had been corresponding with the Master for almost a year, if he didn't now like our accents or the cut of Red's jib, he could still reject the boy.

An Oxford friend had recommended the school; the Master had sent its entrance exam to Red's "headmaster" at his Pasadena junior high school; and the whole administrative staff plus ourselves had been torn between laughter and tears as we had studied it. Red had been nearly fourteen then, in the ninth grade, and was just starting Latin and algebra. Yet the exam, which English boys take at thirteen, required knowledge of both Latin *and* French, algebra *and* geometry, and there was even a section to test his familiarity with Scripture. It was obvious that he couldn't pass it. Since we had already read in the school catalogue that "boys of 11 or less at the time of entry are not expected to show knowledge of Latin, French, Algebra, or Geometry, but will have an opportunity of doing so," we accepted as fact that our young product of the American public schools was far, far behind his contemporaries in England.

Besides, the Sputniks had gone up just a few months earlier,

and Americans were reeling with shock—including me, who should have known better. My newspaper specialty for many years had been to report news of education. I'd been in so many schools I was frequently taken for a teacher, and I knew perfectly well that those members of our citizenry who were attacking our schools as failures had obviously not been near one lately. Nevertheless, if one hears often enough that American children are always put back a year or two in England, or that the academic standards of English schools are much higher than those of American schools, or that discipline is much tougher and grading much more objective, it's hard to disbelieve.

The Master of Magdalen College School had told us that foreign boys need not pass the entrance exam, and together we had outlined a program of private study to prepare Red for his English year. In addition to the Latin he was taking at school, he had been privately tutored in French. And as soon as summer vacation began, he did a cram course in geometry, and extended his acquaintance with Caesar and the subjunctive. So here he was in Oxford, ready or not, and there we were descending Headington hill in dappled sunlight, and in a very few minutes we found ourselves at the door of a monstrous Victorian mansion across the bridge from Magdalen College.

The school takes boys from nine to eighteen, many of the younger ones on musical scholarships. It is supported in part by the college across the way, in order to have a handy supply of choirboys for its chapel services; in fact, one of the tourist attractions of Oxford is to watch the choristers, in pint-sized caps and gowns, trotting across the bridge for Evensong. But Red is no singer, so he was to enroll—if they'd have him—as a paying student.

When our ring was answered, we were led through a dim hallway into a dim study. There the Master, a dim silhouette

against what light there was, greeted us. A short, graying man with a bristly mustache, a soft voice, and a kindly manner (whom had I been expecting? Wackford Squeers?), he asked Red some questions about his background in math and science, and we all made small talk. Had our journey from the States been pleasant? Yes, very. We had accommodations in Oxford? Oh yes—a nice little house in Headington. Professor Beadle would be lecturing at the university? He was going to try. He was scheduled to give two series of lectures on biochemical genetics. How interesting. (We learned later that the Master is a Latin scholar and a historian, so he *was* being polite.) Finally George asked a question: How much was the tuition?

The Master paused and reflected. Then: "I'm not certain. I believe it was to have been increased this term. Let me inquire of the secretary." He excused himself and left the room; and we eyed his departing back respectfully. In as much as Mr. Bennett at Balliol had been unable to tell George at what intervals he would be paid, I was now convinced that English academic people dwell in a much more rarified spiritual world than we dollar-conscious Americans.

Outdoors again, the interview over, Red asked, "Did he accept me, Pop?"

George replied, "In the absence of a negative, we'll assume a positive. I guess you're in, boy."

So we went shopping for school clothes.

The school outfitter occupied a plain little shop with an oriental rug on the floor. The salesman spread out an impressive —and impressively priced—array of undershirts, underpants, knee-high wool socks, gray Viyella shirts, red-striped black ties, gray worsted trousers, red-bound black blazers, visored caps, red-bordered black Rugby socks, navy twill shorts and red Rugby shirts, a white wool sweater that looked good enough for the

Duke of Edinburgh, gray Shetland sweaters, a mackintosh, and a heavy wool duffel coat. We bought most of it.

The only items that were compulsory, he told us, were the cap and school tie, but most of the boys wore the blazer, too. Both it and the cap were ornamented with a lily embroidered in white. This symbol derives from the school motto, "Sicut Lilium," which derives from the lilies of Magdalen College. They in turn derive from the lilies of Eton College, which were borrowed in 1458 by William of Waynflete, Lord Chancellor of England and Bishop of Winchester, when he founded Magdalen College. I don't know where Eton got the lilies, and am willing to stop at 1458. It is impressive enough to know that Red's school was founded soon after the college from which it takes its name, and that on the day Columbus set sail for the Indies pupils at Magdalen College School were intoning their Latin lessons in a building extant.

Red was rather taken with himself in his new uniform. I too considered it an improvement over the blue jeans and cotton sport shirts he had been wearing at his Pasadena school. "But, Mom," he cautioned, "don't let the word get back home that I'm going to a school whose motto is 'Pure as a Lily.'"

As I watched the salesman total the bill, I said to myself that it was just because I was new in England that English money was incomprehensible, and that I'd get the hang of it in no time. This was a false prophecy; I never did. Not that it was difficult to shift from dollars to pounds as the basic unit, or to decide whether a given item was a good buy at its price. An experienced shopper can do *that* whether the medium of exchange is clamshells or coins.

My basic trouble was that I never learned to count my change. I'd repeat like a litany—"Twelve pence in a shilling, twenty shillings in a pound"—and find myself staring helplessly

at a fistful of huge copper pennies, silver sixpences, yellow three-pences, and those look-a-likes, the two-shilling piece and the half crown. I couldn't even pronounce them easily. Hardly ever did I go to the post office without eavesdropping in admiration as someone asked for a tuppence-ha'penny and two thr'p'ny stamps, and ten bob worth of savings stamps.

A tanner is a sixpence, a bob is a shilling, a quid is a pound, and a guinea *isn't*. It would be worth twenty-one shillings if it existed; or maybe it does, in a ghostly way, because prices of merchandise or services with snob appeal (i.e., Red's white sweater) are quoted in guineas. But whenever one pays a five-guinea bill by check—by cheque, I mean—it is written as five pounds, five shillings.

Loaded with bundles of clothing for Red, we drove back up Headington hill and shopped for the house. I was still, of course, in the sampling stage, getting acquainted with shopkeepers and stocks by trying them all.

In a country where cookies and crackers have to be bought as biscuits, where lemons are advertised as a condiment for pan-cakes and chili sauce is chutney, where tapioca is sago and is ground as fine as corn meal—speaking of which, there isn't any, the hopefully bought box of corn *flour* turning out to be corn*starch*—where, in short, so many foodstuffs come in un-familiar shapes and textures it was surprising to meet so many old friends: Heinz, and Birds Eye, Chase & Sanborn, Kleenex, Dreft, and Lux. These familiar brand names gave me a false sense of security, for the products that bear these names are blended for English tastes. The tomato juice was spicier and the coffee was more bitter than we were accustomed to, and even a Betty Crocker cake mix—her English name is Mary Baker—came from the oven much drier and more crumbly than in the United States.

But it was fun to buy and try, and that particular day's shopping spree yielded a treasure—a package of fruit gelatine that American grocers would do well to copy. Any woman who has tried to make up half a recipe of powdered fruit gelatine— what's half of three ounces translated into standard measuring spoons?—will appreciate my delight when I opened my first English package of the stuff and found a rubbery block of gum, scored in squares. Half the squares equal half a recipe: hail Britannia!

In addition to foodstuffs my shopping list that day included waxed paper, dishcloths, thumbtacks, and a couple of frogs for the bouquets I hoped to keep in the house. Since we had decided to plant a small flower bed in front of the wall outside the kitchen window, George wanted spring bulbs, and some kindling wood for both the fireplace and the Rayburn. We were having a tough time keeping either one lit.

We found the bulbs at a florist's shop, and they were so big, beautiful, and cheap that George got drunk with enthusiasm and bought ten dozen. My request for frogs produced, first, a blank look from the salesgirl; second, when the function of frogs was explained, a ball of chicken wire called a maizie; and third, a politely suppressed but unmistakable giggle. What odd names Americans give to ordinary objects!

The kindling turned up at the ironmonger's, where it was packaged as a neat little bundle of thin, six-inch-long sticks and was called firewood. Because there were so many hardware items on display I asked for the thumbtacks here, and ran into another language barrier. "They're metal," I said, "with broad flat heads and sharp points. I want them to fix some oilcloth to a shelf over my sink. . . . Oh? *Drawing pins?* Well, think of that. And I'll find them at the stationer's? Thank you."

At the stationer's I also found the waxed (that is, "grease-

40

proof") paper, but I never repeated the purchase. The stuff came in flat sheets rather than on rolls and was so stiff it crackled like parchment. As for the rest of my list, dishcloths seemed to be nonexistent in England. Pot holders too. I later imported some of both. The English housewife grabs a towel or the corner of her apron and wads it around her skillet handle.

That afternoon, as George was planting the bulbs, we had our first caller: Kitty Turnbull. A mutual friend had written her to look in on us, and since Kitty is both dutiful and curious, here she was—a modish young woman, her fair hair dressed in a bouffant Paris style, her tweeds faultless, her smile of greeting echoed in her eyes, her voice the bird song that makes the speech of the cultivated English woman so beguiling.

She had brought us a jar of marmalade and a marrow—which is a kind of giant zucchini—from her garden, and I gave her a glass of sherry. (I was too timid to propose tea, what if I forgot to heat the pot?) Later, when we took her on a tour of the place, she nodded her head in the direction of the side yard and remarked, "Isn't that *like* Americans, though! Improving the place, and you're only going to be here a year!"

I cooked the marrow for dinner. It tasted like wax, and the ice cream I'd bought the day before had the consistency of gravy when I took it out of the ice tray. But there were no tears that night. No house is strange once you've opened its door to a friend. No soil is alien once you've planted bulbs.

4

"WHAT are we doing today?" George asked the next morning.

"Picking apples. Name tapes have to be sewn on all of Red's school clothes. And shouldn't you go to the lab and let them know you're here?"

"Let's go on a trip, instead. I'd kind of like to see Stonehenge."

We got back three days later. We had traveled on some terrifying highways and beautiful byways, had fallen in love with pagan Britain and pub signs, had eaten incredibly uninteresting food at amazingly cheap and well-run hotels—and, in sum, had begun to understand why people who emigrate from England ever afterward yearn for it.

Oxford, fifty miles west and slightly north of London, lies in the center of the plain where the Thames rises. The nearby landscape is green and watery, and the fields flow away from the streams in long, undulating slopes. None is without a stand of splendid trees—linden or beech, elm or oak. Ringing the plain on the south and the west is open, windy country that rises into those uplands the English call downs. Sometimes one sees flocks of sheep idling along on the lower slopes, and leggy white pigs rooting around the trees. It was this country we explored, our route swinging across Oxfordshire into Wiltshire and down into Somerset, skirting the Bristol Channel, as far as Wells.

Before the Roman came to Rye or out to Severn strode,
The rolling English drunkard made the rolling English road.

42

. . . and there hasn't been any compelling reason for straightening it, so it still meanders through the countryside like a lazy river, its channels marked by hedges or windrows of saplings. There are surprises around each bend, like trinkets tumbling from one of those coiled-paper balls that children love to unwind: a thatched-roof cottage of Cotswold stone, salvia burning bright at its doorstep; a sweep of flatland supine under a canopy of rolling cloud; a squat gray church in a distant valley, its spire poking a supplicating finger above a smother of trees. These little panoramas flash into view and vanish as swiftly as if they'd been shaken out of a kaleidoscope, and we found them utterly enchanting.

We paid more attention to the landscape than to the road—at first. Then we learned that the surprise just around the bend might equally well be a lorry loaded with brick. It would come panting toward us up a grade, a big black sedan trapped in its wake. As we'd come in view of each other, the black sedan would pull out to pass—and do so, gravel spurting behind its wheels, while George swerved, braked, and cursed. *"The fool! The damn' fool! He crossed the double center line!"* Indeed he did. British drivers cross the center line as gaily as if they were winding a Maypole from Brampton to Bournemouth. The only English road more treacherous than the commonplace two-lane road is the "modern" three-lane highway. Motorists contest the right to use the center lane as ferociously as if the drivers were jousting in a medieval tourney—minus the chivalry.

The British death rate per automobile miles traveled was publicized while we were in England as almost 70 per cent higher than in the United States. The reason was obvious: only recently have great numbers of Britons been able to afford cars, and the highways are flooded with motorists who haven't yet come to grips with the fact that survival depends on driver

discipline. They fail to signal; they park on the road on blind curves; they maintain an erratic pace. They scared the daylights out of us. George's reaction was to avoid all main roads—which is a good idea anyway if you're not in a hurry, the virtues of shun-piking being self-evident—but my reaction was to avoid driving altogether. In fact that first jaunt of ours made such an imprint on me that I turned frail and timid, and never afterward drove the car in England.

English acquaintances who know the United States were astounded when they learned that I refused to drive. "But you drive at home, don't you?" one inquired.

"Yes, of course I do."

"On the—er—freeways?"

"Yes."

"Traffic jams moving at sixty-five miles per hour, that's what they are. Make you nervous?"

"Not particularly."

"Well"—here came the trump card—"the English drive *much* slower."

So they do. That was one of the reasons for my nervousness. Many vehicles go so slowly they invite foolhardy behavior by the drivers they inconvenience. I had the misfortune to be behind the wheel on a stretch of road near Swindon, when we came upon a very small youngster riding a very large bicycle up a hill. The road was a narrow slot between high and thorny hedges. To attempt to pass would have been utter folly, so I shifted to lowest gear and we crept uphill at the cyclist's pace. As he approached the crest, the child—despite manful exertions—began to wobble. Watching him was a nightmare in slow motion. But it was mercifully brief. Suddenly his front wheel yawed wildly, and he toppled into the dust. Fast on his feet, he was, too; back

44

on his bike and under way before I'd gotten our stalled engine started again.

George's nerves, however, were equal to such wear and tear, and when there was no alternative to traveling on a main road, his bravado matched that of our hosts. Oddly enough, to drive on the left (a traffic pattern that the English share in Europe only with the Swedes) caused him no difficulty—as long as we were in motion. There were occasional tight moments, though, when habit reasserted itself. Leaving a service station in the pretty town of Marlborough, and desiring to turn right, George swung into the near lane—as he would have at home—and found that this maneuver had placed us eye to eye with an oncoming double-decker bus. Fortunately it had good brakes, and so did we.

One of the joys of motoring in England is the absence of billboards. (The English call them hoardings.) We gladly swapped the occasional merriment provoked by Burma Shave signs for the aesthetic satisfaction of gazing at scenes from Constable and Turner. In towns and villages—and we went through one at roughly fifteen-minute intervals—the inn and pub signs were a recurring delight. Sometimes they had been mass-produced by a brewing company, sometimes they had been painted by loving hands at home, and occasionally they were genuine works of art. A pirate with a patch over his eye and pistols crossed over his chest marked The Crossed Arms. A dewy-eyed, fuzzy-maned king of the jungle welcomed us to The White Lion; a big-kneed, green-antlered deer to The White Hart; and a jaunty rooster to The Fighting Cock. George kept hoping we'd see a Cock 'n' Bull, but we never did.

A puzzlement was the occasional sign that labeled a pub as a "Free House." "Maybe they supply free peanuts or potato chips with your second pint of beer," George guessed.

"Potato *crisps,*" I corrected. "Potato chips are French fries."

"I'll bet they're free of some kind of control," Red said—a guess that was close to the truth. The keepers of free houses have no tie-up with a particular brewer and serve various brands.

At Avebury, George developed the passion for prehistoric stone circles that burned in him undiminished throughout our English year. It was misting that day. Below the dull gray of the sky the trees and grass in the giant Avebury ring had a somber bronze cast, and the ancient stones dripped water. They're not so very high—three to fifteen feet—but the protective rampart makes up for what they lack in grandeur.

Bounding through long grass, trousers wet to the knees, George explored the ditch that encloses the circle. "Must be forty feet wide," he reported in sepulchral tones from below, "and anyway fifty feet high. Gosh, what an earth-moving job. And without any tools. Isn't that what it says, Red?"

"Not quite," Red answered, reading the guidebook through a plastic film, then shouting down into the ditch. "It's supposed to date from the Stone Age; and *they* had tools."

"I'd sure hate to tackle a job like this with a stone shovel," George said as he scrambled back to us. "How big does it say the circle is?"

"Over four hundred yards. It's the largest and the oldest prehistoric monument in Britain."

"Now, we've *got* to get to Stonehenge."

We did, some hours later, and it added fuel to the fire. Even in rain—or maybe because of the rain—this much-photographed (and therefore familiar) antiquity was more awesome than I had expected. Unlike Avebury, Stonehenge rises from a flat plain, has no protective nearby village, no encircling embankment. Its huge slabs have the desolate beauty of Ship Rock or other lonely landmarks in the American Southwest, and they seem much

46

higher than their twenty-or-so feet. George was fascinated by the engineering of the lintels that span several of the slabs across the tops—"See how they're morticed!" "Look at that dovetailing!" —and speculated all the way to Bradford about the method of transport the Bronze Age Britons must have used to haul the "foreign" stones in Stonehenge all the way from Wales.

Bradford is a charming little town beside the Avon River. (No, not *that* Avon; another one. The name derives from the Celtic word for river, and it pops up all over England on streams miles distant from Stratford.) We paused on the outskirts and got out the yellow book that, together with Ekwall's Dictionary of English Place-Names, the Ogrizek guide to Great Britain, and a sheaf of ordnance maps, formed our motoring library. The yellow book, prepared by the Automobile Association, rates hotels by a system of stars, like a Michelin guide, and we were about to stay at a two-star hotel—having been challenged to do so.

It was Roger Mackenzie who had issued the challenge, a twinkle in his eye. "Five-star hotels are much too grand to be found outside of London," he had said. "You might find a four-star hotel in Bath or Bristol, but otherwise I'm afraid you'll have to settle for three stars. A two-star hotel is absolutely unthinkable for Americans, of course, because none of the rooms have private baths. Only the British patronize them. . . ."

So naturally we stayed at a two-star hotel, The Swan, in Bradford. It sold us so thoroughly on two-star hotels that we ever afterward sought them out. But Roger was right about them: we never ran across any other Americans in these citadels of Britishness.

Aside from the fact that our rooms had gables and leaded glass panes in the windows (one of which was stuck shut and one of which was stuck open) and that the view from them

down on the High Street of town was delightful, I have forgotten the exact appearance of The Swan in Bradford. I can, however, draw a composite portrait of British two-star hotels:

One enters them through a small dark foyer, in no sense a lobby, and often even bereft of chairs. Its dark wood dado is topped by beige paper patterned in faded scrolls of indeterminate design, much of which is hidden by a notice board on which are posted what the English call adverts for garden fêtes, musicales, and other fund-raising events for Disabled Sailors or Distressed Gentlewomen; the monthly program of the local cinema; schedules of river trips; and announcements of bargain-priced excursions by coach to Brighton or Woburn Zoo.

Buried deep in a closet-like cubbyhole is a trim little woman in a flowered dress and a crinkly perm. She may, but more often does not, ask the guests with the harsh American accents to register their passport numbers along with their names and addresses, and politely takes no notice of the bemused expression on their faces when she says that the price of their rooms will be twenty-one shillings each. That's approximately three dollars and includes a hearty breakfast. (We could never take this price for granted, and always reacted as if we were getting a rare first edition for twenty-nine cents. The two-star hotel is one of the best buys in Britain; it's a pity they can't export it.)

A porter summoned by a bell that one hears tinkling faintly in the distance pops in, wiping his hands on an apron. Since there are no lifts in two-star hotels, he totes the luggage up the several flights to one's rooms. The staircase, which cants to one side and is carpeted in turkey red, has as many turnings as an English road, plus a tendency to vanish at each floor and start up again around the corner. As one climbs, the porter indicates the location of the public rooms—which are on the first floor (the first floor *up,* of course)—and asks if the newcomers would

48

care to stop off in the lounge for tea? No? Then on one forges and is soon in temporary possession of a high-ceilinged room with flowered wallpaper, a washstand, an enormous mahogany wardrobe, one straight chair, and a magnificently comfortable bed with four puffy pillows. Somewhere in the room is the only source of illumination, a forty-watt light bulb, and a gas heater. If fed a shilling, this latter will yield enough warmth to damp-dry socks draped on the rungs of the chair. The bath and the toilet—separate rooms, these—are somewhere down the corridor. They, like the bedrooms, are immaculately clean.

There are no "Come as You Are" signs outside English hotels, and people *do* dress for dinner—even if "dressing" consists solely of putting on a fresh blouse. Dinner itself costs approximately a dollar, begins with soup, progresses to lamb with watery Brussels sprouts and two kinds of potatoes, and ends with something custardy. Wholly innocent of seasoning, it's not so much bad as dull. But the linen and glassware are shining bright, the pace is leisurely, the service good, and—New Yorkers, take note —the waitress often smiles.

A sure way to throw an English provincial hotel kitchen staff into uproar is to ask for coffee with your dinner. The proper time and place are after dinner, in the lounge—a biggish room full of dun-colored furniture, faded brocade or chintz draperies, gleaming brass bowls full of flowers, and a lithograph of Salisbury Cathedral among the prints on the walls. Here, bathed in the polar glare of blue-white fluorescent lights mounted in the ceiling, one sits and sips in silence, as if performing a sacramental rite—unless the hotel's modernization budget has gone into a television set instead of into fluorescent lights; *then* one sips one's coffee in flickering darkness while Perry Como—yes!—shuffles through a song.

The Swan Hotel in Bradford taught us how to order milk for

Red. At breakfast we asked for "two coffees and one milk." The milk came in a pitcher, boiling hot, with skin on the top, and Red reacted as if he'd been served hemlock. From then on, whenever we ordered, we were careful to be exact.

"Cold milk, in a glass?" the waitress would quaver. *"Cold milk, madam?"*

"Yes, please. Cold milk, in a glass." I'd keep my tone carefully matter-of-fact, as if I considered cold milk as sensible a breakfast choice as bloater or pressed ox. The milk was always produced promptly, deliciously fresh, deliciously cool. The English are rather fond of eccentrics, even American ones.

During the night we spent in Bradford, the rain had stopped, and in the morning the town lay spangled in sunshine. We ambled through crooked streets, across a bridge, and into a tiny Saxon church. Of tannish stone, scabrous with age, it was thick-set, fortress-like, and sheltering. God must have been much closer to the altar in those early days—before His children learned to elongate arches, fling their churches high, and fill them with light.

There's a tithe barn in Bradford, too, the first we'd seen—or even heard of. We squished down a rutted lane, side-stepped a herd of cows, and eventually found an explanatory plaque. "Built over a period of 97 years by several Abbesses of Shaftesbury . . . completed in 1350 . . . depot for the collection of that tenth of a man's grain and livestock which he owed to the Abbey," it said.

The barn was huge, much bigger than the church we'd just left, but it looked more like a modern seed-and-feed storehouse than a fourteenth-century relic. That's because it had a corrugated metal roof and iron scaffolding all along the sides—temporarily, we discovered, when we ventured inside. There were half a dozen workmen in the damp gloom, some lost in inky

50

darkness under the roof, some laboring with chisels and buckets of pitch in light admitted through the doorways. A brawny chap, slapping pitch on a hunk of beam that had been laid across sawhorses, stopped whistling "Some Enchanted Evening" as we took tentative steps across the threshold. He eyed us as we approached, and answered our question before we could frame it. "Death watch beetle 'as rotted 'er out," he said. "From the States, are 'ee?"

On then to Bath, old when the tithe barn at Bradford was new. Julius Caesar didn't sleep there—he never got north of London—but the Emperor Vespasian did; and so did Beau Nash, the dandy who made the town a fashionable eighteenth-century spa. The reason for Bath's long fame is its hot springs, allegedly therapeutic, and certainly relaxing. The magnificent colonnaded Roman bath—which still receives water through the original conduit—caused George to expand his newly born enthusiasm for stone circles to include the engineering know-how of the Romans. I found myself, instead, lost in speculation about the ladies who had ornamented those tiled decks and pillared corridors some 1700 years ago; bits of delicately crafted gold jewelry, exquisite tortoise-shell combs, and smooth-polished ointment jars remain to indicate that they were women of taste. Red's interest was concentrated on a series of stone markers that the occupation forces had set up along the roads of Britain and that have now been gathered into the museum at Bath. "To the Lady Nemesis most sacred, Vettius Benignus pays his vow," one said. It's a thrill for a Latin scholar, especially a fledgling, to decipher even a single word from an original source.

But there's more to Bath than baths. Overlooking the Roman relics is a sixteenth-century lace-paper valentine, Bath Abbey. This light and airy Gothic cathedral is not the first church to

rest on this site, but the only trace of earlier structures lies in a list on one wall of the present cathedral.

"Look, Red," I said, "here's what I meant about living history. See how the list begins with an abbess named Bern-guidis, in 681? And how the last Saxon name was Wulfwold, in 1061?"

"Battle-of-Hastings-1066," Red intoned, reciting a date that every schoolboy memorizes. "Sure. The title changes to 'Prior' right afterwards. Look; there's a French name, Walter de Anno, in 1261."

My eye continued down the list. "You can see surnames evolving, too," I said. "Hugh or John was enough, at first. But by the sixteenth century, the heads of church had modern names like William Holeway, there. I wonder why they changed the title to Rector?"

"I don't think that surname theory of yours is right, Mom," my son objected. "The single names could have belonged to monks and the rectors could have been ordinary clergymen. The timing is just right, because Henry VIII dissolved all the monasteries sometime in the 1500's."

Bath was our first English cathedral, and we tiptoed through it very respectfully. In most American churches one doesn't feel the presence of people unless they are actually there beside you, but even when empty an English church throbs with life. That's because it's a sort of family Bible for its parish or see, its walls being studded with memorial plaques or lined with tombs of long-gone V.I.P.s, and the tattered banners of some ancient, valiant regiment may hang from its vaulted archways or pillars. All of which give it an air both solemn and stately. Hence it was a shock and a delight to see, in Bath Abbey, a slotted black box with a sign on it that said: "Archdeacon's Box.

Questions, Suggestions, Objections, Help for Lame Dogs, Anything."

We never saw a wisecrack like this in any other English church; it may have reflected the sophisticated and cosmopolitan character of this particular town. Even if the Romans had never laid an inch of pipe there, Bath would be worth visiting for its magnificent Georgian houses and the Circus and Crescents around which they curve. The guidebook said, and accurately, "So cleverly has Bath preserved its sense of the past that you expect at any moment to encounter fat, smiling Pickwick." Which is quite a feat, in as much as modern motor traffic is about as thick as in Oxford, and TV aerials sprout from the roof tops like lightning rods in Kansas.

Like Rome, Bath is a city poised on seven hills, and there are more of the same to the south of it. The country is rocky and bleak, with starved-looking farms clinging to the hillsides, limestone quarries in abundance, and subterranean rivers flowing through caves under one's feet. We had intended to pause briefly in the city of Wells and drive then to Glastonbury, which legend says was the site of Camelot. But we didn't, partly because the drizzle that had come on at noon was a driving rain by the time we got to Wells, and partly because even in driving rain Wells Cathedral is so impressive one simply *can't* pause briefly.

We found rooms at The Swan—two out of three English two-star hotels are called The Swan—and then stood at our windows staring in awe and admiration at the pile of rain-black stone across the way. It is smaller than Bath Abbey, older and less lacy, and, we thought, more beautiful. Facing us were two square towers, between which sculptured figures in arched niches rose in vertical columns across the entire façade. The sky was beginning to clear, and against a patch of clear blue in the east

a central, higher tower was silhouetted, this one with delicate pinnacles probing the sky. The over-all effect was of great dignity and strength.

"It's getting pretty dark," George said, "but would you like to go over there anyway?"

We would, and in twilight hush we made our first acquaintance with one of the great treasures of Britain. The nave is framed by thick pillars, each a cluster of smaller columns, that are briefly interrupted by ornamental capitals before they soar into Gothic arches. The famous arches of Wells, however, are the inverted ones in the center of the cathedral. Joined point to point with upstanding arches on the four sides where the transepts cross the nave, like hourglasses, they not only support the weight of the central tower but also add architectural dynamism to the interior. Pointed arches carry the eye up but do not bring it down. Not so at Wells: there is a stirring sense of motion in these arches, a majestic rise and fall and rise again, the rhythm of waves at sea.

On this particular late afternoon the ceiling had vanished in brooding obscurity, shadows were deepening within the cathedral itself, and our footfalls echoed hollowly as we moved swiftly along. Then we came upon the Chapter House stair. I could wish nothing better for other tourists than that they should approach it as we did, out of a vast and gloomy church, and find it suffused by cold light filtered through rain clouds. The staircase is narrow, edged by clustered columns and arched openings, and appears even higher than it is because of the sharply vaulted ceiling overhead. The stone treads, hollowed by the passage of countless feet, curve, halfway up, toward a doorway on the right. The light lay luminously along the irregular hollows in the steps at the base of the staircase, then fell fully on the risers of the steps above us, and because a greater area

54

was illuminated as one's glance was pulled upward, the light seemed to grow brighter. It gathered itself, finally, into a wedge of whiteness at the point where the stairs vanished. The scene had the emotional impact of a white wax taper burning in the dark. It was tantalizing, too. What mystery lay beyond? Heaven itself?

What *did* lie beyond was a lovely room, circular and delicately fan-vaulted, with stone niches where cathedral officials sit for chapter meetings. But it was no more than lovely, and even the staircase had lost its ethereal splendor by the next morning, when we raced back to take a photograph of it. By then creamy sunlight was pouring down the steps, suffusing stairs and walls alike with cheerful radiance. It was beautiful still, but in flat light it was stripped of mystery. One knew that the curving steps would lead to a man-made room.

The whole cathedral was different in the morning. Warm and human. A gnarled old man was vacuuming the rug in front of the lectern. The church ladies were twittering away as they arranged their bouquets. Somewhere off-stage we heard the starts and stops of a choir rehearsal, and in due course the choirmaster led his boys—the littlest one skipping in order to keep up—into the stalls. A blue velour rope was drawn across the transepts to keep the curious out, but those sweet, clear voices formed a background, like the murmur of a brook, to our further explorations in adjacent aisles.

There was humor in the cathedral, too. Wells has a famous fourteenth-century astronomical clock, out of which, when the hour strikes, knights come galloping. In opposite circles, round and round they go, lances poised, each giving the other an awful wallop as they pass. There's another kind of animated clock on the north side of the cathedral; and a series of small sculptures in the nave that *almost* move, so vigorous and free is

the carving. These are tucked into the curlicues of the capitals on the pillars, and are a lively record of thirteenth-century rural England.

Interested in fashion, whatever the century, I noted the men's Dutch bobs, their helmets and cowls, their leggings and boots. George, the farm boy ascendant, prowled under the figures of countrymen, muttering, "Pitchforks with only *two* tines?" Red found a series of figures that told a story: of thieves who had stolen apples, or maybe potatoes; were caught; and beaten. Their rigid fingers spoke eloquently of pain. There were birds and flowers and reptiles, and all manner of living creatures memorialized in stone, and the six hundred years between them and us quite melted away.

While George and Red, having paid a shilling for the privilege, climbed to the top of the central tower, I made a pilgrimage from tomb to tomb, standing over the effigies of bishops long since turned to dust, studying their carefully arranged garments, expressionless faces, and unseeing eyes, trying to imagine what they were like in life. If I had been living here in the fourteenth or fifteenth century, would one of them have baptized Red at the cathedral's Norman font? Or would they have been too grand for that rite? Come to think of it, what status in life would *I* have had?

When the men returned, they reported their finds, seen from on high: a moat on the south, and a "pretty little row of houses on a dead-end street to the north." The proper name for this latter is a close, and the one at Wells was built in the fourteenth century. It was a fit subject for a Come-to-Britain ad. It enclosed a chain of identical small stone houses with identical chimney stacks, like toy soldiers lined up on a nursery floor, that stood shoulder to shoulder behind their common low stone wall,

geraniums and dahlias making tidy splashes of color in their identical dooryards.

The moat, on the other side of the cathedral, encircled the Bishop's Palace. This, a series of buildings facing into a quadrangle like an Oxford college, was of the same stone and of the same period as the cathedral and had the same feeling of dignity and strength. We joined a little knot of sight-seers at the edge of the drawbridge, to watch the performing swans. Twice a day they sail up to a bellpull dangling from a window on the moat and give it a tug. An anonymous hand then tosses out bread. There are ducks in the moat, too—beautiful iridescent mallards among them—and what entranced us most about the feeding ceremony was to see how the ducks held back, in an outer ring, until the regal swans had fed. "And that," said George in his professor-of-biology voice, "is what is meant by pecking order."

Having dallied so joyously in this exquisite cathedral town, there was no time left for Glastonbury, or the Cheddar Gorge, or Exeter, or much of anything else. Red's school took up in two days, and the name tags had yet to be sewn on his clothes, so we lit out for Oxford.

I have reflected often, since, upon our good fortune in having gone exactly where we did that first time out. A question often asked us in later months was, "Are you getting to see anything of the *real* England?" and our questioner always relaxed and smiled with approval when I catalogued the sights we had seen on that first trip. Part of our joy in it, of course, could have been due to novelty and our own romantic expectations. There was a honeymoon haze over everything during those first few weeks. But the lingering enchantment of that trip was due in greater part to the fact that what we saw was choice. Stonehenge, Bath, and the cathedral city of Wells are all best-of-show. Our later wanderings demonstrated that in no other direction from Oxford

are there so many miles of consistently lovely countryside, and never again in one journey did we stumble upon such a richly complementary series of ancient buildings and towns.

Occasionally now I swap experiences with other Americans who have visited England, most of them having "done" it in a week or less as a fragment of a European tour. Shortness of time and the fixed ideas of travel agents or hotel porters have usually led them to equate rural England with the bus run between London and Stratford, and the best that many of them have to say about the trip is, "It was awfully pretty in stretches." So is the drive from New York to Boston, but it is not my idea of the *real* America. What we experienced on that first outing in England was comparable to a journey across upper New York State at its brilliant best, or a circle tour from Monterey to San Francisco to Carmel on our own West Coast.

5

AT the end of Red's first day at school he let himself in so quietly I didn't hear him. But when the hall door creaked, I pounced. "Well, how did it go?"

"All right."

"I mean, *really*. Tell me all about it."

"It was O.K."

"Were the boys friendly?"

"They were O.K."

"Meet anyone you especially liked?"

"Mom! On the first day?"

Then I noticed—much too belatedly—that Red was wearing his shuttered look. He gets it whenever his aunts tell him how much he's grown since his last birthday or whenever family visitors impale him with a "Well, Son, and what are your ambitions in life?" So I shut up. I don't know yet whether his first day at school was an utterly bewildering and painful experience or only mildly unsettling.

However, within two weeks such phrases as "jolly good" began to pepper his speech, homework had changed to "prep," and anything that was both trivial and useless had become a "waffle." His accent on words like "necessary" began to shift forward, and before long he (alone in the family) was unselfconsciously saying "lehzure" and "shedule."

He began to come home brimful of classroom anecdotes about

59

Sid and Froggy, who turned out to be not schoolmates but masters. They were nicknamed so irreverently as a reaction, I dare say, to the formal "sir," which had to be incorporated in speaking to them at school. One of his earliest, and most pleasant, discoveries was that they were human, in the mass neither better nor worse than the teachers he had had in Pasadena. (Incidentally, there is no more acute judge of a teacher's ability than a teen-age schoolboy.) "The only way they differ from the ones I've had at home," he said, "is that it's harder here for the class to get 'em off the subject of the lesson and onto personal reminiscences."

In his early weeks he had both a minor triumph in class and what seemed at the time to be a major disaster. The triumph came about this way:

"We've been reviewing Latin grammar, you know, and today we got into the negative imperative. I knew the sentence on the blackboard, but the other boys didn't have a clue."

I interrupted. "Hah! And American school children are supposed to be so far behind the English!"

"Hey, let me finish. Ben—that's Mr. Thomson—tried to drag the answer out of the class, and couldn't, and finally he said, 'Well, I suppose it's understandable. You had this verb form such a long time ago.' The reason I knew it, Mom, was because I learned it *just before I left home.*"

The disaster involved a theme, for the writing of which class time was allowed. Accustomed to the assignment of such essay titles as "My Summer Vacation" or "Why I Liked This Book," the title assigned for *this* essay threw Red into a flat spin. It was "The Joys of Poverty." He used up most of his time trying to decide what joys there might *be* in poverty (never, as a child of this affluent generation, having known any), wrote a sentence or two in his workbook, and decided that he'd polish it at home

that evening. But, no; this essay was to have been completed during the class period. The workbooks were collected, and when they were returned, Red found himself looking at the only failing grade I believe he's ever received. It was a nasty shock, but a salutary one, and—I'm jumping ahead, now—by year's end, he had learned to organize his thoughts so well and express himself so clearly that his composition was better than that of many college students in the United States.

There were a number of American boys at the school. Some of them committed a breach of etiquette at the school's first Rugby (pronounced "Rugger") match. Watching the St. Edward's five scoop up the ball after a stupid fumble by the M.C.S. team, several of the Americans had booed. Red had not been at the game, but he *was* at the school assembly when the Master cut the booers down to size. "He shredded 'em into little pieces," Red reported, adding, with awe, "And he never even raised his voice."

Fresh from the land of sis-boom-bah and kill-the-ump, the Americans had a hard time at first learning to applaud good plays by *either* team. They were allowed to yell, "Good show!" or "School! School!" although Red says that I am wrong to add those exclamation marks, that they suggest too much unbridled emotion. But in time the image of cheerleaders and baton twirlers faded from the young American minds, and they learned (to their everlasting benefit) the basic lesson of British sportsmanship—that it isn't who wins but how the game is played that counts.

Rugby is a fast, hard-driving game similar to football; but is played without helmets, shoulder pads, or other protective devices. Our only other information about the game came from the salesman who sold Red his Rugby boots.

"Ever played Rugger, lad?" he had asked.

"No, I haven't," Red had replied, his gaze riveted on the wicked-looking cleats studding the boot soles.

The salesman had said, handing over the boots, "Boy, it's *murder!*"

Not surprisingly, therefore, Red approached his first match with something less than galloping enthusiasm. He came dragging home with mud in his hair and mud *inside* his shorts; he looked, in fact, as if he'd been wallowing in the field instead of running across it. He also had a cut on his hand. I got all fluttery and maternal.

"Cut it out, Mom," he said, parrying my attempts to bandage his hand. "The ground was slippery because it was misting, and I kept falling down. That's why I'm so muddy. Nobody pushed me. The game actually isn't as rough as I expected. In fact, whenever it *did* get rough, one of the fellows would sing out, 'What d'you chaps think this is—Yank football?'"

One of the best things about the school was that the boys accepted him as an individual, and not as an oddity by reason of his nationality. Oh, once in a while someone would try to imitate his American accent in order to ridicule it, but Red could never accept this as a personal insult, since it sounded so funny to him too. "Like trying to talk hillbilly with a clothespin on your nose," was how he described it. "You just ought to *hear* how they say, 'Reach for the sky, podnuh!'" Forewarned, he had let his crew-cut grow out before we arrived in England, and the only real ragging he got was directed at his "Teddy boy shoes." They looked bizarre to his schoolmates, because of the moccasin welt.

I was collecting a host of questions about the school. What were the "sets" he occasionally mentioned? His "house"? What was the role of the "prefects"? The sixth form included the oldest boys, and it differed in some way from the others, but how? I

62

decided that the answers could wait, though, until I'd solved some of my domestic problems. I couldn't seem to get *settled*. But my mind was easier, now that I knew Red was making friends and the strain of being a stranger was wearing off.

I quit worrying about him altogether the day he said, "Birkett and I tried lunch at the Muni"—the Municipal Restaurant, a cafeteria not far from the school—"and it wasn't bad. Only a shilling, too."

"Only a shilling. *Fourteen cents?* At that price, what on earth did they give you?"

"The daily special. I don't know what was in it."

"A meat dish?"

"I guess so. With potatoes and bread and Jell-O."

"Well, what did the meat look like? What shape was it?"

"Lumps."

"What color was it?"

"Sort of gray."

"What texture?"

"Soft."

"Good grief, Red!"

"But it was nice and hot, Mom."

6

ANY intelligent workingwoman who is also a housewife and mother learns to streamline and organize her household routine. For years I'd done my marketing and household chores on a once-a-week basis, and then on a big scale. I am also a great one for storing kitchen utensils and house-cleaning equipment at the site of use, and for arranging furniture and household accessories so that nothing has to be stepped over, walked around, edged past, moved closer, or pushed out of the way. These habits died hard. The keeping limit of our "fridge" was three days, and I couldn't carry home enough food to last us a week, anyway —even after I acquired a wicker shopping cart. I made good progress in routinizing the household chores, although George did boggle occasionally at my idea of breakfast priorities: first the Rayburn got fed, and then the family. But I never succeeded in rearranging the furniture so that any of us could ignore it.

It was my search for an extension cord—I wanted to position a lamp close enough to a chair so the occupant wouldn't have to sit sidesaddle when he read—that acquainted us with an idiosyncrasy of English houses that has been far less publicized than their plumbing or heating but is of the same order. English electric outlets are simple enough in themselves, but to get any juice out of them requires an awesome superstructure of custom-

fitted plugs and adaptors and causes the baseboards of English rooms to bristle like hedgehogs. Here's why:

1—Electrical outlets are designed to supply a specific amount of amperage. These outlets are called points, although they don't have any, being punctured instead by three holes.

2—These holes are spaced differently in outlets of differing amperage. For example, the holes are bigger and farther apart in a 15-amp. outlet than in a 5-amp. outlet.

3—Since appliances are designed to require a certain amount of amperage, their plugs have three prongs sized and spaced to fit the outlet whose amperage delivery corresponds to the amperage requirement of the appliance.

Pretty neat scheme, eh? It protects heedless or stupid citizens from the consequences of plugging an appliance requiring fifteen amperes into an outlet that can deliver only five.

But there's a hitch.

What if a room contains only a 15-amp. outlet, and the householder wishes to plug into it a heater that requires 5 amps? He's out of luck, because 5-amp. prongs aren't spaced to fit 15-amp. holes. Suppose, too, that he has a 2-amp. lamp. *Its* prongs won't fit 15-amp. holes either. One solution would be to put 15-amp. plugs on both appliances, but then of course they could be plugged in only one at a time. And think of the waste, using only 5 amps. or 2 amps. when all those *other* amps. are available but untapped.

Therefore, the adaptor was invented.

This gadget comes in varying amperages too. It has prongs that fit the holes in a given-size outlet, but its surface is studded with holes properly spaced for plugs of lower amperages. The combinations and permutations of holes in adaptors are astronomical. The first time I examined the display of adaptors at Shergold's the Headington Ironmonger, the bounty dazzled me.

Three conferences with one husband and two ironmongers later, I discovered that one can indeed find an adaptor for any combination of appliances except a 5-amp. adaptor into which can be plugged two 2-amp. appliances, which was the kind we needed.

With such adaptors in one's outlets one can then plug in appliances almost as freely as in an American house—unless, of course, the outlets in a given room won't carry the amperage of a particular appliance. In that case one either rewires the house or uses a broom instead of a vacuum cleaner. A broom gets into the corners better, anyway. Our particular choice was whether to sit in the dining room, which was warm because it had the only 15-amp. outlet in the house and therefore was the site of a high-wattage electric heater, or to sit in the living room, which had comfortable chairs but was cold because it had only a 5-amp. outlet.

I shall mention for the record but without elaboration the fact that some appliances have plugs with two prongs instead of three. Some plugs come with built-in fuses and require special kinds of adaptors. Equally specialized converters and adaptors are necessary if one wishes to plug 110-volt American appliances into 230-volt English outlets. (We decided not to mix our volts. We had our hands full dealing with the English ones.) We were also spared the necessity of coping with square-prong plugs for square-hole outlets—a new type of installation that was just beginning to catch on. At one of our conferences with the ironmonger Mr. Shergold told George that great efforts are being made in England to establish the new square-prong plugs and square-hole outlets as standard. George said, dead-pan, that he thought such standardization would be a good idea.

Oh yes. I never got an extension cord.

I had spotted, with delight, a launderette within easy walking

66

distance, and assumed that I could use it as I do the one I patronize at home—for the rough-dry laundering of such items as towels, bed linen, and cotton knit underwear. But, alas, it had no dryers. For an extra penny one could whirl one's wet-wash around in a drum called an extractor, and then tote it home to dry on the clotheslines in the garden.

I tried this for a while, but it wasn't satisfactory. The laundry didn't dry on wet days because I was usually somewhere else when the showers began, and by the time I got home the terry towels were dripping their sodden selvages into the Brussels sprouts. And the laundry didn't dry on dry days, either, unless there was a good brisk wind. It took me two weeks before I suddenly realized why there was no warmth to the sun: it was never overhead, but spun around the garden at tree-top level. When I shared this exciting intelligence with the family at dinner, Red gave me a compassionate glance, and said, "My gosh, Mom, we're fifty-two degrees north. What else did you expect?" Foreign residence has great value, I've decided, for women who don't understand what fifty-two degrees north means until they wonder why there's never any hot sun on their clotheslines.

Eventually I gave up, bought a rack, and installed it in the solarium. We came, in time, to accept as normal the sight of wet underpants banked with ferns.

That was after Lady Headington had left town, however. I didn't make any radical changes while she was still dropping in to collect her mail—and, incidentally, to check up on my house-keeping habits. I soon learned that one doesn't have to offer tea. Instant coffee will do very well, and the two of us had many a chummy cup together at England's coffee-break hour, 11 A.M.

One morning when she arrived I was putting away my groceries. Included in the lot was a box of eggs, and as I tucked

them into the fridge, Lady Headington suddenly asked, "Why don't Americans eat boiled eggs?"

"They don't?" I said, startled. "How queer." Then, realizing that she was talking about *us,* I asked, "What makes you think so?"

"A friend of mine who visited one of your large cities—Boston, I believe—told me there weren't any eggcups on sale in the shops."

I suppressed a smile. "Perhaps she didn't look in the right departments," I said. "One *can* buy eggcups in the United States, and people do eat boiled eggs. But my way of serving them is to remove them from the shell and transfer them to custard cups."

From the bemused expression that spread over her face it was obvious that eating boiled eggs from custard cups is just as peculiar as not eating them at all.

Lady Headington was a widow, I learned, who lived in Oxford because she had long loved its beauty and the tone given it by the university. But we should have come before the war, she said, before what she obliquely referred to as "the present situation" had developed. The twin causes of her disaffection, I discovered, were the welfare state and the Morris Motor Works (both of which seem clearly destined to endure).

The heavy truck traffic on the street outside caused everything loose in the house to vibrate, and one day as she listened to the ship's clock stutter when it struck, she said, "This was always such a lovely, quiet street, before there were so many factories at Cowley. Lord Nuffield has been a great benefactor to the university, I can't deny that, but I do wish he had started repairing his bicycles somewhere else."

Nevertheless, the workman who was then William Morris *did* expand his bicycle repair shop and garage on Oxford's Holywell

68

Street into the gigantic empire that now produces England's best-selling motorcar. The Morris Works, along with a complex of steel fabricators and other heavy industry, has dug itself into a big wedge of countryside that lies southeast of Oxford, and with its growth has changed Oxford from a sleepy university town into a booming industrial city. There is good reason now for wags to call the university "the Latin Quarter of Oxford," and it is accurate enough that the only civic greeting posted at the railroad station is a large sign that says, "Welcome to Oxford, Home of Pressed Steel." As an economic entity the town could function perfectly well if the university and the colleges vanished overnight.

Lady Headington didn't like the class of people who had been attracted to Oxford by ready jobs in the factories. She warned us to beware of the rough crowd who frequented the pub across the street, and urged us to call the police if the noise got out of hand. "They aren't people from this neighborhood," she said. "They come over here from one of the council housing estates near Marston." She spoke with the same distaste one sometimes hears in America when "those people who live in the slum clearance projects" are mentioned.

(Actually, we found that the people who frequented the pub were well behaved and orderly, and after they observed how much trouble George had in garaging our car when their cars were parked bumper to bumper at the opposite curb, they tried to leave turning space for him.)

Lady Headington had paid a colossal sum to have the house redecorated, and her most frequent lament was that in England today one can't get any service from people in the service trades. She was dead right on *that* one; higher paid jobs in the Morris Works certainly created an acute shortage of domestic workers and repairmen in Oxford. Among the businessmen screaming for

help was the present proprietor of the Morris Garage on Holy-well Street, who advertised week after week, in increasingly urgent terms, for a repairman. There was a sins-of-the-father quality about this situation that I found singularly affecting.

Nor did Lady Headington like the "new" university—no longer the exclusive preserve of the rich and the well born, but now an institution to which admission is gained primarily on the basis of academic ability. When family position and financial resources determined who went to university in England, many a young man grew gray at Oxford. But now that three out of four undergraduates, having passed competitive exams to qualify for entrance, are financed by the government, the male equivalent of America's college widow is in residence no longer. A certain zaniness and charm of manner have vanished with him; things just aren't done as *nicely* any more.

"I can remember the time when a few undergraduates might have brought shopgirls to the spring boat races on the river," Lady Headington remarked, "but they most certainly never married them. Now, I dare say"—her mouth drawing into a thin line—"some are comfortable *only* with shopgirls."

Thus, she introduced us to a theme that was often to recur in conversation with upper-class English conservatives: nostalgia for the good old days before the welfare state had corrupted the working classes.

I crowned the morning coffee breaks by inviting Lady Headington to dinner, at which I gave her a typical Sunday-on-the-farm menu: fried chicken, mashed potatoes with gravy, and chocolate cake à la mode. She was polite about it, if not really rapturous, and especially praised the cake. I thought it a bit of all right, myself, because I'd baked it in the Rayburn. The icing hid the cracks.

Two days later, convinced at last that we were not wild In-

dians (red), she went off to Africa to visit relatives. Our correspondence thereafter took on a ritualistic pattern. My letters began, "I'm sorry to have to report that the refrigerator has ceased functioning altogether this time"—or that a paraffin heater had smoked up the living-room wallpaper, or that the roof had leaked, or that a bit of wall had collapsed. Her replies began, "I am so sorry that you are having all that trouble with the refrigerator"—or whatever it was—"and would suggest that you take it up *directly* with Cooper's. They assured me . . ."

We had a living link with Lady Headington, however, in the person of Mrs. Iris Blount, her—and our—"daily." Domestic workers aren't called "chars" any more, at least in Oxford. They're too scarce. Another few years of famine and they will be, as in America, "the lady who comes in to help." Characteristically, they work only a few hours a week, for spending money. And they are not disposed to slave for anybody. As long as England is prosperous, Mrs. Blount and her kind will dwindle in numbers, as they have in the United States, and the English housewife who used to have servants will do without them.

I could have done without Mrs. Blount, because all she did in the four hours a week she allotted to us was to lay a fresh coat of wax over last week's coat of wax in bathroom and kitchen. But I would have missed one of the greatest delights of the Oxford year if she hadn't come on Tuesdays and Fridays to share her wit and wisdom with me.

She was a wiry little woman with straight brown hair, sharp features, raw, roughened hands, and a complexion that always reflected in its color the vagaries of the weather. She came whizzing up to the house on a bicycle in whose basket she carried the fleece-lined house slippers in which she liked to work. Her first move after getting into these slippers was to run around the house opening all windows and doors in order to admit some

good English air into a house that I persisted in keeping stuffily hot. I then closed the doors and windows as unobtrusively as possible, and she reopened them as unobtrusively as possible, neither one of us ever taking official notice of the other's action.

Mrs. Blount was a kitchen philosopher. She would suddenly pause in the midst of her waxing and say, "Mrs. Beadle."

I'd respond, "Yes?"

"I always say you get out of folks just what you put into them."

"I say the same, Mrs. Blount."

Then she'd resume her waxing.

Or: "There's talk at the Works"—her husband was employed at the Morris plant—"of a strike. Now, if you please, what's the sense of another strike? A man gets a raise and up go his wife's prices. But"—slap! slap! with the waxing cloth—"does he give her any more money? No! The wives ought to strike for stabilized prices. That's what *I* say."

Mrs. Blount was a local woman, although her speech was not as thickly overlaid with Oxfordshire dialect as that of the gardener, who dropped his h's like 'ailstones. There was nothing wrong with her brain: she got the American monetary system straight after one telling, whereas I never understood the British system; and she was at least no more confused than I was about the difference between Republicans and Democrats. But she was naïve about a great many things. She believed the weather predictions in the almanac, for example, her faith in no way dimmed by the fact that the predictions were invariably wrong, and the amount of medical misinformation she possessed—and acted upon—was encyclopedic. The highlight of an outing to London with some ladies of the Mothers' Union was having her shoes blacked. "It was in Charing Cross I had it done," she said. "I've

never seen a bootblack before. I thought they just had them in America."

I thoroughly enjoyed her company. She enjoyed mine. I expect both of us, on Tuesdays and Fridays, regaled our families with anecdotes about the other's odd ways. But our mutual affection was based on more than the entertainment value to be derived from our differing backgrounds and the differing cultures that had produced us. I admired her for her forthright honesty and good humor. She felt protective toward us, strangers in her land.

One day when I was out she reported that a phone call had come in for George. The caller had been a man "with a funny way of speaking—a foreigner, I dare say." Their conversation had gone like this:

"Have I the home of Professor Beadle?"

"Yes."

"Is the Professor there?"

"No."

"Can you tell me at what time he will return?"

"No."

"Well"—the caller was evidently striving for a light touch—"at least, I have located his home, have I not?"

At this point in her recital Mrs. Blount turned a worried face to me. "Mrs. Beadle, that's what gangsters do, you know."

"Oh, Mrs. Blount," I replied. "You've been seeing too many American movies on television."

"No," she insisted, "that's how it is. A gangster finds out where someone lives, and the next thing the whole family is dead in their beds."

"So then what did you say to the man on the telephone?" I prompted.

"I hung up," she said.

7

ONE fine day in October, Cyril Darlington—Oxford's professor of botany, a tall, handsome man with the bearing of a Roman senator—said to George, "Convocation is meeting in an hour. Why don't you come along with me?"

"I can't," George replied, having been cramming a bit on university protocol. "I don't have a gown. And if I had, I couldn't wear it. I don't have a degree yet."

He has seven, in fact. What he meant was that he didn't have an *Oxford* degree. The university forbids the wearing of academic regalia other than its own, and in order to get visiting professors like George into acceptable garb it routinely awards them an Oxford M.A. degree.

"Borrow a gown and come along anyway," the Prof said. "It'll be all right."

"Tell you what," my husband rejoined. "I'll run over to College and ask the secretary about it. I might as well find out when I'm supposed to get that degree."

The secretary told him, "I think you already *have* a degree. Wasn't it granted by decree?"

"Nobody told me," he replied.

So the secretary called the registry. Yes, Professor Beadle did have an M.A. degree. "Then," asked the secretary, "may he attend Convocation today?"

74

"No, I'm sorry," said the registry. "He hasn't signed a matriculation form."

George hurried over and signed the form, borrowed a gown, hood, and mortarboard from the college porter, and set off with a Botany Department demonstrator (the equivalent of an assistant professor) to Convocation.

"You're not wearing a white bow tie," his companion told him. "So you mustn't wear your hood. A hood can be worn only with a white tie."

George stuffed the hood in his pocket.

At the Sheldonian Theatre they found Prof Darlington, who remarked to my husband, "Too bad you don't have a hood."

"I have. It's in my pocket. I can't wear it because I don't have a white tie."

"Oh, that rule doesn't apply to this particular Convocation."

So George put on his hood.

Convocation was impressive, he told me. But he didn't pay as much attention as he should have to the business of the day—partly because a lot of it was transacted in Latin, and partly because he was too occupied counting white-ties-with-hoods, colored-ties-with-hoods, and colored-ties-without-hoods. The three categories, as far as he could tell, were neck and neck.

A few days later I happened to be in the vicinity of the Sheldonian as another university ceremony was about to begin. The Sheldonian, by the way, is just up the street from Balliol, on The Broad. As one rounds the corner from Cornmarket Street, one's gaze is pulled along a concave line of buildings directly to this seventeenth-century neoclassic masterpiece of Christopher Wren, its roof surmounted by a gallery and a gleaming white cupola. Interspersed in the railings of the fence that surrounds the circular gray stone building are pedestals on which perch the leprous, weather-beaten busts of—maybe—Roman Emperors.

75

Max Beerbohm thought they were, anyway, and it was on their brows that great beads of perspiration glistened when Beerbohm's Edwardian enchantress, Zuleika Dobson, glided past the Sheldonian in her landau that May Monday in 1910 or so.

The young women whom I saw gathering on that same spot were not of Zuleika's ilk. Nice-enough girls, clean-scrubbed and tidy, but unlikely to inspire mass drownings because of unrequited love. They looked a bit like magpies, in their limp black academic caps, black academic gowns, white shirts with black string ties, black skirts, black stockings, and black shoes. There were clusters of men in The Broad, too, in similar dark garb, except that their heads were covered with square mortarboards, and white bow ties glistened under their chins.

I knew why they had gathered. Term had begun, and these new undergraduates were going in coveys to the Sheldonian for the matriculation ceremony, which would make them, officially, members of the university. I also knew—I'd been doing some cramming too—that for them to be members of this university was quite unlike being students at Harvard or the University of Michigan or Caltech, or any other American university.

One of Oxford's favorite jokes—in which the protagonist is usually an American—has to do with the tourist who asks a native to direct him to the university. A variant has a dumb bloke from Kansas searching for "the campus." Neither, of course, can be found. The university is a human institution and a way of life, not a physical entity. It welcomes the scholars, establishes the broad outlines of their courses, provides lectures for them, examines them, and grants their degrees. And for this it needs a few buildings. Among them are the Sheldonian Theatre, which I was then facing, the Bodleian Library just behind it, the Examination Schools on High Street, and the science labs

on South Parks Road—where, presumably, George was at that moment deep in the business of making notes for his first lecture series.

But such campuses as will be found at Oxford—in the American sense of a grouping of buildings on common acreage—are those that exist within the walled and cloistered colleges, some thirty in number. Balliol's layout was typical, although by now I knew that its buildings and gardens were not particularly distinguished. (As soon as I had convinced myself that the Rayburn was not going to blow up in my absence, I had launched a regular program of visitation, and by early October had ticked off a round dozen colleges.) The older colleges are clustered in the center of town, some with common walls, others separated by the markets and shops, garages and hotels of the city. Most of the women's colleges and that other nineteenth-century addition, Keble College, are on the fringes of the city center, to the north. It is fashionable in Oxford to look down one's nose at Keble, a mammoth jukebox of multicolored brick in a style of architecture described by its detractors as "Early Bloody." The newest college, just-finished Nuffield (gift of the head of the Morris Works and bearing his name) is hard by the railroad station, on the west. Nuffield is also the butt of gibes—for its "brazen spire atop a Cotswold cottage." But I rather liked the Victorian lustiness of Keble, and I suspect that the main strike against Nuffield is that it's new. Give it twenty years of smoke from the trains across the way, and it ought to have an acceptable Oxford patina.

The Oxford colleges got their start in the Middle Ages. They were simple rooming houses at first, with a master in charge to see that the young scholars behaved themselves and got enough to eat. From these halls they went out to lectures given under the auspices of the university. If a boy had a bit of trouble with

77

his Latin, nothing could have been more natural than to ask help from the house master; and so a teaching function was added to the colleges. They are still the basic social and instructional units at Oxford.

Modern undergraduates come to the university ready to concentrate in one narrow field of scholarship. The liberal-arts bias that encourages American college students to sample widely of varied course offerings does not exist at Oxford; the program there is more similar to that of the graduate schools at American universities. Oxford has fourteen areas of specialty, of which the most demanding and the most honored is Ancient Philosophy and History, a course known simply as "Greats."

Whereas the American student "majors" in a subject, the Oxford undergraduate "reads" it. Literally. His work is directed from his college by one or two tutors who are experts in his chosen field. For three or four years, in weekly private session, he presents an essay based on his reading, hears his mentor discuss and criticize it, may be forced to defend it, is finally sent on his way with a new reading assignment and a new essay topic. That's all there is to the academic side of an Oxford education: Mark Hopkins on one end of a log and a student on the other. It's the best possible method of teaching, and also the most expensive. The cost can be justified only if teacher and pupil are of top intellectual caliber.

Given close fellowship with brilliant minds in an elegant and civilized setting, it is not surprising that the Oxonian's loyalty and affection go first to the company of people with whom he has lived. (That's all that "collegium" means, anyway—a company of like-minded people.) The American university graduate identifies himself as a Yale man, but the graduate of Oxford is likely to tell you that he was at Balliol.

It has been this way almost from the beginning. Nobody re-

membered the university with special affection. It was only cold lecture halls and colder-eyed examiners. Therefore, the rents from a bit of property or some fine silver plate passed from a fond graduate to Merton or Exeter or Queens, or to whatever college was his ancient English equivalent of good old Kappa Sig. Hence, over the years, the colleges grew wealthy, developed into wholly autonomous institutions, became more important and more powerful than the university. Although they have now been forced to yield ground to the university for the maintenance of the modern science labs that no individual college can afford, they are still far more than the administrative subdivisions that the word "college" connotes to Americans when it occurs within the context of university organization here.

Just how important the colleges are George had discovered when he'd gone to the Bodleian to sign up for reading privileges.

"Are you a member of the university?" the librarian had asked him.

"Yes, I'm the Eastman visiting professor this year," he had answered, trying not to sound smug.

He could have spared the effort. "Oh?" she had replied. It was obvious that she had never heard of the Eastman professorship, which is a chair supported by a trust set up in the 1920's by George Eastman of Kodak fame and occupied annually by a distinguished American scholar. "Well, I'm afraid I shall have to ask you to take the pledge," she said.

He had done so, hand raised as when giving the Scout Oath:

"I hereby undertake not to abstract from the Library, nor to mark, deface, or injure in any way, any volume, document, or other object belonging to it; nor to bring into the Library or kindle therein any fire or flame, and not to smoke in the Library; and I promise to obey all the regulations of the Library."

Then the librarian had handed over a long printed form, saying, "Now, will you be good enough to fill out this application?"

As George had sighed and had got out his pen, she'd had a second thought. "I don't suppose you are by chance a member of a college?"

"Why, yes. I'm a Fellow of Balliol."

She had hurriedly retrieved the form. "Oh, I *am* sorry, sir. I didn't understand. In that case, you need not fill out the application."

He thought that incident was funny, and in following days brought home other bits and pieces of information revealing how wrong we were to have assigned the colleges a subsidiary role in the university.

"Guess what, honey? I found out today that the university can't admit any students. That's the prerogative of the colleges. What's more, they don't have to report to any central agency how many they have accepted in any given field. Believe it or not, the Prof didn't have any notion of how many undergraduates were going to turn up in botany this term until they actually arrived at the lab!"

Later: "I was chatting with Mr. Bennett at College today. He says that the university doesn't have a purchasing department, and that each college bursar buys the small quantities he needs of staples like light bulbs and paper goods and cleaning supplies. I asked Mr. Bennett if anyone had ever suggested joint purchasing in large quantities in order to save money, and he said he believed that such a scheme *had* been proposed once but that nothing seemed to have come of it."

And also: "I don't see how this can be true, even at Oxford, but here's how I heard it. The Botanical Garden—you know, the buildings and grounds along the Cherwell just below

80

Magdalen Bridge—is owned by Magdalen College, and they lease it to the university. Somewhere in the deed or lease there's a provision forbidding vehicles to drive onto the property. And for a solid week during one cold winter, while the supply of coal to heat the greenhouses dwindled away to nothing, Magdalen refused to let the university deliver coal—because it had to come by truck!"

George's attitude toward the preservation of such individual liberties ceased to be one of detached amusement, however, after he'd sampled the Oxford library system. It was, in fact, on the same day that I came home all steamed up about "the charm and quaintness" of the undergraduates at their matriculation ceremony that George paused at home only long enough to slam down some books and announce that he was going up to the post office to send a cable to Pasadena.

"What for?" I asked.

"I want the lab at home to air-mail the August *Proceedings of the National Academy of Sciences*," he snapped. "It's buried so deep in the Bodleian, or the Radcliffe, or *somewhere*, that they probably won't find it until Christmas."

There are over fifty libraries at Oxford, some maintained by the university, some by the colleges, some by departments. Cataloguing systems vary from library to library, and sometimes even within them. There is no central catalogue that lists what's supposed to be in all, and such lists as are available are often out of date. In trying to run down one periodical, listed at two department libraries, George had found that one of the two had stopped subscribing to the magazine in question in 1933, and the other had sold its back copies during a period of economic pinch. He still talks about the fact that to locate all reference material pertinent to a survey of evolution required visits to seventeen libraries.

This sort of thing doesn't bother a lot of people at Oxford. Some have more fun sampling their way through the Bodleian than women at what the English call a jumble sale. A copyright library, like the Library of Congress, the Bodleian is a repository for every book that's been printed in Great Britain for hundreds of years. One friend reported with great glee that he'd come upon *The Life and Times of Mickey Mouse* there. But George is a do-it-now person, a lover of efficiency, and to the end of our stay in Oxford he marveled that so many people do get good research done there.

Nor did he—essentially a transient, especially as Oxford reckons time—ever feel the sense of close kinship to the others in his college that is the basis of the pride with which Englishmen knot their old school ties. The Fellows at Balliol were very kind, but he *was* a Supernumerary Fellow—that is, he could attend college meetings and voice opinions, but could not vote. That privilege had been withdrawn after Felix Frankfurter, an early Eastman professor, had scared the Fellows half to death by participating vigorously in college business.

George went to one college meeting and came home amused and exhausted. "I don't know enough college or university politics to understand what they're talking about," he explained, "and they swallow half their syllables when they speak, so I don't even hear all the words. They pause and breathe in the middle of the sentence, rush past the period at the end, and pause again in the middle of the next sentence." He grinned. "If I could only learn to do it too, I'd sure be able to keep the floor in meetings at home. Nobody would know when to interrupt."

Thereafter he used the college more as a club than as a headquarters. He lunched and dined there often, but otherwise he was content to remain a Supernumerary. (He delightedly found

the word defined in the Oxford Dictionary as "an extra person engaged for odd jobs.") His heart was really in the lab, anyway; the atmosphere there was more familiar.

Oxford undergraduates specializing in science take courses comparable to those an American college student would take, with the core of instruction centered in the laboratory rather than in the library. This sets them apart from people in the humanities, a small enough cleavage in itself, but one that is deepened by the scientists' careless observation of certain hallowed Oxford rituals—the wearing of academic gowns to lectures or tutorials, for example, and by the fact that scientists (as in the United States) are currently the fair-haired boys in academic circles. It isn't easy for the arts-and-letters people (who dominate the colleges) to see modern science usurping so much of the attention—and, more cruelly, the money—that once went to divinity schools and to Greek scholars. One can hardly blame some of them for hoping that, if they ignore science, maybe it'll go away.

Oxford undergraduates, regardless of their field of specialty, are not required to attend any of the formal lectures scheduled in great abundance for the general edification of anyone who wishes to come. These were the sort that George was to give, and he was as nervous as a cat in March on the first Thursday of Michaelmas term, when he was to make his debut.

Vivian Galbraith, a retired Oxford professor of history —peppery and Puckish at seventy-plus—had spent some time in Pasadena the year before we came to Oxford, and he had heard George give a Caltech lecture on heredity. Intended for the general public, it was long on simple illustrations and short on scientific jargon.

"That's it! That's it!" Professor Galbraith had said. "That's what you must give them at Oxford. You'll have a crowd the

first time, of course—one always does. But if you want them to come back—not that many *will,* you understand, and you are not to take offense, it's just that they *don't*—why, give them a show!"

Roger Mackenzie, on the other hand, had advised something solid and meaty. "If you could bring us up to date on what Crick is doing with DNA . . ."

"But he's at Cambridge. Surely at Oxford they know what *he's* doing?" George had interrupted.

"Don't count on it," Roger had replied. "And I hear Kornberg is getting some amazing results with *in vitro* synthesis; and Meselson—he's your chap at Caltech, isn't he?—has something interesting going with density gradients."

As a result of this advice George faced his first audience in a state of some confusion. Then he had a flash of inspiration. Looking up from the lectern, he announced, "I propose, ladies and gentlemen, to lecture American style."

It was a good lecture, Cyril Darlington said afterward—solid and meaty, but presented with enough showmanship to keep the audience awake. However, it didn't depart in any significant particular from standard academic format, which is international. On the way out of the lecture hall the Prof said to George, "What did you mean by that 'American style'?"

"Not a thing," George cheerfully replied. "I was just protecting myself in case anything went wrong."

84

8

"WHAT'S all the stir about?" I asked Mrs. Murchison as she dumped the potatoes into my wicker shopping cart. There were bobbies all along the London Road, and no one was being allowed to park.

"I 'ear it's that German."

"Oh yes. President Heuss. I've been reading the speeches he's made in London."

"What makes 'im think 'e's wanted up 'ere?"

"My husband told me he's going to give some money to the university, so that young German students can come on scholarships. There's going to be a fine luncheon for him, and toasts to international understanding, and all that sort of thing."

"A-a-h!" She resolutely turned her back on the door, an act of denial as well as of disgust, for there was no shopkeeper on the London Road who kept a closer watch on the comings and goings outside her door than Mrs. Murchison, the greengrocer's wife.

I knew that many members of the university were finding the prospect of Heuss's visit extremely distasteful too. They had nothing against him as an individual, but the cold gray years of work and want were still too near, the memory still too green of cities blasted into bits and bodies buried under rubble. An Oxford acquaintance, returning from a September holiday in Europe, had told me, "It's not the Americans one notices now, but the

hordes of Germans on tour. How can they? How *dare* they go back—and expect a welcome?"

President Heuss was well aware that he was not a popular visitor to England. The speeches he had made in London had revealed as much. Perhaps that's why, as his car swept along the road to Oxford that day, bearing him to still another meeting with Englishmen who had not sought the meeting, his expression was so pensive. A very old man, his face pale and drawn, he sat slumped in the back seat of the limousine, his shoulders hunched and his head drooping.

A handful of people—I had waited, of course—stood on the curbs to watch the small cavalcade go by. That's all they did: just stood. Heuss had probably seen similar stolid clusters of people all along the route. On a sudden impulse—he looked so very tired—I waved. Save for a lift of his eyes in my direction, he did not acknowledge the wave. Feeling embarrassed by my demonstrativeness, I went quickly to finish my errands.

Next day, at the butcher's, I overheard two women discussing Heuss.

Said one, "Did you see that German yesterday?"

Replied the other, "That I did."

"I hope you didn't wave to th' old devil."

"Not me. I don't think my generation will ever forgive 'em. Having your life messed up twice—once in your childhood and once in your marriage—is enough for me."

I thought, as I pretended to study the kidney pies on the counter, *We Americans, buffered by the broad Atlantic, have no idea how narrow the English Channel really is.*

A few days later, in contrast, the mood along the London Road was festive, and electric with anticipation. I hardly recog-

86

nized the drab store fronts, draped as they were with bunting and bristling with flags.

To see flags is unusual in England, since they aren't flown routinely over public buildings as they are in the United States. When you *do* see them, therefore, you know something very special is afoot; in this case, a visit from Elizabeth the Queen Mother, who was dedicating a new wing at the local hospital. Since her return route to London lay right past our front door, I was excited too.

A little before 4 P.M.—she was due at 4:15—I went outside. A flag had blossomed over the door of the pub, and the pub-keeper and his wife were just coming out of the house. We smiled at each other across the narrow street.

The next gate to creak open was that of the house two doors down. A "welfare case" lived there—a desperately poor woman whose husband had abandoned her and their four children; they cried a lot. But now they were silent, and clean, and even the baby in its pram looked alert. The older children held small flags.

Slowly other householders slipped out from behind their walls and strung themselves along the sidewalk: old Mrs. Edward with a shawl clutched to her bosom; the Brown youngsters—they had flags too—and their big black dog; the plump little housewife who ran the Saturday-night bingo parties; Mr. Brockton, the grocer at one end of the street; Mrs. Harris, who managed the bakery at the other end; the vicar's wife and her pig-tailed Margery; the palsied boy, Leslie, who lived in the stone cottage next to ours; and a tweedy matron from The Croft, with two terriers on leash.

At first there was a general murmur of conversation among neighbors, but it dwindled as watch hands crept toward the half hour and the Queen Mother had not come. It was dusk by then,

and the feeble street light in front of the pub had been lit. The wind was turning raw. Children posted themselves on the curbs and craned their necks, but each pair of headlights they spotted at the far end of the crooked street turned out to be an ordinary sedan, or a delivery van, or a pair of bikes in tandem. At 4:40, Red came loping along from school and joined the vigil. The welfare case's youngest began to whimper. The terriers tugged at their leashes. And then it was 5 P.M. and full dark. I could no longer make out the colors in the flag over the pub door.

Turning to old Mrs. Edward, I said, "We'll never be able to see the Queen Mother now—even if she does come this way."

"Oh, she'll come," my neighbor replied. "She's late because they planned too grand a tour of the hospital for the time allowed, and she's made herself later by looking at everything with careful attention and stopping to talk with the patients."

"How do you know?" I asked.

Simply, my companion answered, "She's like that."

Just then a bright-eyed child spotted the blue light of an approaching police car. We all surged to the edge of the pavement.

There were no sirens, no outriders on motorcycles. Just the escorting police car—a sleek black Jaguar—and the big brown Daimler in which the Queen Mother was riding. She had turned on the light inside the car so that she could be seen. All in pale blue, she sat beautifully erect in the center of the back seat, exactly as a thousand news pictures have shown her—calm, gracious, smiling.

From the lighted car she could not possibly have seen the people on the dark street. But she knew they'd be there, out somewhere beyond the reflection of herself in the car windows.

And so she smiled to the right and waved to the left, then smiled to the left and waved to the right, exactly as if she were seeing each of us.

An American crowd would have cheered. The English were silent. But up and down the street the women's handkerchiefs fluttered in the cold night air, like a swarm of white butterflies. The children waved their flags. The pubkeeper raised his arm in a salute. And my teen-age American son swept off his English schoolboy cap and bowed.

Standing there in the dark, seeing but unseen, the loyal and loving people continued to flutter their handkerchiefs and to wave their little flags until the big brown Daimler reached the end of the street, turned the corner, and vanished from sight.

The next day, still moved by the mutual devotion I had witnessed, I told Mrs. Blount how we had seen the Queen Mother pass by. She was pleased for me, but a shade superior. She, it seems, had seen the *young* Elizabeth. In person.

The occasion, she told me, had been a royal visit to Banbury, for which the Queen's route had taken her within three miles of Headington. Mrs. Blount had bicycled over to join the throng along the highway, and, sitting now on her knees in the center of my kitchen floor, a waxing rag clutched in her rough, chapped hands, she told me about it.

"The Queen was dressed so fine and looked so pretty, waving and smiling at everyone, and we could all tell"—here, Mrs. Blount's small, pinched face turned positively radiant—"that she was so *happy* to see us!"

I found this comment affecting, too, and repeated it the same evening at a dinner party. The Oxford professor who was my dinner partner laughed a little at Mrs. Blount's naïveté, then

said with a certain condescension, "The Mrs. Blounts of England are our staunchest royalists, you know."

I didn't tell him that it was his own wife, a well-traveled and sophisticated lady, who had asked me earlier in the evening whether I had yet got a glimpse of "our sweet little Queen."

9

THE university year is divided into three eight-week terms, named in accordance with the Anglican calendar: Michaelmas, Hilary, and Trinity. Michaelmas term was the hardest one for us, of course, because we had so much to learn. Like many Americans now abroad, we were anxious to "do the right thing" in a foreign country, but Oxford academic society a) has so many rules that hardly anyone knows them all; b) permits wide latitude in their observance; and c) assumes that a gentleman will *sense* which rules he may overlook and which ones only a cad would ignore. So we had to feel our way.

Oxonians are very sociable. They pack all their entertaining into Term, the long intervening vacations being used for gathering strength for the next go-around. And Michaelmas term, because it follows the longest vacation and is the start of the academic year, has the giddiest whirl.

A spate of sherry parties began it for us. They were indistinguishable from cocktail parties in the United States, except that waiters passed decanters of sherry—"Dry or sweet, madam?" —instead of martinis. Cocktails aren't commonly served in Oxford; hard liquor (meaning scotch or gin, bourbon being unknown in England) is too expensive. Nor do the English have the highball habit. On those few occasions when cocktails were offered by a host wise in the ways of Americans, he couldn't

force himself to recognize our barbaric tastes to a greater extent than by the addition of *one* ice cube to the glass.

"How are you liking England?" a bearded gentleman with leather patches on the sleeves of his tweed jacket would ask.

"Just fine," I'd reply.

"You'll be missing your steam heating by now, I expect."*

At first I went to the trouble of explaining that Californians don't have steam heat, and in fact tend to keep their houses rather cool. But I soon gave up. The skeptical eyebrow and the rising "Hmm?" are well-honed English social weapons. So I'd shift to the weather.

"It hasn't been so very cold yet," I'd say. "Just rather wet."

It had been, too: showers nearly every day, with the luggage in our closets having to be regularly checked for mildew, and the spongy stone of our house soaking up water from the earth so the wallpaper was chronically wet a foot or two above the baseboards. One good thing, though—I never had to sprinkle "dry" laundry before ironing it.

"Yes, filthy weather, isn't it?" my partner would say. "Wettest year in my memory. We had no summer at all."

Then we'd drift off into the crowd, and I'd find myself face to face with a lady I hadn't met. I'd give her my name and ask for hers. She'd tell me, and add, "Now of course you'll remember it. You Americans are so *good* at names."

(Not all of us. At the end of our time in Oxford one woman who had made this comment at an early sherry party told me gently that her name is Thompson. I'd been calling her Mrs. Johnson all year.)

People who remember names by word association are in trouble when it comes to the heads of Oxford colleges, because

* Americans like their rooms boiling hot.

92

they are addressed by title, and many have the same title. I never met both the Rectors—of Exeter and Lincoln—but the one I knew was not a very clerical type. Nor could I associate "Warden" with the friendly, forthright, easygoing head of Rhodes House, where Rhodes scholars are looked after. Oriel has a Provost, and so has Queens; Balliol and University have Masters; Magdalen and Corpus Christi have Presidents; Somerville and the other women's colleges have Principals; and Christ Church has a Dean. One says, "Good evening, Master" or, "I was saying to the Warden just the other day . . ." And if one is new to Oxford, it is quite possible to get through an entire year without ever hearing a head of college identified by name. We were well into spring—and had once been a guest in his own house—before we knew that the Vice-Chancellor (of the university), who was also the President (of Magdalen), was T. S. R. Boase.

Oxford's social etiquette, like so much else in the town, is Victorian. One doesn't telephone an invitation; one writes it. Also the reply. I can recall only one telephoned invitation to an important dinner party, and that was necessitated, the hostess said, by the fact that the date was so close. The date was actually three weeks hence—long enough in California to plan and invite people to a wedding.

The first time I opened an invitation and noted the phrase "7:45 for 8:00 P.M.," I was baffled. I now think that this uniquely English convention is a boon to mankind that should rank with the Magna Carta, marmalade, and madrigals, and I wish it could be exported to America. What the phrase means is this: If you want a glass of sherry before dinner you are expected to arrive at 7:45. Dinner will be served at eight. What's more, dinner *is* served at eight. Nobody has sat around for an hour and half drinking spirits and eating peanuts. Guests come to

table not only sober but with an appetite. What a bonus for the cook!

One day in October, Kitty Turnbull dropped by to take me to a meeting of the Wives' Fellowship—I was in the process of joining every organization that stretched out even a tentative hand of welcome—and I showed her my note of acceptance to a dinner party to be given by the Vice-Chancellor. "Is this OK?" I asked. "The form, I mean?" I had written:

<div align="center">

Professor and Mrs. G. W. Beadle
accept with pleasure
the kind invitation of the Vice-Chancellor . . .

</div>

duplicating, as is correct in the United States, the form of the invitation.

Kitty wrinkled her brow. "Why, of course," she said. "That will do very well. However, there is *another* way of doing it, too."

Thereafter I acknowledged formal invitations properly: "Professor and Mrs. G. W. Beadle accept with pleasure the kind invitation of . . ." running the phrases together into a solid block.

On the night of the Vice-Chancellor's party, as George was zipping me into my evening dress, he suddenly paused and exclaimed, "Oh, my gosh! My gown is at Balliol."

"What difference does that make?"

" 'At functions attended by the Vice-Chancellor, members of the university will wear academic gowns,' " he intoned. "University rule."

"But this isn't an official university function," I protested. "It's social. Surely people wouldn't wear academic gowns over *tuxedos?*"

Completely unsure, we decided to seek advice from the porter

94

at the Vice-Chancellor's college. Oxford legend has it that college porters know everything. This one assured us that the occasion *was* social, and that gowns were not required. But when we arrived at the Vice-Chancellor's lodgings and his manservant opened the door, his mask slipped a bit. We noted a small twitching of muscles around his mouth.

"Should I be wearing a gown?" George hazarded.

Jeeves murmured that it was customary.

George said he'd drive over to Balliol and get his gown.

Jeeves pointed out that it was almost eight o'clock. In Oxford one is never tardy—that's one of the inflexible rules—and to have gone for the gown would have made us late.

At this point my eye lit on a table in the foyer. It was piled with academic gowns. "How about my husband's wearing one of those?" I asked. Jeeves gave his permission.

Properly garbed, George mounted the stairs and we greeted the Vice-Chancellor. But the joke was too good to keep, so George promptly confessed that he was wearing one of his host's gowns. The Vice-Chancellor was amused and genial. "Watch as the other guests arrive," he said. "Half the men will be wearing gowns, and half will ignore the rule."

He was exactly right. Of the four other men, two had gowns and two did not. One of these latter, the new professor of medicine, hadn't even heard of the rule. It impressed him no end, he said, that George had so quickly mastered Oxford etiquette.

The Oxford colleges, having mostly been built before the eighteenth century, lack certain amenities—handily located bathrooms, for instance—but by way of recompense possess the kind of silver that few Americans ever see outside a museum. Thus they set a table that is visually so satisfying it doesn't much

matter what the food tastes like, especially when it is served with first-rate wines.

An elegant English dinner menu, such as the colleges serve, has a Victorian flavor: soup course, fish course, joint of beef or lamb and three vegetables, a pudding or pastry of some sort (never cake or ice cream), fresh fruit, and cheese with crackers. If it's a private party, such as the Vice-Chancellor's, and ladies are present, the ladies leave the table, powder their noses, and drift into the drawing room. In ten minutes or so the men come along. Coffee—strong and bitter-black—is served demitasse. In order to kill the taste it's customary to pour in sugar and hot milk. Liqueurs or port may follow. (Also, some hours later, a need for bicarbonate of soda.)

English academic society puts on full dress much more often than its American equivalent. If a dinner invitation does not specify "informal," guests assume that black ties will be worn. Young ladies then wear short formals, and old ladies wear floor-length dinner dresses. If the invitation specifies "orders and decorations," men climb into white-tie-and-tails, young ladies shift to ball gowns, and old ladies add white kid gloves and tiaras to their floor-length dinner dresses.

It was at an orders-and-decorations dinner given by the Royal Society in London that George met a challenge with more serious implications than being caught at the Vice-Chancellor's without a gown. We had decided to stay overnight at a hotel in the city, hence had brought our evening clothes into town with us. George had rented a full-dress suit in Oxford, supposedly complete with accessories; his distress can be imagined when, upon opening the box, he discovered that no suspenders had been included. Since full-dress trousers have no belt loops, he *was* in a pickle.

I giggled—which, under the circumstances, was most unkind

96

—and offered to run a chain of safety pins all around his waistband, pinning through his shirt and anchoring his trousers to his shorts.

"Very funny," he muttered, and went to the phone. "Is the porter on duty, and may I speak to him, please?" he asked. Then, "Hello. Porter? By any chance is there an extra pair of suspen—er, *braces,* in the hotel? I've just discovered that I left mine in Oxford, and there isn't any other way to hold up my pan—er, *trousers.* What? Yes, evening dress. You'll inquire? Thank you very much."

In a few minutes the room buzzer sounded. The porter stood outside, empty-handed.

"I'm sorry, sir," he said. "There don't seem to be spare bryces anywhere in the 'ouse. But do you 'appen to 'ave a belt, sir? I'd be 'appy to 'ave you use mine, sir, if I could 'ave the use of your belt."

So the switch was made. George's belt held up the porter's trousers that evening, and the porter's braces went to the Royal Society dinner. They were maroon with blue and gold stripes, and the only difference between George and the O.B.E.'s, O.M.'s, and K.G.'s in attendance was that everyone could see their decorations.

I didn't go to many such dinners. All-male banquets—even with white ties required—are not uncommon in England, and, of course, in Oxford itself the best feasts are those given by the colleges. They take place in Hall, where women may not dine. That's another of the unbreakable rules. A woman undergraduate tries it just about every year, is caught, and is "sent down." The Fellows might make an exception for the Sovereign, but for no lesser woman; which reminds me of a story.

A couple of years ago a new official at the American Embassy

in London was invited to dine at one of the colleges and brought his wife along. I suppose they had not read the invitation carefully; goodness knows, it took *me* a while to discard my American-bred assumptions of togetherness and start reading invitations carefully to see whether the pleasure of my company was being requested along with Professor Beadle's.

Anyway, there they were—the invited guest and his uninvited wife. Faced by such a *fait accompli*, it never occurred to the head of the college to have an extra place set for the lady. He simply parked her at his lodgings with his wife. Having gotten all dolled up and driven out from London for a black-tie dinner at one of the famous Oxford colleges with all those fascinating dons, the American wife was doubtless tickled pink to find herself sharing a family dinner with another woman and four small children. Women do not dine in Hall, and that's that.

The glamorous titles of the banquets to which George was invited—the Boar's Head Dinner, the Needle and Thread Dinner, the St. Simon and St. Jude Dinner, a Christ Church Gaudy—filled me with envy, nor was it dispelled afterward when I let my eyes run over the printed menu and feasted vicariously on six courses and seven wines. It wasn't that I was lonely, eating chops at the kitchen table with Red. It was a simple case of nose-out-of-joint. The one I most wished I had been invited to was a dinner to celebrate (it said on the invitation) "the 350th anniversary of Sir Will Davenant's 52nd birthday and his happy release from the Tower after his fourth imprisonment therein, and to drink to the health of the Swan of Isis."

You can get quite a bit of mending done, or letter writing, on those empty evenings when your husband is dining in college. The radio keeps you company until, at tenish, you decide to go

98

to bed with a book. This keeps you occupied until elevenish, when you turn out the light. Just as you are getting drowsy, Himself comes home. And *then* things hum! He bounds up the stairs and into the bedroom. He flings his topcoat onto a chair. He bounces his shoes into the closet. He smells of Corona Coronas. The port was vintage, he says. It is obvious that he has done it more than justice. The roast of beef was jolly good. The Brie was admirable. Old Barclay was in top form tonight. Good chap, Old Barclay, listen to this. . . .

For ten minutes, then, a spirited monologue flows over the head of his supine mate. Finally the contented diner-out stretches, yawns, pats his middle, and climbs into bed. That's when he remembers his manners. "And what did *you* do tonight, dear?" he inquires politely. If she's a good English wife, she doesn't tell him. If she's an American transplant, she does. The telling does her a lot of good, and doesn't disturb him, because he's already asleep.

There are only two courses of action open to Oxford wives: either stay home and sizzle or make a substitute social life for themselves.

One woman I met, whose husband is now at an English university without the college system, is still sizzled. "Once a year," she recalls, "we wives were privileged to go to the Master's Lodge, were given an ersatz cup of coffee and a bun, and were allowed to look through a peephole at our husbands in Hall below, feasting on the fat of the land."

She had been corrupted by residence in the United States and Australia, however, so perhaps the more typical wife is the one who said to me, "Oxford wives have a life of their own. It is quite as stimulating in its way as that of our husbands." She said this most firmly, and since she has been in Oxford thirty years to my one, I should not even now dispute her.

Perhaps, as with so much at Oxford, the satisfactions of a separate social life increase with age.

One thing I *did* learn; you can't beat City Hall. The colleges set a better table than any woman can, and the after-dinner conversation of fellow-scholars in a senior common room is likely to be more interesting than the domestic trivia of a wife's day. So the successful Oxford wife is the one who early accepts her husband's college as his mistress. Which reminds me of another story:

A don and his wife were celebrating their twenty-fifth wedding anniversary and were receiving congratulations on their long and happy marriage.

"Yes, in all these years, my husband has never looked at another woman," said the lady. Then, pausing reflectively, she added, "Of course, he hasn't looked at me, either."

So what were the satisfactions of my separate social life? I spun from women's club to women's club and from coffee party to coffee party. Gradually, out of the initial blur of faces, emerged the few whom I got to know well. There was Mrs. Galbraith, so recently returned from America that she knew what I was talking about when I asked whether the Oxford Girls' High School was what *I'd* call a high school. (It isn't.) There was Doreen Williams, soft-voiced and sweet-faced, to whom I often called a greeting as she whizzed past on her boxer's leash. There was Joan Wheare, brisk and forthright, terrified of being thanked for her kindnesses; and Ilse Cooke, a gentle German whose sons were Red's schoolmates and as English as tea and tweed, who said, "Send Redmond to stay with us if you would like to accompany your husband when he makes a lecture in some other city; you should see as much of England as you can." There was Mrs. Liddell, a neighbor in Headington, who knew its history from way back; and the

effervescent Kitty Turnbull; and Gwendolen Darlington, who tended a sizable garden, ran a sizable house, kept tabs on six children, "helped out here and there" in various groups, and never raised her voice or seemed fatigued.

In company with such women, and others of similar stamp, I heard a chubby little strawberry blonde address the Ladies Luncheon Club on "Our Feathered Friends," the summation of her remarks being that those birds who mate for life are a splendid example of devotion and that humans would do well to emulate them. I was among those present when a gentle little curate, just back from Jamaica, showed some blurry colored slides to the Headington Women's Institute. In the question period following one of the ladies timidly ventured, "Did I note bananas in one of the scenes?" "Yes, indeed," replied the young man. "They—er—raise a good many bananas in Jamaica." Pause. "A *good* many." I also heard a tall gaunt man with a thick Austrian accent and a ravaged face tell the Wives' Fellowship that the solution to the rising juvenile crime rate is not to keep British youth longer in school. "Ve haf been doing that for fifteen years now," he said. "Ve haf extended the school-leafing age und the time of training for a chob—postponing und postponing the entrance of these young people into adult life. But they are maturing sooner biologically, und they face life wit' higher expectations, wit' more *demands,* than was the case twenty years ago."

The coffee parties, like the women's clubs, were comparable to similar gatherings in the United States, except that English-women talk less about their allergies and more about the unreliability of tradespeople. They particularly liked to answer questions about England and give me advice on what to see:

"A doom? I dare say it is an odd word, unless one has always heard it. It's a painting—usually a painting, wouldn't

you say, Elizabeth?—or a sculpture, depicting the Last Judgment. There are still a few churches roundabout which have them. Dorchester Abbey, Elizabeth? No, it's the Jesse window that's famous there. Have you seen the Abbey yet, Mrs. Beadle? Lovely, isn't it? And the almshouses and church at Ewelme? Oh, don't miss those. Charming, and the Duchess of Suffolk's tomb is *quite* unusual."

Conversations about the United States never got much of anywhere. Perhaps the English ladies knew so little about America they couldn't ask intelligent questions; perhaps they were essentially uninterested; perhaps they were fearful that their questions would be construed as criticism. In any case, conversations about my homeland tended to become a sterile recital of comparative statistics.

I remember one coffee party when the conversation came around to the Butlers' plan to take a winter skiing vacation in Switzerland. Mrs. Butler—who knew how big the United States is but understood the implications of size no better than I had understood the relationship of sun to earth in a country that lies fifty-two degrees north—turned to me and asked, "Does it snow very much in America?" Thinking of silent snowfalls in New England valleys, of howling blizzards on Midwest plains, of light dustings in the Border States, and of the sun-scorched dryness of my own desert country, I was stumped. "Well, about the same as in Europe," was all I could finally manage.

Oxford wives talked about clothes and children and domestic help and amusing tidbits in the news: the pet-shop owner who had put a live mouse in a cage with a python and was being prosecuted on behalf of the R.S.P.C.A. "for cruelly terrifying a mouse"; the current controversy among City of London officials as to whether the official mace should be carried crown up or crown down in the presence of the Queen; the campaign being

launched by an association of rabbit exterminators to counteract Beatrix Potter's glorification of the bunny. Rabbits are a terrible garden pest in England, and the exterminators felt that they couldn't make much progress until Flopsy, Mopsy, and Cottontail were accepted as the villains they really are. ("Ri*dic*ulous!" snorted Mrs. Busby-Smith. "And Wilfred agrees. He is writing to *The Times*.")

But the best, and most revealing, conversations were those not directed at me, the visitor and stranger. Topic A among Oxford mothers (once the unreliability of tradespeople got disposed of) was their children's schooling. The focus was completely different from similar conversations at home, however, for there was no expressed interest in what the children were learning. The emphasis fell entirely on kind of school. For example:

"And how is your Eleanor?"

"Blooming, thank you."

"She must be out of school."

"Oh yes. In the summer."

"And is she"—delicate pause—"going on?"

"She's at home just now. Perhaps she'll take up a dress-designing course. Her father's not at all keen on secretarial college or anything of that sort. Or she may go to Paris. Her French is really *quite* good, and with a little polishing . . ."

Unspoken but understood: at sixteen Eleanor had not passed the exams that are a first step toward university admission. She could not, therefore, take the actual entrance exams, which are very stiff; only 5 per cent of the eligible age group qualify. In the United States the Eleanors are held longer in secondary school, then have a wide range of collegiate institutions to choose from—institutions that vary in their degree of selectivity to such

an extent that there's a place somewhere for everyone who wants to "have a college education."

Another overheard conversation went like this:

". . . and the Brett-Hamiltons' situation is such that they simply cannot impoverish themselves further for the sake of the children's education. Veronica did very well at St. Denys; there was never any doubt about her, but Sara is a different sort. Quieter and slower, you know? Phoebe Brett-Hamilton is convinced that Sara will come along in time, but if she doesn't pass the eleven-plus exam in January, there isn't any state school that will care enough to try to bring her out . . . and, of course, the little money that can be spared has *got* to be spent on Charles."

Also:

"Young Tom? He's seven. Still at Greycoats. But it's into the meat grinder for him next year. I shall hate it. He seems such a baby still. . . ."

It was out of such talk that I began to understand the English parent's obsessive interest in schooling: the *kind* of school a child attends has much more vocational and social significance than in the United States.

Charles Brett-Hamilton was in a public school—meaning a boarding school for which husky fees are charged, Eton, Rugby, and Harrow being the first examples of such schools that come to mind—and young Tom was destined for one. In both families it is probable that several generations of boys had gone through the same "meat grinder"—so called because the English public school, like West Point or Madison Avenue, turns out a recognizable product. In the United States the mere fact of attendance at Groton or at George Washington High School affects a young man's adult status in society very little. But the English public-school boy is permanently set apart from his contemporaries and

has a lifelong advantage over the non-public-school boy, because the way he acts and talks and his sense of values become—by virtue of his schooling—those of the English upper class. It is from this class still that the majority of top jobs are filled. So it is understandable that, for reasons of tradition and self-interest, a public-school education is sought for many children—even when, as in the case of the Brett-Hamiltons, the parents can't really afford it.

It was this family that particularly interested me, because theirs is a uniquely modern English plight. In Lady Heading-ton's good old days, before the cost of living and taxes had risen to their present heights, all the Brett-Hamilton children would have gone to public schools. But since 1944 there has been a very appealing alternative. There are excellent *free* secondary schools available now, almost as good academically as the public schools, staffed by public-school men, and with the same values. These are the grammar schools—day schools with a heritage going back to the Middle Ages, when they were established to teach Latin grammar. When the welfare state was a-building, the existing ones were in effect nationalized, and others were established. The purpose was to guarantee that every academically able child, regardless of his parents' financial resources, should get a good education. (Until then there was no universal system of free secondary education in Great Britain.) And the scheme has worked out as well as its planners had hoped: bright children from poor homes are getting much better educational opportunities than ever before in English history.

But, as with so many schemes that look good on paper, there is a catch. The grammar schools take only the academically most able, the brightest 20 per cent of eleven- and twelve-year-olds, who are chosen on the basis of a qualifying exam ("the 11-plus"). The other 80 per cent, it is assumed, are not able to

same exams be offered as those that conclude the basic course of study at the grammar schools? If course content were the same at both kinds of schools, one big block to attendance would be removed. We'd do it in America by putting pressure on our local boards of education. Oxford had a Local Education Committee, I knew; I must find out what its role was.

Then my thoughts grew personal. What kind of a school was Red in? It had a different label altogether; it was a "direct grant" school. But what was that? A grammar school? A public school? I was aware by now that it was a good school: several English mothers, on hearing that Red went there, had turned a shade frosty. Their sons had not been accepted, and the unspoken implication was that English boys were surely better qualified than an *American*.

The list in the back of my journal—headed "Find Out Why"—grew daily longer. Any day, now, I would make some appointments to visit schools and talk with headmasters. Meanwhile, the weather's pretty decent, so why don't we run over to Wroxton Abbey and have some Banbury buns for tea?

10

THE head of an Oxford college tells this story:

After he had given a public lecture, a little lady bustled up to him and enthused, "Oh, Master, that was splendid! Your topic was a subject about which I have always been so confused!"

Pleased, he said, "And now you understand it better?"

"Not really," she replied, "but I'm confused on a much higher level."

That's how a newcomer to Oxford feels as he tries to get the organization of the university straight in his head, and I dare say that's the effect our explanations had on our first visitor from home, Janet Lindvall. Being with us was more pleasant for her than to roam around by herself while her engineer husband was in Russia on an official visit. And her coming was wonderful for us, because it gave us a chance to show off all our newly acquired knowledge.

Essentially, we told her, the university is not unlike the United States of America, especially during that period when we were governed by the Articles of Confederation, and is just as subject to confusion, inefficiency, and jurisdictional disputes as the federal government and any of its sovereign states.

The university has no permanent head, in the sense that American universities have presidents. (And no trustees, either. Faculties of European universities are horrified that Americans

not only allow but actually encourage *businessmen* to set policy for academic institutions.) Oxford's official head is its Chancellor, a noted citizen who serves for life but takes no active part in university affairs and is recognized by all as a figurehead. Such leadership as the university actually gets is provided by the heads of colleges, who take on the job of Vice-Chancellor in rotation, for two-year terms each. The only source of administrative continuity, therefore, is provided by the Registrar, a paid officer; and a host of advisory or legislative bodies. These have the advantages and disadvantages of government by committee anywhere.

The largest of these bodies is Convocation, a group composed of all graduates with M.A. or higher degrees—some sixteen thousand people, scattered all over the world. Naturally, only a fraction of them is ever on hand to consider university business. But they have the *right*. Some years back, when the university proposed to eliminate an entrance examination of a religious nature, elderly clergymen crept out of retirement all over the British Isles and converged on Oxford in order to vote against the proposal. All that defeated them was a last-ditch appeal, by proponents of the resolution, to those younger members of Convocation known to have a more "modern" viewpoint. In London the City was pretty well emptied on the day Convocation voted to eliminate the religious exam.

In practice day-to-day decisions of the university are made by dissolving Convocation into a smaller body called Congregation. This group, composed of those who are actively at work in the university, numbers about a thousand. And *it* elects the eighteen members of the Hebdomadal Council (delicious name!), who really run the university. More or less, that is; one of the first lessons one learns at Oxford is that nothing is exact. There is also a body called the Curators of the Chest, who control the university purse strings. It has equal status with the Hebdomadal

Council. The only way to resolve a stalemate between them is to appeal to Congregation.

In short, it takes a long time and a lot of talk to get anything done at Oxford. It is so decentralized, and individual liberties are so jealously guarded, that nobody knows for sure what anybody else is doing—at either the college or the university level. To emphasize this point, George told Janet how, many years ago, Balliol had acquired a house for the use of the Eastman professor.

"It needed fixing up," he said, "and Balliol split the responsibility between the two bursars. The domestic bursar had charge of the house interior, and the estates bursar had charge of the house exterior. Well, when the job was done and the bills were rendered, the domestic bursar decided to have a look at what he was paying for. The biggest single item of expense had been the paintwork inside the conservatory—and guess what? He discovered that after his men had done their painting the men hired by the estates bursar had torn the conservatory down!"

Janet dissolved in laughter. "You're making it up!"

"Well, it was told me as fact. And it certainly *could* have happened. Oxford is that kind of place. No strong central administration, thirty-five autonomous colleges that intend to stay that way,* operation by conference and committee."

We had explained the tutorial system to her, and the dual social-instructional role of the colleges, but she didn't understand how university appointments fitted into the picture. Janet is a

* The year after we were at Oxford a new Chancellor had to be elected by members of the university. One reason that Sir Oliver Franks, an Oxford resident, lost out to Prime Minister Harold Macmillan was that Franks would be too close. The dons felt that he might take too seriously the opportunity to provide administrative leadership for the university.

long-time member of the League of Women Voters and likes to get all the facts.

"You introduced me to Professor Darlington the other day, when you took me to the lab," she said, "and you told me that he's the head of the Botany Department. That's *university*, isn't it? All right. And he told me that his college is Magdalen. Does that mean that Magdalen appoints the head of the Botany Department?"

"No," said George. "Well, yes, in a way. The professorship carries with it a fellowship at Magdalen, so the college has a voice in choosing the professor. But the actual appointment is made by the university.

"Professorships are rare appointments, though," he continued. "Let's take a more typical example—the appointment of a reader or a demonstrator, someone equivalent to our assistants and associates at home. Suppose the Faculty of Physical Sciences, which includes chemists and physicists, regardless of their college affiliations, should decide that more-up-to-date instruction in nuclear physics ought to be offered. Suppose, too, that the Faculty Board believes that Dr. So-and-So is the best man for the job.

"They could go ahead and make him an offer, but since a man doesn't have much status at Oxford without a college affiliation, the first effort of a Faculty Board is to try to find a college willing and able to take him on as a tutor. It is also nice for the university budget to have a college pay part of such a man's salary.

"Naturally, since he will be closely associated with them socially, the Fellows of the college will be interested in what kind of a person the candidate *is*, as well as in what he knows about the atom. They'll give due weight, of course"—and here George grinned—"to the fact that part of the man's salary will be paid by the university.

"But let's suppose that this particular college has a majority of Fellows whose hearts belong to the humanities, and also a big enough endowment so they can afford to be independent. They might say to the Faculty of Physical Sciences that there are quite enough science chaps around the college already and that what they really want is a man who knows something about Plutarch.

"So," George continued, "the Faculty of Physical Sciences will then start all over, and try to ease its nuclear physicist into Oxford life via *another* college. And at the same time, mind you, the Faculty of Theology may be hunting a spot for a specialist on liturgies, and the Faculty of Modern History may be trying to place an expert on constitutional law, and some of the colleges may be trying to wangle university jobs for men *they'd* like to hire.

"In the end, of course, if none of these deals work out, and either the university or a college is convinced that it has to have a certain man, it hires him. Colleges have been known to hire tutors despite the fact that the professor in the same field of specialty has said he won't have the man in his department under any circumstances."

Janet thought it all over. "I believe the story about the Eastman professor's house," she decided. "If so much business at Oxford is done by conferences and committees, people here must just hate to write memos or check with anybody they don't absolutely *have* to."

I had been invited to a luncheon during the time of Janet's visit and telephoned my hostess to ask if it would be possible to bring my guest. Mrs. Ward-Spencer was delighted. "Mrs. Sutherland is among those who are coming," she remarked. "Have you met Mrs. Sutherland yet? You haven't? She rather collects

Americans. And now"—there was a ring of triumph in her voice—"I've got two!"

There was a lot of talk that day about the progress of construction on a new by-pass road just outside Oxford. The theory was that it would relieve the heavily congested streets in the city center by, in particular, diverting heavy traffic bound from the south of England to the industrial north—but the ladies were not at all sure that it would.

"That's what they said about the Southern By-Pass," Mrs. Sutherland remarked (to whose credit it should be noted that she had paid no undue attention to either Janet or me). "But as far as I can see, it's stickier than ever around the Carfax."

"My husband has completely given up driving to work," I said. "He can't stand the traffic. So he walks."

"He *walks?*" exclaimed Mrs. Ward-Spencer. "From Headington? It's two miles."

"He follows the footpaths, and angles across country, so it really isn't that far," I said. "And it's terribly pretty. He's especially fond of the ducks, and all those willowy clumps along the river."

"He walks," Mrs. Sutherland repeated in tones of wonder. "How very un-American."

Oxford is like Boston: it's got itself backed into such a tight corner that the only practical solution would seem to be for the city fathers to tear it all down and start over. Only of course they can't, partly because such a course would in itself be a decision, and all they have been willing to do for the past ten or fifteen years is to talk; and partly because the easy way to achieve an efficient street plan and an orderly flow of traffic would require the partial destruction of some of the city's finest historical monuments. And not even the most ruthlessly progressive American could justify street widening that would elimi-

nate the seventeenth-century baroque porch on St. Mary the Virgin Church, or damage that charming eighteenth-century bottleneck called Holywell Street—just to speed a van full of refrigerators through town. What is needed is a bold and imaginative town planner, someone as dynamic as Robert Moses, and as persuasive as Circe; and it wouldn't hurt at all if he'd taken a First in Greats at the university in his youth and is now known to be keen on association football, a kind of soccer that is highly popular with the working classes. Lacking such a person (and I don't suppose he even exists), the good citizens of Oxford are slowly suffocating in their own exhaust fumes.

Janet was surprised by the prevailing Victorian architecture of Oxford. I had been, too; I suppose the British Travel Association ads were at fault, for they emphasize thatched-roof cottages, half-timbered fourteenth-century inns, and Scottish baronial castles. If one expects buildings that are either quaint or magnificent, it's a shock to come face to face with so many great, gaunt mausoleums of polychromatic brick, each with as much gingerbread decoration (in stone, rather than band-sawed wood) as any Midwest Gothic.

However, even these are not typical. The most usual house in Oxford or elsewhere in English Midlands cities is a tall, narrow, brick duplex, each side with two bay windows up and two bay windows down, all of them angular and graceless. For some obscure reason such houses are called "semi-detached." I have never seen two halves of a peach more closely joined, but the individual owners treat each half as if the other half were miles away. It is not uncommon to see the wood trim on one side of such houses painted orange, with a green door, and that on the other side a like combination of red and maroon. If the house itself is paintable, the walls of each half may be of different colors too. The paint, incidentally, is almost certain to be fresh,

the brasswork on the doors as shiny as daily polishing can make it, and at any season of the year there is sure to be a potted plant or a bouquet of flowers behind the spotless windowpanes of the inevitable bays. The English are house-proud.

They're illogical, too. Against the outer walls of such dwellings are the water pipes, wholly exposed to the weather and almost sure to freeze at least once in the course of the winter. I called a batch of these to Janet's attention as we chugged home toward Headington after our luncheon party. "There's a joke about those exposed pipes," I said. "At least six people have told it to me. 'Yes, but when the pipes *do* freeze, they're so easy to get at.'"

The two of us made daily pilgrimages to the various colleges. I took Janet to my favorites, and we ticked off some new ones. They're all different. In some you feel as if you're strolling through the grounds of a Stately Home—as at Worcester College, with its lovely lake; or at Magdalen, which has a deer park, magnificent gardens, a piece of the river, well-preserved buildings of uncommon beauty, and so many tourists the undergraduates have a hard time getting through the gates. In some colleges time seems to have stood still since some golden moment in history. The Great Hall at Christ Church College is one of those; it could have been yesterday that Henry VIII dined at High Table there. In some colleges you are especially aware of the *flow* of time. New College is one such. In its cloisters there are medieval stone saints, an eighteenth-century fire engine, and quantities of flesh-and-blood pigeons: together they distill the essence of a five-hundred-year span into the living present.

"New College?" Janet asked. *"How* new?" (She was getting wise to Oxford ways.)

"Fourteenth century."

She giggled.

"There are four or five that are older," I said. "Incidentally, the people who started this one got the land cheap because the victims of a plague had been buried here. When we get into the garden you'll see a nice long bit of the old city wall, and a mound where King Charles mounted his cannon when he was trying to hold out against Cromwell. The cloisters here were used as an arsenal."

"They're very impressive," Janet said, pausing to read a plaque to the memory of John Galsworthy. "But I've been wondering something about Oxford. I suppose even here things wear out and have to be replaced, or additions are required. With the past so—well, not actually pressing down on you, but so *dominant*, however are they going to switch to a more modern style of building? The architecture just won't jibe."

"I think that's why people here turn their noses up at Nuffield College," I said. "That's the new one down by the railroad station, remember? It tries to look like the old colleges, but its lines are more streamlined, and its spire is very modern. Over-all, it's neither fish nor fowl—not good modern, not good eighteenth century. Matter of fact, I haven't seen any really exciting modern design so far in England—it's either too belligerent, like that technical college we pass on the bus when we come into town, or too timid, like Nuffield."

"Fred and I stopped off at Harvard on our way to England," Janet said, "and they've certainly got very *modern* modern mixed in with their older buildings. The campus reminded me of Henry Dreyfuss's contention that if a work of art is good of its period, it'll go well with the best work of other periods."

"Come on into the chapel here," I proposed. "You'll have a chance to see whether you agree with him."

The Oxford colleges are most dissimilar in their chapels. Christ Church's is so big it's a small cathedral; in fact, it serves as

the cathedral for the city, too. I liked going there because more than any other place in Oxford I could feel the centuries rushing by. The historical journey begins with the sturdy Norman underpinnings, continues as the eye arrives at the delicately fan-vaulted fifteenth-century ceiling, lingers on the muted greens and blues and careful brushwork of the seventeenth-century windows, zips by the ruby-red and sapphire glass the Victorians installed, and finally comes to rest on yesterday's bouquets, lovingly and artfully arranged by the ladies of the church guild. Brasenose College has a fan-vaulted ceiling too, but it's been grafted onto wood and painted, and it has a nice air of country freshness. Keble's chapel is a boisterous blending of brick and mosaic. Hertford's has a Quakerish simplicity. And Trinity's is as florid as a fruitcake. Sometimes, when you steal into one of these darkened interiors, you catch an undergraduate practicing on the organ. He pretends that you aren't there, and so do you, and a lovely quarter of an hour ensues.

At New College chapel Janet thought that the Joshua Reynolds windows, all in shades of gold and bronze, were as beautiful as I had thought she would, wrinkled her nose at Epstein's very modern, very blocky sculpture called *Lazarus*, also as I had thought she would, and said, "Ooh!" when she spotted the mass of carved figures (the reredos) behind the altar. But what both of us saw for the first time was a girl on her hands and knees in a corner of the antechapel.

"Is she praying?" Janet whispered, and I couldn't answer, so we eased over to one side to get a view of what she was doing.

The girl had a great sheet of paper laid over one of the brasses, which are tomb ornaments of a type popular in the Middle Ages. They are portraits in one plane of the worthy who lies below them, and are fun to study because they reproduce

the actual clothing of their day much more faithfully than stone tomb effigies do. The latter are great on classical drapery but skimpy on detail, and if you want to know how a fourteenth-century knight really looked in mixed mail and plate armor, you have to find the brass engraving that was set into the lid of his coffin.

The brass that the girl was bending over was one showing a bygone don in fifteenth-century academic dress, and she was making an impression of it by rubbing a black waxy ball across the paper she had laid down—just as children "copy" coins through paper. When she paused to rest, I asked, "What are you going to do with it when it's done?"

"Hang it in my digs. If it's good enough; this is my third go at it. It takes a bit of practice to maintain an even pressure as one rubs, and the paper shifts rather easily."

(Subsequently I saw some framed rubbings of brasses. They make handsome room decorations.)

Poor Janet, as the first of our American visitors, got the full treatment—but she was game, and kept asking for more. I took her to the spectacular chapel at All Souls College, which has some famous brasses and a magnificent reredos; the statues in this one, forming a breath-taking backdrop for the altar, are large, well-separated, and in full relief—obviously portraits. I think of them still as "all the souls of the faithful departed" for whom the college was named. Magdalen's chapel has windows painted in sepia-and-white chiaroscuro, in which the combination of light coming through the glass plus the artist's technique in rendering shadows gives a three-dimensional quality to the figures. Exeter's chapel is a little jewel, a miniature St. Chapelle, and so is its Fellows' Garden—a tiny sunken garden tucked into a narrow opening between two high and ancient gray

stone buildings, with the classic cupola of the Radcliffe Library and the frilly pinnacles of St. Mary's filling the sky beyond it.

The Rector of Exeter is an astute and affable gentleman named Kenneth Wheare. (Along with his wife and son Tom, he gave us exceeding comfort and joy throughout our Oxford year. It is as much the example of their friendship as any other circumstance that now makes us especially watchful of the welfare of *our* visiting families from overseas.) He tells with great glee of how, one day, he observed a couple of American tourists —a father and twelve-year-old son—wandering around, out of visiting hours, in the Fellows' Garden. The man was taking pictures, and the boy was romping on the grass. Hating to yell at them—conduct unbefitting a Rector—but wishing to register his displeasure at their trespass, he stood at the window of his study, puffing furiously at his pipe, and glared down at them. It was the boy who caught sight of him. Whereupon, he caroled out to his father, "Hey, Dad, *look!* These ruins are inhabited!"

Exeter, Lincoln, and Jesus colleges lie close together on the quaint little Oxford street called the Turl, all three of them presenting similar façades to the street. It's hard to distinguish one from the others, out of which fact has grown a favorite Oxford joke. A newcomer—American, of course—is alleged to have said, "I can never tell the difference between Lincoln and Jesus." His guide replied, "No American can."

I paced Janet up to the roof of St. Mary's for a view of the colleges from above—the city looks like a leafy bower from that height—and down into the crypt of St. Peter-in-the-East, which was built within a hundred years of the Norman Conquest and has probably had a puddle of rain water on the floor ever since. We saw the famous chained books in Merton College library, a nice reminder of the days when books were as precious

as jewels and had to be guarded from thieves; and went into the Christ Church kitchen, where the huge fireplaces and spits long enough for a side of beef remain unchanged from the sixteenth century.

The headmaster of Red's school, Robert Stanier, had by now become a person instead of a title, and we had also met his wife, a charming woman who is Oxford's unofficial poet laureate. Under the pen name of Culex her verses appear regularly in the Oxford newspapers and have been reprinted in two small volumes. Toward the end of Janet's stay with us, and after a particularly exhausting day of sight-seeing, I got out *Culex's Guide to Oxford*, flipped it open to a favorite verse, and laid it on Janet's lap. She read:

TOURIST'S ROUND

Marcato con brio Into the Chapel and round the Quad
Up the Turl and down the Broad,
Through the Kitchen and up the Stair,
Hurry on, madam; quicker, sir.

Presto Here's the glove Elizabeth wore,
Mark the genuine Norman door.
This is Cardinal Wolsey's hat.
And that is where the Parliament sat.

Rallentando (I could do with a seat—and how!
Not now, darling, hush, not now!)

Prestissimo Keble's the one that's made of brick.
Magdalen's strong on the perpendic.
Gilbert Scott on the left, and then
On the right for Christopher Wren.
Notice the Epstein on your way,
Very symbolical, so they say.

Rallentando	(I think—you know—I'm feeling queer.
Dolorosamente	What I need is a glass of beer.
	Hush dear,
	Not *beer,*
	Not *here.*)
Marcato da capo	Into the Chapel and round the Quad,
	Up the Turl . . .

Janet smiled, closed the book, wiggled her tired toes, and said, "Amen!"

II

"HERE'S my gamma card," Red said one evening, handing across the dinner table a sizable piece of pasteboard labeled "Position Card."

"Why 'gamma card'?" George inquired.

"That's what the fellows call it. Because the lowest grade is gamma. I didn't get any." (Was there a trace of smugness in his voice?)

The card was ruled into squares, as American report cards are, with the first three letters of the Greek alphabet replacing the A's, B's, C's, D's, and F's commonly used in the United States. The back of the card provided the key:

α shows that the boy is in the top section of the class
β shows that the boy is in the middle section of the class
γ shows that the boy is in the bottom section of the class
The sign * indicates that a boy has made a commendable effort
 even if he remains in a low section of the class
The sign ± indicates that he has not done as well as he should
 even if he is in a high section

"But, George," I said. "That's *comparative* grading. Remember that ruckus at home a couple of years ago? The people who demanded that A must stand for 90, B for 80, and so forth? One of their big talking points was that the English schools have such tough and objective standards of grading."

George, himself a teacher, brushed that aside. "You can't give course grades on that basis, anyway. Just exam grades . . . Look here; what interests me is this 'set' scheme. If I understand the theory, this starred alpha that Red got in physics ought to mean that he'll be moved up to a higher set so he'll have to work harder."

Red groaned. We ignored him; it had a ritualistic ring.

"The English have a wonderful word for it," I said. "They call it 'stretching.'"

Sets are ability groups. In each subject the boys had been divided into fast, average, and slower-moving sections; each of these sets met as a class. Red was in Set I in English, math, history, and geography; Set II in Latin and French; and Set III in physics, chemistry, and biology.

His starred alpha in physics indicated that he was doing top work and had made a "commendable effort" besides. He had also gotten an alpha in Latin. These alphas could promote him to a higher set—to Set II in physics and to Set I in Latin. But he'd gotten a beta in French; it would have to come up to an alpha before he could move to Set I. Conversely, if it dropped to a gamma, he might sink into Set III.

Thus, within a school whose pupils were already highly selected for academic ability, three degrees of competence *in every subject* were recognized—a device that not only made teaching easier, because the boys in a given class were more nearly equal in ability, but also one that rewarded industry and punished laziness in the pupils. It's a fine scheme. It deserves an alpha with *two* stars.

The list of subjects was much longer than Red would have been taking at home. In addition to those listed on his card, he was taking art, physical education, and Scripture—for which no grades were given. The school packed them all into a thirty-

six-hour week by varying the number of hours assigned weekly to each subject. Latin, French, and the subject Red now called "maths" rated five hours each; everything else got less. He had had a choice of Greek, or geography and art in the same time slot; otherwise there were no electives.

At the top of the card the name of Red's "house"—Wilkinson—appeared. There wasn't any house, in a physical sense; it was a system of organization (borrowed from boarding schools like Eton) that created small fraternal groups within the school. I had at first thought of Red's house, in American terminology, as his home room. But it was far more—a clan, almost. Intramural athletics and other contests were organized as matches between houses. Each had a master whose job it was to keep tabs on the progress and problems of the boys in his group. Since the number of boys in a house didn't exceed seventy-five or eighty, and they remained in the same group throughout their school days, in time the housemaster would get to know them—and vice versa—really well. The English house system deserves an alpha with two stars too.

(Some American school districts are now using a variation of it to create small groups within huge schools, to give pupils a sense of "belonging." For their entire time in high school pupils are assigned to one specific block of classrooms, with a specific group of teachers; going out of their school-within-a-school to labs, shops, auditorium, and cafeteria, which the entire student body shares in common. It's an excellent way to combat the impersonality of numbers.)

A few days after the position card had been signed and returned, George and I set out, as summoned by letter, to a meeting of the school Parents' Association.

"And I was so pleased to get free of the P.T.A. for a year," I

remarked, as we picked our way along a pitch-black path toward the only lighted building on the school grounds.

"Somehow, I think you *are* free of the P.T.A.," George said as we entered. He was right: there were as many fathers as mothers in the audience; the hall was full five minutes *before* the meeting was scheduled to start; no paper drive was announced; and nobody said a word about Understanding Your Adolescent. It was all very restful.

The chairman announced that the Christmas Fair the preceding year had made £160, up £40 from the year before. He said that Mrs. Pye would have charge of it again and that she needed ladies to help with the teas; in fact he believed that she would welcome a word after the meeting with any of the ladies present who wished to offer their services, isn't that correct, Mrs. Pye? A little red-haired woman in the front row bounced to her feet, nodded vigorously, and beamed at the audience. All around me I heard voices murmuring that they'd be delighted to help out. *This is most certainly not the P.T.A.*, I thought.

It was at this meeting that I learned what a direct-grant school is. It's a private school that receives tax support (in the form of a grant directly from the Ministry of Education). In return it must take up to half its pupils as "free" boys—mostly those who have passed the local 11-plus exams with distinction. Other pupils pay fees as they would at any private school anywhere. They are admitted at the discretion of the headmaster, or on the basis of passing exams of his choice. Thus, schools like Magdalen College School include boys from both upper and lower social classes. (At this very parents' meeting, I caught the "oi" sound that replaces "i" in Oxfordshire speech, an accent that will be gone from the voices of their sons by the time they have been exposed to BBC English throughout their school years.)

There aren't many direct-grant schools in Great Britain—fewer than two hundred. They are relics of that pre-1944 period when established private secondary schools were offered tax support as an inducement for taking in bright but poor boys. Now, however, the direct-grant schools compete with the state-supported system of grammar schools, their greater prestige and smaller classes creaming off the most able youngsters. Hence they come under sporadic attack. But their champions defend them because they are "a blending of rich and poor, and for that reason a bridge between the state schools and the wholly independent schools."

The history of the direct-grant schools has a parallel in the church schools which, in the nineteenth century, provided all the elementary education there was. It is characteristic of the English, who never discard anything that still works, to have supplemented existing facilities rather than to have created entire new systems, as Americans would have done. Therefore, today, there are church schools (of various faiths, not just Church of England) that get their *operating* expenses from tax funds, retaining responsibility for capital improvements along with the right to choose their entire teaching staff; and there are other church schools that are supported completely by the taxpayers. In return these have no say in the appointment of teachers, except for the headmaster and the teacher who provides religious instruction. At the two extremes, as in the United States, lie the wholly independent schools and the wholly tax-supported schools. With regard to these latter, it always amused me—recalling bitter fights at home over Released Time for Religious Education or the propriety of reading the Bible in public schools—that English law makes an assembly with prayers mandatory in any school that receives tax money.

By American standards it's a crazy quilt of a school system.

We could never make it work; we have too Teutonic a fondness for codification and chains of command. But tolerance, respect for tradition, and a stubborn distrust of centralization have characterized the English for generations. They like cautious experiment rather than radical change, and if this predilection sometimes muddles them up, costs them money, and slows them down, at least it spares them the disillusionment that can follow the collapse of some grandiose but untried scheme. The lack of acceptance of the secondary modern schools may arise in part from a feeling that the reforms of 1944 were too sweeping.

A couple of weeks after the first Parents' Association meeting at Magdalen College School, we groped our way back—this time in dense fog—to a meeting of Wilkinson House parents. The nearest American equivalent would be a grade-level meeting, but American parents would not have been so deferential in their greetings to the housemaster and his two assistants, who greeted us in black academic gowns and apologized for not being able to offer us a cup of tea on such a damp, chill night.

The purpose of the meeting was to answer parental questions, some of which were as universal as the existence of schoolboys:

"How hard should I press my son in the matter of prep?" a father asked. Answer: "Be quite strict, but adjust to the boy. If he works fast, and can finish in twenty minutes, don't force him to spend thirty. If it takes him too long, be sure he is spending his time profitably. The most important thing about prep is to make him understand that he's not doing it for Old Mr. So-and-So, but for his own sake."

A mother asked if something couldn't be done to get the boys to bring their damp towels home, instead of letting them mold in their lockers; a father requested that a stern warning be given to those bike riders he'd seen on the streets riding side by

side—"a very dangerous practice"; and another asked what the parents of fifth-formers should be doing, if anything, to plan for their sons' university admission two years hence. In America the answer to that last one would never have been phrased as it was in Oxford. The housemaster began, "Some Oxford colleges prefer that the boy apply at the end of his penultimate year. . . ."

There were half a dozen American families represented in the group. (This was due in part to the fact that the university draws many foreigners to Oxford, and in part to the fact that Mr. Stanier likes Americans. He thinks that they liven things up.) The questions asked by the American parents were of quite a different order from the questions asked by the English parents:

"In determining grades, how much weight do you give to recitation, how much to homewor—er, prep, and how much to examinations?" asked a man from Massachusetts. (Home university, Harvard.) The housemaster looked startled. He finally replied that there was no rigid formula.

A woman from Illinois (home university, Northwestern) wanted to know what percentage of class time was set aside for conversational French. She finished with, "What is your policy in this matter?" The housemaster must have fought back a smile —what very *American* questions!—as he answered that the masters were aware that conversational skill was desirable.

In short, the Americans wanted details of curriculum, and the English—as I had already noted at ladies' coffee parties—did not. Did the English refrain because they already knew the answers or because they thought that what the schools teach is none of their business? A little of both, probably. Americans, of course, consider everything that goes on within a school as very much their business. ("We *pay* for them, don't we?")

It was certainly not my intention to alter the genteel tone of the meeting, but the minute I uttered my question I sensed that it was as tactless as mentioning socialized medicine among a group of American doctors. My question was this: "I've been reading in the papers that there is considerable opposition to the establishment of comprehensive secondary schools such as we have in the United States. Could you tell me why?"

The housemaster flushed slightly. Then he took a breath and replied. "We in the grammar schools are not opposed to the idea," he said, "but we believe that the political pressure to build more comprehensive schools—there are, as you no doubt know, a good many of them in London—is unwise. They have been in existence only ten years, and many of us feel, since they are still experimental, that it is too soon to judge them.

"Secondly, the heart of the grammar school is the individual attention and supervision which it makes possible. The boys have direct contact with the headmaster. I don't see how that would be possible in a school with two thousand children. It *is* the essence of a comprehensive school that it must be large, I believe?"

I nodded. "Yes, since it includes children of all academic abilities—that is, both those who would go to grammar schools and to secondary modern schools, here. Unless there is a large group to draw from, it's impossible to find enough pupils of the *same* academic ability to make course offerings sufficiently varied."

The housemaster continued. "Many of us are not at all sure but what the academic-minded boys would be held back by the presence of the others. It is our experience in the grammar schools that individual progress depends on the homogeneity of the group. Slow boys would be bewildered if put in a fast group, and of course fast boys would be held back by the slow."

130

I opened my mouth to argue—well, at least to *clarify*—the point, since the academic-minded pupils in most American high schools take academic courses, and the slow pupils don't; but George put a cautionary hand on my arm, and I remained silent.

"Finally," the housemaster said, "it's the same principle that causes one to send a promising musician to a music academy rather than to a village choir. Since the future of our country depends on brains, many of us believe that our job is to find and train those intelligences which will be capable of the judgment we need for the nation's future welfare. And the grammar schools seem to do this job exceedingly well."

He was dangerously close to an un-English show of emotion, and his audience was so stirred they spontaneously applauded. I murmured a meek "thank you." Flustered by having allowed himself to be carried away, the housemaster cleared his throat, smiled apologetically, and remarked, "I'm afraid it's become a political plank."

I didn't find out until later that the London comprehensive schools are the work of a Labour-dominated city council that has built them as much (or maybe more) for social as for educational reasons. Since the present system of segregated schools helps to maintain class distinctions, England's socialists hope to eliminate such distinctions by establishing comprehensive schools throughout the country. You can hardly blame the class that is about to be eliminated for objecting.

It is a widespread assumption in England that the academically most able children cannot be well educated in comprehensive schools; I am not at all certain that anyone really believed me when I told them that we *do* put children of varying ability into specialized groups. The educated Englishman's other fear of the comprehensive school, however, is justified. The out-

ward mark of education is good speech. The educated English-man fears that the distinctive accent and discriminating word choice at present built into the elite 20 per cent of school children would be blurred and diluted by everyday contact with the other 80 per cent. And he's right.

Personally, I think that day is coming. But as of now, quoting an Oxford headmaster, "Speech matters. Oh, how it *does* mat-ter!" Or, quoting an Australian scientist newly come to Oxford, "I've no liking for class schools, so I tried sending my boy to the neighborhood state school. He's begun to speak with an Oxfordshire accent. Well, his future is in England. I've no right to handicap him. Next term, he's going to a private school. You see? No neutral position is possible."

12

ENGLAND had been green and glowing with bloom when we arrived. Gardens were bright with dahlias, daisies, and delphiniums. The rain would knock their petals off and bend them to earth, but every morning they'd be upright again, full of fresh bud and blossom. Lawns and meadows were pure plush, and it was like being in ocean depths to look up from below at the rich dark canopy of green that linked the trees together.

Then the chestnut leaves had begun to turn and fall; a few drifters at first, but by late October a bronze carpet lay across the paths in the parks. The sun rose later every day, blood-red through low-lying mists. The lush green of the countryside began to gray, a milky wash suffused the blue of the sky, and even at midday the air had a smoky haze.

On such a day we set out for Stratford-on-Avon. We were tired of people, tired of sherry parties, tired of tossing tidbits of news to each other when we happened to meet on our own doorstep. Deciding that our family batteries needed recharging, we'd gotten tickets for *Hamlet,* and now, a little after noon, we were ready to go.

"Red roads, or yellow?" George inquired. "Yellow!" Red and I chorused—meaning that we wanted to travel on the secondary roads, which are yellow on the maps. These are the roads that take one to places with marvelous rolling names like Wotton under Edge, Weston super Mare, Fifehead St. Quintin, and

Norton juxta Twycross. There are lots of other Nortons: East, King's, Pudding, Brize, and Cold (to name a few); and almost as many Bartons: Steeple, Upper, Nether, Earls, and Abbot's. Sometimes the neat little country signposts made us snicker; names like Lower Swell, Little Crawley, and Great Snoring were always popping up. But whenever we got to thinking that English place names were just too droll for words, we could count on Red's reminding us of American towns like Down Sockum and Truth or Consequences. Then he'd dig into the Ekwall dictionary of place names, and together they'd peel the centuries back like the layers of an onion. English place names are living relics of changing languages and ownership over the course of a thousand years, and we never passed through towns like Stretton-on-Fosse or Duntisborne Rouse without learning some history.

(OK, since you ask: The Old English word for "Roman road" was *straet*, and a town on a Roman road was a *straettun*. One of the famous ancient roads of Britain led southwest from Lincoln to Bath, and was distinctive because of the *fossa*, or ditch, alongside it. A hamlet in what was to become Warwickshire therefore distinguished itself from other towns on Roman roads by identifying itself as the one on the road by the ditch. As for Duntisborne Rouse, a good many invaders of England march through one's mind as one ponders its name. In Saxon times, it was a place by Dunt's *burne*, or stream; with the Norman Conquest it passed into new hands. In the thirteenth century a Roger le Rus held it—his family name already evolving from the French *roux* that had described some forebear's hair.)

The yellow roads, and the towns they led to, always yielded some small delight. Often it was a sign announcing the presence nearby of an Ancient Monument, which always brought George braking to a stop and sent the lot of us scrambling up a

muddy lane to gaze at a Long Barrow or a circle of lichen-encrusted stones dating from 1500 B.C. Once we had stopped in the town of Cricklade just as the children were queuing up for their harvest service at the church, their little arms strained around giant cabbages or already-wilting bunches of daisies to take to the altar. In Cirencester two waiters had fallen into a quarrel while advising us whether the town's name should be correctly pronounced Cisseter or Cissester. (It was there we first saw the shop sign "Carpenter, Joiner, and Undertaker" and suddenly realized that England is blessedly free of mortuaries.) In Lower Slaughter we had met three geese as rapacious as the bears in Yellowstone, as well as an itinerant blacksmith who had showed us a horseshoe made in the fifteenth century. "And a proper prize it is," he said. "The Victoria an' Albert 'ave offered two quid for it." He kept it wrapped in velvet in the back of his rattletrap truck.

So on this Saturday in October we set out for the north with high hopes. We were not disappointed. Just beyond Woodstock we came up behind a gypsy caravan, and in due course eased past it. The entourage, in the order in which each unit came into view, included a lithe young boy riding bareback on a rangy little pony; a pony-drawn cart whose paintwork was gay with flowers and scrolls; and, at the head of the procession, a brand-new house trailer. It was peacock blue and white, and its chrome trim sparkled in the sun. So did the bangles on the bridles of the horses that were pulling it. Walking alongside was the head of the family, a short, swart man wearing gold earrings, denim Levis, and sneakers. As an Oxford don might put it, *tempora mutantur, et nos mutamur in illis*.

Not far from Shipston-on-Stour, in a green bowl of meadows and woodland, we found Compton Wynyates, its mellow pink brick dyed red by the setting sun.

"The chimneys," I said as we shuffled up the graveled drive, our half crowns ready for the caretaker's little black box. "Look at those spiraled chimneys. Like fluted candles."

"This place is Elizabethan?" George asked.

"Earlier." Red answered. "It says in the book on Stately Homes: 'Dates from 1480, a picturesque example of Tudor domestic architecture. Owned by the Marquess of Northampton, D.S.O. Wednesdays, Saturdays, and Bank Holidays, 10 to 12, 2 to 5.'"

A plump and cheerful little woman took our money and asked if we minded joining the other party, which turned out to be two Amazons in whiskery tweeds. They ran a seaside resort in Devon, they told us, and now that the season was over, they were off on a busman's holiday. They didn't miss a thing: they thumped the Silent Lady in the drawing room, rapped the paneling beside the staircase, assayed the amount of bullion in a gold-embroidered tapestry, and tested the bounce in the mammoth Jacobean bed in which Henry VIII had once slept. All in all, they saved us a lot of trouble.

At the top of the house lay the Council Chamber, a handsome room in unstained oak, with bands of carved holly for trim. Above it, reached by a twisty staircase hidden in a closet, was a cubbyhole the guide called "the priest's room." The phrase was apparently self-explanatory to the tweedy ladies, but I wanted more. "Why so hard to get to?" I asked. I was thinking, *The chapel is three flights down, wouldn't you think they'd have quartered the priest somewhere handier?*

"It was customary during the Reformation, madam. That would be in 1530 or thereabouts," the guide amplified. "When England became Protestant, most of the nobles remained Catholic. But to do so openly wasn't—er—wise. This family, like so many, was Protestant downstairs and Catholic upstairs. This room is where they hid their priest."

136

Meanwhile, George had been looking down into the garden. He turned to the guide and asked, "Was there a moat?"

"Oh yes, sir, but it was filled in, sir, when the house was defortified after the Civil War. That was the price of its being returned to the owner."

"The *English* Civil War," Red hissed. "In 1642. Puritan Parliament against Anglican King."

The guide heard. "This was a Royalist house, of course. Loyal to King Charles. Did you notice in the chapel that most of the glass is clear? The original stained glass was destroyed by the Roundheads." Then, as we picked our way downstairs, "If you have time before you leave, visit the parish church at the bottom of the drive. The tomb effigies there were mutilated at the same time. They were retrieved later from the moat."

It was a pretty little church, the only one we saw in England with two aisles and a double-arched ceiling (like a pair of bread loaves). Originally one side had been a light color and the other dark, to represent day and night, but all that remains of this whimsey is a fading sun and a waning moon preserved under glass.

We had intended to stay the night in Stratford, but it was so full of Ye Old Chintzy Tearooms and Ye Quaint Souvenir Shoppes that we kept right on going until we found a nice, non-touristy two-star hotel in nearby Warwick. Then we returned to see *Hamlet* at the Shakespeare Memorial Theater. The performance was full of heroic flourishes, sonorous soliloquies, and snippets of humor, and even George stayed wide awake through the bits that tend to drag. I can still see Ophelia, a blonde with a body as slight as a child's, twisting a lock of fair hair with eloquent, fluttering fingers. The memorable death that night was the death of her mind; it perished in weak spasms, like an abandoned kitten.

We awoke on Sunday to not-quite-fog, and to air so still the

Avon was like gray glass. Framed by the muted reds and golds of turning trees, Warwick Castle rose wraithlike in the mist. Even the swans were still. We walked in silence across the bridge, feeling as if we should apologize to someone for our footfalls.

Suddenly George turned and looked back. "Why does it look so familiar? We've never been here before."

Red laughed. "Disneyland, Pop."

"*Disneyland?*" He looked again. "Good Lord, you're right. It *does.*"

By the time we got to Kenilworth Castle, a lemon sun was weakly shining. Open to the elements, the Gothic-arched windows, in what must have been the great hall, made sharp silhouettes against the pale blue sky; all else was tumbling down in rosy ruins. We climbed a mound across the way so that we could look into what must have been elegant gardens when the Earl of Leicester threw his lavish parties there for Queen Elizabeth.

"Remember how Amy Robsart fell through the trap door?" I mused. "They never proved he had her pushed, but I'll bet he did."

"Who?" said Red. "The Earl of Leicester? Over there?"

"The Earl of Leicester, but not over there. In a house near Oxford. In fact, she's buried in St. Mary's. I've seen the marker."

"*Who,* Mom?"

"Amy Robsart. The Earl of Leicester's wife. They said he got rid of her so he'd be free to marry Queen Elizabeth. Only she never asked him. That story was in *Kenilworth.* I remember weeping buckets. . . . You kids don't read Walter Scott any more in school, do you?"

As we clambered down from the mound, Red set the record

straight. "Sure we do. Some. I read *Lochinvar* in eighth grade. And I tried *Ivanhoe* just last year. But I quit after a couple of chapters. It had too many 'forsooths' and 'thou hasts.'"

"You could have finished it at the barbershop," said George. "They have it in their collection of comic books."

"*George!*"

George grinned at Red. "She always rises to the bait, doesn't she?"

Homeward bound in a lackadaisical Indian-summer mood, we rambled in loops and whorls through the lovely Cotswold countryside. Through Pillerton Hersey, Pillerton Priors, Fulready, Whatcote, and Whichford. Westering sun lay over the land like a benediction. Nothing moved. Even the bird song was hushed.

Beside the pretty, reed-edged Windrush River lies the tiny town of Minster Lovell. Of its ruined manor house, built in the fifteenth century, nothing remains complete, yet it's easy to people it with ghosts. A diamond-patterned, cobbled pathway leads to a squat-arched portico, beyond which lies the great hall, and one can pick out the shape of the rooms that once enclosed a giant countyard. Rising four stories high on the river side is a tower from which I suppose the Barons Lovell watched for enemies. Rounding the base of that tower myself, I came face to face with a placid cow and yielded the field with a yelp. George said, "Shoo, Boss," and the cow ambled off. But the spell was broken: the Lovells returned to dust.

It was twilight now; the air was cold and wet, and streamers of mist were rising from the river. There would be hot soup at home, a cozy fire, and comfortable beds. Tomorrow was a school day. As the little pink house in Headington finally came into view, George said, "Well, that was a very satisfying excursion into culture." We all agreed, nodding at each other benignly.

13

BY November, Oxford was home. I would always be an alien, of course, but I was no longer a stranger.

I was wholly sold on the leisurely pace of English journalistic writing, which puts into the twelfth paragraph what American reporters are taught to put into the first. My eye slid without affront over such phrases as "the committee have . . ." or "the government are . . ." and it was exceedingly restful to be free of Orphan Annie and Dick Tracy. To have ads on the front page of a newspaper now seemed right; in fact, I had become completely addicted to reading the daily appeals on behalf of the Society for the Assistance of Ladies in Reduced Circumstances, announcements of voice trials for church choir schools, offers to swap tickets for *My Fair Lady,* suggestions that household renovation problems be brought to the Woodworm and Dry Rot Center, and the U.F.A.W.'s pleas that the reader buy a fur coat that had been humanely farmed rather than "made of wild animals that died in long-drawn agony."

On the domestic front I had washed my hands of the Rayburn as a cooker, a decision that had improved my disposition enormously. I had ceased longing for sturdy kitchen matches, paper towels, and the box-boys who sack your purchases in California supermarkets. I hardly saw the hogs' heads, neatly sawed in half, that were a staple item at the butcher shop. In

making a telephone call from a public telephone I automatically pushed the B button to complete the connection, and I was making progress in crossing streets with English abandon (that is, whenever and wherever I felt like it)—a practice that had given all three of us regimented Californians a giddy sense of freedom. However, I was still looking in the wrong direction when I stepped into the street, and I couldn't seem to stop calling a block a block.

It wasn't difficult to switch, as a driver, to the left-hand side, but pedestrian habits must be much more deeply ingrained. All of us long continued to look left when we stepped off the curb; whereupon, with alarming frequency, we'd hear a squeal of brakes on the right. Even by the end of our Oxford year, when I *had* learned to look right, I never could quite resist the need to sneak a quick look left, just to make sure. I remember reading the memoirs of an English girl who had posed as French and had been a spy in Occupied France during World War II. The Gestapo finally nabbed her because she glanced involuntarily in the wrong direction while checking oncoming traffic.

As for blocks, the term isn't used, because few English cities are laid out on the grid system so common in America. You can see the difficulties one might run into: if four side roads enter a major street on its north side and none on its south side, how many blocks long is it? But this measure of distance is so deeply imbedded in American usage that I never quite broke myself of the habit of directing English acquaintances to our house by telling them that it was "three blocks from the Headington traffic lights." The English measure similar distances by time, as in: "Jackstraws Lane? It's down the London Road a bit, and the house you're after will be just beyond the first turning. A ten-minute walk, I should say." (With experience one learns to translate this into: "Twenty minutes of hard walking will bring

you close enough to ask for further directions while leaning against a wall and catching your breath.")

By November I knew at what point on the bus route the fare changed from fivepence to fivepence ha'penny; I had ceased to be startled by the fact that the street called North Parade was south of the one called South Parade; and I had learned that houses on different streets were not necessarily numbered after the same system. On some the even numbers were on one side of the street and the odd numbers on the opposite side, as in the United States; but every so often, having started with Number 1 on the southeast corner, I had found myself doggedly pursuing Number 20 up to the end of the street, across to the other side, and back down to the southwest corner, opposite Number 1.

Finally, I was making great strides with my English. Advanced level. I had mastered Basic English much earlier, and now knew as well as any native that electrical appliances have to be earthed, that a sponge is a cake, that a rag is a practical joke, and that a crocodile is a column of school children walking two-by-two. I had learned the hard way that I should not have asked for suspenders (for George's pants) when what I really wanted was braces (for his trousers) unless I was prepared to take home garters (for my girdle). All *that* is elementary. I was now mastering the fine points.

I had very nearly figured out, for example, under what circumstances to add an extra "do," "have," or "got." (Ask an American, "Are you going to town tomorrow?" and he responds, "I might." The Englishman says, "I might do.") I could say a proper "thank you," which sounds something like "nkew." I was also making progress in the art of not saying anything, substituting a murmur in the throat for the expression of any emotion from acquiescence to indignation. And I knew what a

hostess meant if she asked me whether I'd like to spend a penny. The euphemism arises out of the fact that it costs a penny to use a public rest room, only they're called public conveniences; and you've only got yourself to blame if you ask for a bathroom when you don't want to have a bath. Incidentally, it's American to *take* one; and the only place in England where one bathes is at the seashore.

I was also learning—although I never mastered the art—to distinguish the delicate nuances of phrase and accent by which Englishmen gauge each other's class. It wasn't hard at either end of the scale, of course. The dropped or added "h," the nasal vowels, and the affectionate diminutive are easily recognizable lower-class labels—just as the broad "a," precise word choice, and careful articulation are marks of upper-class speech.

Our university acquaintances found it howlingly funny whenever George called me "honey" (which he does habitually), because in so doing he was using lower-class idiom. And I must admit I was startled one day when a workman in a greasy trench coat and visored cap approached me on the street and asked, "Can ye gi' me a penny for two ha'pennies, love?" This, and "duck," have no more personal significance as forms of address than the upper-class "sir" or "madam."

I was told that the conquering Normans, who spoke French, whereas the conquered Saxons spoke a Germanic tongue, set the precedent for an upper-class mode of speech. Now, nine hundred years later, the differences between upper and lower, or between regional and "proper B.B.C.," or between Oxfordshire (county) and Oxford (university) are primary tools of social appraisal. Whereas two Americans, falling into casual conversation on an airplane journey, have to *ask* each other about schools, clubs, favorite sports, and hobbies, in order to find out whether they might have mutual interests, two Englishmen in

similar circumstances know everything they need to know about the other's background the minute they exchange their first words. (Assuming, of course, that they speak. However, if silence should continue long enough—say, from London to Istanbul—this in itself is a good indication that they are both Old Harrovians who should have spoken sooner because they would have had so much in common to talk about.)

It would be stupid to claim that there are no classes in the United States, but there is no widely recognized badge of caste comparable to that of English speech. Here—especially in the West—the educated or the well-born man speaks essentially like the shopkeeper or the telephone repairman, and the possession of a regional accent has no effect on social status or job opportunities. Personally, I like it that way. The class stratifications in England made me uncomfortable (a common American reaction there). But my encounter with our dustbin man at least demonstrated the *usefulness* of class-calibrated speech in working out social relationships. It came about this way:

Our dustbins (garbage cans) were emptied on Thursdays by a sparrow-like man with a leathery face, a spreading but virtually toothless smile, and a dialect so incomprehensible that it might as well have been Bantu. Like a code that needed solving, it intrigued me; and I took to popping out of the house whenever I heard the clatter of can covers. We got to be quite friendly, despite our almost total inability to communicate.

One day he arrived as I was taking a snapshot of Red in his school uniform. Observing the camera, he capered about so, pointing to himself, that I took a picture of him, too. The result was such a good likeness that I had an enlargement printed for him. But he did not react as I had thought he would. He stared at it disdainfully and tossed me such a skimpy "thank you" that my feelings were hurt.

144

I related the incident to another professor's wife when she dropped in for a cup of coffee.

"I believe I know what the trouble was," she said. "The dustman would gratefully accept the picture as a gift from the lady of the house—and you *are* the lady of the house, of course. But he can't tell, by either your accent or your manner, what kind"—meaning class—"of person you are. So I expect he might have been afraid that you were about to propose *selling* him the picture. And if that should have been your intention, the less pleasure he showed the less likely you would have been to have set a high price."

What my friend meant when she mentioned my manner was the free-'n'-easy assumption of equality with one's fellow-man that distinguishes Americans in England quite as much as their American accents. In the United States, although the upper classes and the lower classes are no likelier to dine at each other's homes than in England, there is less of a gulf between them in public life. They mingle with less self-consciousness because they have had more shared experiences. The P.T.A. and the Scouts are great levelers; everybody reads the same kind of middle-class newspaper; and anybody's child can go to college. As a result, we tend to think of each other as individuals, or as members of a certain economic or professional group, rather than as members of a certain social class.

This egalitarianism, and the "Hi, Mac" form of address that grows out of it, both amuses and exasperates our foreign visitors. "It's not that I want the lad at the petrol pumps to address me with cap in hand," complained one of our distinguished English visitors, justly proud of his professorship, his D.Phil., and his O.B.E. "But I must admit I cringe when he bellows out, 'Harya today, Doc? Fillerup?'" (I have been thinking about him afresh just now: as I typed this paragraph, a United Parcel delivery-

man brought a package—and lingered long enough to say, "Your new landscaping looks swell. I've been meaning to tell you.")

Except for noticeable deviants from the norm of dress and manner—slouching boys with duck-tail haircuts, for example—a certain kind of behavior is not, in the United States, equated with a certain social class. In England, alas for me, it *is*. I remember with shame the day I jollied the bus conductor into allowing my unauthorized presence aboard his big red juggernaut.

From the beginning of our stay in Oxford I had been annoyed by the location of the railroad bus stop. It was necessary to disembark on the far side of a busy and sometimes treacherous street, then pick your way across as best you could. While you were dodging traffic, the bus was making a U-turn across the same street. Then it paused at the curb on the station side before it began its return trip to the city center.

As the bus approached the station stop on the particular day I am remembering, I suddenly thought, *Why shouldn't I make the U-turn with the bus?* I was the only passenger aboard, and decided to chance it. So I announced to the bus conductor that I'd ride across the street.

"Not allowed, ma'am," he said.

"Oh, come on," I wheedled, giving him the kind of a smile that used to produce bacon from under the counter during the war. "You're going over there anyway. Be a sport." I spoke with the same bantering cajolery I expend on parking-lot attendants, at home, when I'd like them to call my hour and five minutes of parking time an even hour. Sometimes I make it ("For a gorgeous doll like you?"—I'm definitely a matron—"Sure!"), and sometimes I don't ("Lady, with a swanky car like yours"—it's a '51 Plymouth—"you can spare the dough.") No hard feelings, either way.

146

But the English bus conductor didn't respond in kind, as his American counterpart would have done; he just turned away and signaled the driver to start. Feeling half elated and half let down, I sat silent while the bus swung into the street and completed its turn; then overcompensated by uttering a too effusive "thank you" as I arose from my seat to descend.

The bus conductor came vigorously to life. Flashing a big gold grin, he responded, "Me pleasure, duck!" And squeezed me around the waist as he helped me down.

I stamped up to the station, embarrassed, ashamed, and out-raged. I was still sizzling when I reported the incident to George that evening. "That wouldn't have happened at home. Now, *would* it? Of course not! An American bus driver wouldn't get fresh just because I kidded him along. Now, *would* he?"

George laughed until he cried—which made me even angrier, and more ashamed. After that I minded my manners.

One of the complaints that some foreign exchange students express, after spending a year in the United States, is that visitors here don't meet a broad enough sample of Americans. That's true. Foreign students tend to be most welcome in academic and upper-middle-class circles. Joe Doakes, who runs the bottle-capping machine at the soft-drink plant, is usually too shy or too uninterested in other cultures to venture far from his TV set or expand his world much beyond the familiar faces he knows at the plant, the union hall, the bowling alley, or his lodge.

So it was with us at Oxford. We were immobilized in the academic group—not that we struggled any, for they were charming, witty, friendly people—and our knowledge of "the working classes" came from casual encounters in stores, hotels, and on trains. We never got to know our gardener at all; he came and went as if he'd been ectoplasm. I never met any of Mrs. Blount's family, although I knew a lot about them; or saw

her home. We didn't patronize the pub across the street, because it was not natural for us to do so. Our social needs had many other outlets, and the regular patrons would have rightly suspected that we were there merely to observe the quaint customs of the natives.

Within the university circle it was, of course, the wives I came to know. They were upper-class by birth or by reason of education, and what they lacked in gusto they made up for in grace. Their self-control was a delight to watch and a model to copy. Once I was a tea guest when the man of the house was fifteen minutes late. The hostess was in a dreadful spot: should she keep me waiting, a crime against convention, or proceed without the host? She waited, and when her husband came strolling in—without apologies—she said, without any show of anger, "Alfred, it was naughty of you to have been so late today." In similar circumstances I couldn't have resisted the urge to have shot him just *one* you-heel-you glance.

Oxford wives work hard. And they don't complain. They don't participate in community welfare activities to the extent that American women of the same class do, but I dare say *we* wouldn't have enough energy to join political action groups, discuss the Great Books, attend School Board meetings, ring doorbells for the Cancer Fund, and pour orange juice at the Bloodmobile, if we had to spend as much time in obsolete kitchens as our English counterparts do.

One activity they are spared is the car pool. Two-car families are rare in England, and there are plenty of no-car families still, so Sonny gets where he has to go by bus, bike, or shanks' mare. Unfortunately Mum does too. She is usually seen trudging along the streets with a canvas satchel in one hand a string bag in the other, both bulging with the day's food purchases. Or she hops on her bike and wheels down to Sainsbury's at the

148

crack of dawn—meaning 8:45 A.M., the English being late risers—hoping that she'll be first in queue for that day's special on cheese. On her way home she stops at the launderette to see if the notice she posted in search of domestic help is still on view; she's had no replies. It's there, all right, and so are a dozen other pleas just like it, all growing dusty and frayed. She stops next at the ironmonger's to order paraffin for her stoves, making a mental note at the same time to trim the wick on the one in the dining room; it's gone a bit smoky. Then she matches a bit of yarn at the draper's, picks up a skirt and a suit at the dry cleaner's, and arrives home in a sprint because it has started to rain and there is laundry on the lines out back.

More and more English women are acquiring laborsaving appliances, but the heart of the housework problem is that their houses are badly engineered, especially the numerous surviving Victorian ones with the scullery in the basement, the dining room on the floor above, the drawing room above that, and the bedrooms still higher. If there's anything to be said in praise of retribution it can surely be said that today's English wife understands the lot of her grandmother's Irish servant girls much better than grandmother did.

The really rich still have servants, of course, just as they do in the United States. And some of the great houses are still run with as much style as in the old days. The experience of one American we know attests to *that*. He was weekending at the home of a British peer, and on retiring was detained by the butler.

"Would you care for morning tea, sir?" the butler asked.

"Why, yes, that would be very nice," the American responded as he started up the stairs.

"Pardon, sir. Would you prefer India, Ceylon, or China?"

"India, I guess," and the American took another upward step.

"Milk or lemon, sir?"

"Oh. Milk, please." Assuming that the conversation had terminated, the American turned away and began to climb briskly.

But from below came a final question. "Er, one more thing, sir. Alderney, Jersey, or Freesian?"

This kind of service will undoubtedly endure, on both sides of the Atlantic, within the homes of that tiny fraction of the population that has the ability to obtain it and the capacity to appreciate it. What has changed in the United States and is changing in England is the availability of servants to the upper-middle and professional classes. Dons' wives in Oxford two generations ago would have had a cook or a maid; today they're lucky to have a "daily." They are forced, therefore, to work as hard as the servants their predecessors once employed—just to keep their families clean and fed.

But that's not the whole of their problem. They are forced to observe, or are clinging to, niceties of etiquette that further burden them. I put away my damask tablecloths years ago, and so did most American housewives, because we haven't time to wash and iron them and still be Den Mothers. We've shifted—not without some feelings of guilt, to be sure—to stainless-steel flatware and to paper napkins, to drip-dry clothes and to one-bowl cake mixes. But Englishwomen haven't made these compromises yet—partly because they can't afford the extra cost of preprocessed food or commercial laundry charges, but also because they are still trying to do things *nicely*. In consequence they are still polishing heirloom silver, ironing sheets and shirts, dusting Dresden bric-a-brac, and cooking at least four meals a day.

What I came to call the English non-dinner hour plagued

150

us from our first week in Oxford, and was one of the few situations to which I never grew reconciled. In part this was due to my refusal to spend as much time in the kitchen as English-women do, and in part because it has been our long-time family custom to share the news of our separate activities at a communal —and early—dinner. The elimination from American schedules of afternoon tea, which in England is more than a snack but less than a meal, keeps us all more or less on the same eating timetable. But in England, after 4 P.M., everything falls apart.

If father is dining out that night, mother may turn tea into supper for herself and the children at five. The same thing may happen if both parents are going to the theater, with curtain time at seven, except that they'll be hungry again at ten, so Mum will fix a light supper after the performance. If the household's regular dinner hour is at eight, and nobody's going anywhere, and the children are so starved when they come home from school that an early meal is indicated, Mum feeds them at five-thirty and herself and father at eight. Unless, of course, father has to go to a meeting at eight, in which case she prepares a light tea at four and they all eat dinner at seven.

English husbands are not indifferent to the plight of their wives. The Saturday shopping crowds are full of fathers trailing children after them like the tail on a kite, and many of them routinely lend a hand with the washing up after dinner. But woman's work is still exclusively woman's work to a much greater extent than in the United States. One senses a kind of separateness, of husbands and wives keeping segments of their lives closed from each other—not in a spirit of concealment, but simply because men and women are assumed to have different interests and non-overlapping responsibilities.

Husbands and wives go about together socially less than we do in America. Each is likely to have separate clubs. Although

women were not excluded at the pub across the street from our house in Headington, the majority of patrons were men. The wives, presumably, had had their social outing during the day. And even when the sexes are together, there is far less fuss about Fair Guinevere than in the United States. American men are said to spoil their women. I guess they do; it's a hangover from the frontier, where there were never enough women to go around. In England hotel waiters are the only men who hold chairs for ladies as they seat themselves at the dining table. Englishwomen get along without much show of gallantry and seem resigned to a lower status in society than their militant American sisters will accept. There is usually a differential between men's and women's salaries, even if they are doing the same work, and fewer educational opportunities exist for women. Against which can be set the emotional security that comes from knowing who you are and what is expected of you: the English are less confused than Americans about the roles to assign, in the family and in society, to men and women. In England the diapers—no, the nappies—are still changed by women.

Now, anything that's generally true of England is exaggerated in Oxford.

Shortly after our arrival there, and before I realized that I was going to be spending so much of my time with women, I had been invited to dinner by a don's wife. She is a talented sculptress, and after dinner she showed her guests around her studio. One piece particularly caught my eye. It was some ten inches high and depicted two figures. The dominant one was a lion of a man in academic regalia, his gown falling in massive folds from his shoulders to his firmly planted feet. Head back, chin up, paunch rounding gently forward, this was a man with the universe in the palm of his hand. He was unmistakably an Oxford don. A step behind him stood a dowdy little woman.

There was a shapeless hat on her meekly bowed head, a shapeless jacket drooping from her slightly stooped shoulders, the hint of a wrinkle in her stockings. Equally unmistakably, she was the don's wife. The title of the figurine was, *It's a Man's World*.

It's a man's world at Oxford because, as Roger Mackenzie had explained, so many of the colleges have an ecclesiastical—even a monastic—background, and ritual observances have a way of persisting at the university long after the social structure they once reflected has passed away. The decision, at the end of the nineteenth century, that dons might marry was forced on a reluctant university by the obvious fact that many of them were raising families in North Oxford houses just beyond the university's jurisdiction.

So, too, the medieval position of women remains in more than memory. During Janet Lindvall's visit George and I had taken her to Evensong at Christ Church College chapel. When we entered the nave, by the transept, which separates the altar and the choir from the lower pews and in the middle of which stands the Bible on its golden lectern, the verger had indicated that we were to go left, into the lower pews. But he had detained George long enough to say that *he* might go right, if he cared to, closer to the altar. It seems that in Christ Church chapel women may not sit above the Bible.

It's been only forty years since women have been admitted to the university. Some of the old-timers still consider it a regrettable decision. There is a rule that a don need not deliver a scheduled lecture if fewer than two people are present; and one old misogynist, a few years back, on finding a male and a female undergraduate awaiting him, addressed the gentleman thus: "Sir, since you are the only person present, I shall not lecture today."

The girl undergraduates—they are never called "coeds,"

because no undergraduate college is coeducational—are hedged in by more restrictions than the men, may still not join certain university clubs, have a stricter code of behavior. But they have come a long way from that period when, the story goes, a girl was sent down from her Oxford college because she had spoken to a male cousin in the street. ("It is not so much the grave immorality of your conduct I deplore," her Principal had said. "It is the terrible bad taste.")

Little by little the university is letting the girls move into the twentieth century. Or perhaps it would be more accurate to say that the last two reforms have been achieved by feminine vanity, a potent weapon even at Oxford, and one that the dons have been unable to combat. They have long ceased enforcement of the no-lipstick rule during examinations; and theirs was, at best, a pyrrhic victory on the issue of whether the girls might wear nylon hose with the sober black and white garb prescribed for university ceremonials. The assumption of the 1920's was that the girls' black stockings would be opaque, but modern technology changed all that. The girls'—er—limbs became so noticeable, as nylons got more sheer, that a special university committee was convened a few years ago to consider the problem. After a bit of wrangling, it was decided that female undergraduates might continue to wear nylons *only if they had a seam up the back*. What this has accomplished, as far as I could see, is to trace even better the curve of a comely calf. Furthermore, some of the girls wear their black skirts very short and full, and elongate their ribbons ties so they reach below the waist—a *très chic* costume, especially in conjunction with those filmy nylons. Such outfits meet all the statutory requirements, yet somehow the total effect isn't at all what I think the dons had in mind when they drew up the rules.

Members of the men's and women's colleges meet at lectures,

154

share a certain amount of club life, and presumably sometimes date each other. But the impression a visitor gets watching clusters of undergraduates come and go across town, is that men and women are far more segregated than at an American university—and need each other less. One senses the same apartness in them that is characteristic of their elders. They seem to be easier in the company of their own sex. Maybe the sex-segregated lower schools are to blame; with very few exceptions the grammar and public schools are not coeducational. There is no doubt that America's high marriage rate among teen-agers is encouraged by proximity. But perhaps the English system goes too far to the other extreme, diverting youthful passions to the playing fields so successfully that too little ardor remains for people. Or perhaps the English coolness is just on the surface, a hangover of Victorian propriety, for they certainly haven't always been that way. The Elizabethans greeted strangers with a kiss. Today it's all you can do to get them to shake hands.

Which brings to mind George Mikes's unsurpassed summary of English domestic relations. A Hungarian by birth and a Briton by naturalization, he says, "Continental people have sex life. The English have hot-water bottles."

14

NOVEMBER 5 is Guy Fawkes Day, which is an English Halloween with bonfires and fireworks. It was rained out in Headington, except for one chin-up family who burned sparklers under cover of umbrellas. In downtown Oxford fewer cars were overturned and fewer eggs thrown than is usual, and those mostly by Teddy Boys masquerading as undergraduates.

Our Thanksgiving feast was a similar fizzle. It didn't feel right from the beginning, partly because nobody else was celebrating the occasion and therefore we were going to have to do our family feasting early—both George and Redmond having inescapable commitments on the proper Thursday night. But the weather was against us too.

By now the gardens were empty of bloom, and the trees were bare, leaving a somber landscape: blackish-green pines and ivy, lacework skeletons of beech and linden, stumps of willows mirrored in gray rivers. The only brilliant color was the crimson stain of Virginia creeper on the stone walls of the colleges. In its way it was a very beautiful landscape still . . . but then the fogs came, draining from the scene what little color and contrast remained. The fog rose in eerie banners from the lowlands and shrouded us on our hilltop. It muffled sound, disoriented us afoot or in a car, pressed down on us like a soft, wet blanket. For twenty-six of November's thirty days there was fog, and it took all my reserve buoyancy to maintain enthusiasm for such

difficult extras as the assembling of turkey and the fixin's in a land where no one else wanted them.

First I tackled Mr. Weaver. He was hacking a loin of New Zealand lamb into chops, while one of his apprentices laid them out on an enameled tray for display in the shopwindow.

"And what will it be for you, young lady?" (Mr. Weaver addressed every customer under thirty as "madam" and every customer over thirty as "young lady," which helped to explain the long queues one always had to stand in at his shop. Also, he had good meat.)

"Mr. Weaver, can you get me a small turkey?"

"Now? In November?"

"Yes, I know it's early and they don't really come on the market until just before Christmas. But do you think you could get me one now? The American Thanksgiving is next week, and I'd like awfully to have one. If it can be small."

"I'll do m'best. *How* small?"

"The oven is only eighteen inches deep and fifteen inches wide. Small enough to fit the oven."

"Well"—doubtfully—"I'll do m'best." The current apprentice (they came and went so fast, usually bandaged on departure, that I never knew their names) smiled and ducked into the refrigerator room out back. Imagine ordering a bird in *inches*. Dotty, these women!

The turkey that was eventually produced was a shade too large for oven or pan, so Mr. Weaver squashed it together and trussed it heavily. When I put it in the oven, it looked like a mummy. It was nearly as old, too; I couldn't help thinking, as I kept basting it with butter, that since it had survived so long it was a pity to have killed it.

By then, of course, I knew that the dinner wasn't going to turn out well: the yams I had found at the one shop in Oxford

that stocks exotic foreign delicacies (these had come from Malaya) had turned out to be rotten, and the almonds for the turkey dressing were rancid. Despite a trip to several specialty food stores in London, I had not been able to find canned pumpkin, so I had made a lemon pie; but by dinnertime the fine frothy pile of meringue that had crowned it in the morning had shrunk so that it looked like a disc of damp cotton flannel. The crust wasn't very good either.

"Look at it this way," George said as I was mournfully finishing off my piece of pie. "The Pilgrim Fathers probably didn't think *their* first Thanksgiving in the New World was a proper feast either."

"And they had ninety uninvited guests, besides," Red added.

I was touched by their efforts to comfort me. We did the dishes together, while George made some outrageous puns, and then we all sat in front of the fire and ate a box of rich English chocolates. Everything taken together, it didn't turn out to be such a bad day.

The next day was glorious. Not weatherwise (if you'll pardon the Americanism), for it was gray and foggy in Oxford and in London. We went to the city, Red and I, on a very early train; he had been invited to attend the dedication that day of the American Memorial Chapel at St. Paul's Cathedral. The reason for the invitation was that the uncle for whom he had been named was among those Americans who had been in Britain's service in World War II. A bonny lad and an idealistic one, the other Redmond had been unwilling to wait for his own country to get into the fight. He came to England in 1941, as a knight-errant in RCAF blues—and always will remain one, for he was killed in 1943. It was to honor such servicemen, and the thousands who died later, that the American Memorial Chapel had come to be.

Those Americans who had come, pretending to be Canadians, were merely in the vanguard. More than a million Yanks followed, under their own flag, and by 1944 had completed the greatest foreign invasion in British history (and the only successful one since William the Conqueror's). Americans who were safe at home, or whose hearts were in the Pacific, did not realize what an impact this "invasion" had. Nor did I until our Oxford year. Here's how it was, as condensed from *Britain's Homage,* a book about the American Memorial Chapel:

Among those million Americans there were many who, coming from the prairies, from the Arizona desert, or from the open farmlands of Iowa, felt miserably restricted by the hedged tininess of the English countryside. Some, who had no knowledge of cities at home, were bewildered and lonely in the vastness of London; others, from Chicago, Los Angeles, or Detroit, could find no cheerfulness in the minute villages around their Devon training areas or East Anglian bomber bases. They never learnt respect for the British telephone system, admiration for British plumbing, or love for the British climate. (Throughout the American forces, there was a popular saying that England would be a wonderful country if only they put a roof on it.)

The spirit of '76 is a highly seasoned brew. The doughboys came to Britain with little faith in British military prowess; they viewed the British not as the heirs of Blenheim, Trafalgar, and Waterloo but as descendants of the men who blundered at New Orleans and Saratoga. Many of them had been educated to a belief in British arrogance and British aloofness; almost all were certain that the British lacked humor.

In return, the British thought the G.I. over-paid and over-medalled. The American soldier and sailor was never short of food (though he was always hungry) and certainly never very short of money. The few pleasures that the Germans had left to the British now had to be shared with the Americans—all so

thirsty, so eager for hotels, taxis and entertainments, that the British sometimes wondered uneasily if anything at all would be left for them.

Jukeboxes blared across the fields to homes which had barely forgotten the sound of horn-dancers and town crier; baseball diamonds appeared on village greens and in city parks; Coca Cola and ice-cream sodas were served within a few yards of the village pub; and American beauties by Varga or Petty pouted down from the walls at British girls who were learning to "get in the groove" at Saturday night hops. The British soldier in Libya or Burma could not be expected to weigh altogether dispassionately the importance of the American war effort when he heard that his fiancée was walking out with a G.I.

On both sides the first deliberate attempts to be amiable were sometimes disastrous. A nation that was sacrificing not property and ease alone, but life itself, found it hard to endure admiration that was centered on the "quaintness" of its country towns. On the other hand, men who were devoted to a past that had produced Washington, Jefferson, Lee, and Lincoln could not but resent the indulgence extended toward the "newness" of America.

Yet affection grew with time. As the months and years passed and as Britain shared, in ever greater degree, the triumphs and tragedies, the frivolities and the ambitions of the Americans based there, the British people learnt that America is both an entity and a conglomeration of diversities, that there are many who are typically American but no such thing as a typical American.

Finally, as column after column of American and British troops moved southwards, embarked, and set out for France, it seemed impossible to think of this new Armada as British or American. Those ships carried men—"our men"—to one of the greatest and most perilous adventures in the history of the West.

The comradeship of war may fade with the passing of time,

and bickering, jealousy, and suspicion may again become the common currency of international relations. But individuals have longer memories than nations. There are in the United States a million citizens now living ordinary American lives who once lived extraordinary lives in Britain. They neither forget their experience nor, surely, do they remember only what is to Britain's discredit; while the British, for their part, though they may smile or sigh at some of their recollections, have not lost respect and affection for them nor pride and sorrow for those of them who died in Britain's midst.

Therefore, when the peace was made and the twenty-eight thousand Americans who had died while based in Britain were counted up, it seemed fitting to the British to honor them all, as individuals among them had already been honored by plaques and tablets in country churches. There was no better choice than St. Paul's Cathedral: St. Paul's, where Nelson and Wellington and a host of Britain's greatest military heroes lie buried; St. Paul's, whose dome, when London was burning, had "seemed to ride the sea of fire like a great ship, lifting above smoke and flame the inviolate ensign of the golden cross."

And so, in 1945, the British people were invited to contribute funds for the building of an American Memorial Chapel in their great and famous cathedral. Those were lean years in Britain. Cold. Gray. Spiritless. Dismal as war had never been. There was little food, little fuel, and the people were tired to the bone. But the pennies, sixpences, and pounds came in: from a home for soldiers' widows; from British ex-servicemen; from a lady who missed "the dear boys who came as members of our family to our fireside"; from the children of an orphanage because "American soldiers and airmen used to come and play with us and sing with us."

The chapel was designed as part of the restoration of the

bomb-damaged east end of St. Paul's, was started in '51, and finished in '58. Now, on this raw November day-before-Thanksgiving, Red and I were among the throng of three thousand who gathered to dedicate it. As we mounted the stairs to the great West Door, I visualized the earlier Redmond on this same spot. He would have climbed the steps briskly and anonymously, just another sight-seeing serviceman in the crowd. We mounted slowly, past a spit-and-polish honor guard of American servicemen standing at attention, with a military band at our backs. The precious tickets of admission trembled in my hand.

We were shown to seats in the south transept, obliquely under the great dome. It was exciting to watch the other guests and dignitaries arrive: gentlemen in striped trousers and cutaways, American and British servicemen in burnished full dress, choristers with their chins buried in stiff Elizabethan ruffs, City of London officials in ermine-edged red robes, clergy in crimson silk and gleaming gold brocade.

The service began with the processional to the choir of the Cross Bearer, the Choristers and Vicars Choral, the Prebendaries, the Archdeacons of Middlesex, Hampstead, and Hackney, and the Bishops Suffragan of the Diocese. (The British do ceremonies spectacularly well; maybe because, to start with, they don't feel silly in satin breeches or wigs.) Then came the Lord Archbishop of Canterbury, the Bishop's Chaplain Bearing the Crozier, the Lord Bishop of London, the Lord Mayor Bearing the Pearl Sword, Vice-President Nixon of the United States, and Her Majesty the Queen. (Solemn ceremony or no, heads craned. I should particularly have liked a glimpse of the Queen, if only so I could have swapped impressions with Mrs. Blount. But the Queen is petite, and friends who have asked me if I saw Elizabeth while I was in England have had to be satisfied with a description of her hat. Beige.) And then . . .

Whilst there is played upon the Trumpets, and then upon the Organ, the Third Mode Melody by Thomas Tallis, OLD GLORY shall be carried by the Colour Party from the Nave to the High Altar, to be received by the Dean. And so it was done. The flag-bearer had fine broad shoulders and a crew-cut. I felt a quick little stab of homesickness.

Then shall the Choir sing Psalm XVI. And they did, their voices as pure and passionless as alabaster: "Preserve me, O God, for in thee have I put my trust."

The Canon-in-Residence shall read the Lesson, taken out of the Twelfth Chapter of the Second Book of the Maccabees. And he did so: "For if he had not hoped that they that were slain should have risen again, it had been superfluous and vain to pray for the dead."

The Lesson ended, all shall stand, and the procession shall be formed to proceed to the American Memorial Chapel for the Dedication and Consecration. The Bishop of London dipped his thumb in holy oil and traced the Sign of the Cross at the center and four corners of the altar and blessed the altar ornaments, and then the Queen unveiled the memorial inscription on the marble pedestal that supports the Roll of Honor. (The Roll of Honor, a vellum book, has 473 pages. One is turned each day: over a year for just those Americans killed in Britain to pass in review!)

And finally the Archbishop of Canterbury read that passage from *Pilgrim's Progress* that ends this way: "When the day that he must go hence was come, many accompanied him to the riverside, unto which, as he went, he said, 'Death, where is thy sting?' And as he went down deeper, he said, 'Grave, where is thy victory?' So he passed over, and all the trumpets sounded on the other side."

At which point in the service, high above us on the gallery

that encircles the dome of St. Paul's, a lone bugler sounded taps. The plaintive notes hung throbbing in the silent air above the silent congregation, and memories of Red came flooding back. The younger Red, my son—to whom the older one is nothing but a snapshot—stirred at my side, moved not for himself but by the general poignancy of the moment and the fact that I had tears in my eyes.

Before they could spill over, from the west end of the cathedral came that breezy call to life and action, reveille, sounded by massed trumpeters of the Household Cavalry. And then we all arose, three thousand strong, and sang "The Battle Hymn of the Republic" as if we really meant the Lord to hear us.

The Archbishop of Canterbury pronounced the blessing, Old Glory came back down the aisle as the congregation sang "The Star-Spangled Banner," and the service concluded with the British National Anthem. Our diction on this last one was a little blurred, but I think we could be forgiven. Too many in the congregation, out of long habit, started off with "My country, 'tis of thee," managed to switch to "Long live our noble Queen," but reverted unconsciously in the third line to "Of thee I sing." It didn't really matter. We had come there, as the Dean of St. Paul's had said in describing the American war dead there enshrined, in common cause.

15

I have done my husband an injustice. I've given the impression that he's an average American husband and father, cooler-tempered than some, warmer-hearted than others, an ex-Nebraska farm boy who has never outgrown an addiction to puns and who in Britain acquired an addiction to prehistoric relics. All that is true. But the most important fact about George is that he's a scientist. I think he would have come home if both the laboratory and the house had caught fire at the same time, but I'm glad he never had to make such an agonizing choice.

Scientists are not necessarily odd. But they *are* curious, and when a good one tackles a problem whose solution, he feels intuitively, is hovering somewhere just over his shoulder, he is likely to spend a good deal of time on it. That's what George had done. His specialty is genetics: the science of heredity. It is a young science, dating from the rediscovery, in 1900, of Mendel's classic paper on his experiments with peas, but George's particular biochemical brand of genetics is much younger, dating only from the 1920's. Earlier geneticists had concentrated mostly on the mechanics of inheritance. (Is eye color controlled by one gene or several? How are genes arranged in the chromosones?) George and scientists like him grew interested in the functioning and structure of the genes themselves. It seemed likely that they were not merely passive carriers of

hereditary characteristics but active directors of chemical processes, also.

So George teamed up with a chemist friend, E. R. Tatum, and the two of them did an experiment to find out. They irradiated millions of plants of *Neurospora crassa*, a red mold that grows on bread, thus causing mutations (changes) in some of the genes. If genes control chemical processes—metabolism is a basic one—some of the next generation of *Neurospora* plants should fail to function properly, Beadle and Tatum figured.

And that (although I'm oversimplifying) is how it worked out. Eventually they found a mold that functioned just like its parent mold except that it could not make Vitamin B$_1$, *and the reason was one altered gene.* Later they found dozens of other examples that could mean only one thing: that genes not only carry the recipe for the man who is to grow out of a fertilized egg cell, but they also direct his chemistry of growth, development, and functioning.

This was a great discovery, and is the reason my husband is well enough known in science to have been invited to Oxford. It is also the reason for his being awarded, in December of that year, the Nobel Prize given annually to a scientist who has done notable work in the field of physiology or medicine. He shared the honor with his co-worker, Ed Tatum, and with Joshua Lederberg, a younger scientist who, in applying their findings to bacteria, had made some great discoveries of his own.

A Nobel Prize is the top accolade a scientist can receive. Getting it would be unalloyed joy if it came like a bolt from the blue, but George had almost a week of cliff-hanging before the official announcement was made. The news leaked to newspaper reporters in Stockholm, they alerted the international wire services, and for a long seven days a non-stop press conference

went on in the homes and labs of that year's Nobel laureates. Reporters and photographers hounded Tatum in New York and Lederberg in Wisconsin and Beadle in England.

"How do you feel about this great honor?" they asked. "What will you do with all that money?" The first question has only one answer—"Fine!"—and the second is none of their business; besides, how do you answer such questions when you don't know for sure that you've actually won the prize? On a number of occasions the rumored recipients have in fact been passed over, and George was determined not to assume that he had been awarded the prize until he had an official notification from Stockholm in hand. The waiting was hard; on the day before the official announcement was due, he came home and said, with a rueful smile, "Well, I *am* in a stew. After I finished my lecture today, I discovered I'd given it backward."

But the rumors were based on truth, and, with confirmation, the atmosphere changed to jubilee. George could not have taken two steps on the Caltech campus without having his hand shaken or his back slapped; but this was England. To spare him the embarrassment of public attention, none of his colleagues at the lab or at the college mentioned his award in company. Those who happened to run into him when he was alone cleared their throats diffidently, essayed a mild handshake, and murmured, "Spendid news about your—er—honor"; or simply, "Good show!" It would have been a lonely time for him if breezy American greetings hadn't come pouring in by cable, sea, and air.

"After all the publicity over the Pasternak affair," wrote a friend at Yale, "I have taken a poll. The general feeling here is that you ought to accept it; to hell with trying to keep up with the Russians."

With typical irreverence a group of graduate students in

the Caltech biology division wired: TREMENDOUSLY PLEASED AND PROUD. COME HOME. BRING MONEY. Among the list of signatories one name—no odder than any of the others, from Western Union's viewpoint—appeared, but upon seeing it George laughed until he had to wipe away the tears. This "signatory" was N. Crassa: his old friend, *Neurospora crassa,* the red bread mold.

His mirth diminished, however, and was replaced by a bull-dog tenacity when he received a two-page cable in code. He recognized it immediately as the work of a colleague at Caltech, because it was based on the four units of nucleic acid that make up the genes. (It is the specific sequence of these units that spells out the "message" of the gene.) George had to do a preliminary translation from chemical biology into the English alphabet before he could even start to decode the message, and he must have put in forty frustrating hours on it. Solved at last, it read: "Break this code or give back Nobel Prize." George said that it was a mighty close call.

The messages piled up on the desk and overflowed to the dining-room table. The motorcycle-mounted delivery boys, who at first had thrust each cablegram at me as breathlessly as if they were bringing serum to a dying child, now lounged in the doorway with a sheaf of envelopes and a bored "'Ere's another lot of 'em, ma'am."

But Mrs. Blount remained enormously impressed. One day George found her reverently dusting the pile. "These are all cables, Mr. Beadle?" she inquired. He assented, and then she said, "Just think of that! To have come all that way under the ocean. It's a miracle, like!"

To this day I tend to think of the Atlantic Cable as Mrs. Blount did. There's something very satisfying in the mental picture of a gigantic pneumatic tube on the ocean floor, with slips

168

of paper scurrying back and forth like change and sales receipts in a department store.

There were letters and conferences originating in England, too. Sir Hans Krebs, professor of biochemistry at Oxford and a Nobel laureate in 1953, invited us over for tea and briefed us on what the actual presentation ceremony in Stockholm would be like. Willis Lamb, an American who is now Oxford's professor of physics and who won his Nobel Prize in 1955, warned us to take an extra set of studs and plenty of safety pins. He broke the only collar button he had with him just before the very formal awards ceremony got under way. Consequently his recollection of the ceremony is a little fuzzy; he was afraid to turn his head and almost afraid to breathe, for fear the smallish safety pin that held his collar and his shirt together would suddenly yield to the strain.

My own dress presented no problem, and we solved George's special wardrobe requirements by renting a full-dress suit with three complete sets of accessories. But what of Red? Letters flew back and forth between me and Mrs. Sanger (whose husband, a Cambridge professor, had won the chemistry prize that year for his discovery of the molecular structure of insulin) as to what our schoolboy sons should wear. Neither of us liked the idea of putting fifteen-year-olds into white ties and tails, so we decided on dinner jackets for them. I forthwith rented a tuxedo for Red. I can still hear his pleased and startled "We-e-ll!" as he glimpsed in the pier glass the suave man-about-town he had suddenly become.

On the morning of our departure for Sweden the fog lifted just long enough to let us take off. We were glad to go, even if into the wintry north, for someone had told us that they have central heating in Sweden. They had sun, too, for our arrival in Stockholm. That afternoon, as the plane glided in, the white

apartment houses that ring the city were warm and rosy in sunset light. "Sunset at two-thirty in the afternoon," I mused. "Think of that." Red gently replied, "Mom, it's the same latitude as Juneau."

Waiting for us were Professor Caspersson and his wife; he was to introduce George at the awards ceremony, and his smile of greeting made us feel good all through. There was a horde of reporters and photographers on the airstrip, too, their hats tipped casually back on their heads and show-me expressions on their faces; and behind them stood two diplomats, one American and one Swedish, with *their* hats (Homburgs) as soberly straight as Elder Bradford's, and pearl-gray gloves on their hands. The American one had simply come to add his word of welcome, but the Swedish one had come to stay. His name was Lennart Dafgård, and his job, in a word, was us. Each Nobel laureate, on arrival, was assigned an attaché from the Swedish Foreign Ministry, whose responsibility it was to deliver his charges to whatever place they were supposed to be in the course of the week—on time, properly dressed, and properly briefed. Fortunately we took an immediate liking to Lennart, who was young and personable, and he to us; otherwise the enforced togetherness of this system might have created problems.

After George had told the reporters that he felt very highly honored to have been named a Nobel laureate and had dodged the question of what he was going to do with the money, we were driven to the Grand Hotel, which overlooks a long arm of the sea, Old Town, and the Royal Palace. Our suite of rooms was enormously big. Tastefully decorated in the best that Sweden has to offer. Warm. (The merry little hiss of the radiator sounded like an angel chorus.) Fragrant with flowers. And sited to command a spectacular view of the city. George watched with amusement as I inspected the bathrooms and closets

and tested the beds. He says that I was lit up like a skyrocket. "It's not exactly a two-star hotel," he said. I grinned at him. "I think I can manage to get used to it," I replied.

Our mentor materialized at the door. "Now we must work," Lennart announced. And work we did. We plowed through a seven-page memorandum in which was set down our program for the week. He handed us an inch-thick stack of mimeographed sheets containing the biographies of the Swedish royal family, whom we were not only to meet but to dine with. He told us that time would be found for teaching George to bow and me to curtsy. In short, he scared us to death.

In the course of the next two days we got around. We went to two dinner parties and a formal reception, made the acquaintance of schnapps and smoked reindeer, and learned the etiquette of *sköl*. (Lift your glass, look deeply into your partner's eyes while drinking, lower the glasses with a little salute, *then* smile, and be sure to *sköl* your wife before the dessert course or you'll owe her a pair of silk stockings.) We learned to shake hands with our host and hostess immediately on arising from the dinner table, our thanks being in the nature of a short speech rather than a few polite words.

The Swedes are great handshakers and speechmakers, and we suddenly realized how much we had missed, in England, the heartiness and lack of constraint in social relationships we are accustomed to at home. Stockholm looks like an American city, too. Rarely homesick in Oxford, we suddenly developed a terrible yearning for the United States; or maybe it was just a yearning for the simple and uncomplicated life we lead in California. Unaccustomed to court protocol, we felt like country mice unable to handle the excitements that city mice take in stride. George, in particular, needs the solitude of the laboratory, and the sudden hot spotlight of fame made him nervous. I got

jumpy too after a newspaper reporter and photographer ambushed me in a store where I was buying a pair of galoshes, and asked me my opinion of Swedish fashions. Me! I was one of *them*. Reporters don't interview other reporters.

Lennart brought his fiancée, a beautiful brunette named Agneta, to the hotel to coach me on the curtsy. "The head, too, please!" she had to keep saying, because I tended to concentrate so hard on maintaining balance while my knees were bent that I kept forgetting that my head should be bowed too. George, meanwhile, was being rehearsed with the others for the awards ceremony, and the timing of standing-sitting-and-bowing made him dizzy. He spoke for both of us, as we were finally dressing for the big event, when he said, miserably snapping his braces over his shoulders, "Honey, I wish I were home making compost!"

I don't know how it was for him an hour later, but it was marvelous for Red and me. All we had to do was watch a glorious spectacle in Stockholm's white and gold Concert Hall, its stage banked with yellow chrysanthemums and hung with blue-and-yellow Swedish flags, its red plush seats filled with a festively dressed audience.

After we were all in our places, a fanfare of trumpets announced the entrance of the royal family. After they were all in their places, another fanfare announced the entrance of the men we had gathered to honor, doors at the rear of the stage opened, and in came the seven laureates. (There had been a rumor that Pasternak's chair would be placed with the others and be allowed to remain pointedly empty, but the rumor was unfounded. There were only seven red plush chairs standing ready on the stage.)

First, in the order determined by their fields of specialty, came the Russian physicists. They were small men: Cherenkov, with

172

bristly gray hair and a determinedly jovial air; Frank, dark and shy, with perennially downcast eyes; and Tamm, a man with snowy hair and such an expressive and cheerful face that he had become the darling of the photographers who dogged us all. Next, in strode the British chemist, Sanger. Neat, spare, suave, he was the only one of the lot who looked wholly poised. Finally, the three American geneticists—Beadle, Tatum, and Lederberg. They looked great to me, especially Beadle. They all bowed to the royal family and took their seats.

Then came speeches of welcome, speeches to explain the work for which each man had received his award, and a speech explaining that although Boris Pasternak "does not wish to accept the distinction," his refusal "in no wise alters the validity of the award." (All eyes turned to the three Russian physicists, who moved not a muscle.) Finally the great moment came. Each laureate walked down the steps from the stage to a carpeted dais in front of King Gustav VI Adolf. The grand old gentleman stepped forward and handed the prize winner his gold medal and his diploma, meanwhile pumping each hand and saying what appeared to be far more than a few perfunctory words of congratulation. George says that he was too excited to remember what the King said to him.

Then off we all went to the Town Hall for the awards banquet. The laureates and their families gathered in a small anteroom, where we were herded into position by the ambassadors or other representatives of our various countries. (Only the United States lacked an ambassador; it struck us as doubtful wisdom to have allowed him to go home and not to replace .him for this occasion, the most important one of the year for the Swedes.) We American women were nervous in anticipation of the impending curtsy; the men, on the other hand, were gay and relaxed. They'd *had* their baptism.

173

As it turned out, we needn't have worried. The King and his entourage came into the room so quietly and moved so swiftly, and we were packed so closely together, that all we could manage was a jerky series of bobs. (But I did keep my head down.) In fact, after the King had passed by, George found himself introducing the members of his family to the Swedish royal family just as if all of us were at a Caltech New Faculty Reception.

The King is one of those public figures, familiar through photographs, who looked and acted exactly as I had thought he would. A tall man, and far less stooped than one would expect for his seventy-six years, there were both warmth and gentleness in his face and manner. His queen, Louise, is small and gray, an unpretentious woman with great simplicity of manner and great dignity. Princess Sibylla, the former Crown Prince's widow, is also small and gray, but is consciously chic; her back was stiffer and her manner more aloof than the Queen's. The three princesses, her daughters—Margaretha, Birgitta, and Desirée—looked exactly as princesses should look. They, and the other ladies, wore white, pale blue, or pale gray, with broad Swedish blue sashes across the bosom, and tiaras or other jewels —not so lavish as those of the British royal family when *they* are on display, but an eyeful nevertheless for us colonials.

The handshaking over, we took our places for the procession. The King escorted Mrs. Cherenkov, the only Russian wife to have come to the ceremony. She was wearing a handsome gold and white brocade dress, and in the cloakroom behind us she had left a superlatively beautiful full-length mink coat. (Mine was squirrel.) I was escorted by Prince Wilhelm, the King's seventy-four-year-old younger brother—a gaunt, gray bean-pole of a man with slight palsy and courtly manners; and George escorted the Baroness Rudebeck. He liked this charming lady

on sight because she came up to him and said, "You take me."
Later she invited us to visit her at her castle sometime.

Then, with "the Nobel children" and lesser lights stringing
out behind, we proceeded through a long hall between columns
of curtsying and bowing dinner guests and entered the banquet
hall—the famous room that is gold mosaic, from floor to
ceiling, fifty feet high. The Swedes, missing their summer sun,
use candles with a bountiful hand anyway, but for this occasion
there were hundreds of them reflected in the golden walls. The
state table was a mass of gold candelabra and high vases full
of red carnations and mimosa. Under any other circumstances
I would have stopped and gasped.

Commoners do not often dine with kings, and when they
do—if they have any sensibilities at all—I doubt very much
that they enjoy it. But if any king could bridge the gulf of awe
between himself and the public, it would be Gustav Adolf.
I sat on his left. Gracious, kindly, attentive, he was what the
British call a homely person. I talked rather more to him than
would ordinarily have been the case at a dinner party because
Mrs. Cherenkov, on his right, spoke no English, German, or
French, and he spoke no Russian. They exchanged smiles and
bows, and that was about the end of it. Midway through dinner
the King had an inspiration: turning over his place card, he
wrote on the reverse side (in English) a message that began
"Welcome to Stockholm," sent it to Professor Tamm with a
request that he write it in Russian, and upon receipt of the
translation presented it to Mrs. Cherenkov with a gesture of
apology for not being able to say it himself.

As for what he said to me, I remember with special delight:

"Would you like me to tell you about my family . . . ?
Across from you at the table is my wife. The Queen was born
in England. That is why we speak English so much in our

household. . . . Then, there's my brother, beside you. He's a poet. . . . And across from him is the Princess Sibylla, the wife of my eldest son." His voice softened. "He was killed in an airplane crash many years ago."

The King took a sip of the water in his wineglass and continued, "Over to the right is my son Bertil." His voice warmed. "A good boy. A fine boy." (Bertil is in his forties.) Then, inclining his head toward the three young princesses, in turn, "And my granddaughters are fine girls, too. . . . Some other members of the family are not here. Two other sons. And my daughter, of course. She is in Denmark, where she is the Queen." All this was said with simplicity and affection, as if these individuals were being identified at a college reunion for the benefit of a classmate. It is no wonder the Swedes dearly love their king.

After dinner there were speeches—of which the hit was Professor Tamm's. He began in Swedish, which caused the audience first to gasp with surprise and then applaud with pleasure, and then switched to English: a nice bit of gamesmanship all around. Nobody except the Russians seemed to speak Russian, and nobody except the Swedes (and Professor Tamm) seemed to speak Swedish.

Finally we all moved out to the balcony overlooking the beautiful Blue Room (so named because it was to have been blue, but is actually red). In here, to salute us, marched the medical students of the university, all in white ties and tails, wearing white student caps, and carrying colorful banners of various student associations. Despite the modern dress there was a feeling of medieval pageantry about it—the bright banners in the courtyard, the royal family on the balcony, the guests packed on the staircases, their clothes as rich as jewels in the spotlights.

176

We were standing on the balcony too—George and I, with Red at a little distance—when an unfortunate incident took place. Among the guests was a distinguished American visitor, governor of one of our great sovereign states, and his wife. (No, I do not intend to name them. I don't believe, for one thing, that they were willfully rude. Only stupid.) Being in Europe at the time, they had decided to pay a quick visit to Stockholm and had been added to the banquet guest list. As the guests chatted, after the student serenade, the governor and his wife worked their way up to the King and engaged him in conversation.

Suddenly the lady to whom I was talking—one of the Queen's ladies in waiting—looked past me and drew in her breath so sharply that I turned and followed her gaze. The governor was patting the King's arm, to emphasize a point. Almost immediately thereafter the governor's wife reached for a medal that hung from a ribbon around the King's neck, swung it out from his shirt front, and examined it with a pretty show of interest in its details.

Red, standing near a press attaché from the American Embassy, heard him say, "Oh, my God!" as a flash bulb popped. The picture was featured in the Swedish press the next day, and the reaction of the Swedish people was expressed by an anonymous note that I (much publicized as an American journalist) received in the next mail. It said: "We are shocked here in this Kingdom the way how an American woman dare behave herself vis-a-vis His Majesty King Gustaf VI Adolf of Sweden (look enclosed photograph). No people of the whole of Europe—in however high position whatever—would dare to do anything as this." George said that we should not criticize our compatriots too harshly, since we might have pulled comparable boners ourselves but had been spared their being publicized.

The next night was full-dress too, and equally sumptuous. We dined at the Palace.

During the few months we had been in England we had seen enough castles and mansions so that the Palace was not remarkable. It had a suitable number of lofty rooms, old portraits, crystal chandeliers, and French furniture. What *was* uncommon and made us gasp was the flowers: hundreds of huge bronze chrysanthemums in high silver vases the length of the dining-room table (which seated a hundred), and, in the drawing room, a forest of white lilac trees in tubs, and masses of primroses in pots. The footmen were in livery, several with high plumes on their hats, some carrying staves, and the ladies in waiting were in court dress—rather sober costumes with an eighteenth-century look to them.

The atmosphere was markedly different from the night before. The curtsies came easier; the conversation flowed more smoothly; we were relaxed; it really was a party. George's dinner partner was the Princess Birgitta, pretty but shy. Beside her plate, as at those of other members of the royal family, were a gold eggcup, a bone-marrow scoop, and an extra napkin. She told George that the napkin represented "dining at a special table" and the eggcup represented the distrust of Swedish cooking held by her ancestor the first Bernadotte. (Students of history will remember that the Swedes ran out of royalty in the early 1800's and imported a Frenchman to start a new ruling house.)

After dinner, as we sat talking in the drawing room, Professor Tamm passed around some Russian cigarettes. They were larger than ours, with black tobacco halfway up the tube, and nothing but the tube above—a sort of filterless filter. It was necessary to keep puffing at them as if smoking a pipe. Professor Cheren-

178

kov went to great pains to tell everybody that these were the *cheapest* Russian cigarettes, ". . . not of the best quality."

The next three days should have been a letdown but weren't. The weather, moderately cold on arrival, turned bitterly subzero. Our Southern California son saw his first icicle, and George and I re-experienced the cold noses, throbbing fingers, and exhilarating lightness of spirit that we remembered from youthful Midwestern winters. One enchanted afternoon Lennart and his beautiful Agneta took us to Stockholm's Skansen Park, where a curious hush lay over the zoo, and only the short, quick yaps of a caged coyote broke the stillness of midday twilight. And one morning we had an opposite kind of fun: prowling through Stockholm's huge NK department store, as fine as the best that America has to offer. Red didn't mind waiting while I shopped; he kept going out of the store and returning through the curtain of hot air that served instead of a door, marveling with each passage at its effectiveness.

Our last morning in Stockholm began at 7:30 A.M., when we were awakened by the sound of faraway singing. As we drowsily began to come alive, the hotel-room door opened, and in came a gorgeous blonde in a long white dress with a red sash, her hair wreathed in lingonberry greens and crowned with burning candles. She was followed by two younger girls in similar costumes. All were singing "Santa Lucia" and bore coffee and cakes. The haunting melody, the flickering candles in the dark room, and our own half-asleepness gave the moment a dreamlike quality —until the inevitable photographer popped through the door, and the aroma of strong coffee brought us upright. George's only complaint about beginning the day in this fashion was that the girls wouldn't stay.

Thus began the Festival of Lights. Its central figure undoubtedly dates from that period in the Middle Ages when Sweden

was Catholic. But the wreaths of candles and the sheaves of grain that many of the Lucias carried—we saw Lucias all over town, all day—must go back to some ancient pagan festival that sought to bring light to this darkest time of the year. That evening, when we dined with the medical students of the Caroline Institute, we toasted our final Lucia—in good, hot Swedish glög.

That was a gay party, more high-spirited than previous ones, because it was basically a young folks' affair, with much drinking and singing. To me the girls' dress was a special delight. Oriented toward Paris as definitely as California girls are not, they wore enchanting little knee-high trapeze jobs and pointy shoes; each had done her hair with great individuality; and they were as delectable as French dolls. It is a libel on Swedish women to picture them as buxom blondes with braids coiled around their heads.

However, none of us oldsters had the students' stamina, and shortly after midnight we gave up. We climbed down from the chairs on which all had been standing while singing and swinging our arms in unison—it was like a scene out of a Svenska *Student Prince*—and said our good-bys and stole away. The fixed smile on Red's face and his stiff-kneed walk expressed the fatigue that was suddenly drowning us all.

The next evening made quite a contrast. Our plane couldn't land at fogbound London and took us to Manchester. From there we began a long, slow crawl south by train—a trip that took three hours longer than the flight from Sweden. We had to change trains in Birmingham, waiting there between 11:30 P.M. and 1 A.M. The station was drab and dirty, and the cold air that swirled into the waiting room whenever the door was opened had a merciless bite. The connecting train arrived in Oxford at 2:45 A.M., and there wasn't, understandably

enough, either a porter or a taxi in sight. As we heaved our luggage off the train and staggered down the platform, I said (because I wanted to cry), "Well, the royal coach seems to have turned back into a pumpkin." But perhaps it was none too soon. The next morning, when we all felt better, George said to me, "Wow! Another week like that one, and I'd never have gotten you into the kitchen again."

16

GEORGE came upon me, a week later, morosely wrapping up a book I'd bought for Red for Christmas. The paper was a thin tissue of poor quality, and the only ribbon I'd been able to find in Headington was sleazy quarter-inch rayon.

"It just won't make a proper bow," I complained.

"Don't take it so hard," George said.

"And the stores don't have any gift boxes."

"Gad, that's awful."

"Well, you don't have to be sarcastic about it. Sure, it's trivial, but Christmas trimmings mean a lot to me."

"I'm sorry, honey," he began.

"Don't apologize! And don't sympathize!" I snapped. Then, contrite, "George, I'm sorry. I'm *homesick*." I hid Red's book among the linens; happily *that* closet was free of mildew. "Maybe it's the dismal weather. Wouldn't it be nice to sit in hot California sun for just an hour?"

"Have an orange," he said. (We'd been sent a whopping big box of Arizona citrus fruit; you'd have thought, from the way we'd dug in, that we all had scurvy.)

As I ate my half, I expressed another regret. "It was stupid to have mailed our gifts to the folks at home before we went to Sweden. There were so many wonderful things I could have bought in Stockholm, light enough to have gone air mail."

"Now, honey. What you did send was very nice. You said

so yourself. Especially the toys." He looked at me slyly, and I made a face at him, and then we both laughed. My blue mood began to lift.

The day I bought the toys had started like this:

"How come you're all dressed up?" Red had asked at breakfast.

"And what's the rush?" George had added.

"Because," I had answered them both, scooping up their egg plates and plunging them into the dishpan while their forks were still in mid-air, "I have to go Christmas shopping in London. I hate to go shopping in London. For that matter, I hate to go to London."

They knew I did. It was necessary to take two busses to get from Headington to the Oxford railroad station, then ride for an hour and a half in a musty railroad carriage. In the city I would put in five hours beating my way from one unfamiliar store to another, being jostled on the sidewalks, and getting lost on the Underground. Finally, the whole train-bus sequence would have to be repeated, at the height of the rush hour, with queues a block long, and by then it would be raining.

"But why London?" George had asked. "Why don't you get what you want in Oxford?"

"Because I can't, that's why. The gifts for the children back home, anyway. The least we can do, it seems to *me*, is to send them typically English toys. And all I've seen in Oxford are Roy Rogers guns and Wells Fargo stagecoaches. Imagine that! In *England!*"

George, who knows as well as any husband that a wifely tempest based on a point of trifling importance is the kind most likely to annihilate the innocent bystander, had made some noncommittal but sympathetic noises. Then he had said, "Tell you what. I'll meet the train. Save you the bus ride home."

This had been an incredibly generous offer on his part, for it meant that he would twice have to drive through the traffic tangle at the Carfax—and at its peak of ferocity. For a moment I had been tempted to be a martyr and refuse, but I had finally thanked him and said that I'd appreciate his meeting me.

Which he had done, and I *was* grateful, for I'd made the train with only seconds to spare, and there were six people in all the second-class compartments already. Even though each compartment is supposed to hold eight, passengers who claim the seventh and eighth places are always treated to a battery of drop-dead looks from those who have to make room for them, and that's what had happened to me. Besides, the racks were full of the other passengers' boxes, brief cases, suitcases, shopping bags, Thermos kits, overcoats, raincoats, bowlers, bundles, and books, so I'd had to hold mine on my lap the whole two hours en route. Not that the trip should have taken so long, but at Didcot the train had just sat in the dark and panted for thirty minutes.

When I'd finally squeezed my way past the gate guard at Oxford, splashed through the puddles, found the shelter of the car, and dumped the packages on the back seat, George had said cheerily, "Well, it looks like you had luck with your shopping."

"Yes."

Halfway up Headington hill he had tried again. "Pleased with what you got?"

"I guess so." I was beginning to relax. "Yes, I am. The toys, especially. The nieces and nephews will love them."

"Good." Now that he could tell that I was calming down, George said what he had wanted to say that morning. "Honey, I wish you wouldn't knock yourself out like this. It wouldn't have mattered whether they were 'typically English' toys or not."

184

"As a matter of fact, they're not." And then I had giggled. "Even in London I couldn't find one darned English-made toy that I couldn't have duplicated in America. The ones I got were all imported from *Germany*."

England doesn't make as much of a fuss about Christmas as the United States does. All in all, it was rather pleasant not to have one's sense of anticipation whipped into a frenzy. Father Christmas was allowed to stay at the North Pole instead of being forced to serve time on red plush thrones in department-store Toylands. There were no Christmas trees sprayed pink or blue, and no reindeers and sleighs poised, floodlit, on roof tops. There weren't even any holly wreaths—to speak of—on the doors. "An American custom, that," the nurseryman told me when I bought our three-foot Christmas tree. "But it's beginning to catch on here, too."

Even before we'd gone to Stockholm, we'd begun to get Christmas cards from home. These were from well-organized friends who had bought their cards in August, affixed the stamps in October, and whipped them off the minute the "Mail Early" placards had gone up at the post office. The bulk came later, of course, splashy with air-mail stamps, our address so swiftly scrawled it was barely legible. What a good many of these cards had in common was that they had been chosen especially for us, and featured Victorian carolers warbling under gaslit street lights, boars' heads being borne into medieval halls, or stagecoaches pulling up on snowy roads at English inn doors. A customary postscript said something to the effect that the sender was terribly envious to think of us celebrating Christmas amid traditional scenes of this sort.

Snow? We had a dusting. Oxford rarely has snow before Christmas, and not much after. Carolers? Oh yes. We had *them*—by the dozens. They were mostly urchins. They came

in groups of two or three, their grubby fingers clutching worn hymnals and their faces blue with cold. Invited inside, they sang a carol or two in thin little voices, eyes fixed on the ceiling and socks falling down, pocketed a coin apiece, and departed blushing. These onslaughts by the young resembled nothing so much as the visits of Halloween trick-or-treatsters at home, and the novelty of hearing "Adeste Fideles" as a soprano duet finally wore off. One evening, when George answered the doorbell, I heard him say, "As it happens, we're busy right now. But here's a shilling. Why don't you go sing a carol for someone else?"

Red got invited to a spate of dancing parties—the only time during our Oxford stay that he had any social contact with girls. The parties themselves were more like dancing classes than the parties he goes to at home, but in one respect they were identical. Whenever, at a December sherry party, I happened to mention that we had a fifteen-year-old son, my companion would often become extremely cordial, details of Red's dossier would be delicately extracted, and the next mail would bring him an invitation to a dance. Extra men are apparently as scarce in England, and as prized, as in the United States.

"What'll I wear, Mom?" he asked when he was getting ready to dress for the first party.

"Your gray flannel suit and a sober tie," I replied. I'd been caught out on many a detail of English etiquette, but this time I knew that I was on firm ground. English teen-agers are much less precocious socially than their American cousins. They're allowed far less freedom, remain subordinate to the adults in the family much longer, begin to date much later. Consequently I was sure that their party clothes would compare to those an American twelve-year-old would wear to a wedding.

When Red returned from the party that night, and when in the course of the post-mortem I got around to the who-wore-what, he said, "Guess how many gray flannel suits there were? Two. The other guys wore tuxes."

"Good gracious! What did the girls wear?"

"The girls? I didn't notice. Dresses, I guess."

(Men! I checked this detail at a subsequent party. The girls weren't precisely in strapless tulle, but they weren't wearing prim little navy velveteens with lace collars, either.)

The next morning at breakfast Red remembered an unreported tidbit. "You know how cars drive on the left, here?"

"Yes?"

"Feet do too. At home the man leads off on the right foot. Here he leads off on the left. I sure stepped on a lot of toes last night."

But he received other invitations and kept on going—in his gray flannel suit. Nobody cared. Bless the English.

The weather, which hadn't been really bad, turned awful just before Christmas. Coincidentally my mother arrived for a visit. She shivered and shook, but her upper lip is as stiff as any Briton's, and soon the house began to show signs of her presence. The tub in which I'd set our little Christmas tree acquired a shiny skirt of aluminium foil. (That extra "i" is not a typographical error, and the word is pronounced "aluMINium.") The few plants in the solarium that had survived my haphazard care began to look as if somebody loved them, and our silver gleamed.

It is from my mother that I have acquired my sentimental attachment to traditions, whether within the family or on a broader scale, hence I was particularly pleased that she was with us on Christmas Eve at Magdalen College. There, for an enchanted four hours, Merrie Olde England came to life.

The great hall was garlanded with evergreens. Their pungent fragrance, released by the warmth of candles massed on ledges around the room, mingled with the aroma of mince and sausage pies and the tantalizing spicy smell of mulled wine. William of Waynflete—generally referred to as The Founder—looked down upon us from the walls, along with other venerable churchmen, nobles, and Old Members. Perhaps their smiling ghosts were at our elbows as we filled the cup, drained the barrels, trowled the ancient Christmas carols. There was certainly *some* presence in the room that was not of this century. The choirboys sang the old, old carols—"Lullay my liking," "The Holly and the Ivy," "Ding dong merrily"—as well as a Bach oratorio, their voices soaring sweet and high above a mellow bass recorder. Just before midnight we all launched into "Adeste Fideles." Warmed by wine and good fellowship, our voices beat against the rafters on the final *"Venite adore-ay-mu-us Do-o-minum."* And then everyone fell silent. A prickle of anticipation coursed through the hall. Finally, far and away, in silver notes, the college clock chimed twelve. *"Gloria in excelsis Deo!"* the choir exulted. A loving cup, garlanded with ribbons, made the rounds. And then the tower bells began to peal . . .

Change-ringing is a uniquely English art. It combines four or more bells of different pitch—Magdalen has ten—each of which is rung in a different pattern. The rhythms overlap, blending into a rolling, tumbling medley of sound that makes the heart lift and the spine tingle any time you hear it. But on that particular Christmas Day in the morning, as we left the college, the clangor of bells overwhelmed and enveloped us. They beat us to earth. They tossed us heavenward. Even the cold stars seemed to shimmer in the midnight sky, and the rapture was almost impossible to bear.

After that anything would have been an anticlimax. Yet our

own family Christmas celebration was warm and jolly, the roast chicken an unqualified success, and we spent a cozy afternoon chatting about Christmases past and Christmases yet to come. In the evening we witnessed another traditional Oxford celebration of the season: the Singing of the Boar's Head Carol at Queens College.

Once upon a long time ago the Fellows of Queens *did* assemble on Christmas night to eat a boar's head decked with flags and gilded holly, and it is the bringing to table of this delicacy that is still commemorated. But only a handful of dutiful Fellows gather at High Table now, and only for the ten minutes it takes the procession to advance through the hall— first the cantor, then the choirboys, finally the cooks holding the boar's head aloft on a heavy silver platter. It was a pretty parade, but somehow it was as two-dimensional in effect as the same scene on one of those Christmas cards we'd received from home. Perhaps making a fuss over a boar's head that nobody was going to eat gave the ceremony its essential hollowness.

On the day after Christmas, Boxing Day, England collapses. Nothing runs, no newspapers are published, and people either slump deep in their armchairs at home and look at the telly, or go to visit friends and drink mulled wine. The regulars at the pub across the street had a riotous party, from which they exited flushed and merry, wearing paper caps and tooting toy horns and revving up a storm on their motorcycles before they went swooshing off into the night.

The Darlingtons had asked us to attend a Christmas pantomime with them. "They're as traditional as plum pudding," Gwendolen had said. "Let's all see *Cinderella*. The children too, of course."

Mother and I were delighted. George and Red were wary. Cinderella is a saccharine tale to start with, and to see it in-

terpreted without dialogue (that's what, by definition, a pantomime is; or so we thought) sounded much too hearts-and-flowery to my menfolk. But affection for the Darlingtons tipped the scales, and we accepted.

Well!

The performance started pretty much as we had expected, with the fluffy little blonde who played Cinderella scouring the pots and pans in the castle kitchen. Then the scene moved to a garden, where we met Prince Charming. At this point I did a double take: it was obvious, as His Highness came mincing across a bridge, that he was female. Rather gorgeously so, too: I've never seen longer, shapelier, or better-displayed legs. While he—she?—was warbling a love song to Cinderella, I shot a glance at Mother. Her lips had drawn into a disapproving line. I felt squirmy myself. This was all very—er—*irregular*.

I whispered to Gwendolen, "Isn't it a little odd to cast a woman in that role?"

She whispered back, "Not at all. The Principal Boy is always a woman. With good legs. It's traditional."

The real love interest, it turned out, was supplied by a male character called Buttons—a simple villager, he, who kept trying to win Cinderella right up to the final scene with the slipper. By that time, however, the actual sex of Prince Charming was immaterial, for we had gasped with laughter through a dozen scenes dominated by the Ugly Sisters—who were *men* ("it's traditional")—and clowns, besides. In addition to their slapstick, in the grand tradition of the Keystone Kops, we had endured some off-color jokes, had politely applauded a ballet sequence featuring a group of earnest but muscle-bound maidens, and had been truly charmed by some well-drilled child dancers called Vera Legge's Moonbeam Babes. They did a precision drill with hula hoops, a Charleston that was the cat's

meow, and—well, somehow, we rather lost track of Cinderella.

On leaving the theater we ran into the Morrises, also with their children in tow. They asked how we'd liked out first exposure to an English pantomime.

George was still wiping his eyes and chuckling. "I never thought I'd see anything as corny as that in Oxford," he replied.

John Morris repeated, in puzzlement, "Corny? Is that good or bad?"

"Good," George said. "I was born in Nebraska."

The joke was neither very good in its own right nor suitably chosen for an English listener, but it had an Olsen and Johnson flavor that was entirely in keeping with the tone of the evening.

open and shut. Papa was a pharmacist then, and our little Indiana town had been badly hit by a recession. His wages were only seven dollars a week, and we were having a hard time making ends meet. Then, just before Christmas, he had to have all his teeth pulled, and that used up every penny of savings.

"His employer knew what our circumstances were, and he wanted to be helpful. He offered Papa a loan so that we children could have a nice Christmas, but Papa thanked him very stiffly and said that we'd manage with what we had.

"What we had was potato soup for Christmas dinner, and our presents were merchandise that you could get with soap coupons. Instead of a doll, I got a framed picture of a lily. That was the year I learned that there isn't any Santa Claus."

I stood up. "I'm too Irish"—*my* father had been a McClure, two generations from County Antrim—"to be that proud. But I guess there's something of Grandpa Bothwell in me, or I wouldn't be going out on a day like this."

My neighbors had shamed me into sweeping the sidewalk every day. However cold or blustery the weather, the wife of the pubkeeper scrubbed the pub steps every morning. Old Mrs. Edward, a frail little body of eighty-plus, was just as reliable about tidying her section of the pavement, which adjoined ours. On this particular morning she was finishing her chore when I—bundled in a duffel coat, wool cap, mittens, and fleece-lined boots—joined her. *Her* sweeping costume consisted of a wool cardigan over a cotton dress, and it made me colder just to look at her. We were having ten degrees of frost that day (Americans would call it twenty-two degrees above zero) yet she seemed perfectly comfortable, and even lingered for a moment after she'd swept the last gum wrapper into the gutter. The weather was beastly, didn't I agree?

I did. But even when I was most uncomfortable I had to

194

admit that it wasn't so beastly as we had come to England prepared to endure. The many people who had warned us about England's "dreadful winter cold" had neglected to specify degree and duration, and to George and me, raised in the American Midwest, dreadful winter cold meant weeks of near-zero temperature, blanketing snow, and icy winds. Oxford's worst is the palest imitation of that. Warm ocean currents keep winter temperatures relatively high—in the thirties or forties, which is nippy enough, goodness knows, if the air is humid and one's house is uninsulated. But it certainly isn't "dreadful winter cold."

The fact that none of our informants had adequately stressed was the changeability of English weather. For such a little island Great Britain has enormous variety: there can be a snowstorm raging in Kent and a spring rain falling eighty-five miles away in Berkshire. The daily weather reports in the newspapers are split into individual forecasts for six different districts. (Not that they appeared very different to a casual reader—they usually said there would be "sunny intervals and scattered showers, probably cloudy later, with drizzle or rain spreading from the West.") The consequence of this changeability was that a given pattern of weather rarely lingered longer than a few days. Just about the time that a cold snap prompted the writing of some poor-little-me letters home, the temperature would rise and it would rain. The weather having thus moderated, the fact that our house was uninsulated no longer mattered so much, and this, in a nutshell, is why English houses are that way.

The English don't believe in storm windows, either. Which is silly, because newer houses are using sizable areas of glass (all single pane) instead of the little leaded windows of yore. In Minnesota people could freeze to death in such houses. In England, where indoor temperatures can *easily* be maintained at about twenty degrees above freezing, inhabitants just shiver and

carry on. I suspect that those stiff upper lips of theirs are camouflage for chattering teeth.

Joan Wheare said that I was wrong, that there is real exhilaration in sliding between icy sheets toward the comforting discovery of a hot-water bottle at one's toes. And the distress of a certain Oxford don was genuine when it was proposed by the head that central heating be installed in one of the buildings at his college. "But, Master," he protested, *"then the whole building will be warm."*

It's true, too, that the English are hardy. Babies get aired regardless of weather, and no amount of cold alters the wearing of short pants by little boys, even though their bare knees turn blue. They consider themselves warm if they have thick, woolly scarves around their necks. In rain only Americans and the infirm aged wear galoshes or rubbers. Furthermore, normal body temperature among the English, according to their household fever thermometers, is 98.4—in contrast to America's 98.6, so maybe they *do* have a greater inbred tolerance to cold.

But I am not convinced that it's wholly a matter of physiology. There's still a strong streak of Puritanism in the English. They've convinced themselves that it's immoral to be too comfortable. Deprivation builds character. Chins up, lads, chilblains are *good* for you! At any rate, they couldn't have picked better spots for mortifying *my* flesh. The most uncomfortable room in most English houses is the cubicle where the toilet is installed, and the next coldest room is the bath. If cleanliness is next to godliness, I slipped from grace during the Oxford winter. It took more moral fiber than I possess to lower myself into the clammy embrace of a porcelain tub in an unheated bathroom, just on promise of having a warm towel when I got out.

That January, Oxford had a fair sampling of any kind of weather you'd care to name. It was both inspiriting and un-

settling. There had been snow right after Christmas, not much, just enough to make inch-high caps on the gravestones in St. Andrew's churchyard at the bottom of our street. Then rain. Then frost. Then frost with fog. (That was the worst; it bit to the marrow of the bones.) Then two brilliant days of hoar-frost, when the sun shone down from a cloudless, cold blue sky on a world that sparkled with diamond dust. Every blade of grass, every twig, every ivy leaf was rimmed with chalky white, and the whole landscape had an ethereal beauty I've never seen matched by either sleet or snow. Then rain again. And another bout with fog.

Our little pink house immediately reflected all changes in outside temperature, humidity, or wind direction, and it was impossible to maintain anything like an even moderate warmth inside. If, in mild weather, I turned off the stoves overnight, the temperature always seemed to drop and by morning the inside panes of the living-room windows would be faintly rimed. If there was a brisk wind, drafts shot across the floors or played around our shoulders, and if we cut their force by closing all room doors, the burning paraffin in rooms without cross-ventilation made us feel logy and gave us headaches. Finally I threw up my hands and decided that it was simpler just to keep the stoves going full blast all the time, opening windows as necessary to prevent anoxia. Mr. Shergold the Headington Ironmonger must have thought that we either bathed in or drank the vast quantities of paraffin he delivered, since no one could possibly have burned so much fuel.*

Whenever a day looked passable, and sometimes even when it didn't, we continued our sight-seeing. ("Neither snow, nor rain,

* On the other hand, these customers were Americans. And Americans *do* keep their rooms boiling hot.

nor heat, nor gloom of night . . ." applies to tourists, too.) We took Mother, one leaden Sunday, to Blenheim Palace, Churchill's birthplace. It had an austere and forbidding beauty, the great gray pile of stone that is called England's Versailles rising out of a snow-powdered park, the lovely gardens laid out by Capability Brown hidden from view, the lake turned steely gray and desolate. We also drove over to Ewelme, whose watercress beds were a slash of brilliant green—of pulsing life in a near-dead world—and whose little church and ancient almshouses were as charming as we'd been told.

It was there I saw my first tomb with the dear departed in sculptured stone, richly arrayed and serenely beautiful, atop the coffin; and in a narrow enclosure beneath the coffin an effigy of the same person in a simple shift, face wracked by pain and body emaciated by disease. A nice reminder, this, that fine robes and high position—this was a sixteenth-century duchess of Suffolk's tomb—do not get one into heaven, and that in the end all men meet their Maker on equal footing.

On each of those January Sundays, Mother and I went to a different church. The Anglican churches were half empty; the English are not a nation of churchgoers. Although St. Columba's Scottish Rite Presbyterian was packed, Headington Baptist (it was odd to hear such churches called "non-conformist") had only a handful. They were working-class people in that congregation, scrubbed and tidy, and the only churchgoers of the lot who spoke to us, the strangers in their midst, after the service.

We didn't attend any services at what the English call "the R.C. churches," but we went to St. Andrews for Boy Scout Sunday, and its service was so high that only the Mass in English distinguished it from Roman Catholic. Wearing short-sleeved cotton shirts and corduroy shorts, the St. Andrews Scouts sat together in the front rows of a church so cold one could

198

see one's breath. Mother's attention drifted away from the service as she watched one little boy's lips turn blue. I was less concerned because I'd been in England longer and knew that he'd arrive home rosy, and perhaps even warm, after a lively run in the brisk January air. The scene from that service that remains brilliantly in my memory is how sudden sunlight streamed through the old stained glass into the choir, and how the clouds of incense floated lazily in the brightness like dust motes in the hot air of an August noon in California.

In town we dutifully "did" a few of the colleges, but it was too cold to linger long in most of them. I suspect that my mother's enduring enthusiasm for New College chapel is tribute not to its greater beauty but to the fact that she examined its details in greater comfort. It has radiators underneath the benches where tired sight-seers naturally sink down to rest.

Hilary term began in the third week of January, and although the high excitement and the frantic socialization of the first term had disappeared, the pulse of Oxford life quickened. As the undergraduates and dons returned from vacation, the city streets grew gay again, and the Carfax became once more an international crossroads.

Mother and I were en route to a luncheon one day, when a fashionable French lady boarded our town-bound Headington bus. Blond as a biscuit from creamy angora hat to pointed pale beige slippers, she sputtered and waved her arms as she thrust a card at the bus conductress. The broad-beamed, ruddy-faced country girl read the address on the card, shifted her gum, patted Madame on the shoulder, and cheerily replied, "Don't worry, love. We'll find it. Fi'pence ha'penny, please."

As we waited in queue at the bus transfer point, we saw a tiny Indian lady in a bright sari and fleece-lined boots, pushing her brown baby in a pram like a galleon. A blue-black Nigerian

and a red-bearded Scot, both with college scarves around their necks, overtook her, cut around her—one on each side—and continued their earnest conversation across the pram until they had forged ahead sufficiently to walk again side by side. Behind us, clustered at a shopwindow, were three Latin-American girls rolling their eyes and trilling their r's as they window-shopped for shoes. On the drab street, among the pale-faced English in dun-colored clothes, the señoritas looked like goldfinches that had somehow wandered into a flock of sparrows.

"The only thing that's missing from this scene," I said to Mother, "is an undergraduate in a purple exercise suit running through town. They do it all the time—five or six mile runs, just for the fun of it."

She agreed that it was all very exotic, and did I feel a slight drizzle beginning?

The days seemed very short now, because so rarely was there sun. One evening, homeward bound from a visit to St. Edmund's Hall—a kind of Lilliput among the colleges, with all their charms in miniature—Mother waved her hand (the one that wasn't carrying the umbrella) at the shrouded windows we were passing. "They look so—so unfriendly. So withdrawn," she said.

"It's just the English need for privacy," I replied. "It shocks them to see the way Americans leave their blinds up or their draperies undrawn. At least half a dozen people here—of those who've visited the States—have mentioned our lack of fencing, and the way that lawns often blend into neighboring lawns. I suppose all that openness seems to them like pitiless exposure."

"Speaking of exposure," my mother said, "I *do* wish you'd do something about your bathroom window. Not even a casement curtain over it."

"Oh, I don't think anybody can see in," I replied. "The only

200

house in sight is way across the park. Besides, our view out is awfully pretty. Even in winter."

(Much, much later—just about the time we left England, in fact—the thought occurred to me that maybe Mother Knew Best. Perhaps the lady of that distant house was a bird watcher equipped with binoculars. There had been certain indications that walled houses and curtained windows don't mean the absence of watchful eyes behind them. In the spring, sometime, a neighbor casually mentioned that my husband had been out working in the garden uncommonly early. I knew, from having been shown through her house, that the only view of our garden was from her cook's window, a dormer on the third floor. And another neighbor asked if she might have the block of American air-mail stamps from a fat letter we had just received. She knew that we had them because the mailman had drifted into the habit of showing off our mail to other people on his route. I think now that the Englishman's sense of privacy is illusory.)

Early in February, Mother decided that winter's traces were too long for *her* powers of endurance and that she'd do her waiting for the hounds of spring in the civilized comforts of steam-heated America. With her departure I settled down to huge quantities of reading and occasional fits of self-pity. I had developed an intermittent, deep-seated pain in my middle that alarmed me. Maybe I had an ulcer. Or cancer. Red was a source of worry too. He looked like a wrung-out chamois skin and was just as limp. I plied him with eggnogs and fretted.

"Well, call the doctor and ask his advice," George suggested. "That's what we're paying him for."

This was a jest, because—since we didn't pay taxes—Dr. Cullen's services didn't cost us one penny. In Great Britain everyone who applies for free medical care may have it, whether or not he has paid a farthing into the common pot. And if some

Frenchmen pop across the Channel to get free dentures? Or some Irish girls emigrate briefly to give birth to out-of-wedlock babies? Ignore the free-loaders, the British reasoned when they set up the National Health Service: *It will be cheaper to treat those few who aren't legitimately entitled to the service than to keep detailed records for the many who are.* Earlier in the year, when we had filled out three lines on a three-by-five card and had thus become entitled to free medical care, we had recalled without nostalgia the forms in triplicate that we had filled out at home in order to apply for or collect medical insurance. We had thought, too, of the avalanche of paper work that buries employers, doctors, hospitals, and insurance companies in the States. I still don't understand how the same people who persist in such absurdities as putting water pipes on the outside walls of their houses could also have adopted such a brilliantly logical solution to the problem of administering with a minimum of red tape a program of medical care for fifty million people.

As for the doctoring, it seemed fine. I *did* call Dr. Cullen, as George had suggested, but since Red didn't have any alarming symptoms—just pallor and general lassitude—there wasn't much the doctor could prescribe beyond a nourishing diet and plenty of rest. Unless, of course . . .

"Dr. Cullen, do you think that a course of vitamins might help to get the boy back on his feet?"

No sooner had I voiced the question than I wanted to withdraw it. I had suddenly recalled a fragment of conversation I'd overheard at a coffee party. The speakers had been the wives of two doctors. One had said, "Ian has a couple of new patients—Americans." The other wife had groaned. Then both had laughed, and the first one had said, obviously mimicking, "How about some vitamins"—only she pronounced it "vittamins," English style—"and a shot, huh?" So I knew that

preventive medicine of this sort isn't so fashionable in England as in the United States, and I wasn't surprised when Dr. Cullen vetoed vitamins and recommended patience.

Then I went in to see him myself about the pain in my middle.

Sitting on a hard bench in his "surgery"—which means office, not operating room—and clutching a number, as in a butcher shop back home, I waited no longer in his clinic-style outer office than I am accustomed to wait in doctors' offices at home. The difference in America is that you have an appointment. Also, the furnishings are more de luxe here, the magazines are slicker, there's a glamorous receptionist, and the doctor wears a white coat. English doctors sit behind their desks looking like loan officers in a bank.

Dr. Cullen listened to the recital of my symptoms, made an examination, said that nothing seemed to be badly amiss, but that perhaps I should be examined by a specialist. One way you can identify an English doctor as a specialist is that he has dropped the label. Dr. Cullen sent me to Mr. Gray, an internist, as a private patient—which meant that I had to pay for his services.

Mr. Gray took me thoroughly apart. Then he said, lifting a letter from a file, "I concur in Dr. Cullen's diagnosis."

"Oh," I asked, "did he make one?"

"A hypothesis. But he wanted me to rule out other possibilities. I have done so."

Here it comes, I thought. *Be brave.*

"You seem to have a pulled muscle in the diaphragm, Mrs. Beadle. It will right itself in time. Unless, of course, you submit it to further stresses."

And so it did. The pain in my middle went away soon after George and Red took over the job of toting in the heavy scuttles of coal for the Rayburn.

That's all the medical care I needed in England. So I'm no authority on socialized medicine. I *heard* that English doctors still don't like it much. But the public likes it fine, so I'm afraid the doctors are stuck with it.

Would it work in the United States? I suppose a pent-up demand for medical services would overwhelm our doctors just as it did the English ones when the plan first went into effect. But I also believe that Americans would *continue* to make more demands on their doctors than the English now do. Our attitude toward health is different—and it isn't just a matter of being more sold on vitamins and shots, either. There must be neurotics in England, as in my homeland, who consult doctors as a substitute for entertainment, but in general the English are less prone to worry about their health, take less elaborate precautions to protect it, and ignore minor illnesses to a much greater extent than we do.

Some 25 per cent of Oxford babies are still born at home—partly for lack of hospital facilities, but partly because a good many women prefer it that way; and the midwife, who in America supplies health care primarily for hillbillies and the indigent, has in England a respected and vital place in the medical hierarchy. It is assumed that English mothers are quite capable of ministering to all but the most catastrophic illnesses of their children, and there's much less folderol about sanitation. An English schoolteacher, doing a stint in an American school, reported her astonishment when a child dropped an unwrapped "sweet" on the floor, to see the little girl pick up the candy and throw it into the wastebasket—instead of popping it into her mouth, as an English child would have done.

At Red's school, if a parent requested it, boys who had been ill were excused from participation in the compulsory Wednesday-afternoon games—but not from attendance. If they were

204

well enough to be in class, they were well enough to go to the playing field, the masters reasoned. And since one got colder standing and watching a game than running with the pack, most youngsters with a dislike of sports didn't use the sniffles as an excuse to escape. Furthermore, this lack of pampering seemed to do children no particular harm. "You've got a temperature, but you might as well go back to class—you've had a temperature for months," said a school nurse to one little American girl whose mother I knew. In general, most of the American children in Oxford got through their year in England with fewer ailments than at home.

Kitty Turnbull summed up this Spartan streak—at least for the distaff side—when she said, "Women of other countries seem to go to bed when they feel unwell. We Englishwomen go for a brisk walk with the dogs."

18

IN February all hell broke loose in the education committee of the Oxford City Council. In March the Cutteslowe Walls came tumbling down for the third and final time, and the education committee's controversy expired in a bitter deadlock. In each conflict the battle lines were drawn between Labour and Conservative, between industrial middle class and educated upper class, between Town and Gown; and although technically the final score was a draw, the defenders of the *status quo* had the edge.

Town won the battle of the walls. Nine feet high and with spikes on the top, they had been erected in 1934 to divide a group of private houses from the council houses (that is, those built by the city and rented very cheaply to working-class families) of the Cutteslowe Housing Estate. The people living in the council houses had been forced by this barrier to make a half-mile detour before they could reach the busses or shops on a nearby main road. Consequently they had put pressure on the city council. It, in due course, had declared that the erection of such walls was illegal, hired a steam roller, and demolished them.

None of this had sat well with the owners of the private houses, nor with the firm that had built them. So they had taken their case to court—and had won it. As a result, the city council (with what indignation can be imagined) had been forced to rebuild the hated walls. In 1943 a tank on army

maneuvers had knocked one of them down—*that* time the War Office had to pay for reconstruction—and a little later an automobile had crashed into another one. Despite these ups and downs, however, the Cutteslowe Walls in 1959 were still as strong and as high as when they had first gone up, and were as galling to the tenants of the council houses.

This time the city council got rid of the walls by buying them from the private housing company that had originally erected them. And it was with considerable ceremony, one misty, moisty morning in March, that certain Labour members of the city council superintended the wielding of pick and chisel on the Cutteslowe Walls. A few spectators gathered to watch and to pick up fragments of brick for souvenirs. A lady whose house was on the non-U side of the now-crumbling walls said, "I didn't want to miss this. I'm thrilled to bits." A gentleman on the U side, cornered by a newspaper reporter, said that the presence or absence of a wall made no difference to him.

He was quite correct. The Cutteslowe Walls were only a symbol of a barrier that no pick and chisel can destroy. Perhaps on some future day the descendants of the people who live on Aldrich Road will feel free to drop in for a chat at a neighbor's house on Carlton Road. But not just yet. There is a breach between the English upper and lower classes everywhere, but in Oxford the apposition of the Morris Works and the university intensifies it.

Ever since the first poor scholars began to invade the streets of the city back in the twelfth century, Town has been at odds with Gown. Mobs of people, instead of vehicles, used to join battle at the Carfax. The famous St. Scholastica Day slaughter in 1355 left sixty dead in its wake and saddled Town with an annual ceremony of penance that persisted well into the nineteenth century. There are no street fights today, save for an

occasional attack by Teddy Boys on undergraduates, but the schism persists.

It is rooted, as I suppose it always has been, in such universal human emotions as envy of the rich by the poor, fear of the priesthood by the laity, distrust of the landlord by the tenant. And it is aggravated by the fact that the university people remain so snug, smug, and seemingly impregnable behind their college walls—despite the presence of social and economic forces in England that seem to promise all men equal status.

The educated and the well-born upper classes are bulwarked by tradition and by unshakable confidence in the worth of the system that produced them. Britain could not have won its empire without an elite class trained for leadership. The remnants of that class are not emotionally convinced that the problems of commonwealth require different solutions. Unfortunately the working classes want—well, they aren't quite certain of what they *do* want, because economically they've never had it so good and culturally they don't know what they're missing, but they know that they *don't* want quite the status they've got.

Oxford's industrial middle and lower class is proud of the university and the distinction it gives the city, yet they resent it and the privilege it stands for—an ugly combination of emotions. I can still hear the frosty reply of a member of the Headington Women's Institute when I asked if the organization included any university wives. "It's not likely you'll find any of *them* in a group like this," she said. "We're mostly business and non-conformist clergy."

A secondary-school headmaster told me, "People on the wrong side of Magdalen Bridge"—that is, the industrial side of town— "sometimes refuse free places in the city grammar schools if their children are accepted at the fee-paying schools, attended by dons' children. If they can't crack the university circle themselves,

there's always a chance of doing it through their children."

One of Mr. Weaver's itinerant apprentices, while hacking away at a hog's jaw under my fascinated gaze, identified the cut for me as a "bath chap." I didn't catch the phrase, asked him to repeat it, and got a malicious answer. "Lud! I said it wrong. In Oxford, it's a bawth chawp." This sally brought the house down, both behind the counter and in the queue of housewives waiting to be served.

The schools, of course, remain the best avenue for upward social mobility. If a child from a working-class family is bright enough to get a scholarship at a public school like Eton, he may eventually move in upper-class circles. This is less true if he wins a grammar-school place, for he then goes home every night and is re-exposed to the uneducated speech and standards of his family circle—a problem that many such boys solve by learning to speak and act one way at school and another way at home. However, by the time either boy has finished at a university like Oxford, very little of his origin shows in his speech or in his sense of values.

George Bernard Shaw has been quoted as saying, "If Oxford is not highbrow, what on earth *is* Oxford?" An undergraduate may be the son of a Birmingham collier and his speech may still be faintly tinged with Black Country dialect, but the college porter will address him as "Mr." He and his fellows are always referred to as "gentlemen." And his tutor will offer him a choice of sherries as gravely as if he were a connoisseur. Thus he begins to become one. There isn't much doubt that life as lived in the Oxford colleges stretches the mind, sharpens the wit, and refines the taste. It turns out young men who read *The Times* or the *Manchester Guardian* instead of one of the incredibly cheap and trashy tabloids that abound in England as a sort of opiate for the masses. The English university graduate is more likely

to spend his entertainment money on theater than on TV, and in August he avoids the Coney Island-type resorts in South Devon as if they were ridden with plague.

In short, education can do for the poor-but-bright what birth does for the gentry.

But that's not what the Labour party wants for English youth. It wants "parity of esteem" not only in systems of schooling but also in adult life, and correctly sees the segregated schools, with their class connotations, as a barrier to the accomplishment of that goal. Hence the drive for American-style comprehensive schools. The defenders of the established order, on the other hand, are alarmed at the thought of losing their elite trained for leadership—a certain consequence, they believe, if all children are mixed in common schools. Then, too, there's that matter of "correct" speech; they fear that the King's English will be corrupted into something like the slovenly diction of Americans. One father—politically such an avowed socialist that even in tolerant Oxford there was a certain amount of headshaking over his radical views—told me that he was completely in favor of comprehensive schools, but not for *his* children. "I can't have them talking like oicks!" he exclaimed, referring to the *i* sound that in lower-class speech is pronounced *oi*.

Such sentiments are general in England. In Oxford, in February of the year we were there, they exploded into public controversy over a proposal to reorganize one of the secondary schools. Because there have been some hot fights over educational issues in Pasadena, I followed the Oxford equivalent with special interest.

Here's the background:

The Boys' High School, a city-run grammar school, had for years occupied cramped and unsafe buildings in downtown Oxford. It was now (meaning, since this was England, in a few

years) about to move to a new site on the northeast side of town. The city also planned to build a desperately needed new secondary modern school on a site directly across the street. The proposal that was causing the controversy was that the two schools be combined—not quite into an American-style comprehensive school but into what is termed a bilateral school.

The grammar-school side of it would enroll boys from all over Oxford (those who had passed the 11-plus exam), whereas the secondary-modern side of it would include boys from the immediate neighborhood only (none of whom would have passed the 11-plus exam). They would, presumably, be kept in separate classes—the grammar-school boys taking tougher academic subjects than the secondary-modern boys. But they would mix in such all-school activities as sports and dramatics, during recreational periods and recesses, and at the assembly-with-prayers, which by law must occur each day in every tax-supported English school.

I don't know what the Labourite proponents of this scheme proposed to do about uniforms. To ask the grammar-school boys to cease wearing this symbol of superiority—*or* to ask them to share it with the secondary-modern boys who hadn't earned it— would be to stir up an immediate hornets' nest. Yet to withhold a uniform from the secondary-modern boys attending the same school with the grammar-school boys would be a constant visual reminder of inferiority, as demeaning and as infuriating a label as a scarlet A or a yellow J.

Any American who knows anything about his own country's school system will see three advantages to the bilateral scheme: the slow starters among the secondary-modern boys could move more easily into grammar-school courses, whereas the quick fizzlers among the grammar-school boys could drop Latin and switch to subjects less demanding; the over-all cost of school

construction and maintenance would be less, owing to the elimination of duplicate facilities such as libraries, kitchens, and shower rooms; and teachers with specialties would have a greater chance to utilize them. (With a larger student body to draw from, an exceptional music teacher, for example, could put in a full day teaching music.)

But these considerations hardly got mentioned in Oxford. At the February meeting of the city council's education committee, discussion (if it could be called that) had bogged down on the pros and cons of segregation by academic ability, both sides becoming so supercharged emotionally that they had all ended up on soapboxes. In fact, one of the defenders of the bilateral scheme had gotten so carried away that he had said, "It is Little Rock mentality to believe that educational standards depend on the segregating, at age eleven, of one group of children from another. In Oxford, if you fail the eleven-plus, it is the equivalent of having a black skin in Arkansas. You are not allowed to mix."*

Feelings had run so high and so many intemperate remarks had been made that the committee members subsequently became a little ashamed of themselves and began the March meeting with a show of concord. As I settled myself in the council chamber's visitors' gallery—pleased to find a vacant seat next to Lady Healey, whose husband is a professor at the university —one of the councilmen on the Labour side was saying, "I don't think we cut too good a figure a month ago. Let's try to keep it clean and dispassionate today." A clergyman in the supposedly non-partisan middle agreed, but unfortunately added, "Politics is recognized as a dirty game. For heaven's sake, let's

* Americans should not underestimate the permanent impact of the Little Rock "incident" on Europe.

212

keep it out of education." Which could have been construed as a slam at Labour. Anyway, that's how the Oxford Labourites construed it, and there was an angry little stir on their side of the council chamber.

The subsequent arguments followed a pattern familiar on this side of the Atlantic, too. First, there were statements from various organizations. The Amalgamated Society of Woodworkers, the Oxford District Trades Council, the National Guild of Co-operatives, the Amalgamated Engineers' Union, and "a group of parents meeting in the Congregational Church hall in Summerton" were all in favor of a bilateral school. Then there were statements of disapproval from the Oxford branch of the National Association of Head Teachers, the Oxford City Secondary Teachers' Association, a couple of other educators' groups, and the very articulate headmistress of the city's grammar school for girls.

A Labourite discounted the educators' advice. He said, "On the whole, changes in schools have been initiated by those other than teachers. It is not up to them but to us to decide whether or not to do it." Beside me Lady Healey drew a shocked breath. "Outrageous!" she gasped. I couldn't help smiling at this reverse twist of a situation familiar in America. Here it is the conservatives and many academic people (for whom Admiral Rickover and Arthur Bestor are spokesmen) who challenge the authority of the professional educators. In England it is the socialists.

Next, the defenders of the *status quo* had their say. "The Boys' High School has a proved place in the educational scheme here," a Conservative with quivering white mustaches proclaimed. "There is also a long-felt need for a secondary modern school in North Oxford. We've badgered the authorities for

thirteen years to approve it. Are we now going to risk the failure of *both* schools?"

A woman's voice from the Labour side cried, "Failure? There are at the very least a hundred bilateral schools in the country, one as close as Reading, operating very successfully."

As if she had not spoken, the retired brigadier (he must have been!) continued. "If we insist on ignoring our own teachers' advice"—his tone suggested that a difficult medical case was about to be snatched from a Fellow of the Royal College of Physicians and given to a witch doctor—"perhaps we might consider the opinion of the National Foundation for Educational Research. In its opinion comprehensive and bilateral schools are still experimental. Another ten years may be required before they can be properly assessed."

From the Labour side, in a heavily accented Oxfordshire voice, came a sarcastic rejoinder. "Oxford is a city of l'arnin'; and here's where educational experiments should tyke place."

Then the amateur psychologists had their turn. "In a bilateral school," said one, "the grammar-school boys will always be at the top. The secondary-modern boys will develop a real sense of inferiority—which may last all their lives. Let them have separate schools, so the secondary-modern boy will have some chance for leadership among his own kind."

"He's crazy," I muttered to Lady Healey. "The grammar-school boys won't always be at the top. There's no correlation between being able to learn Latin and to sing like an angel. A secondary-modern boy could be a dunce scholastically, but the star of a choral group. . . ."

Torn between politeness and avid interest in the proceedings, she gave me a distracted glance, and I subsided. Anyway, the Labour side was rebutting the inferiority gambit. "Will the secondary-modern boys *really* feel more inferior within the school

214

than walking down Marston Ferry Road in the morning and turning right while the grammar-school boys turn left?" a councilman was saying.

The amateur educationists had a chance to talk too. "As a bilateral school, academic standards will fall," prophesied a Scots-tinged voice from the Conservative side. The speaker added that it was impossible for a teacher to cope with grammar-school boys and secondary-modern boys at the same time. "One needs an entirely different teaching technique for each," he said.

"Not all that different," I muttered, but low enough so that I wouldn't disturb Lady Healey.

It had not, apparently, occurred to any of the committee members to send a delegation to visit some of the bilateral or comprehensive schools already in existence. Nor did they really want to consider viewpoints other than their own. As I watched the clock hand inch past five o'clock, and listened to the argumentative aggressiveness of the Labourites and the disdainful rebuttals of the Conservatives, I thought of an American wisecrack: *My mind is made up, don't confuse me with facts.*

It was obvious that a vote on the issue would go against the Labourites, who were outnumbered by Conservative and university representatives. Finally the chairman of the committee (Labour) slowly rose. His face was set in lines of sadness and anger.

"I've leant over until I've nearly cracked my backbone trying to make this a good compromise," he said. "And now I'm done with it. Except to say one more thing. There's risk in all change. But there's more of a risk in *no change at all!*" His gavel banged down with a sharp crack like a pistol shot. "Meeting adjourned."

The galleryites—a pro-grammar-school crowd—were tickled pink at the stalemate. They went chattering down the stairs like

a bunch of magpies. I walked down, more sedately, with Lady Healey. She, too, was relieved that disaster had been averted.

Then: "You started to say something that I'm afraid I didn't quite catch," she began.

"It was just an idle comment," I replied. "Of no particular value at a meeting of this sort. And I do apologize for having diverted your attention from the floor. Have you all been well? It's been a nasty time, so many people down with the flu. . . ."

19

IT wasn't really such a bad winter—seen from the vantage point of May. But at the time there seemed to be an awful lot of February and March. Spring was coming. You could see the signs: snowdrops blooming along the hedges, an early crocus or two, the lilac buds swelling. But spring itself remained out of reach, like a lollipop held frustratingly just beyond a child's grasp.

The snow and frost of January had been followed by a week of false spring, when the air grew balmy and people laid off their scarves; and everything that had been frozen suddenly thawed. Old walls all over Oxford collapsed—including a hunk of ours—and within a few days the entire Thames Valley was flooded. Meadows turned into ponds; ducks paddled through goal posts on school playing fields; drowned stalks of Brussels sprouts swayed gently in their watery graves—and everyone who hadn't gotten flu in December promptly came down with it. Then the fog rolled in again. On February 17 the Oxford *Times* announced in boldface type that "six minutes of sunshine were recorded in Oxford yesterday, the first time the sun has been seen since February 5." In between fog and frost and snow it rained. We all felt oppressed, and tired, and jumpy.

I tried to "think positive"—and the negative thoughts loomed larger and blacker. Shopping had always been fun, because to look at the labels on canned goods and shipping crates was like a world tour: butter from Denmark, lamb from New Zealand,

tomatoes from the Canaries, wine from Yugoslavia, oranges from South Africa or Israel. Now this game lost its allure, and all I could see at the market was the lack of celery or lettuce, or anything else crisp and green. Sometimes, at the city's one shop that catered to foreign tastes, I could find capsicums (green peppers), hothouse-grown in Israel, but they didn't allay the craving for something juicy.

It had always been a sporting challenge to hunt for a pair of shoes or a blouse in both the correct size and a desired style, but now I grew cross because the English refuse to learn the mechanics of stock control. I very nearly reduced to tears the gentle little shopgirls who say, with such sweet apology, "I'm sorry, madam. We seem to be out just now." (Heavens, it isn't *their* fault.)

I got picky about workmanship and refused to pay the window washer for an especially slovenly job. Until then the fact that the average English workman has no pride of craft had been a mild astonishment (since I had expected the reverse), but essentially unimportant. After all, unlike my Oxford housewife friends, I wasn't going to have to live permanently in a house like theirs— with linoleum laid in humps and wallpaper carelessly matched and paint dribbles at the corners of the moldings. But now, suddenly, I found myself taking shoes back to the cobbler for "a proper job of stitching." I thumped around after Mrs. Blount, finding fault with the way she did the corners. And I told Red that if he didn't find another barber I was going to cut his hair myself, I was sick and tired of his looking as if he'd kept his hat on while his hair was being cut. (Actually there were some pretty good barbers in Oxford; Red had simply picked a bad one. His nickname in the trade was Slasher Slade.)

There is almost always a funny side to irksome situations, but in February and March I couldn't seem to see it. I was outraged

instead of amused when a jeweler on the High Street, whom I had asked to estimate the cost of restringing a pearl necklace, held the remnants of the strand between two fingers—as if it were a decaying fish—and said, with consummate distaste, "These, madam, are *paste*." Dammit, I knew they were paste. I just wanted an estimate on how much it would cost to restring them.

My chronic feud with the laundry that did George's shirts—every housewife in England has a feud with her laundry—erupted into permanent estrangement. I knew that the Royal Rose had outmoded equipment, that many of its workers were ill with flu, and that its proprietors deserved my patient understanding. I had survived the capricious changing of delivery and pickup dates, and the starching of handkerchiefs and bath towels, and had even found a small measure of excitement, when opening each week's bundle, in seeing whose clothes were mixed in with mine this time. What finished me off was the time of year and the addition to George's shirts of a gimmick borrowed from the United States. His shirts, which went to the laundry with buttons wherever buttons should be, had always come back with most of the buttons missing; I was used to *that*. What infuriated me now was that the laundry took to sewing on one button, then slipping over it a tag that said, "This button was missing and has been replaced by the Royal Rose Laundry."

The roof sprang a leak and the man who promised to repair it never showed up. The second man who promised to repair it came the day after he had said he would, then left a huffy note because nobody had been home to admit him. The remaining apples in Blaze's 'ouse began to spoil; and the only surviving geranium plant in the solarium quietly shed its two remaining leaves and expired. The fridge—which had been wheezing alarm-

ingly for several months—finally went conk; and the damp spots on the wallpaper rose another foot above the baseboards.

Oh, I was loaded for bear, all right, the day the phone went dead.

"And what about the telephone listing and bills?" I had asked Lady Headington when we had moved in.

"It will be easier to keep the listing in my name," she had said. "And I've given the telephone people instructions to send the bills to Mr. Bennett at Balliol."

This struck me as odd, and the domestic bursar had confirmed my view. The rent he paid, yes, but not the utilities.

Therefore, I had telephoned the telephone company. (As an Oxford newcomer, I had not yet learned that Oxford's preferred way of communication is to write a letter.) Accounts had informed me that our phone number, Oxford 61840, would have to be carried in our landlady's name since it could be transferred to our name only with her permission, and she had by then left for Africa. Accounts would, however, see to it that we were listed with Directory Enquiries as a second user of 61840. And, finally, Accounts had said that they "most certainly did *not* have instructions to send the bill to the domestic bursar at Balliol; that would be most irregular."

So we had relaxed, used the phone, and made a kind of uneasy truce with it. We soon grew accustomed to male operators on the night shift, but we had never ceased to long for the speedy American "Number, please?" We stewed and fretted while waiting for the operator to answer; while holding one end of what was obviously an open wire but that remained mute during the long minutes when the operator was presumably making the connection; while trying to converse against background fireworks; and while trying to rouse somebody, anybody, on the frequent occasions when a lifted receiver produced no dial tone,

220

no voices, no nothing at all. This last circumstance we had come to attribute to the Other Party on the Line, whose children either took the phone off the hook or who removed it herself during their nap time so the dears wouldn't be disturbed.

English phone bills are rendered at six-month intervals, by which time, of course, the sum can be staggering, but what had surprised us more than the amount of our first phone bill (in January) was that it had been sent to the domestic bursar at Balliol. Mr. Bennett had promptly forwarded it to us, and we had as promptly paid it. I had no doubt of this fact until one day in March. At 8:30 that morning I lifted the receiver in order to place a call to London. Getting no response, I assumed that the Other Party on the Line had left the receiver off the hook again. *Those children!* I thought. At 9 A.M. the situation was unchanged, and at 10 A.M., and at 10:30. So it was in no gentle mood that I stamped next door and asked a neighbor if I might use her telephone in order to report that mine was out of order, and to place my London call.

First I called Faults and Service Difficulties. No answer. Faults and Service Difficulties was probably putting on the water for her eleven-o'clock cup of tea.

Then I dialed Operator and placed my call to London, saying that although I was calling from 62389 I wanted the call charged to 61840, my own number, which appeared to be out of order.

"One minute, please," said the operator, and vanished from the line. I shifted the receiver into my other hand, opened my coat, and leaned against the wall in my neighbor's hallway.

When the operator cut in again, she said, "I'm afraid I can't bill the call to 61840, madam. It's out of service."

"I know it is," I replied. "That's why I'm calling from 62389. I've tried to report that 61840 is out of order, and I'll try again

as soon as I've gotten this London call through. Meanwhile, however, I *would* like to be connected with London."

The operator was patient and courteous. "61840 is not out of order, madam. It's out of service. Inoperable."

"Inoperable?" I asked. "Why?"

"I'll connect you with Enquiries, madam."

While waiting this time I caught a fragment of another subscriber's telephone conversation. This is also par for the course in making an Oxford phone call. The trouble with it is you never hear enough—just ". . . black bile and all that vomiting . . ." and then the voices fade away.

Enquiries came on the line. "Why is my phone, 61840, not working?" I asked. Enquiries told me that 61840 was out of service. "That's right," I said, and I could feel my blood pressure rising. My voice had already risen. "I *know* it's out of service. WHY?"

Enquiries left the line. On cutting in again she said I'd best talk to Accounts.

The knowledge that I was about to talk to Accounts put me immediately on the defensive. Had the phone company deliberately cut off our service? If so, non-payment could have been the only reason. But we'd paid our bill. Promptly. Hadn't we? Certainly. Well, almost certainly . . .

Then I remembered that the checkbook was in my purse. I fished into it, got the checkbook, and riffled the pages. (This is not an easy job one-handed, while clutching the receiver of a wall telephone, in a dark hallway.)

I dropped the checkbook just as the operator came back on the line.

"Are you there?"

"Yes," I said in a small, meek voice, ready to eat crow.

The line went dead again.

222

I retrieved the checkbook, found the January entries, found the record of payment. We *had* paid. O.K. Whatever the trouble was, it wasn't non-payment.

Accounts came on the line. She informed me that 61840 was out of service because the bill had not been paid.

"WHAT?" I yelped, now suffused with righteous wrath. "I have my checkbook in hand. We paid you on January 22."

Not the January bill, Accounts replied. The February bill.

"No February bill has been rendered," I snapped.

Oh yes, one had been, said the Voice with the Smile, only she was having to work at it now. "It was for an overseas call. We bill those separately. However, the bill was returned to us by the post office. Undeliverable to the subscriber at that address, I believe. The subscriber is no longer in residence, I believe?"

"Yes, that's right," I said. "She's in Africa. But we———"

"It is unwise"—and now Accounts' voice had taken on a faintly disapproving tone—"to leave a telephone in service in an unoccupied house, madam. Someone might break in and use it."

"But the house *is* occupied. Or are you suggesting that *we* have broken in and are occupying it illegally?" (There was a horrified gasp at the other end of the line.) "We rent it from the subscriber. What's more, you people are perfectly well aware of the fact. When we took the house, we arranged that we should be listed at this number too. As second users of the phone."

"Oh, but that listing would be in Directory Enquiries, madam. This is Accounts."

I took a deep breath. I was beginning to feel weary. Then a new thought struck me. "Besides, I don't see how the bill could have been marked undeliverable, and returned, because you haven't been billing the subscriber at this address, anyway. You send the bills to the domestic bursar at Balliol, he sends

them to us, and we pay you. Or at least that's how the January bill was handled."

There was a long pause. When she spoke, Accounts' voice was very frosty. "I'm afraid that would be most irregular, madam."

I fought for control. Then, very slowly, I said, "All right. Let's skip all that for the moment. Tell me just one thing: how do I go about getting my phone to work again?"

"We'll be most happy to release the line, madam, now that we know the house is occupied. Shall we render another bill, madam?"

"Yes. And address it this time to Beadle, will you? B-E-A-D-L-E. Now, can I make that London call? And charge it to 61840?"

"Certainly, madam." She was all brisk efficiency again. "I'll give the operator the necessary clearance."

So I placed my call again, including the request that it be billed to 61840. The operator bounced right back with the information that 61840 was out of service, and therefore she couldn't charge the call to that number.

I banged the phone down, went up the street, and placed the call from a public pay phone. I was so angry that the friend I was calling said later I sounded like a sergeant major *ordering* her to have lunch with me the following day, when I expected to be in the city.

Then I lifted the receiver again, intending to call somebody—anybody—in the main office of the telephone company, and blow his head off. But the thought occurred that I'd had conspicuous lack of success thus far in transacting business with the telephone company on the telephone. So I hopped the next bus and went downtown to see the telephone company in person.

I was taken care of by a genial Scot named Drummond. He settled me solicitously in a comfortable chair. He asked if he

224

could fetch me a cup of tea. He listened to my tale and made copious notes. He sent a messenger to Accounts to get the file on 61840. He sympathized with my annoyance. He knew exactly how I felt, having himself been recently dunned for three pounds that, it turned out, was owed the merchant in question by a man named Diamond. This was a shocking thing, really, since he, Drummond—like myself—had a horror of being in debt and had always paid his bills promptly. Finally he conceded that the telephone company had been "a wee bit inefficient." But, on the other hand, "The subscriber had really ought not to have kept the phone in her name if the bills were to be paid by someone else." Then he escorted me to the door, thanking me for my promptness in bringing the matter to his attention. I found myself apologizing for having taken up his time on such a trivial matter.

Our next telephone bill—the closing one—came to us in the United States eleven months after we had left England. It had been sent to the domestic bursar at Balliol.

20

AT noon, on that late March Sunday, the air felt surprisingly warm. We could feel sun through the mist, and George suddenly said, "Let's get out of here."

We went to Coventry, partly because it was close enough for a half-day trip and partly because someone had said to me, when I had been less than enthusiastic about the modern architecture I had seen in England, "*Do* go to Coventry, then. The new cathedral is quite good."

Nothing about the approaches to the city—miles of red brick houses and modern factories—resembled the environs of that other city George and I had once visited, half a world away, which had also been virtually obliterated by one bombing raid. Yet parallels with Hiroshima were inescapable: both cities are almost treeless at the center; both are rebuilding in a modern style at odd variance with surviving prewar architecture; and both have preserved fragments of bombed buildings as permanent war memorials. Hiroshima's was once a museum, the framework of its original dome traced now by a skeleton of rusted steel. Coventry's is the spire and ravaged walls of its ancient cathedral.

From the city square, with its prim gray statue of Lady Godiva, we could see the cathedral's frilly fifteenth-century spire, a visual feast in rosy stone. It looked much the same as many another spire in many another English city, and the approach was the

same—through a network of narrow little streets that afforded no long view of what lay ahead. The air was gentle, and Sunday lassitude lay over the town. Hence, nothing prepared us for the shock of finding ourselves, abruptly and violently, in a ruin.

Of the cathedral itself, only one row of windows is left. A few bits of glass cling to the mullions. The dome of the sky is now the roof of the cathedral. Stumps of pillars remain to mark the center aisle, and graveled paths and plots of grass have replaced the floor.

The nave remains. Where once the altar stood, laid with fine cloth and holy vessels, a rough stone altar now stands. It was constructed from the ruins by an elderly stonemason who had been the cathedral's night fire watcher. On the center of this altar is a huge charred cross, made from half-burned beams that fell from the roof into church during the raid, in 1941, that nearly destroyed Coventry. Behind the altar, following the curve of the apse, is a legend in gold. It says, "Father, Forgive."

As tourists, we are great chatterboxes. I like to spin fantasies about the people who once inhabited a place. Red sees to it that I stick to the facts; it annoys him for me to populate a Tudor castle with Stuarts. And George discusses camera angles. But in the ruins of Coventry cathedral we were all silent. It was like being at a funeral.

Over to the left, in line with the transept of the original cathedral, the handsome new cathedral was then abuilding. It lacked the porch that by now has linked it to the ruins of the old cathedral, but it was easy to visualize the eventual unity of the two. Standing in the ruins, one looks up the center aisle of the new cathedral all the way to the altar. And vice versa: as worshipers leave a service, the ruins ahead underline the fact that men have yet some distance to travel if brotherhood in God is their aim.

227

Out in the ruined church, exposed now to the weather, are many of the memorial plaques that once lined the interior walls. The one I noted in particular was put up in the twenties "to the glorious memory of the officers and men of the Royal Warwickshire regiment who fell in the Great War." That was the war to end wars. Remember? Yet twenty years after that memorial to the fallen of World War I had been dedicated, Coventry was in flames.

As the roof burned off the cathedral, and the pillars collapsed, and a hailstorm of steel and stone filled the air, the bronze of that plaque was slashed like tissue paper. The torn metal curled back a little, and in consequence several letters in the inscription cannot be seen. It doesn't matter. Out in the open as it is, and with that gaping wound across its face, the message comes through loud and clear.

As we were tiptoeing out of the ruins, I glanced back. Behind the outdoor altar, and below the legend in gold, was a bed of crocuses. A toddler, straying from his parents, had wandered over to the flowers and had bent to pick, or perhaps to smell, one. His mother caught sight of him just as I did.

"Alfie!" she called in horrified tones. "*Alfie!* Leave off that!"

Alfie's lip quivered, but he stood his ground. I don't know whether he picked, or smelled, his crocus. What I'd *like* to know is whether his generation will do better by the world than mine has.

21

GEORGE had brought the three letters home and had dropped them, without comment, in my lap. One was from the Accademia Nazionale dei Lincei, in Rome, inviting him to participate in a colloquium on evolution in early April. The other two were from professors at scientific institutions—the Marine Station in Naples, and the university at Strasbourg, in southern France—asking him to stop off, going or coming, and give a lecture.

"Oh, George!" I enthused. "Say yes. It's during Red's Easter vacation, and we could all go. Think of seeing St. Peter's and the Colosseum, and the Tower of Pisa, and Pompeii. Would there be any chance *at all* of our getting to Sicily? I was reading the other day about some marvelous Greek ruins they've just found there. And the mosaics at Ravenna, and that cemetery in Genoa, and the double church at Assisi, and St. Mark's in Venice! Just think how restful it would be to glide lazily along those canals, and how good it would feel to sit in nice hot sunshine in the plaza, and feed the pigeons. I don't know whether from Strasbourg we should go west to see Carcassonne—I suppose Spain is out of the question, hmm?—or whether we should go over to the Black Forest and then maybe take a nice long boat trip up the Rhine. Oh, George!"

"That's how I figured you'd react," he said. "So I've accepted all the invitations."

Therefore, three days before Easter—my overinflated itinerary considerably shrunken, and our luggage limited, by George's edict, to the absolute drip-dry minimum—we left a blinding downpour behind us in London and flew to Milan. It was misting. By the time we got to Venice, it was raining harder than it had been in London. The pigeons in the plaza were so water-logged they couldn't fly, and huddled under the tables instead and complained about their neuralgia. Red didn't like the smell of the stagnant water in the canals, and George took a violent dislike to the gaudy Oriental opulence of St. Mark's and the glittering baroque ceilings in the Doge's Palace. There was an enchanting interlude when we all went to Torcello by launch, where the mosaic wall in the eleventh-century church nearly knocked our eyes out; but we got soaked to the skin en route, and, returning, two U. S. Army wives in the same party loudly compared notes on how to "Jew down the natives"—a good many of whom were within earshot—so we got a little sick to our stomachs, too.

Consequently, it would be more accurate to say that our Italian holiday began somewhere around Ferrara. The smartest thing we did in Italy was to journey by CIAT sight-seeing bus, which travels just far enough in one day to allow you to sleep in a proper bed at night; stops long enough at major tourist attractions en route to let you decide whether you want to come back sometime; and is cheap. Meal stops are *not,* as so often when traveling by bus in America, at roadside diners full of flies and the smell of rancid cooking oil, but at decent hotels that serve meals that seemed to us incredibly good—especially after our months in England. I can still see the beatific expression that spread over George's face when he tasted his first Italian meal. "Good Lord!" he exclaimed. "It's seasoned!" I ate lettuce salads as if they were guaranteed to make my hair curly, and Red

230

gorged indiscriminately on green noodles, lasagne, or any other form of pasta. There was no indication that the Italians have even *heard* of Brussels sprouts.

Spring was, of course, further along than in England, and the countryside had a new-minted freshness. In Lombardy the peach trees had looked like spun-sugar candy, and even the distant horizon had been pinkish. As we traveled into Emilia, it was the snowy pear trees that delighted us, espaliered on wires instead of walls; and the cylindrical haystacks, which had been bitten into so heavily during the winter that now they resembled giant apple cores. Later, on the other side of the Apennines, the country grew drier, with many vineyards and olive groves, the hills crowned by remnants of castles or monasteries, each with a straggle of red-roofed and white-walled houses below it. Each new view seemed to be as perfectly composed as if an artist had set the scene. And the sun? The sun was so hot it soaked through to our bones. It was like a quick trip home to Southern California.

We had been forced to choose between Pisa and Ravenna. I don't know what we missed, but what we got was a couple of hours of awed exposure to the masterworks in mosaic that adorn the several churches of Ravenna. In the cavernous dimness of San Vitale and the cathedral baptistry, every inch of flat surface is paved with rainbow chips and spangled with gold. Set among scrolls and garlands, stylized beasts and birds, the Apostles stare grimly down from each vault and arch, and above them soar stern-faced angelic hosts. (Although, had I been a fifth-century Christian, I doubt that I would have dared to lift my eyes so high.) Galla Placidia's little grotto-like mausoleum is, by contrast, serene and restful, and almost cozy. The deep delphinium blue of one vault there is as vibrant with life as if the mosaic had been laid just yesterday. St. Appollinaire Nuova is in still

different mood. An airy church, its interior colonnaded, it has twin processions of saints and virgin martyrs set against panels of blazing gold. They walk toward glory with both feet forward, Byzantine style, their great black eyes staring somberly into eternity. They took my breath away.

Back in the outside world again, and trying to bridge the gap of fourteen centuries represented by the church behind us and the CIAT bus whose seats we were settling into, I was surprised to discover that Mrs. Norris had remained in the bus while the rest of us were in the church. She was a widow from Massachusetts whose children had sent her on a round-the-world tour after her husband's death. She had now been on the road for five months and had another month to go. The only animation I had seen her display so far on this particular stage of her journey was when she had told her seat mate about the dolls she'd been buying for her grandchildren.

"Oh, Mrs. Norris," I exclaimed. "The mosaics were *so* beautiful. You really should have . . ."

She raised a gray, dull face from her Perry Mason paperback. "I'm tired of looking," she said.

Florence was—well, does anyone have anything harsh to say about Florence? I moved in a golden haze. Up the Campanile of Santa Maria del Fiore—by *Giotto;* somehow I'd never associated his genius with anything as strong and sensuous as that tower. Past the spendid tombs and musty relics of Santa Croce. Down the shadowy corridors of San Marco, with their delicate and moving frescoes by Fra Angelico. Around the Boboli Gardens. ("Why are these gardens so famous, honey?" "Darned if I know. It's not self-evident, is it?") Into the Palazzo Vecchio and the Bargello, with a pause to study the various *Davids* and the joyous Della Robbias. Through the Uffizzi Gallery, with its gold-drenched thirteenth- and fourteenth-century miniatures, its ex-

232

quisitely melancholy Botticellis, its superb lighting and sense of spaciousness; then on to the Pitti Palace—which was just the reverse. In fact, it became a chore there to look at Old Masters, however old and masterly.

George quit the museum circuit cold, but I continued to slog it out, with Red and the guidebook in faithful attendance. One afternoon I turned to him wearily and said, "Sweetie, pick out a few big names in each room, and we'll look just at those." He replied, reprovingly, "Mom! You sound like an American tourist!" So *we* abandoned art galleries too. And stopped being so intense about seeing everything we were looking at. One of the unexpected pleasures was the handsome archaelogical museum, which had a lilt you don't expect to find in an archaelogical museum. It is full of Etruscan sarcophagi, with the dear departed sculptured in reclining poses as if at a feast, instead of laid out flat with hands piously crossed. And there were some wonderful weird vessels on display, probably urns for ashes, but each with people's heads for stoppers.

The recollection of Florence that has lingered longest, however, is not of the dead but of the living. One afternoon we visited five Tuscan villas, where we were rewarded by the sight of elegantly clipped privet and tulip-rimmed pools and a wistaria that cascaded like a lavender waterfall down the entire side of a three-story building. The tour finished at a teahouse on a hilltop in suburban Fiesole, the red roofs and towers of Florence spread magnificently at our feet.

"When I get my first million, this is where I'm going to have a villa," I dreamily announced as I finished my frosted teacake. (Since this was a sight-seeing tour, with little chance of tips, the cakes had been distributed in accordance with a rigid formula— one plain and one frosted, no picking and choosing.)

"Right here?" George asked.

"Well, somewhere near here. Isn't Florence the most heavenly place? I almost don't care whether I see Rome. . . ."

An extra teacake—frosted—came sliding quietly onto my plate. I looked up at the waiter in surprise. His eyes were shining and his smile would have melted the Greenland icecap. *"Grazie, signora!"* he said.

That same evening we said farewell to our friends at Al Campidoglio, a modest restaurant we'd stumbled into our first night in Florence and had thereafter visited daily.

"Buon giorno. I mean, *buona sera,"* I had said on that first arrival.

"Good ev-e-ning, madam," a beaming waiter had replied. "I am a visitor one time in youra New York."

"How did you know we are Americans?" George had asked. We were wearing English clothes, and his camera is German. So far, those accouterments—plus the fact that the *signora* obviously wasn't interested in shopping—had made it difficult for Italians to guess our nationality.

"No one but Americans eatsa dinner at six o'clock."

The people at Al Campidoglio had fed us superlatively well, had let us pat their big gray cat, an unusually aloof feline named Carnera, and had taught us how to read Italian menus. Until then we'd picked our food by intuition or by how nice the words sounded, as a woman picks a race horse—a system that produces surprises both pleasant and otherwise. Who'd ever think that anything as melodic as *fegato alla veneta* would turn out to be plain old liver and onions?

When we finally said farewell—our *per favores* and *pregos* were coming out pretty smoothly by then—the two proprietors and our special waiter pressed souvenir ash trays upon us, shook our hands non-stop to the end of the block, drenched us in *arrivedercis,* and in general stirred up a hoopla that in any

234

American or English city would have caused a crowd to collect to see what the trouble was. The only holdout was Carnera.

My second million is going into a villa at Perugia.

The monastery at Assisi sits on the crown of a high hill and looks like a suburb of heaven. En route from Perugia, on a Sunday afternoon, our bus churned dust on a band of pilgrims, some fifty-odd, the men in worn dark suits (how hot they must have been!) and the women in clean cotton housedresses and white kerchiefs. Their path, like ours, led through a mean and dirty little town at the foot of the hill. The road was lined with café-bars with TV sets going full blast, and the local hot-shots were stunting on their motor scooters to impress the local belles. I tried to visualize how the approaches to the monastery must have looked before the invention of the internal-combustion engine and TV. Was it easier to sustain the spiritual fervor of such a pilgrimage in the old days? Or even then were there ugly distractions en route, and a cluster of crassly commercial souvenir shops on the threshold of the church?

The greatest good fortune that can befall tourists—the company of a guide who loves what he's showing you—welcomed us to Rome. Our guide was an old friend, Professor Claudio Barigozzi, of the university at Milan. A geneticist like George, his non-scientific specialty is Roman history. He is a jovial and excitable fellow whose almost unaccented English is so rapid-fire it tumbles, and he showed us around the Forum and the Palatine as if his own family had been very recently in residence.

He led us down into the huge arena whose fallen pillars and roofless buildings suggest the recent occurrence of an earthquake, swiftly took us to a wide stone platform, and sat us on some chunks of marble for a little lecture:

"This place was low and wet. A bog. No, that is not the English word. A marsh? Yes, a marsh. Nobody lived *here,* but

on the hills—the Capitoline, from which we just now descended; the Palatine, to the right; and the Esquiline, to the left. They came here in the beginning only to buy and sell, and sometimes to bury their dead.

"When? Perhaps in the seventh or eighth century *Ante Christum*. After many years, when the villages on all the hills had joined together, then the Forum became also a place for all to meet for politics, for religion, for courts. It was then a—how do you call it?—a civic center. They drained away the water of the marsh and built many fine buildings. This"—waving now at the platform in front of us—"was one. This was the place where the leaders addressed the people. This is the rostra."

"Not rostrum?" I asked.

Claudio beamed. I had apparently set something up for him. He pointed a finger at Red. "You study Latin in your school, do you not?"

"Yes, sir."

"What means 'rostrum'?"

"Gee, I don't know, sir."

"It means 'beak.' As a bird has. The fronts—the prows? yes, the prows—of warships had beaks. In the fourth century *Ante Christum*, Rome won a great sea victory. Many prows from enemy ships—many *rostra*, you see now from where the name derives?—were returned to Rome and affixed to this platform. Then, when the politicians later told the people it was necessary to go to war again"—here, Claudio gave an expressive Latin shrug—"they could promise great victories by pointing to the rostra."

"Scalps," George murmured.

"Pardon?"

"The rostra were like the scalps the American Indians took as *their* trophies of victory."

236

"Yes, yes. I have seen them on the television." He stood up. "Well, that is enough seminar, eh? Now I will show you some of the old Forum. That is, the Forum of the Republic. In the republic there were no buildings in the center of this place. It remained open, for citizens to meet and vote. Such meetings were not necessary—you understand?—in the time of empire. So the center was then filled with fine monuments and temples."

Claudio led us to the sacred black rock where there is an inscription in Latin so old it's not quite Latin; into a miraculously empty Curia (and happy we were to share it with ghostly senators instead of with chattering tourists); past the dramatic remains of the temple of Castor and Pollux; to the spot where Julius Caesar was assassinated; and finally back to the east side of the Forum, where he sat us on some fallen pillars for another "seminar."

"Do not forget," he said, "that this place was inhabited for four times as many years as the United States is old. The new parts"—he smiled broadly, anticipating the styled-for-Americans witticism that was shaping up—"that is, the parts that are only a thousand or fifteen hundred years of age, those parts are laid over the old ones.

"Now, this building behind us"—we turned around and found ourselves looking at a vast open expanse studded with stumps of pillars in richly veined marble—"was a basilica that is very ancient at the bottom. Perhaps two centuries *Ante Christum*. But it was changed and added to, many times." His voice dropped and grew reflective. "It had great pillars along the front, and much gold ornament outside and inside. It must have been a splendid sight before the great fire. I shall show you some coins that melted and have attached themselves to the marble pavements of the portico."

"That was Nero's fire?" I asked, feeling very knowledgeable.

237

"Oh no. Much, much later. The fire I speak of was by design —an act of conquest by the German Vandals."

"In World War II? But I didn't think the Germans——"

"Mom!" Red interrupted. "Vandals with a capital V."

"That is correct," Claudio resumed, beaming at Red. "The German tribes who came down from the north in the fifth century of our era, when the empire was dis—how do you say it? disbanding? disrupting?"

"Disintegrating?" George suggested.

"Yes, yes. *Disintegrating.* You can see proof right from where we sit. After perhaps the first century of our era, the people did not care any more about quality"—another expressive shrug— "and the artisans ceased to take care. Look at the block of marble beside the basilica. The big one, where you can read 'Caesar Augustus' and 'Senatus.' The art of cutting such excellent letters was lost by the second century. Now, see these stones at our feet. They have bad letters, not so sharp and elegant. Much more rude. Rude?"

"Crude, perhaps?" I suggested.

"Yes, crude." Indeed they were, and from then on we had fun dating fragments of incised stone according to the quality of workmanship. We accurately placed the Arch of Titus as before the second century, and I made amends for mixing my vandals and Vandals by correctly deducing (from the seven-branch candlesticks on the frieze) that this arch was erected to memorialize the Roman conquest of Jerusalem.

Claudio declared a recess by guiding us into the courtyard of the Vestal Virgins' house. We were bemused by the serenity of the place, despite throngs of tourists and the half-wild cats that darted from sunny ledges to shadowy niches in the ruins. We sat contentedly, soaking up the beauty of redbud and wistaria, of ivy twining through empty doorways, of field flowers

238

sprouting from grassy crannies in tumbled brick. Then our lessons continued.

"The house of the Vestals was two or three stories high," Claudio said. "As you can see, this courtyard is close to the Palatine Hill. The house where the priestesses lived was so close it was made strong by arches planted in the hill itself. But even the priestesses could not live on the hill. That was reserved for the emperors.

"Just above, and a little to the right, was the palace of Caligula. His famous bridge—he was a crazy sort of fellow, *un esibizionista,* you know?—was affixed at this corner of the Palatine, so he did not need to descend to the Forum but could walk above, to the Capitol, like a god. It was, of course, destroyed by the fire."

I essayed a cautious question. "Nero's fire?"

Claudio considered. "Perhaps. But Nero's fire started at the far side of the Palatine and came down the hill on our left side. No, I think more likely Titus's fire. Twenty years following Nero's. It started on the Capitoline hill and came this way through the Forum, and then burned *up* to the Palatine on this side."

So we went up to the Palatine too. This hill is the cradle of Rome. We saw the walls that some ancient Tarquin king had built in the seventh or eighth century B.C. to fortify the city; and the site of the temple where the augurs had stood to seek omens in the flight of birds; and the pit into which each immigrant had tossed a handful of earth from his native land to signify his new loyalty to Rome. "In those days," Claudio reminded us, "to come from the shore of the Adriatic was to come from a foreign land." We wandered past the remains of villas and palaces, one complete with a sizable stadium, that eventually had replaced

239

the straw-and-wattle dwellings of the earliest Romans, and wound up on a platform overlooking the entire Forum.

Half to himself, Claudio murmured, "Such a view they must have had!"

"Who?" I asked.

"Tiberius, first, because it was first his palace on this spot. But he could not look down into the Forum quite so much as we do. Later emperors made the palace bigger. Sometimes they only wanted to make it bigger to show they were bigger emperors than someone else—you know?—but sometimes they had to build additions because of destruction by fires."

I started to ask *whose fires?* but decided I didn't really want to know. Despite the spell that Claudio had woven, we were all beginning to reel with fatigue, our guide included, and in unspoken consent we turned from the platform and started slowly down the hill. The path we took was through a wooded section, dark and sheltered, and for at least a little while we walked in company with the Caesars' ghosts. I know exactly when we hit the twentieth century, though. "It's three o'clock," said Red. "How about some lunch?"

Rome is a big city, impersonal and in a hurry. The sidewalks overflow; you sprint across the howling thoroughfares in hope that the life you save will be your own; and in the crammed-to-bursting trams or busses your timid *"È questo l'omnibus per le Stazione Centrale?"* is unheard and ignored. But Rome is also a city where sheep still graze along the Appian Way, where everyone takes a two-hour siesta in the middle of the day, and where nobody is too preoccupied to admire a chubby baby or a pretty girl.

George's head seemed set on a swivel, and I couldn't blame him: the girls were as tempting as ripe peaches. They were wearing their hair bouffant and tousled that year; quantities of eye

make-up; no lipstick—and lots of leg showed below their short, tight skirts. Their shoes were so pointed and the heels were so high that the old Chinese art of foot-binding seemed humane by comparison; yet there wasn't a female tourist resting her feet and sipping a drink at a café on the Corso who wouldn't have cheerfully tossed her wedgies into the nearest fountain if she could thereby have achieved such a devastating walk.

Italian men aren't comparably exotic—except the carabinieri, whose Napoleonic hats, cavalry boots, capes, sabers, and plumes are straight out of an operetta. On the afternoon that one of these gorgeous gentlemen flung himself into the street and stopped traffic for me, I really regretted the limitations imposed by age, a girdle, and thick ankles. That was also the afternoon that I stayed only twenty minutes at the Borghese Gallery—and thereby finally convinced myself that, as far as Old Masters were concerned, I'd had it.

George felt the same way about both art museums *and* churches, and the only Roman church he visited willingly was St. Peter's. Inside the huge basilica Red was intrigued by the markers on the floor of the nave that give the lengths of Christendom's major cathedrals—or, at least, those that are shorter than St. Peter's, and I guess most of them are. I was prepared for the general richness and elegance of detail, and for the enormous size of the place—they say that thirty thousand people can worship there at one time—but why don't the guidebooks mention the chandeliers? They're exquisite. "When they're all lit, San Pietro looks like a ballroom instead of a church," Claudio Barigozzi's charming wife, Amalia, told me.

I wished that we had been there on Christmas Day, after an American friend then living in Rome told us what it had been like:

"Church services at home are pretty sober and slow-paced,

so that's why we weren't at all prepared for the joyousness and gaiety of the Mass the Pope read here. . . . There were hundreds of candles; yes, the chandeliers were lit too. And a grand procession, with all kinds of dignitaries. . . . Italian soldiers don't go much for close-order drill, you know, and they just sort of sauntered down the aisle, looking handsome and colorful. Right after them came the Swiss Guards, who *are* well drilled; they knelt as one man, and darned if I know how they managed to avoid whopping the man ahead with their halberds. . . . After them came Pope John, his tiny feet in satin slippers on a satin pillow, blowing kisses to right and left as he was carried along the aisle in a sedan chair. Everyone applauded and *applauded*, and it was half festival and half religious service."

From the standpoint of architecture and decoration St. Peter's left no particular afterimage on my mind, except of overwhelming richness and bigness. The three other major Roman churches have more character: St. John Lateran is baroque and brassy; Santa Maria Maggiore has an appropriate chaste serenity—it makes you think of a young girl in white organdy with blue ribbons; and St. Paul's-outside-the-Walls (a new church) is full of vigor, especially its cloisters, which are bordered with gay and glittering Moorish pillars, no two alike. All these I visited, with Red loyally in attendance; also Santa Prassede and Santa Pudenziana, the oldest churches in the city. That is, they were built as churches, not Christianized from pagan temples. Speaking of pagan temples, we also paid a dutiful visit to the Pantheon, which was officially Christianized, but it didn't take; and to St. Clement's, which was fascinating because there, below the new (twelfth-century) church is an early Christian one, and below *that* is a pagan temple. You can see them all.

After taking a couple of standard guided tours by bus we quit the chain-gang approach to sight-seeing. Aside from a tour

of the catacombs, where a warm and witty Irish priest from Boston turned us into second-century Christian martyrs (of the fainthearted variety, I'm afraid), the usual guide's patter was too learned-by-rote. The scientific meetings had swallowed George after our third day in Rome, so Red and I simply set out each day with our Baedeker, a loan from a friend in Oxford.

It had *its* limitations, too, for its owner's assurance that it "was not the latest edition but still quite serviceable" had not prepared me for the fact that it had been published in 1904. Since then there have been a few changes, even in the Eternal City. The Italians make no concessions to tourists who don't speak the language, neither in labels on museum exhibits nor by hiring multilingual guards, so I'd get cross occasionally when I really *wanted* to know what I was looking at, and the Baedeker listed something in that spot that had been moved elsewhere. Red's good humor was unfailing. (In fact, during that year away from home he turned into quite a boy.) "Look at it this way, Mom," he'd say. "There aren't very many tourists here who have the 1904 population of Rome right at their fingertips."

The Vatican Museum staff must have shifted things around quite a lot since 1904, for we had a terrible time finding the Laocoön. Once found, it seemed surprisingly small, and without emotional impact. The entire museum was so full of treasures it cloyed—except for a small room filled with Greek and Roman animal sculpture, enchanting pieces, many of them of domestic animals. It was nice to feel this homey link with the ancients whom we had come to know mostly as heroic figures in cold marble togas. The Sistine Chapel was clogged with tourists. You'd have thought that a convention was in progress there, and the message of the magnificent Michelangelo frescoes was virtually drowned out by the babble.

243

We got lost quite often, Red and I, but it didn't matter, because there was often a park to sit in, or a plaza with a fountain, and once we had ringside seats at the formation of a funeral cavalcade. If it couldn't be described as gay, at least "festive" will do: a mountainous black and gold hearse on wheels led off, drawn by six handsome black horses with black plumes on their heads, after which a swarm of little Fiats jockeyed into position, each with a floral spray strapped to its roof.

George found time for a family excursion to the Villa d'Este (of the exuberant fountains) and to Hadrian's Villa. This place was to the emperor's palace on the Palatine what Windsor Castle is to Buckingham Palace, and here again we experienced that sense of a civilization suspended but not dead that had been so sharp in the Forum. (I'm not so sure we've made such an enormous amount of progress in the intervening 1800 years, anyway. We're still carrying water in the same kind of pipe, and our dyes fade faster.)

Hadrian seemed to have had twentieth-century man's chronic problem of no privacy and tried to solve it by building himself an artificial island in the center of an enormous plunge. The bridges to it were swiveled so he could maroon himself out in the center when he wished to think through a problem without interruption; and if people really left him alone out there—instead of yelling from the far side that the engineers were here about that wall he wanted built across the north of Britain, and would he please approve the seating chart for the state banquet tomorrow night?—his view of the cloud-swept sky with cypresses and Roman pines silhouetted against it must have renewed his energies.

Oh, being in Rome was exhilarating!

Being in Naples was not. Naples is poor and ragged and dirty, and nobody smiled until he saw the color of our money. We ate

delicious French-fried octopus there, George gave his lecture, and Red and I saw some incredibly beautiful lithographs, in brick red on marble, that had been at Pompeii and have been preserved at the National Museum in Naples.

At Pompeii our guide was a little man with a stony face and a smile that he clicked on and off like a flashlight. "Ladeezagentamen, theesaway pleez!" he kept saying, flourishing a stick that he used as a baton. And it annoyed him to have anyone linger behind or ask questions. His manner made me cross: here was a city that was virtually complete except for the roofs on the buildings—it was buried by volcanic ash, not by lava—and it would have taken such a *small* expenditure of imaginative explanation to have made it live again.

George said afterward that the poor fellow got off on the wrong foot, as far as I was concerned, from the moment he took us in tow, so there was no way he could have handled our visit to the House of the Vetii to my satisfaction—but even George agreed that he showed singular lack of tact.

The House of the Vetii was a high-class house of prostitution (or so our guide said). Its patrons were women; hence two rooms include pornographic paintings or phallic sculpture. These have been officially barred to the sight-seeing public, but the guides have keys and will show this forbidden fruit in return for a "leetle sometheeng" in the palm of the hand.

As we approached the place, our guide halted us, and we formed into the tight semicircle we had learned that he favored. He thus found himself staring into a random assortment of attentive faces, a few of them juvenile. He solved this problem by pointing his stick at an American mother with a seven-year-old girl and a ten-year-old boy, saying, "Signora, be so good as to remova yourself an' ze leetle ones. Ladeezagentamen, within theesa house there is sometheeng *mos'* remarkable . . . Signora,

245

thees is not for ze leetle ones, remova zem, pleez . . . some-theeng *mos'* remarkable, ladeezagentamen, which eesa not per-mit' to be seen, but I weela show eet to you for a leetle some-theeng extra for the responsibeelity . . . *Signora, ze leetle ones!*"

He had shifted from guide to tout too fast for the mother of the leetle ones to react as swiftly as he desired. They were a nice family group, incidentally, the kind of American tourists Euro-peans don't notice because they're so well behaved; and now, flushing deeply, she yanked the children off to one side. The little girl, uncomprehending, broke into tears. "But, Mommy," she wept. "Wasn't I being a good girl?" The father of the family stood like a lummox, a flush suffusing *his* face too; and the distaste I had previously only felt suddenly came up in my throat.

The guide's eye then lit on Red—a six-footer, but lean and beardless. "Theesa young man?" he said, glancing around the circle to see which of us claimed the boy. "He stays," I said, through gritted teeth—and without considering the effect of what I might be letting him in for.

The House of the Vetii is a really lovely place, now that I think about *it* instead of the guide; but on that day I went through it wearing a face like Carry Nation in search of an ax. George didn't dare show his amusement until that evening, when he finally exploded in a great burst of laughter. "There aren't many boys," he said, wiping his eyes, "whose first visit to a whorehouse is engineered by their *mothers!*"

I was still feeling waspish. "Well, dammit," I said. "You men were just as bad as the guide. Smirking and sniggering and slipping him his 'leetle sometheeng.' Not one of you had the courage to tell him you weren't interested in his precious ex-hibits!"

"But we were," George said.

246

The next day we went to the top of Vesuvius. This is a very non-U excursion; the guidebooks assume that you will go to Capri, and People-in-the-Know recommend Ischia. We had a fine time on the top of Vesuvius.

We had asked the hotel porter how to get there. "There is a bus," he said, "but much walking is required. Very much walking, perhaps too much for the signora? So it would be better to hire a car and driver." He knew just where we could get a car and driver, too, and would be delighted to make all the arrangements.

"Thank you very much," George said, "but I don't believe we'll put you to that bother." George's only quarrel with Italians was that their prices fluctuate according to what the traffic will bear; on the toll road between Naples and Pompeii, for example, small cars pay a hundred lire, big cars pay two hundred, and American cars pay three hundred. So George made his own arrangements for our trip.

He should have broadened the area of independent inquiry a bit further, though. When our hired car pulled up at the base of the ski lift that takes one to the actual summit of the volcano, a bus was there ahead of us. The excessive amount of walking the poor signora had to endure was three steps. However, the driver of our car was a pleasant companion and an informative guide, and it was a delight to be able to ask him to stop whenever we wanted to study the crusty black channels of lava flow and follow their course down the slope of the mountain.

From the summit the view of the Bay of Naples is breathtaking, especially when contrasted with the gray shale, the desolate emptiness, and the sinister appearance of the little puffs of steam that escape from fissures in the crater. Our guide there was a bouncy little fellow who called us *Mamma, Papa,* and *Bambino,* and sang "O Sole Mio!" as he led us around the rim.

On the next day we found out for ourselves why the guidebooks tend to go off the deep end and surface dripping superlatives about the Sorrentine Peninsula. There is a somewhat comparable coastline—sharply indented rocky cliffs, with scores of little coves and bays—north of San Francisco, but the Pacific never has the brilliant blue serenity of the Tyrrhenian Sea, nor is the air so fragrant and balmy, nor the verdure so lush. On that one-day circle bus trip from Naples to Amalfi the excitements came so fast our senses reeled. Idyllic vistas of vineyard and orchard were succeeded by deep, craggy canyons, and these in turn by glimpses of the sea—that incredible sea, neither turquoise nor emerald nor sapphire, but a mixture of each—around whose sheltered bays a host of pretty little villages cluster. It was hard to say which was lovelier: the trellised and terraced lemon groves, themselves a sea of rich, deep green, or the olive orchards seen at the moment a ripple of wind turned a whole hillside of them into silver.

We were glad to get to Ravello, partly because by then we desperately needed to sit still and contemplate just *one* beautiful scene, and partly because the twisting roads we had been traveling were beginning to make us dizzy. They might have, even if we'd been driving our own car, but the bus driver, a carefree Neopolitan, had flung us up and down hill and around hairpin curves as if we were carrying the good news from Ghent to Aix, honking the while.

"Whew!" said George as we dismounted at the hotel where we were to have lunch. "That guy missed his calling. He'd have a wonderful time riding a horse at Santa Anita race track." Then, as an afterthought, "Especially if he could honk it."

Ravello's cathedral has bronze doors that stirred me more than the famous Ghiberti ones in the Baptistry at Florence, and a spectacular mosaic pulpit resting on carvings of wild beasts. It

also contains a splendid Jonah and the whale. (Finding them can be a great sport, because in earlier centuries no one knew what a whale actually looked like, and the sculptor's or artist's imagination had free rein.) But the great glory of Ravello is its hilltop site, with the sea curving sweetly far below; its round-topped pines, the wild exuberance of its flowers, and the exhilarating freshness of its air.

The afternoon run took us through Amalfi, once a powerful city-state and a rival of Genoa for control of the Mediterranean, now a sleepy fishing village with a leftover cathedral. You reach the church by climbing a colossal flight of steps, but it's worth it. The Moorish arches and the polychrome façade have a lively lilt; the church inside was especially festive on that particular day because it was decorated for a wedding.

The last important town on our route was Sorrento, where we stopped for tea. Sitting at a café in a little plaza, we were entertained equally by the other customers and by the parked donkeys, the latter crowned with feathers and melodic with jingle bells. We were all relaxed and happy; it had been a perfect day.

"I think I'll have a villa here, too," I announced. "Well, not right here. At Ravello."

"There goes the third million," said George. "But go right ahead. It's *your* money."

22

ONE of Mussolini's boasts was that he'd made Italian trains
run on time. They still do. They are fast, clean, and progressive.
Their "couchette," for example, is a quasi-Pullman accommoda-
tion unknown to America, and it's a dandy. You sleep flat, on a
narrow bunk, removing only your shoes and as much other
wearing apparel as the circumstances dictate, i.e., the temperature
of the compartment, and whether you are sharing it with a
stranger.

We had only one complaint after a day and a night aboard:
European railway roadbeds have a bit too much bounce to the
ounce. Furthermore, three weeks of hard traveling had tired us
all. So, when the conductor stuck his head into our compartment
and announced that we were arriving in Strasbourg, we got to
our feet wearily and began to assemble our gear like a family of
robots.

As we left the train, however, my spirits lifted, and I said,
"Well, this ought to be fun. Aren't we lucky to be staying at a
castle? Maybe they'll have silk sheets on the beds."

Red, who had had less natural upholstery between him and
the couchette bunk than either of his parents, said, with a sigh,
"I don't care about the sheets. I'll settle for a mattress."

I had written to Professor Leonidas Lavande, dean of the
University of Strasbourg's Faculty of the Natural Sciences, and
had asked him to secure hotel accommodations for us. He had

replied, with apologies for his English, that if we would consider remaining in a small castle of his familiarity, he would dispose us there. I had written back ecstatically, saying that we'd like nothing better than to be disposed in his castle. Now we were ready for the comforts that we hoped it would hold.

Professor Lavande is a distinguished scholar, burdened with many administrative duties, but he was at the station himself to meet us, and in every word and gesture demonstrated the depth of his heart and the breadth of his desire to make us welcome. A tiny man whose bright eyes and animated gestures made him look like a chickadee with bifocals, he greeted us with such enthusiastic handshakes and hand-kissings that there seemed to be three of him.

"Ah, *Professeur! Madame! Monsieur!* We are ver' happy for you! Wel-come . . . ! *Héloïse!*" This last was addressed to his wife, a Junoesque woman who looked as if she were used to mothering everyone within range, beginning with her husband. On signal she stepped forward and greeted us warmly and gently, and in her turn presented M. Maurice, a slim young man who said, with no trace of accent, "Welcome to Strasbourg. We've been looking forward to your visit." He'd taken his Ph.D. at Cornell, it turned out, and would be George's translator when he gave his lecture on the following day. Now he was to be our chauffeur to the castle.

"It is not ver' far. *Deux kilomètres seulement,*" the dean explained as we whizzed off into the night. En route, with considerable help from M. Maurice, he told us that the castle had been given to the university, was now being used as a residence for students and some faculty members, and—a new idea— also as a university guesthouse. "You will be *les premiers!*" he exclaimed, then, interrupting, turned to the driver. "*Non, non, Adolphe! Tournez à gauche, ici. Ensuite, allez tout droit!*"

It was no wonder that M. Maurice was having difficulty finding the castle: he had never been there, we were out in the country, and there wasn't a signpost or sign of human habitation. But in due course, after many promptings by the dean, the headlights picked out a pair of gateposts and a double line of trees. The car shortly came to a stop in front of a vast black bulk in which—although it was only 9 P.M.—not a window was lighted.

We groped our way up some steps, and Professor Lavande rang a bell. Nothing happened. He rang again. This time the big door swung open, revealing a man in a white shirt standing in an unlighted hall. "Ah!" he exclaimed. *"Les invités! Soyez les bienvenus! Entrez! Entrez! Prenez garde à la marche, s'il vous plaît!"* Then he spouted a stream of French much too fast for my ear to follow.

"He says to watch your step," M. Maurice translated, as we stepped inside, "and he apologizes for the delay in answering the door. The house has just today acquired a television set, and everyone is in the drawing room enjoying the entertainment. The shooting was so loud at the moment of your ring that it was not heard."

"Don't tell me they're looking at an American cowboy movie!" I exclaimed.

"C'est Garee Coopair," remarked the housemaster, who was now leading me by the elbow up a pitch-black staircase. *"Un type gonflé, n'est-ce pas?"*

There was light at the top of the staircase. Our little cavalcade bore left, followed a corridor, descended a short flight of stairs— "Be careful of these, it is easy to fall," M. Maurice translated— and arrived with a flourish at a tall white door. When the housemaster flung it open and we stepped inside, I couldn't suppress a gasp.

252

The room was perhaps thirty feet long, with a handsome marble fireplace and a mirrored wall at one end. French doors in lieu of windows opened on what was probably a balcony, and the high ceiling was exquisitely patterned in floral garlands and cherubs. The floor was richly polished parquet, in the dead center of which was a three-quarter bed and an army cot. Neither had bedspreads. At the far end of the room, in front of the fireplace, stood a heavy black desk and two straight chairs. With them counted, the tally of furniture in the huge room was complete. As my glance swung back toward the two beds, I noted in passing that there were pale blue satin swags across the French doors, but no curtains or shutters.

The dean had, so to speak, come to point. Every muscle taut, he was studying my face. *"Est-ce satisfaisant, madame?* It will suit? It is O.K.? *Oui? Non?* The family will be *confortable* here?"

I looked again at the two narrow beds. *He had said "the family," hadn't he?* Red's plaintive willingness to settle for a mattress leaped to mind. *But at least his strip of canvas won't bounce,* I thought, and turned to Professor Lavande. "It's lovely," I said. *"Très bien!* I mean, *très beau!"*

"Very good!" George echoed. *"Merci! Merci!"* And Red rallied round with a sickly smile that was intended to express pleasure.

The dean relaxed. He beamed. He led us to the bathroom. It was tile, half as big as the room. He threw open the doors of a vast wardrobe, where there was an inviting expanse of rod (and not a single clothes hanger). He apologized for the lack of bedspreads, which had been promised by the laundress and had not quite yet *arrivés.* We said it was a nothing. Finally he opened a door we had not noticed because it had been framed into a panel. Beyond was a smaller room in which there was another

253

bed. *"Parfait! Parfait!"* I enthused, and Red's smile turned genuine. The family would be quite *confortable* now.

Later, as we were preparing for bed, Red came ambling out of the bathroom with his mouth full of toothpaste foam. "Hey, Mom," he said. "There aren't any water glasses in there."

Coincidentally, George found them—three of them—on the mantel. They had been filled with charming little bouquets of field flowers and set out to welcome us.

"Who cares about silk sheets?" I said, removing one of the bouquets. "Here, Red. I'll hold the flowers while you use the glass. Bring it back full, will you?"

At nine the next morning, fortified by a soup bowl full of black coffee and a hard roll apiece—how *do* Europeans find strength to face the day on the kind of breakfast they eat?—we were waiting out in front of the "castle" for Professor Lavande to pick us up. Now that we could see it, the castle had revealed itself as a medium-sized manor house whose only real distinction was a pretty lake at the rear. Whatever elegance the interior had once had was long since gone, swallowed by the wear and tear of student occupation. The drawing room looked very much like the lounge of a Caltech dorm. We also suspected that the rooms we were occupying had not really yet been set aside for visitors to the university, but had been commandeered especially for us.

A puff of dust down the driveway announced the dean. He arrived this morning in his own car, a tiny two-cylinder, two-horsepower Citroën that carried us off to town with valiant putt-putts that made me think of the nursery tale about the little engine that got to the top of the grade by telling itself I-think-I-can, I-think-I-can, I-*thought*-I-could.

George was to give his lecture at eleven o'clock *précises*, and would surely welcome *un petit tour des laboratoires* first? Sure,

said George, he'd be delighted to see the labs. As for *Madame et le garçon,* Mme. Lavande would meet us at *les laboratoires* and would then accompany us to the cathedral. Would that suit? "Oh, *oui!*" I replied. *"La Cathédrale de Strasbourg est très—uh—famous pour sa beauté!"*

(I remain convinced, despite some evidence to the contrary, that one should attempt to speak the language of the country one is visiting. In Italy, since I knew no Italian at all, I had been content to limit myself to the easily learned polite phrases. But I had once known French, of which there remains a sizable residuum of vocabulary—no grammar—plus enthusiasm. As a result, my French is like that of the tourist who, Art Buchwald alleges, arrived at a station just as the train was pulling out. Seeking assistance in boarding, she called out, *"Aidez-moi! Aidez-moi! Je suis gauche derrière!"*)

I intend to return to Strasbourg someday, if only to look at the cathedral, which is a beauty in roseate stone, with a spire like a perfectly held high-C; but Mme. Lavande ran us through so fast it was like being on one of those Cinerama bobsled rides. She took us up the 343 spiral steps of the tower at the same pace. Maybe there are 345; Strasbourg's was the only church tower in Europe that we climbed too swiftly for Red (a dedicated step counter) to be sure of his tally. Anyway, the view down on the tiled roofs of Strasbourg was *enchantante.* Then we whizzed through the Old Town, and arrived at the lecture hall, breathing hard, at eleven o'clock *précises.*

George, as he waited to begin, had a white, strained look. I ascribed it to his general fatigue and to the nervousness that always grips him before a lecture. But he told me afterward that it was due in part to his having waited until the last moment before asking Professor Lavande if he "might wash his hands." He should have known better. The dean showed him to a lab

with a washbasin in one corner and stayed with him, beaming, while he miserably washed his hands.

The lecture was to take an hour, but since allowance had to be made for periodic translation, George had cut it to the bone. It would just fit within the time limit, he had told me. Now, as Professor Lavande rose to introduce him, he sat poised on the edge of his seat, like a racing greyhound waiting for the barrier to lift.

"*Mesdames, mesdemoiselles, messieurs,*" the dean began, "*nous sommes reúnis pour rendre hommage au savant le plus éminent de notre temps, un homme possédé par le feu du génie. . . .*"

Five minutes later, the flowery preamble completed, he began George's biography. "*Notre hôte distingué est né à Wahoo, Nebraska,*" he commenced, and I groaned inwardly. Any introducer who begins with the great man's birth can be counted on for full details of everything that has happened since. It took fifteen minutes for the dean to list every scientific paper George has ever published, every honor he has ever received, and every academic society of which he has ever been a member.

The summation, a masterpiece of adulatory oratory, took a final five minutes, in the course of which Professor Lavande bestowed on George a full measure of the scientific glory to which he is legitimately entitled, and credited to him in addition half-a-dozen significant discoveries he had nothing whatsoever to do with.

It was a splendid speech, and when George finally rose to his feet, I could see that he'd just as soon let matters rest right there. No matter what he said, it would be an anticlimax. However, he and M. Maurice in turn attacked the newest developments in biochemical genetics at a tempo rivaling Walter Winchell's.

256

They concluded, to deafening applause, only ten minutes beyond the hour that had been assigned for the lecture.

"*Magnifique! Magnifique!*" exclaimed the dean, shaking George's hand. "Was it not truly *magnifique?*" he said to me, ·kissing mine. "*N'est-ce pas pour nous un honneur insigne?*"— to anyone who would listen.

This wave of enthusiasm and good cheer swept us from the lecture hall to Strasbourg's finest restaurant, an Alsatian version of the Top of the Mark, with a splendid view of the city, the cathedral, and the lush green countryside beyond. We thought that Professor Lavande had said that this was to be *une petite réunion* of people from his lab, but it was in fact a civic banquet. Everyone was there, from the mayor on down. George was enormously touched by this compliment.

The conversation was animated; the toasts were overwhelming; the food was the best we had eaten since we left America (so we ate too much); the wines were superlative (so we drank too much); and the day was excessively hot. In short, by three o'clock, we were groggy and ready for a siesta.

"What a splendid banquet, Professor Lavande. *Très magnifique!*" I said, "*Nous sommes très*—uh—very grateful to you! We cannot thank you enough! But perhaps now we should return to the *château* for a little rest? *Un petit repos, n'est-ce pas?*"

"*Ah, oui! Oui!*" the dean replied. "It makes us ver' happy now to conduct you to *les autres laboratoires,* the ones there was not time to see this morning. *Oui?*"

"A tour?" George said. Then, with a little effort. "Fine. I'd like to, very much."

By four o'clock we had toured *les autres laboratoires*—so tidied-up, in obvious expectation of our coming, that it would have been heartless not to have paid them a visit. Then I said,

more firmly, and without relying on fractured French, "Now I think it would be wise for us to return to the castle so that my husband may have a little rest."

When M. Maurice translated this, Professor Lavande's face looked as if he'd just found out that there isn't any Santa Claus. *"Mais nous allions justement vous montrer les environs!"* he exclaimed dolefully.

"The sight-seeing. He is disappointed because he had wanted to take you sight-seeing now," M. Maurice explained.

George looked at his host's stricken face. I knew exactly what he was thinking: Professor Lavande had obviously knocked himself out making arrangements for our comfort and pleasure. We could only guess at how many conferences, how much persuasion, and how much bullying had been necessary to make everything just right for us. The banquet alone . . . and the slicked-up labs, with everyone in white smocks, like a battalion ready for inspection . . . and our rooms at the castle. . . .

"Why, we'd very much enjoy some sight-seeing," George said. And then, because the suffusion of joy on the dean's face indicated that another round of handshaking and hand-kissing was about to begin, my husband added, "A *little* sight-seeing would be just fine."

"Bien! Bien! Good, good!" the dean said. "What you like best to see? *Des châteaux, des églises, ou quelques petits villages pittoresques?"*

"Any one of them would be fine. We like them all," I was incautious enough to remark. So we saw some of all—a castle on a hilltop overlooking the Rhine, a *real* castle; and the cathedral at Colmar, where there is an exquisite fifteenth-century painting of the Madonna, a triptych by Matthias Grünewald; and any number of quaint little towns, of which I remember Riquewihr best. A charming place, it has a town gate and a portcullis in

working order, storks' nests on its chimneys, and enchanting shop signs of delicately hand-wrought iron.

Suddenly, at 7:30 P.M., Professor Lavande glanced at his big gold pocket watch. *"Mon dieu! Il se fait tard!* Our guests mus' have a little rest before *le dîner! N'est-ce pas?"*

We were then fifty miles from Strasbourg, but we made it in less than an hour. As M. Maurice's high-powered car zoomed around donkey carts and hay wagons, leaving the drivers apoplectic, my own hair stood on end. Red said later that it was all psychological. "So what if the speedometer did read one forty?" he said. "Mom, that was *kilometers*. In miles, we were only doing eighty."

We drew up in front of the château in a fine burst of gravel, to find it dark again. Obviously the TV was on. We groped our way up the staircase, discovering this time that not even the upper corridor was lighted.

I was traveling very slowly, one hand against the wall, the other clutching Red, but George was striding confidently on ahead. Suddenly, I remembered the three little steps just before one reached our rooms.

"George," I called out, "watch out for the——"

Before I could complete the warning, a ghastly thump sounded ahead, reverberating back down the corridor. It was followed by utter silence.

"Oh, my God, he's killed himself!" I whispered, stunned into immobility.

Just then a single, pungent word—one I had never heard George use before—came booming out of the blackness, and in a minute our room door came open, and light flooded the corridor. George had been going so fast, he said, that he hadn't stumbled on the stairs; he had sailed completely *over* them, soaring into space before he fell. It was a miracle he hadn't broken

both ankles. But he seemed to be unhurt, so he swallowed a couple of aspirins, we all splashed water on our faces, and hurried back downstairs to join our hosts.

Mme. Lavande, accompanied by Mme. Maurice, had brought the little Citroën out, and now the dean became our chauffeur. He stowed Red and me in the back seat of his little car, put George in beside him, and the two ladies in the Maurices' car. We were going, he said, to a restaurant *dix kilomètres au nord*, which he was of good hope we would find *très intéressant*.

With the Maurices creeping along behind us, in their lowest gear, we putt-putted off into the night. We went so slowly, in fact, that the thought occurred to me that we'd be lucky to get there by midnight. The same thought apparently soon occurred to the dean, who stopped the car, signaled to the Maurices to stop, and turned to me with profuse apologies. "Madame, it is of a great sadness, but this little *automobile* has not so moch strengt'. *La charge est trop grande pour une 'deux chevaux.'* You and the boy, *peut-être*, will best pass to *l'autre automobile?*"

We said we'd be happy to, and scrambled into the Maurices' car. George told me later that the dean was just displaying Gallic chivalry when he let low horsepower take the blame for the transfer. The fact was that Red's and my weight in the back of the car had depressed the rear and elevated the front to such an extent that the headlights shone up into the trees; and even with dimming, Professor Lavande couldn't get any light on the road.

The restaurant was one of several that at that time of year serve only one dish—steamed asparagus, the jumbo white kind. The asparagus harvest had just begun, M. Maurice told us, and from now on people would drive great distances for this seasonal delicacy. It was a glorious feast. We were served two liters of white wine, a silver sauce boat holding hollandaise, and another

260

heaped with that whipped mayonnaise of unsurpassed delicacy that only the French can make; and individual platters of piping hot asparagus—a kilo to a platter. That's a little over two pounds. George and Red managed, between them, to polish off a second kilo, but it was all I could do to finish the airy meringue and the cup of strong coffee that completed the meal.

Full and sleepy at 10:30 P.M., we prepared to leave. As Professor Lavande climbed into his little Citroën, M. Maurice offered a diffident suggestion. *"Pardon, monsieur,"* he said. *"Avez-vous assez d'essence?"*

"Mais oui! Certainement!" snapped the dean with considerable asperity, but he got out of the car and ran a gauge stick into his gas tank, anyway. He was astonished, and outraged, to find it empty. *"Ça alors, c'est vide! C'est vide!"* he moaned.

He whizzed back into the restaurant to ask if there was any gasoline for sale—which, of course, there was not—and returned, downcast, to the alternative he had been trying to avoid, the syphoning of a little gas from the Maurices' tank into his. He had been humbled in this fashion before.

En route back to Strasbourg, M. Maurice said dryly, "You see now why, with the dean, it is wise to go in convoy." He told us that Professor Lavande's absent-mindedness had long been a legend in Strasbourg, and that his little car was well known because it had run out of gas so often, and in so many out-of-the-way places. At one time the dean had concocted a foxy solution to his forgetfulness: he had had a special rack built on the back of his car, in which he had had a bicycle installed. Then, whenever he ran out of gas, he could cycle home or to a nearby habitation for help. But, *hélas,* this scheme didn't work either. He kept forgetting the bicycle.

The next morning we had a grand send-off at the railroad station. Professor Lavande nearly wept with joy at our having

come, and with despair at our having to go, and we assured him that we never, anywhere, in any city, had had such a memorable visit. Finally, in a chorus of *adieus, portez-vous biens, merci beaucoups,* and *mille remerciements,* we chugged away.

Leaning his weary head back against the cushioned seat in the compartment, George remarked, "Pretty nice fellow, the dean, eh? Let's see—to return the compliment, we'd have to put him up in Hearst's castle at San Simeon, and charter a plane to show him the sights, and throw a banquet at Romanoff's. . . ."

". . . and I'd take Madame Lavande to San Juan Capistrano Mission while you were showing the dean around *les labora-toires,*" I put in. "But what would be the equivalent of the asparagus place? 'El Poche' or one of those other restaurants south of Pasadena that specialize in Mexican food?"

"Heck no," Red said. "We want a place that's really unique, don't we? We'd take them to that place at the beach that serves buffalo steak."

We might have spun out the fantasy further, but George had fallen sound asleep.

23

THERE is a theatrical trick in which a scrim curtain is hung between audience and stage, a curtain that is opaque until the scene behind it is lit. Side lights first pick out one small section of the stage; then another; and then another. Next, the back and top lights begin to brighten the entire scene. One's sense of anticipation builds and builds, until—crescendo!—the footlights go full up and the curtain rises, and the audience bursts into joyous applause.

That's what our English spring was like.

The little earth-hugging flowers came first, in late February. Snowdrops bloomed in drifts under trees and hedges; then the crocuses thrust their shiny heads above the earth; later, the woods were hazy with bluebells. In March the forsythia opened its yellow trumpets, followed, in quick succession, by the rosy plums, the white cherries, and the pale pink apple blossoms. In April the chestnuts began to unfold, wrinkled and tender, from their furry buds. That's when we went to Italy; when we returned, they had leafed into giant green umbrellas. By May they were studded with white flowering spikes as jaunty as candles on a Christmas tree. In contrast, the labernums, their pendant yellow clusters like showers of golden rain, curved earthward with willow-plate grace. The tulips bloomed and waned and dropped their velvety petals among the scillas. Wistaria cloaked gray walls in mauve, lilacs echoed the note

against a backdrop of green, and here and there a vine of clematis blushed pink.

The rooks held noisy congress in the tree tops, and householders with small paint pots in hand ventured from hibernation to lay fresh trims on outside woodwork. Prams turned up on the streets with fringed cotton-print canopies, the babies inside wiggling bare pink toes, the mothers exposing winter-white shoulders to the sun.

Oh, it was good to be alive in England, now that spring was there! It was a time for flexing the muscles, opening the windows, airing the bedding, and smiling at strangers. It was a time for going outdoors and staying there.

On the first of May we arose at 4:30 A.M. and set out for Magdalen Bridge, afoot, in predawn gray. The fields were cool and wet, the air like glass, and the only sound was a cuckoo's call somewhere up ahead of us. I'd forgotten that cuckoos are birds, not clock parts; their song, at least in the hush of a spring morning twilight, has a wistful sweetness and clarity that is almost painful to hear.

As the footpath we were following eased off to the north, we swung back toward the London Road, and joined it just as it began its descent down Headington hill. It was after 5 A.M. now, and we were no longer alone. Schoolboys in twos and threes whizzed by on their bikes, and coveys of schoolgirls giggled past us downhill, the bright ribbons on their straw boaters floating behind them. Some had wound wreaths of flowers around their hatbrims. This rite of spring we were headed for seemed to be a young folks' festival.

It takes the stamina of youth, or an unquenchable taste for romance, to arise before dawn—or to stay up past it, as some of the crowd that was awaiting us on Magdalen Bridge had

done. As we eased our way into the heart of the throng, we could see that the river was just as full as the bridge.

Undergraduates and town boys, mutually seizing the one annual opportunity to escape the restraints of proctors and policemen, had been up all night, partying on the Cherwell. Now they were jammed into punts, and the punts were jammed so close together that the merrymakers were using them as stepping stones to cross the river. A snatch of calypso drifted up to us on the bridge. If one looked carefully, one could see an occasional champagne cork pop. There were beer mugs, too, but they were being used as balers.

On the far side of the bridge, soaring 140 feet above the lot of us, stood Magdalen College Tower—cold and gray against the blue-white sky, its clock hands gleaming dully in the early light. Red spotted a flutter of white near its top. "Look," he whispered (I don't know why, a yell would have gone unnoticed), "there are the choirboys."

Just then a ray of sunlight touched the pinnacles atop the tower. And the clock began to strike. The hundreds on the bridge fell silent. By the sixth stroke the pinnacles were all alight. Then, like an angel chorus, faint and sweet, the voices of the choirboys floated down to us. "Te Deum Patrem Colimus" they sang, as has been the Oxford custom for five hundred years— on this day, from this tower, at sunup.

(They have not always had such an attentive audience. In the nineteenth century town boys would stand on the bridge, beating on tubs and blowing horns to drown out the hymn. And the angel chorus, ammunition cached under those spotless robes, would race through the song, then rush to the parapet and pelt the town boys with rotten eggs. But as we of the polite twentieth century stood listening, the only sound was a splash and a

muffled yell from the river. Someone had obviously fallen off a punt.)

Then, as the last note of the hymn died away, the college bells began to peal out rich and full—the same glorious medley of sound we'd heard on Christmas Eve, only now the bells were saluting the sun and spring and life and love. They made our juices rise. They set the crowd moving—at a run.

We surged up the High Street, like water escaping a dam. Past Magdalen itself. Past Queen Caroline, unshakably composed beneath her classic cupola at Queens. Down the little lane beside St. Mary's, all of us pushing and shoving and grinning at each other. Into Radcliffe Square. We ringed the grassy plot behind the church, but left it bare.

And here came the Morris Men, to fill it; here they came, jigging into the square! In the van were the flute, the fiddle, and the concertina. And pretty girls with flowers and ribbons twined in their hair. The men were all in white, with flower-garlanded hats, red and blue ribbons crossed on their chests, ribbon armbands, bells and bows on their trousers. And how they danced! Most were young—Morris dances are not for weaklings—but here and there a snowy thatch emerged as a dancer removed his flowery hat to mop his brow and wipe the sweat off his bifocals. The University Morris Men had a turn, and then the dancers from Headington Quarry, and then the Oxford Morris Men. Leaping. Twirling. White scarves snapping. Hat ribbons whirling in horizontal orbits, wooden staves cracking like pistol shots. All the feet in the square tapped time.

Pirouetting on the edge of the grass, the man who was cast as the Hobby Horse bobbed the head of his silly steed. The walking tree called Jack-in-the-Green ambled in his blind and stately way from side to side, we in the crowd grabbing at the chicken-wire cone that encased him, trying to strip off his chestnut leaf

cover. But his champion, the Jester, stuck close: leaping and prancing, his red and purple coattails jingling, he whacked our plucking fingers (and a head or two!) with his skin balloon.

And then the man with the gingerbread sword distracted us further. Packed into the hilt of his ancient cutlass was ginger cake. "Have a bit," he told us as he passed the sword along. "Even a crumb will bring good health until next year."

"If you live, that is," called a voice in the crowd. A wave of laughter rewarded the sally. How *good* we all felt!

The Morris Men exited dancing, jigging and dipping out of the square, round the bend, and into the Broad. Some of us couldn't bear to let them go. We followed along, half-dancing ourselves, as bemused as if the Pied Piper were up ahead. ("*Mom!* For gosh sakes, come back on the sidewalk!")

By now the sun had fully risen, and suddenly we began to yawn—especially those among us who'd been up all night. School children started to scoot home to change into uniform. The big red busses began to grind past, discharging ordinary mortals on their way to work, their placid faces untouched by May magic. And little by little we early birds withdrew into our everyday shells, went home, and took up our everyday tasks.

But even now—two years later, and six thousand miles away—I can still hear, faintly, the sound of the flute and the jingle of bells. I hear it more clearly than the roar of trucks going past a little pink house in Headington or the dull throb of cars and busses tangled at the Carfax.

Oxford has another rite of spring in May: Eights Week, with its bumping races on the river.

For a few the racing days are energetic days. For most they are lazy, sit-on-the-riverbank days. Everyone comes: mothers with babies in prams; school children on bikes; Old Boys with shoot-

ing sticks and field glasses; dons looking most undonnish with their noisy young in tow. Undergraduates, peonies or irises nodding from the lapels of their college blazers, strut about. Or bask in the warmth of winsome smiles from pretty girls in picture hats. (One thinks of peacocks with their hens.)

We went to the races, too, on a breezy afternoon, joining the crowd on the towpath below Folly Bridge. This is a stretch of the Thames that is called the Isis, as befits a town that venerates the classics. There was a busy trade in ferrying people across the river in large, flat-bottomed punts; the objective of most was a college boathouse or barge, above which heraldic college flags snapped briskly in the wind. The atmosphere was as gay and bustling and as fraught with expectation as a medieval tournament. Only the swans, shooed into the reeds along the race course, were argumentative and sulky.

We found a good spot on a bridge near a bend, midway in the mile-and-a-half course. Starting at intervals of a few seconds, the college eights in each race try to catch, and bump, the boat ahead. We had fine luck that day. We witnessed a bump. It happened like this:

The Hertford Eight came surging into view. This was not a competition between the picked rowing men of the universities, like the famous Oxford-Cambridge race at Putney; but even so, the Hertford boat cut through the water with so much grace it was hard to believe that the oarsmen were working as hard as they were.

Right on their heels was Lincoln.

Partisans of both colleges came running along the towpath, dodging prams and knocking over untended bicycles, firing pistols (blanks), and shouting encouragement to their men.

The Hertford cox, sensing peril, shortened the stroke. Backs

bending, oars flashing, the lead boat spurted ahead. But two could play *that* game, and soon the Lincoln bow almost imperceptibly began to overlap the stern of its quarry.

A great roar went up on the riverbanks.

Then the Lincoln cox gave his rudder a gentle flick. His bow just nudged the flank of his prey. No more was needed: he'd made his kill.

The two boats drifted off to one side, Lincoln now a rung higher on its way toward becoming Head of the River.

Although a few dutiful cries of "Well rowed, Hertford!" floated to the panting oarsmen from their supporters on the riverbanks, the fickle crowd was already intent on the next boats to come swooping along: St. Peter's, as it happened, with Jesus in hot pursuit. (I'm happy to report that neither suffered the indignity of a bump.)

And so it goes, with perhaps seven races a day and ten boats in each race, the starting positions shifting about each day in accordance with who did the bumping and who got bumped. Gala "bump suppers" at college reward teams with four bumps to their credit, and on the Monday after it's all over and the swans have possession of the river again, the newspapers sum it all up for another year:

> Balliol, who on the first day of the Summer Eights had ousted Queens from the Head of the River, were never in any danger of losing their place. Merton looking promising, but on Friday they faded, and were caught at the New Cut by a strong but rough Christ Church, who were the only crew in the first division to make their four bumps.

Long afterward, however, the rowing men will continue to argue whether, if the current hadn't been running quite so swiftly when they came out of the Gut. . . .

May, as I said, was a time for going outdoors and staying there. May was a time for walking.

To the west of Oxford, a few miles, is Port Meadow. This flat stretch of pastureland has been owned since before the Magna Carta by the freemen of the city of Oxford. Close by it are the ruins of Godstow Nunnery. There, Fair Rosamond lies buried. If you wish to break your walk, you can stop at The Trout for a glass of ale, and watch the river churn white at your feet as it tumbles through the weir.

Shotover Hill is to the east. Along its ridge is the road that Elizabeth followed when she visited Oxford in 1592; it's the same road that the beaten Royalists took after surrendering to Cromwell in 1646. It's a high road: you look above and beyond the spires and towers of Oxford to a green sea of tree tops and rolling farmland.

Southwest, on the Lambourn Downs, in the Vale of the White Horse, there is another hill—this one surmounted by a vast earthen rampart thrown up by Bronze Age Britons. At the top, where the wind whips your hair and stings your eyes shut and flattens the grass as it surges downhill, the view is wilder and wider-spread, and the sky seems vast.

Yes, May was a good time for walking. May was a time to remember.

24

THAT was the spring of the great Latin debate, at both Oxford and Cambridge. I don't know what the atmosphere was like at Cambridge, but it was on the acrimonious side at Oxford. Blood ran as hot and tempers flared as fiercely as at any ball-park rhubarb in the States.

It was the scientists at both universities who had spearheaded the drive to drop the examination in Latin that was required for admission to either. It was important, furthermore, that the two institutions should make the same decision on the matter. Not that anyone dared insult the "independence" of either university by suggesting that they get together on the problem; it was necessary to rely, instead, on their mutuality of interest and similarity of outlook, and hope that, as so often before, they would muddle through to a similar policy.

The fundamental similarity of the two great British universities, alone in the world in their organization around autonomous colleges and the tutorial system, is recognized by the English in common reference to them as one entity called "Oxbridge." They have equal prestige, and jointly are the mecca for the best young brains in the commonwealth; yet individually they are in hot competition with each other. To keep them well matched is essential. It would serve no useful purpose if their entrance requirements were fundamentally different, and it would cause a lot of agony.

Suppose that young Jonathan Bull, just going into the sixth form at his secondary school, has been so keen on science since he was twelve that he is clearly destined for the laboratory. If Oxford were to require an advanced-level pass in Latin but Cambridge would let him in without it, he might be sorely tempted to prepare for Cambridge—dropping Latin in his last year or two of secondary school and taking more math or one of the modern foreign languages that would be useful to him in science. This better background for science would clearly give him an advantage (at Cambridge) over schoolmates who were playing their cards more cautiously and were continuing to take Latin; so, in due course, the best scientific brains in Britain might end up at Cambridge. This would be unhealthy specialization, for academic institutions not engaged solely in research but also in educating youth should include in their fellowship a broad range of interests and points of view. On the other hand, if by some chance young Jonathan *didn't* make it at Cambridge, his lack of Latin would have disqualified him for consideration by Oxford. The secondary schools would thus find themselves in a difficult spot: which boys should they advise to take Latin and which should they advise to risk skipping it? It is hard enough, at present, to coach pupils for the small differences in qualifications that exist between the two universities.

Suppose the other alternative, now: the elimination of the Latin requirement by *both* universities. This would profoundly affect the secondary-school curriculum, the number of Latin masters needed, perhaps even the textbook business. So the great Latin debate at Oxbridge was more than a high wind blowing through the groves of Académe, and all of educated Britain followed with interest as the dons chose sides.

One hears at Oxford that the scientists have taken over Cambridge. And at Cambridge it's said that the philosophers have it

pretty much their own way at Oxford. Such a claim is patently ridiculous: in institutions so decentralized that college bursars can't even co-operate to the extent of buying their light bulbs in job lots, it would be impossible for any special-interest group to dominate the others. More to the point, however, it isn't true. Although one Oxford scientist insists bitterly that Oxford has a "redundancy of old men who sit about sipping port and discussing the meaning of meaning," it seemed to us that Cambridge has quite enough medieval historians and theologians to meet Oxford eye to eye. As for science, George found that good research and teaching are going on at both institutions—with the same variations of excellence among the various scientific departments that are characteristic of all universities anywhere.

Cambridge struck me as a little more able to make up its collective mind than Oxford, but that opinion is based only on the outcome of the great Latin debate.

At both universities, of course, both pros and cons had been heard in a flow of impassioned oratory. The pro-Latinists had said that Latin is of inestimable value in understanding English and that familiarity with a classical language is an essential component of all true culture, indispensable to any man who wishes to call himself educated. The anti-Latinists had said that Latin grammar "attains a pitch of arbitrary whimsicality far beyond the reach of mere disorder"; that "no serious student of the matter would regard the influence of Latin upon understanding of English as anything but bad"; and that schoolboys would presumably still become familiar enough with Latin (below the advanced-pass level) to acquire whatever cultural benefits might be its to confer.

A humorous footnote to the whole business was that Latin, regardless of its fate as an entrance requirement, remains the official Oxbridge university language. Dons voted either *placet*—

273

"It is pleasing"—or *non placet;* and at Cambridge they had decided, with little public fuss and by a sizable majority (325 *placets* to 278 *non placets*) that in the future candidates might be admitted "without necessarily qualifying in a classical language."

Matters had not proceeded quite so smoothly at Oxford. At Cambridge voting is by written ballot, but at Oxford the *placets* walk through one door and the *non placets* through another, with proctors on each side counting them as if they were livestock going into pens. George (who had cast his vote with the *non placets*) said that it had been a tense meeting indeed, because the lines of gown-clad dons queued up at the two doors had looked so nearly equal. The final score was 249 *placets* to 244 *non placets*. Not that it really mattered, because Oxford had almost immediately reversed itself, reopened the entire matter, and debated it further. The hot potato had been disposed of, finally, by referring it to a committee for further study.

Which is where matters stood that spring when we went to Cambridge—George to give a lecture, I to see the sights. There was, of course, much conversation at Cambridge about the nature of Oxford's final decision. There was an off-chance that the older university just might . . . ("There always is, don't you know? Home of lost causes and all that.") But the consensus was that Oxford would eventually come around. It was unthinkable that the two universities would not again act in concert on a fundamental decision that affected them equally.

(Which is what happened, in case you're curious to know how it all came out. Some nine months later Oxford's committee recommended to Congregation that an advanced-level pass in a classical language should be dropped *only* for candidates holding an advanced-level pass in mathematics or a scientific subject. Anyone intending to read history or economics or modern lan-

guages must still come to Oxford with an advanced-level pass in Latin or Greek. As a Rhodes scholar in residence at the time put it, "Mathematicians or scientists who feel the need of the humanities on the side, as many of them do, will be free to choose Pushkin instead of Vergil. Everyone else who reads Pushkin must do it in addition to Vergil.")

Meanwhile, it was spring in Cambridge; they'd made *their* decision; and how would we like to have a stroll through the Fellows' Garden? Punting on the Cam, we'd find, was just as nice as punting on the Char.

Cambridge is a prettier university town than Oxford, because it has no Morris Works. A number of colleges back up to the river, their gardens overlooking it, and we strolled bemused on paths that wander through these Backs. Nothing that we saw in England was lovelier than Trinity College's living "Persian carpet." Picture this: On either side of a path, two straight young columns of pale green lime trees (Americans would call them lindens) marched to the river. At a distance of twenty feet on each side, a column of white cherry trees shimmered in full bridal flower, their dropped petals spangling the earth below them like confetti. Randomly spotted in the strip of meadow grass between the two lines of trees, red tulips on sturdy stems thrust bold heads to the sky; and nestled at their feet were daisies, early buttercups, and baby blue-eyes, each adding a tiny fleck of color to the tapestry.

When George went off to do his lectures and lab tours, I wandered through the colleges, then to the Church of the Holy Sepulchre. It dates from 1100 and is round; the vicar said that it had been built in imitation of the Holy Sepulcher in Jerusalem, probably by the Knights Templar as a place of prayer for those engaged in the Crusades. As I stood under the massive Norman pillars and compact rounded arches, it was easy for me to trans-

275

port myself to the time of Richard the Lion-Hearted, and to get at least a glimmer of the unquestioning faith of those earlier Christians.

And, finally, on a windy, light-and-shadow kind of afternoon, with white clouds racing in battalions overhead, I visited Ely. Nowhere in England did I see a cathedral so impressive at a distance and so enthralling in its details, nor, oddly enough, one that struck me as so showy—as if several generations of bishops had been engaged in keeping up with the Joneses—and, in sum, so lacking in emotional impact.

I drove out with Mrs. Severs, the wife of a Cambridge don. At first she tried gamesmanship, but as my questions continued to flow, she threw in the towel. "I've never been here before either," she confessed. We both laughed, agreed that one never *does* see the wonders in one's own back yard until visitors force one into it, and proceeded companionably, as fellow tourists.

The area northeast of Cambridge was once marshland in the center of which a wide mound of dry ground rose like an island out of a sea. Although the fens were drained hundreds of years ago, the area is still called the Isle of Ely (the "Ely" from the eels that once abounded there). And to travel over that flat expanse of countryside, especially under a turbulent sky, and to glimpse the vast bulk of the cathedral on the hill ahead, was like seeing a beacon on a dark and lonely night when one is lost.

Although the present cathedral dates from within a few years of the Norman Conquest, a couple of doors ornamented with the rugged zigzag and dogtooth carving of the period being particular treasures, much has been added. I thought that the additions had gilded the lily, but wandered from one to another in a state of exhilaration at their individual perfections. The wooden ceilings are painted in bright colors, those over the transepts having a spirited heavenly host in wood carvings that jut out into space

276

as vigorously as figureheads on the prow of a ship. There's a fifteenth-century chapel with such frilly pinnacles and such intricate stone carving it looks as if the whole of Magdalen College Tower has been compressed into forty square feet. Under the seats of the choir stalls is a series of exquisite wood carvings, many of them domestic scenes from the fourteenth century. In short, everywhere you look, there is abundant evidence that the finest artists and craftsmen of the day—whatever the century—had given of their best. Guidebooks in hand, Mrs. Severs and I looked with special awe at a dimly perceived ceiling carving of Christ—for which one John of Burwell earned two shillings and his meals at the prior's table, back in 1346.

The glory of Ely is its Octagon and Lantern. To visualize it, think first of a church built in the form of a cross, as they always were in the Middle Ages, with a tower in the center where the transepts met the nave. In 1322 this tower at Ely collapsed. The ruin was absolute. Yet out of it came a tower that modern engineers marvel at. New pillars were inserted at the meeting of nave and transepts, eight sets of them, with walls between, to make an octagonal base for the new tower. The diameter of this octagonal space was seventy-four feet—too wide to arch stone—so they got some enormous beams and angled them out from the pillars like the ribs of an umbrella. Instead of letting them meet in the center, however, they were used as struts to support—or, rather, to suspend in mid-air—a mammoth cylinder some sixty feet long. (The downward distance from this same point is ninety feet.) The cylinder, which is the part that is called the Lantern, was then filled with glass, trimmed with carved wood, and covered on the outside with stone, and when done threw a load of four hundred tons on the eight pillars of the Octagon. So well did the medieval craftsmen figure their stresses that for some six hundred years now the Lantern has fulfilled its

purpose—to concentrate a flood of light directly in front of the choir, and thus to bathe the entry to the cathedral's most sanctified spot in heavenly radiance.

"One thing I *do* know about this cathedral," Mrs. Severs said, "is that there's a famous Victorian monument somewhere around. Or perhaps 'notorious' would be a better word."

We found it, in close juxtaposition to the splendid Norman south door of the church, and somehow the thought struck me that the two sets of people—the robust Victorians, and the men of the Middle Ages who cut those twisted pillars and gave them their bold carvings—would have had a lot in common.

The "monument" is a tombstone erected in 1845 to the memory of William Pickering and Richard Edger, who apparently were killed (on the day before Christmas) when working on the railroad that was then being built to Ely. The tombstone bears this verse:

The Spiritual Railway

The line to heaven by Christ was made,
With heavenly truth the Rails are laid,
From Earth to Heaven the Line extends
To Life Eternal where it ends.
Repentance is the Station then
Where Passengers are taken in.
No Fee for them is there to pay
For Jesus is himself the way.
God's Word is the first Engineer
It points the way to Heaven so clear.
Through tunnels dark and dreary here
It does the way to Glory steer.
God's Love the Fire, his Truth the Steam,
Which drives the Engine and the Train.
All you who would to Glory ride,

Must come to Christ, in him abide.
In First and Second and Third Class,
Repentance, Faith and Holiness,
You must the way to Glory gain
Or you with Christ will not remain.
Come then poor Sinners, now's the time
At any Station on the Line.
If you'll repent and turn from sin
The Train will stop and take you in.

On starting back to Oxford, George stopped for gas at a service station on the outskirts of Cambridge. Nearby was a little sweetshop, and outside on the pavement stood a metal sign advertising 7-Up. "I'll be darned," I said. "I thought Coca-Cola had Great Britain all sewed up. For old times' sake, let's have one."

The rosy-faced young woman who uncapped the unchilled bottles for us was disposed to pass the time of day. We agreed that the spring had been lovely, although a mite dry. She asked what part of the States we came from; we said, "California"; and *she* said, "Think of that!" She asked us how we were liking England, and we said we liked it fine. She said, "You *do?*"— with that overtone of surprise, followed by pleasure, that we had so often encountered already in England. Apparently Americans are supposed to complain about something.

Then we told her that we'd been visiting the university. "Very grand it is," she said without noticeable warmth, "and now, of course, you'll be going to the American cemetery. A lovely place. My husband and I did our courting there."

George and I had had no intention of visiting the American cemetery, which we had noticed on the way into Cambridge, but now our interest was piqued. It's off the road a bit, but almost

as soon as one drives into the grounds one can see Old Glory on a flagpole up ahead.

Cambridge's is one of several American military cemeteries in Europe. The War Graves Commission deserves the highest praise for it. One might claim with justice that the chapel is too high for its width, or that the sculptures of American fighting men, posted like sentries along a long wall, are a shade too big for their setting. But the over-all effect is dignified and serene. A series of pools edged with rosebushes makes a kind of mall from the entrance to the chapel, and all the plantings are well kept. The graves lie on a broad, flat sweep of velvety grass, row after row of neat white crosses, with here and there a Star of David as a grace note. Beyond and below them, to a far horizon, stretches a broad expanse of English countryside, a restful symphony of rolling hills and little valleys. And over all arches the cloud-swept sky, the beautiful, boundless English sky.

It should be a source of pride and a comfort to the wives or mothers of those men who lie buried in this spot that it is so lovely that English couples do their courting there.

25

MRS. Blount, her pinched face rosy from the exertion of riding her bike up the hill, let herself in at the kitchen door. I was ready for her. "Ho!" I said. "You and your predictions!"

She bristled. "What about me and my predictions?"

"On March 20 it was soupy fog, and you said, 'Fogs in March, frost in May. Mark my words, Mrs. Beadle, there'll be frost two months from this day.' So I *did* mark your words, Mrs. Blount—right here on my calendar. And I've never seen a finer, balmier day than this one. Where's your frost, Mrs. Blount?"

"One swallow doesn't make a summer," she said, serenely. "There *could* 'ave been frost. Might be, next year."

I smiled. As usual, she'd had the last word. I picked up the notebooks I'd had spread on the big kitchen table and carried them into the dining room. Maybe if I sat with my back to the windows I wouldn't be distracted by all the spring glory outside.

"Collecting your wits again, eh?" Mrs. Blount asked, then broke into that booming laugh that was so much bigger than she was. At regular intervals I sat down to reread, organize, and amplify my various jottings, having learned long ago that, if I allow them to cool too long, I find myself faced with incomprehensible messages like "mst lk int Ox fn s sit." I had once called these review sessions "collecting my wits," and Mrs. Blount thought the phrase was as funny as an English music-hall joke

about Wigan Pier. (The equivalent of Jack Benny's "Azusa, Anaheim, and Cucamonga.")

So I went back to my work, while she started on hers. I'd spent eight months in England by then. Having put in a good many years reporting news of education for my newspaper at home, the one subject on which I was qualified to make judgments was education. *Are* English schools superior to American ones on all counts, as so many Americans believe? The answer to that was easy: No.

The fame of English education is based on the public schools —Eton, Rugby, Harrow, *et al*. They had reached their zenith in the nineteenth century and had been a great achievement—a truly distinctive contribution to world-wide educational philosophy and practice. The best of them are still great schools, although they may look backward too much, forgetting that the commonwealth requires a different type of man than the empire. What was it that King had said? I leafed through the pages of *Other Schools and Ours*. Yes, here it was:

> We tend to forget that a "gentleman" is an item of technology —a device for certain social and economic purposes, whose usefulness is conditional upon its being present effectively and in the right number in appropriate circumstances. British domestic and imperial history has made the "gentleman" an effective instrument of government, public relations, and even of research; but the question is now being urgently asked if there has been an overproduction of this commodity, at least on the mid-nineteenth-century model. Almost every Briton is fully in favor of having as many "ladies" and "gentlemen" as possible; but the whole context of "gentility" (though not necessarily its essence) has been changed by the specialist demands of the scientific and industrial revolution, and also by the fact that most children sooner or later realize they too can lay claim to it. Therefore, the "gentleman"-producing schools, methods, and subjects are now

being re-examined, and in time they may reach a pragmatically justified relationship with the actual conditions of modern Britain.

Anyway, I reminded myself now, the public schools of Great Britain can't be compared to public schools in the United States, because they are private boarding schools, and highly selective. Only a small fraction of British youth—King says 3 per cent—attend them.

The grammar schools, then: they *are* public schools, in the American sense of the adjective, although they limit themselves to educating the brightest 20 per cent of the secondary-school-age population. In cultural and economic background youngsters in attendance are as much of a cross-section of society as those attending any American comprehensive high school. Do *these* schools offer better education than that which the American high school offers to children of comparable intellectual ability?

The answer to that was qualified: *In some areas.* I flipped over the pages of my notebooks and reread comments by American parents then in Oxford. The consensus was that those of our children who were in English grammar schools were getting far better instruction in the use of their own language than they had had in the United States. Red did far more written work than at home—not only note-taking in class but also more essays on the side. Essay titles were more demanding, less "child-centered," more likely to stimulate creative thought. What was the title of that essay he'd had so much fun with? Oh yes: "An Imaginary Dialogue between Beethoven and Elvis Presley." Furthermore, his use of English was checked and criticized by *all* his masters; even in his science workbooks, errors in spelling or in outline form were red-inked. Consequently he had made spectacular strides in his ability to write well.

Another American mother had reacted to this emphasis on English as enthusiastically as I had. Here were her comments, jotted down after she'd made them at a coffee party: "At home in Illinois, it never really mattered to his teachers whether Sidney could spell. He has good ideas, does wonderful creative work, and the overall effect of his reports has been so impressive that he has always been given top grades. But his school here objects very strenuously to misspelling, and marks him down for it. His essay grades have dropped from alpha to beta often enough now so he's got the point—and he's improving."

But ability to spell is only one small part of competence in composition. Here, on other pages of the notebooks, was evidence from English school people accustomed to dealing with American children. They all agreed on one point: "Your children are just as bright, but ours can order their thoughts better"; "American children are more poised, but they don't reason as well"; "They are accustomed to talking, not to writing."

I had seen this myself on school visits. English classrooms, in the primary as well as in the secondary schools, are more formally organized than American ones. They are not *as* formal as we American parents (conditioned by novels of nineteenth-century English schoolboy life) had feared; nevertheless, the master dominates the classroom much more than in America. Children do more memory work and more straight recitation. There is less general chitchat, and, in the lower schools that I had visited, very much less "group project work" than in comparable age groups in the United States. The idea of teaching youngsters to do arithmetic by setting up a toy store in the classroom would horrify most English school Heads. (I don't think much of it myself.) The result of all this is stricter classroom attention to a particular lesson, more consciousness on the part of pupils that an organized body of information is being im-

parted to them in an organized form. *And this,* I thought now, *is good. The more relaxed American classroom is a better learning situation only when a really superlative teacher is in charge. The average teacher is likely to waste time.* I could remember visiting American classes, especially at the secondary level, in which the teacher had allowed general conversation to range far too widely and too unproductively for anybody's benefit.

On the other hand, the English school doesn't make enough provision for individual research of a creative nature. Where was Janice Poole's comment? (Janice was twelve; she had left a sixth grade in Tennessee when her parents came to Oxford.) Here it was. "I think my school in Oxford is just wonderful," she had said, "and I'm going to miss it *very much* when I go home. There's only one thing I miss here. That's finding things out for myself. Here, the mistress just *tells* us, and we write it down."

Then she had hauled out a notebook that she'd made in sixth grade. Red used to do them too, a mishmash of what the encyclopedia and other reference works have to say about a given topic, pertinent pictures clipped from periodicals, handdrawn graphs or maps or other illustrations, and a fancy cover ornamented with those curlicues and other flourishes of which preadolescents are so fond. Janice's special project had been "England," and she had assembled approximately a hundred pages of information on the country she had been about to visit. The result wasn't very exciting by adult standards, but obviously it meant so much to her that she'd brought it with her; and I knew that she'd never forgot any of the information she'd put into it.

Here, too, on another page of my journal was a related criticism: "Pupil art work everywhere very representational, excessively dull and unimaginative," I had said. The English art

teacher sticks a flower into a vase and everyone in the class is supposed to sketch it to look as much as possible like a photograph of that flower stuck into a vase. Red took art too: even at the secondary level there was no instruction in basic principles of composition, only token attention to draftsmanship, no effort to build art appreciation. I had missed seeing the uninhibited finger paintings, the impressionistic blob-and-dribble work, the zestful collages that even very young children in the States are encouraged to do—all of which serve not only the purpose of self-expression but also teach appreciation of color, form, and texture.

O.K. So much for generalizations on method. Now, back to consideration of the grammar-school curriculum. On subject matter other than English, how do their offerings compare with what American comprehensive high schools offer the children in *their* top ability groups?

Well, English youngsters get more foreign language. Starting at age eleven, they take *both* Latin and French. American children commonly (although this practice is beginning to change, I reminded myself) start Latin *or* French at age thirteen. By age sixteen English school children have had five years of two languages; Americans, three years—or maybe only two—of one language. So English youngsters are bound to have a better background in foreign language.

What about history? Courses and standards of teaching seemed to be the same as at home. No civics in England, though. Whatever English youngsters learn about the workings of their national and local government they pick up by themselves. At home—at least in California—the social studies curriculum is heavily loaded with courses on the national and state constitutions and governmental organization.

Math? It's taught in a different sequence in the two countries.

Red had had trouble at first because he didn't know logarithms. But later the class had got into quadratic equations, which he'd had two years before at home. One of the Osborne girls, I'd noted in my journal, had graduated from high school in Illinois, but had gone into a sixth form (the equivalent of first year in college) in Oxford. It was a snap, she'd said. The class was doing co-ordinate geometry, which she'd completed in the United States. But she'd had a criticism when the class got into new work. "It's so *dull*," she'd said. "Nothing but problems, problems, problems. Math can be fun. But *they* don't think so."

The sciences? No better taught than at home, as far as I could tell. More emphasis on lectures, demonstrations, and memorization of facts. George was continually exasperated by Red's inability to explain the significance of any of the facts he was committing to memory in such colossal quantity. *He didn't do any better at home,* I reminded myself now. *If you get a spectacular teacher, you do all right, otherwise it's pretty sterile stuff. . . .*

O.K. I leaned back in my chair and rubbed the back of my neck. What other comparisons could I validly make between the grammar schools of England and the schooling offered the brightest 20 per cent of American children? By segregating the academically able into separate schools and labeling them as elite, English grammar-school pupils become a homogeneous group, high in morale, high in motivation to succeed, easy to teach. *American schools have a very spotty record of separating the brightest ones and putting them into special classes,* I thought, *although they've been doing better, since the Sputniks went up.* What had June Owen written from home the other day? "All the publicity about how hard it's going to be to get into college is beginning to have an effect. All of a sudden, it's fashionable for teen-agers to belong to the school honor society." Good.

Now if we can only get adults to stop sneering when they say "egghead," we'll be on our way.

So much for the brightest 20 per cent, then. Now, what about the secondary modern schools? Do the English do as well by the *majority* of their children as the Americans do? Answer: No. The use of a qualifying exam at 11-plus has too damaging an effect on both a child's self-esteem (a very precious possession for children and adults alike) and on his academic environment.

I considered the traumatic personal effect of the exam first. My notebooks bristled with evidence.

Baroness Wooton of Abinger, in a House of Lords debate on education, had said in February, "The 11-plus examination broods like a monster over every home in England in which there is a child between seven and eleven."

In a lighter vein, noted at a coffee party, here was the comment of another American mother. She had said, "English-women are obsessed by the 11-plus. They talk about it like we American women talk about our operations. And they're so *apologetic* when a child fails."

There on the table beside me, too, was a booklet, just prepared by the city of Oxford's Education Committee for distribution to all parents. After listing the various secondary schools to which children might be assigned, it concluded with a plea that parents not be "over-anxious for their children to qualify for a particular type of school," or at least to "do everything possible to avoid communicating their anxiety to their children." It advised parents not to promise rewards for success; not to have their children coached; not to think "or even to speak of" the pupils in secondary modern schools as having "failed."

If parents weren't doing all those things, I thought, *there'd be*

no need to beg them not to. The booklet certainly confirmed what was said in that clipping from *The Times* that I'd pasted into my journal. In reporting on school selection procedures, it had said that "a mood of disquiet, and even of neurosis, runs wide and deep across the country."

What about the effect of segregation upon a child's academic environment?

There was, first, the pressure upon the primary schools to get "passes." In January, I had clipped a newspaper account of an educators' conference. The director of the Institute of Education at Nottingham University had said, "Selection at age 11 inevitably means selection at age 7." Few primary-school teachers, he had pointed out, can resist the temptation to give more attention to their brighter pupils, progressively neglecting their less capable ones. "What we are doing to a considerable extent in the primary schools is producing backward children," he had asserted.

There at hand, too, was the testimony given me direct by the Leicestershire education officer, administrator of an educational experiment in that industrial area (shoes and hosiery) some fifty miles north of Oxford. Not only has the 11-plus exam been abandoned there, but children aren't segregated into special schools until age fourteen. "If we haven't proved anything else here," he had told me, "we've proved that the 11-plus has a distorting effect on the primary schools. Now that it is not necessary to spend so much time coaching children for the examination, all manner of exciting things are going on in our lower schools."

The Leicestershire experiment also avoids the wastage of middle-echelon brain power that occurs when children are separated into different schools. The greatest bloc of children, in England as in the United States, is in the middle-ability band below the

top 10 per cent or 15 per cent. These "middle" children cluster between, say, test scores of 65 and 85, great numbers of them testing alike, with the scores of great numbers of others only a point or two below. (These are the "average" children that everyone talks about and that nobody—at least in America—claims to have one of.)

Under the English system, those scoring above a certain arbitrary line go to one kind of school and those scoring below it go to another kind of school. Those in the bottom group of the grammar-school enrollment may do fine, or they may have to work so hard to keep up with the others that their school days are hell and they quit as soon as they can. (Although the purpose of the grammar school is not solely to educate for university admission and the professions, the curriculum is structured to that end, and if a child is stretched so far in grammar school that he breaks before he gets to university age, there *is* cause for concern.) As for those in the top group of the secondary-modern-school enrollment, they may do fine, or so little may be expected of them that they may drop to the level of the less capable children below them.

In the Leicestershire experimental schools all children go from their primary schools into what Americans would call junior high schools. At age fourteen, without taking qualifying examinations, they may choose either to remain in these high schools for a final year, or they may elect to move to a grammar school for two years. About 40 per cent do the latter, the local education officer had told me.

By not segregating them into special schools until age fourteen, this scheme keeps the doors of opportunity open for children in the great middle group. More importantly, it keeps the middle group in close contact with the bright ones. Even more than teachers, American school people have often told me, the pres-

ence of alert, above-average pupils spurs on those in the middle-ability group. Yes, here was the Leicestershire education officer's verification of that opinion. "Grouping children of all abilities within the same schools has given a real lift to the children who would elsewhere be in secondary modern schools," he had said. "The headmaster of one of the high schools was telling me the other day that a delegation of his middling pupils had come to him and said, 'The others are doing French. Why can't we?'"

I took another look at my notes. When given a free choice, 40 per cent had elected to go on to grammar school. The usual percentage of youngsters, when chosen at age eleven, is around 20 per cent. Did that mean, I had asked the education officer, that the high schools in Leicestershire had increased the total number of those capable of doing grammar-school work, or did it represent unrealistic choices by youngsters who really didn't belong in grammar school? "Both," he had answered. "However, we have been able to make provisions for those who aren't quite up to the work without changing the standards for the brightest ones."

I thought now, *Those "provisions," almost have to mean a lower standard, or diluted course content, at the low end of the scale. Which is just what defenders of the status quo object to. They say, "Keep the grammar schools highly selective. There is plenty of opportunity within the system as now organized for the few late developers to get an education to grammar-school standard."*

But was there? The Oxford Education Committee's booklet explained in detail that able pupils in secondary modern schools can move on, at age fifteen, to the local technical college and there take courses leading to the same exams that grammar-

school pupils take at age sixteen. It also described the machinery whereby pupils may be transferred from secondary modern schools, or vice versa, at the age of twelve or thirteen. It sounded fine, but on another page of my journal, I had written down the answer, from the head of one of Oxford's three grammar schools, to my query as to how many youngsters actually *do* transfer at twelve or thirteen. "About six a year come in late at my school," the Head had said. "We've such large classes already that it is difficult to absorb more."

There were five thousand children in Oxford's secondary schools. *Surely,* I thought now, *the 11-plus exam isn't so accurate that only a handful of children are incorrectly placed. There must be dozens of near-misses who have been withdrawn from the tax-supported schools. And scores of others who arrived at their secondary modern schools burdened by such a sense of failure that they have remained there sullenly and left there gleefully, creating in passing an atmosphere not particularly conducive to learning.*

I knew that they were allowed out at the end of the term following their fifteenth birthday, a practice that was dumping a lot of young, unskilled workers on the labor market. And I knew that this isn't such a good idea any more. Just as jobs for the unskilled young have vanished in the United States, so are they vanishing in England. There in my journal was a news account of efforts being made in south Derbyshire to find jobs for such young people:

Figures released by the county education committee show that the juvenile employment situation throughout Derbyshire, as in other counties, is deteriorating. In January 1956, only 54 school-leavers were registered as unemployed, while in January 1959, the total was 283. In 1956, there were more than 1700 vacant jobs

292

. . . but by January of 1959 there were only 348. In 1956, £375 was paid in unemployment and national insurance benefits to school-leavers who had been unable to find work; in 1959, the figure was £2,926.

There was now much talk in England of raising the school-leaving age of sixteen, which would force the secondary modern schools to assume, as American high schools have been forced to, the role of custodian as well as educator. And when a school contains any sizable percentage of pupils who actively hate being there, the entire educational program suffers. Which would make the secondary modern schools even less attractive to the education-oriented middle and upper classes.

I stood up and walked to the window. The bulbs George had planted so early in our stay had rewarded us handsomely. The last of the tulips made a gay show of red against the gray stone of the wall. Musing on about the problems of the English schools, I thought, *It sounded so sensible when they drafted the scheme in 1944. To offer equal educational opportunities to all children in accordance with age, aptitude, and ability. The only thing they forgot was human nature. In times like these, separate-but-equal doesn't work in England either. Separate just doesn't seem to BE equal. What a pity that comprehensive schools are suspect for political reasons.*

I sat down again and leafed through my books, turning to the record of my interviews with the headmistresses of two London comprehensive schools. One school was spanking new, the other had been a girls' grammar school that had been reorganized. These had been fascinating meetings, I remembered, because both Heads were so accustomed to having to explain the basic philosophy and organization of a comprehensive school they forgot that *I* was on familiar ground.

"We are so tied in this country to things as they are that it's

293

hard to think of them as being different. But the dead hand of the past does lie *so* heavily on the schools," the former grammar-school headmistress had said with a sigh. "A great many people know that it isn't right to reject 80 per cent of our children; and what's more, we can't afford to. The comprehensive school restores their dignity. It makes them feel they are worthy people."

"Yes, I know," I had said.

"In 1955, at the time this school was reorganized, there was quite a stir among the Old Girls. You know? Letters to the newspapers and a lot of nattering at tea parties. The staff was worried too. For one thing, they were afraid of the secondary modern mob and the secondary modern mums." She had paused and smiled. "It was something of a letdown. They looked the same as all the others, and most of them were thrilled to be received."

What has been the academic record of her girls? "Being in the same school has doubled the number of children capable of doing grammar-school work," she had said.

Both the schools I had visited use the results of the 11-plus exam to determine a child's initial placement in school. "In their first three years," one headmistress had told me, "all our girls take the same course of study, the more able ones going wider and deeper into each subject than the less able ones. Except for French. We divide each age group into eight academic groups, and we offer French only to the top six of these groups. It's silly to expect a girl who writes 'the' as 'hte' to be taught about *le* and *la*."

(As I reread this, my mind swept back across the Atlantic. I remembered a home-economics teacher I'd once talked to, when the schools in her district were under fire for "putting too much emphasis on frills" such as home economics. She had said, "Let 'em say what they will. The girls in my classes are

294

never going to understand algebra. But they're darned well all going to have babies.")

In these London comprehensive schools a pupil is free at age fourteen (as at Leicester, only without the necessity of shifting to a different school) to concentrate on the academic subjects of the grammar-school curriculum or to take one of several more immediately practical courses; the same age at which, in the United States, ninth-graders are choosing a college-prep course, with its algebra and lab science, or a general course, with its business math and personal hygiene. At one of the London schools the girls who didn't elect the grammar-school side had a choice of a secretarial course, a technical needlework and millinery option, a prenursing course, or one which was entitled Retail and Distributive Trades.

This last one, the headmistress had told me, was intended for the very dullest girls—"the ones who are going to leave here at fifteen and stick labels on bottles"—and the school staff had given the course such a high-sounding title in order to make the dullards feel important. "What happened, though," the headmistress had said with a chuckle, "was that far too many of our A-stream—our top-ability—girls elected to take it too. And of course *they* get naughty in a course like that, because it doesn't stretch them enough. Next year, we're changing the title to Salesmanship. That will cool them off."

At the time I'd thought . . . yes, there was my note: *Success of comprehensive school, in U.S. or in England, depends on good guidance or counseling.* English schools don't have counselors, depending on the classroom teacher, the housemaster, the form mistress, or even the Head to do the job. *It doesn't matter much who does it,* I thought now, *so long as someone in the school is alert to the need for pupil guidance and has time to do it. You have to offer Retail and Distributive Trades, or some-*

*thing of the sort, if you have children of all abilities in the
same school. The important thing is to keep those who get
naughty if they aren't stretched enough out of courses set up
for those who are going to stick labels on bottles.*

At this point in the morning Mrs. Blount came into the
kitchen to fix her eleven-o'clock cup of coffee. (It consisted of a
third of a cup of coffee and two thirds of a cup of hot milk,
the whole heavily sugared. She then carried it with her, moving
it down from step to step and sipping as she brushed the carpet
on the staircase.) She didn't interrupt me, but her presence
reminded me of her attitude toward education, and of how
much it differed from that of many American parents.

Mrs. Blount had two sons. One was out of school and in
vague possession of a job as a delivery boy. The other was still
in primary school. His mother sent him in the morning and
asked only that he behave reasonably well while he was there.
She didn't know what he was learning, beyond "lessons." In
fact, she considered my interest in schools, an interest that ex-
pressed itself in *visiting* them, as a shade beyond harmless ec-
centricity. It wasn't, somehow, quite proper.

My notebooks held other evidence of the hands-off attitude
of English citizens toward their schools. Some of them were
apathetic; others, though interested, believed that it is as bad
form to express opinions on the content and methods of edu-
cation as to tell a physician how to prescribe for a patient. Ox-
ford's local education officer had told me, "A Head must expect
to be challenged about his treatment of a particular child, but
not about his judgment on curriculum or school organization."
On the same theme a headmaster had said, "If parents were to
try to tell us our business, it would be news, it happens so
rarely." And a headmistress, mentioning the currently rising tide
of parental interest in education in England, had sighed when

she had said, "It has had an amazing result. We school people now live in a spotlight. I suppose it's better than apathy." But I had felt that she wasn't so sure. At any rate, English school-masters haven't in the immediate past been as interested in public relations as they may need to be in the future. A young curate who'd spoken to the Wives' Fellowship in March had remarked, "These school people don't tell you a thing; they think parents are a dashed nuisance."

We could do with a little more of this hands-off attitude at home, I thought, as I sat with my books and papers at my English dining-room table. *More respect for the educators' professional opinion. Fewer courses of study written into law by legislators under the influence of citizen pressure groups. Less assumption by individual citizens that the school exists to serve their individual children.* By golly, there were cobwebs in the corner of the dining-room again! I'd feather-dusted them down just yesterday. *But on the other hand, the fact that we Americans think of the schools as ours to control makes them much more responsive to changing needs.*

Where was that news letter from home? Yes, I still had it. In the course of the academic year we'd been away from Pasadena, and in response to desires expressed by citizens, foreign-language instruction had been instituted in fifth, sixth, seventh, and eighth grades, including the preparation of all the teachers' manuals and the assembling of instructional materials necessary to the orderly presentation of the courses. English schools couldn't possibly have moved so fast.

But was it lack of citizen pressure that made the English schools slow-moving and rigid? Answer: *Partly, but partly it's the fault of the syllabus.* The necessity of preparing children to take nationally standardized exams at eleven-plus, at sixteen, and at seventeen or eighteen holds courses of study fast to the

outline of subject matter (the syllabus) on which students will be tested. If a Head has his hands full just pounding into their heads the classical physics required for a pass at age sixteen, he's not going to put much emphasis on atomic physics—however desirable he may personally believe that it is, in this day and age, for young people to understand the difference between fusion and fission.

Where was the advice Red's French master had given him? I'd jotted it down somewhere. Oh yes! "Now, don't bother learning the subjunctive; it won't come up in the examination more than twice. It's not worth spending hours and hours learning something which will cost you only two marks if you miss it. Better put your time on learning what you will definitely need."

Red was currently putting in a lot of extra hours studying for three exams his classmates would take at age sixteen. He was having to go at them a year early, because his housemaster thought him capable of passing and that it would be "sporting" for him to try. *Talk about "stretching,"* I now thought, *that boy of ours is as extended as a one-inch rubber band around a twelve-inch parcel.*

I agreed that standardized exams serve a very useful purpose. At home the Iowa Tests had established a national standard, and so had the College Board exams and those for the National Merit Scholarships. But I didn't believe that passing them should be the goal of education. What was it Tryon Edwards had said? "The great end of education is to discipline rather than to furnish the mind; to train it to the use of its own powers, rather than fill it with the accumulations of others." I was inclined to believe that the English schools were oriented too strongly toward the passing of exams.

Mrs. Blount stuck her head around the door. "I'm ready to go now, Mrs. Beadle," she said.

298

I stood up and stretched. Goodness, my back was tired! "It's time for me to quit too. I've been at this since right after breakfast."

As I paid her the five shillings she'd earned that day, I said, "It's a funny thing. I started out this morning to organize my notes on English schools—but I ended up getting some important things straight about American schools. Things I knew perfectly well at home, but I never got into proper perspective before."

Mrs. Blount knew exactly what I meant. "You couldn't see the woods for the trees," she said. "That's an old English saying."

"Yes, I know," I replied. "It's an old American saying, too."

"It *is?*" she said. "Fancy that!"

26

TURNING my notebook sideways to catch the light from a tiny table lamp in the hotel lounge, I reread yesterday's entry, in which I'd described the rolling greenness of Somerset and Cheshire, the dramatic black-and-whiteness of the half-timbered houses there, and the romantic ruins of Ludlow Castle. Then I added a new date line—"May 31, Lockerbie"—and began to write. "Today we crossed Lancashire. It's hilly and rugged, and everything seems to be made of gray stone. Into Cumberland, next. The Lake District is a Wyoming landscape in miniature. There were huge bushes of rhododendrons in bloom. Lupins in great variety, two to four feet tall. Hillsides golden with buttercups all the way to the crown. And behind the lot, wherever we looked, we saw the clear blue of a lake or the hazier blue of a mountain. . . ."

I felt that someone was watching me. I raised my eyes. Someone *was:* the plump little matron whom I'd noticed at an adjacent table at dinner that night. She had an eager, fox-terrier look on her face, and clearly wanted to speak—but couldn't quite force herself to take the initiative.

"I suppose you know the Lake District well," I said. "Lovely, isn't it? We've just had our first look at it."

She leaned forward, a flush suffusing her fair skin, and I thought that she would speak, but, apparently, she needed a bit more encouragement.

300

"Our son is having a school holiday, so we're about to see something of Scotland, too."

She exploded into speech. "You must forgive me, but I couldn't help overhearing your husband's remark to the waitress that your home is in California."

She doesn't look like the type of person who's keen on the movies, I thought. I'd disappointed more than one English fan of Debbie Reynolds or Tony Curtis by having to confess that residence in California doesn't automatically provide one with either a swimming pool or a movie star for a neighbor.

"A cousin of mine is living there now," the lady went on. "In a place called Uplands. Do you happen to know it?"

"Oh yes," I replied. "It's only thirty miles from where we live. A very nice town. Close to the mountains."

"The name suggests as much, doesn't it? It has a very English sound. I should think Cousin Ivy would like that."

(A vision of the citrus groves and sagebrush near Upland sprang to my mind; the place is about as English as North Africa.)

The lady continued, "My cousin writes that she has just got a new house with a paysho. She seems to be awfully proud of it. Would you mind telling me"—apparently this was the question she'd been burning to ask—"what a paysho is? A picture window, perhaps? Ivy says it gets quite a lot of sun."

A paysho? I frowned in concentration. Why, of course! A patio.

"No," I said. "It's not a picture window. It's an inner courtyard. Very much like an English garden, in fact, in that it's walled or fenced, and thus private. But it's likely to be bricked or paved, and your cousin probably cooks out there."

"I'm quite certain that Ivy has a proper kitchen." There was a tinge of affront in my interrogator's voice.

"Of course. I meant that your cousin probably cooks out of doors, *also*. Californians like to grill meat over charcoal or wood in large cast-iron tubs called barbecues, and eat right there in the pa—in the courtyard. It's rather like having a picnic except that you needn't pack a hamper and you sit at a table instead of on the grass."

"One does this even if one has a kitchen close by?"

"Oh yes. There's something very pleasant about dining outdoors, and meat tastes wonderful if it's cooked over charcoal."

"I'm sure it must do." But the lady was merely being polite. Even as my mouth was watering for the taste of a barbecued steak, I was thinking that it *does* sound barbaric to cook over charcoal in a cast-iron tub.

The next morning I had reason to recall Cousin Ivy, and to wonder fleetingly if she had learned to see beauty in the brown and gray-green Southern California scene, so hot with the color of hibiscus and poinsettia and bougainvillaea; its sun so gold and its shadows so strong and black—in all ways so unlike the green and gentle English Midlands, or the blue and silver landscape we were then seeing. It took us five hours to travel the eighty miles from Lockerbie to Glasgow because we were out of the car more than in it, prowling down country lanes and clambering up knolls for better views. It wasn't the countryside alone, lovely though it was, that excited us, but the luminescent skies, and the satin sheen they laid over everything. The light was brilliant without being brittle—so pure and clear it seemed sacrilegious to look up, as if this were the first day of creation.

Glasgow was quite a contrast. We couldn't even see the sky. It's the second-largest city in the United Kingdom and is often compared to Chicago. We wouldn't have gone near it—having made a point, during the preceding nine months, of avoiding industrial cities—if we hadn't wanted to see the Pontecorvos.

Guido Pontecorvo is a geneticist at the University of Glasgow, and with his family had visited Caltech a few years before. Their Lisa is the same age as Red; it was, in fact, a measure of the swift passage of time to observe that the two teen-agers who were now so absorbed in Tom Lehrer recordings had been equally interested, only three years before, in hunting man-eating tigers through the trackless forests of our back yard in California.

As we adults sat and sipped our after-dinner coffee, Ponte asked where in Scotland we proposed to go from Glasgow.

"We thought you'd have some ideas," George replied. "All that's definitely on our list is Edinburgh, and Stirling Castle. But beyond that . . ."

"Stirling Castle?" Ponte exclaimed. *"Why?* It's beastly dull."

"Because it's the site of Bannockburn. Surely you want us to see Bannockburn?" I said. Scots are as emotional about the Battle of Bannockburn—in 1314, when Robert the Bruce out-guessed and outfought a vastly superior army of English—as Americans are about Lexington and Concord. And Ponte is as proudly Scottish as any Stuart or Macgregor. He's been in Glasgow so many years that all save the faintest flavor of his native Italian has faded from his speech, and a slight Scots burr has been added.

Now, he said, "You can see Bannockburn without visiting the castle. As for Stirling, it's up to you. But I *can* arrange that you see a good castle. I'll get my maps and outline a two- or three-day itinerary for—— No! I shall conduct you there myself!"

"But, Ponte . . ."

"Yes! I shall conduct you myself. The lab can spare me; it's only for two days. After I have shown you Eilean Donan"—his eyes were sparkling with anticipation—"it will not matter whether you see Stirling Castle."

In the morning, when the four of us set out for the Highlands,

the sky was pale blue and filmed with white. It had turned stony gray by the time we reached Loch Lomond, and there was an almost invisible mist in the air. This was piny country, gradually growing wilder and rockier as we climbed. The trees grew progressively fewer and more stunted, until they vanished altogether, and we found ourselves in a melancholy but majestic wasteland. There was nothing there but rock and peat and little pewter-colored lakes—the kind of a landscape I'd pick for a science-fiction movie showing the arrival of the first men on the moon. Ponte told us that this was the Moor of Rannoch, part of a vast moraine that stretches from Skye southeast to Edinburgh.

We climbed higher, then, into a rocky defile, dark and desolate, through which a banshee wind was wailing. "A good place for massacres," Ponte said. "Shall I tell you about one?"

Red exclaimed, "This is Glencoe!"

Ponte nodded. "This is Glencoe. It was February 1692, and a blizzard was howling through this pass. . . ."

Alexander MacDonald, he told us, had been the last of the Highland chiefs to swear loyalty to William of Orange. He'd refused, at first—partly out of devotion to the deposed Stuart king, James, and partly out of hatred for the Campbells, who were Orangemen and sworn enemies of the MacDonalds. Finally, though, Alexander had been prevailed upon to take the oath. He did it five days after the deadline that King William had set, however, so the government decided to make an example of him.

There was a law that would have allowed the authorities to drive the MacDonalds out of the glen, and thus to have destroyed the clan; and maybe that's what some official in London thought he was authorizing when he sent a detachment of soldiers to Glencoe. But that's not what happened. The soldiers were led by *Campbells*. Even sworn enemies could not, in ac-

304

cordance with the Highland Code, be turned from one's door—especially in winter; so the MacDonalds took them in, fed them, and made sleeping room for them in their cottages. And then, one raw February morning, the soldiers arose before daylight and massacred the MacDonalds.

It was a rough age, Ponte said, but not so rough that men condoned the massacre of one's hosts. Alexander MacDonald was shot in his bed. So were forty others, including women and children. Some escaped by running into the hills, where most of them froze to death. "A black deed," said Ponte while the wind mourned through the glen. "A very black deed. The name of Campbell still bears a stain in Scotland."

We sat silent for a moment, in the shelter of the car, and then Ponte returned us to the living present. "The country becomes prettier now," he said, "and soon there will be a ferry ride to amuse you."

The ferry was at a hamlet with the singing name of Ballachulish, and from there we drove north and west into seamen's and smugglers' country. The closer we got to Skye, the more rugged the terrain became. Skye itself is the largest island of the several dozen that lie off the west coast of Scotland, like bits broken off a glacier and in some mid-stage of dispersal at sea. They spot the waters all the way south to the coast of northern Ireland, and their names are wonderful: Shona, Scarba, Canna, and Coll; Rum, Eigg, Muck, and Mull. (George said that they ought to be incorporated as investment brokerage firms.)

We first saw Skye as a gray bulk below Dornie Lookout. At the base of that high promontory lies a great body of water, poking its fingers into the numerous little coves and bays of the rocky cliffs that confine it. Beyond these stretch range after range of mountains. That afternoon the water was a dull silver, the mountains a symphony of ever-paler grays, and the sky a

somber slate. Then, suddenly, there was a burst of sunlight behind us. Little spangles exploded all over the water far below, and the rocks and slopes turned molten gold. Against that cold gray backdrop it was a breath-taking and awesome scene. There was nothing to say. We just stood and looked.

At the bottom of the hill is Lake Duich. In the middle of the lake, linked to the mainland by a causeway, is Ponte's castle—Eilean Donan. It's a sturdy stone fortress, small and almost windowless; a spunky, stubborn-looking place. It was a garrison for the Jacobite troops who tried to regain the crown for the Stuarts in 1719. As we came upon it, the sky was nearly covered by an odd, saucer-shaped cloud formation that was gray on top and saffron on the underside. Below it the castle and causeway were the color of dull brass and the water was inky black—save for restless streaks of gold that rose and fell and changed shape with the surge of the waves, as if alive. I've never seen Elsinore, but this was a proper setting for *Hamlet*. Or for a Wagnerian opera.

Scots ought to boast more about their skies.

We sat on the banks and watched the color fade, and Ponte told us about the bombardment of the castle during that first attempt to restore the Stuarts; and about the final attempt, in 1745, when Bonnie Prince Charlie led the invading army himself. He came to grief at Culloden. Just one jump ahead of the militia, he finally got back across the Highlands to Skye, and escaped the militia there because Flora Macdonald dressed him in women's clothing and said that he was her Irish serving maid. "Then, why," said Ponte, turning his voice gruff and accusatory, "does the wench walk so free and bold?" "Because"—his voice was higher and smoother now—"she's nought but a peasant girl. Would an Irish serving maid walk like a *lady?*"

306

It was a wrench to leave the ghosts of those romantic and bloody days and face the fluorescent lounges of the hotel.

The next day we had a picnic lunch by the shores of Loch Ness, hoping that the monster would favor us with the pleasure of his company, but he didn't; and had tea at Inverness, site of Culloden and the capital of the Highlands. It's roughly at the same latitude as Ketchikan on our side of the world, and here again the light had that opalescent shimmer that seems characteristic only of northern skies. Then we drove south through country as bleak as the Moor of Rannoch, with fine whistling-in-the-dark place names like Dalwhinnie and Killiecrankie.

It was a three-castle day. First we came to Blair Atholl, whose castle is so Scottish baronial it looks like a caricature of itself, and in whose fertile fields a herd of Highland cattle grazed—shaggy beasts, with henna-colored coats, as if somehow Texas longhorns had been crossed with Irish setters. A few miles farther on Stirling Castle loomed on the bluff of a hill above us. "Go ahead," said Ponte. He sat in the car while we prowled through the vast gray pile of stone, now a barracks. When we returned, I said, "You were right," and we drove down the hill in silence. Finally, as day died, we came to Linlithgow Palace, in the outskirts of Edinburgh; a lovely place, its ruins preserved in a parklike setting. Mary Queen of Scots was born there. As a little girl, she must have loved watching the water spout from the mouths of imps, dragons, and other grotesque creatures that ornament the frilly stone fountain in the courtyard. For great parties the same fountain ran with wine. The palace custodian told us that, when Queen Elizabeth visited Linlithgow a few years ago, he added red ink to the water to simulate the good old days. "It coom out fine," he said, smiling in satisfied remembrance.

Having now made a circle that had brought us back to within

easy commuting distance of Glasgow, we expressed inadequate thanks for the joy Ponte had given us, put him on a train for home, and set out to see Edinburgh. I've never heard of anybody who didn't think it is the most charming and the courtliest of cities. Except us. The two days we spent there were like paying a duty call on a distant and unknown relative; we did what was expected of us and departed as soon as was decently possible. The one excitement was the Scottish War Memorial, which, along with the castle, perches on a cliff 270 feet above the city. It includes a long bas-relief in bronze, depicting all the service specialties of the Great War. Since the men are shown in full battle dress and each detail of gear is painstakingly reproduced, it's a historical document. But it's a poem, too. The sculptor caught both the pain and the glory of war when he modeled those faces and figures; and I found it immeasurably touching.

When the Romans conquered England, in the first century, the Celtic peoples of the Midlands and East Anglia either got killed, became Romanized, or fled into the hilly fastnesses of Wales and Scotland. Additionally, in the Highlands, there were savage tribes who persistently raided the northern outposts of Roman civilization. To control them, the Emperor Hadrian had a wall built across that narrow neck of northern England that is bounded by such modern towns as Carlisle on the west and by Newcastle on the east. It wasn't a massive or an impregnable wall; it's only fourteen feet high and five feet thick. Its function was mainly to link a series of forts and sentry posts from which Roman soldiers sortied out to engage the wild tribesmen from the north whenever they attacked. It was this wall that had excited our imaginations ever since we had come to Britain—and perhaps it was the knowledge that we were so close to it that made us impatient with routine sight-seeing in Edinburgh.

We crossed Northumberland in rain so heavy that even the

308

foreground landscape was a blur. In looking back, it seems to me that most of the ancient ruins we saw in England we saw in rain, as if the skies were weeping beside a bier. At Housesteads, certainly, the grayness of the sky, the desolateness of the place, and the steady drum of the rain enormously heightened the emotional impact of the place. Housesteads is a farm—Americans would call it a ranch, for all it grows is sheep—which in the seventeenth and eighteenth centuries was a hangout for a band of horse thieves. That's why the Roman wall survived there: no farmer seeking a bit of free stone to repair his barn dared to prowl around the place. The wall must be worked for; it lies out of sight of the road, over the crest of a long hill. We beat our way upward through sodden meadow grass for fifteen minutes before we came upon the first stones of the fort. Then, from the remains of the North Gate, we at last saw Hadrian's wall stretching off to the east, now as 1800 years ago dipping and rising with the contours of the land, until it disappeared in the mist. There was nothing very heroic about it; I don't know why seeing it made all three of us feel so good.

There was another Roman fort at a place now called Chesters, where the baths are exceedingly well preserved, and the variety of relics in the adjacent museum changed our ideas of the kind of men who had garrisoned these places. They were not, as reason should have told us, Italians in short skirts and plumed helmets carrying banners labeled "SPQR," but auxiliaries recruited from Roman colonies in Belgium and Germany. There had been houses and temples and shops adjacent to the forts, and many of the soldiers had had wives. I think of them now as kin to the detachments of federal troops who were stationed at places like Ft. Kearney and Ft. Bridger in the wild American West.

Darkness, and the increasingly clammy feeling of our clothing,

finally sent us on our way; we stopped that night at Durham. But our feeling of excitement and satisfaction persisted, and at dinner we got to talking about how it had happened that the Romans, as sharp as they were, had left no permanent mark of their three centuries of British occupation.

"They weren't really *oppressors,* as I understand how they operated," George said. "They allowed religious freedom and encouraged the natives to become Romans; wasn't that the pattern, Red? They must have recruited for the armies from among young Britons, and there certainly must have been inter-marriage."

"We've seen some of their villas in Oxfordshire and Berkshire," I reminded the men, "so we know it was a peaceful and settled society—at least in the south. But it just vanished."

"I was reading up on it in Trevelyan," Red said. "He says that when the Angles and Saxons and Vikings came, there were so many of them they just overran the place and swamped out everybody who was here. They were superstitious, or something, and wouldn't use the Roman buildings or even the Roman towns, so they burned everything down, and started over. . . . He also said that the Nordic invasion was the most important single event in English history."

"More important than the Norman Conquest?" I asked.

"Yes, because the Norsemen changed the basic character of the people."

"But, Red, it was the Normans who unified the country, who made England a *nation.*"

"Mom, I'm only repeating what Trevelyan says."

We were in a Norman stronghold at the moment, but we didn't appreciate the fact until the next morning. Then we could see how high the twisting streets we had negotiated after dark had taken us. Durham's Old Town, its castle (which is

now the university), and its cathedral occupy a rocky promontory around which the River Wear describes a giant loop. Up on the hilltop we couldn't get far enough away from the cathedral to see it entire, and nothing about the part we could see prepared us for the interior. It had a quite literally stunning effect upon all of us, but especially on George. George, who had done his best to avoid churches ever since our trip to Italy, spent two absorbed hours in this one. Someone to whom we later mentioned the fact said, "Oh yes. Durham is a man's cathedral."

The nave is two hundred feet long by only forty feet wide, and it's bordered by enormously thick pillars, each ten or twelve feet across, joined by Roman arches. Above these pillars is a gallery in which the arches duplicate those just below, except that two smaller arches have been tucked into each big one. A level higher is the clerestory, where the arches are repeated for the third time, but in still smaller scale. All three colonnades are in such exquisite relationship to each other that it takes a while to figure out that it's their perfect proportioning that makes the church interior serene but not static.

The Normans didn't know anything about pointed arches and delicately frilled stonework. Their characteristic ornamentation was a chevron pattern deeply and bluntly gouged into pillars, lintels, or doorframes. Durham's massive pillars have been incised in this fashion, not only in chevrons but also in squares and spirals and vertical bands. The arches that span these pillars, and the simple vaulting overhead, are edged with a saw-tooth trim that has equally primitive vigor. The total effect is of great virility; Durham Cathedral is a superbly strong statement of faith.

At the west end of the cathedral is the Galilee Chapel. The Venerable Bede, England's first historian, is buried there. It lacks Gothic arches too, and the chapel ceiling is low; yet, like

the main sanctuary, it achieves an illusion of light and spacious-
ness that is most uncommon in a Norman church. The airy
feeling comes from a series of narrow, clustered pillars support-
ing four courses of Roman arches. I was bowled over by its
beauty; I think because it was virtually colorless, just a symphony
of grays and oyster whites, the textures varying from flagstone to
polished marble. George and Red took one look and went off to
climb the tower. I was still there when they came back. Just
sitting.

Before we left, I had to have my five minutes to inspect the
literature on display. George always said that it was silly to
examine this material because it's intended primarily for the
regular congregation. But I disagreed. English church display
tables are never standardized; the personality of the vicar or
clerk or dean always expresses itself somehow. As it did at
Durham. On the box asking for contributions, the dean had put
this note, "It costs nearly £2000 a month to maintain the
Cathedral. This sum works out at about £66 per day, £2/10/0
per hour, or nearly 6 d. every half-minute. You might like to
keep things going for a minute or two." We did a little better
than that, with a feeling of gratitude for the privilege.

From Durham south it was mostly a getting home. We'd had
just about all the sight-seeing we were capable of absorbing.

We made good time across Yorkshire, which is England's
Texas. There is windswept moorland in the North Riding,
fertile farmland in the East Riding, and a series of smoky
industrial towns in the West Riding. (Riding *doesn't* mean the
distance a man could ride in a day; it's a corruption of
thriding—one of three parts.) York is at the junction of the
three Ridings. The cathedral there is famous for its medieval
glass, but a colossal restoration project was under way and we

312

couldn't see much but scaffolding. York also has a well-preserved section of medieval city wall that it displays elegantly.

Before we went to bed at home that night, Red brought our books up to date. Gasoline, hotel bills, and food had come to just over fifty-one pounds. That's roughly fifty dollars apiece, for seven days and 1420 miles. It was a mighty good buy.

27

BY the middle of June the myriad greens of spring had gone, and only the burnished oxblood of the copper beeches relieved the velvety dark greenness of the tree tops.

The roses came resoundingly into bloom—scarlet, crimson, apricot, ivory, pink, and gold—against a cool backdrop of delphiniums. Out in the country the verges of the roads were gay with red and rose and pale pink poppies, their fragile petals quivering with every puff of wind.

Gardeners had long since looped the jonquil leaves into tidy knots and had lifted the early radishes from the cold frames; now gardens (and shops) were burgeoning with spring onions, leaf lettuce, succulent baby beans, and tender young rhubarb. Our bushes yielded a seemingly endless bounty of raspberries, meltingly sweet; these, and the new potatoes we dug just before cooking them, made each meal a gastronomic delight.

In June, too, the first salmon came into market. Paler and more delicate in flavor than the Chinook salmon we know on the west coast of America, it turned us into gluttons. English housewives gently cook the whole fish in bouillon and serve it cold, often with crisp cucumbers, and achieve a dish that is ambrosial.

Brussels sprouts were *out* of season.

Surprisingly—it rains all the time in England, ask any American—late June also ushered in a spell of drought. The once-glossy foliage of trees and bushes acquired a dusty film, lawns

burned to yellow, and vegetables drooped in dried-out soil. Hardly any householder was equipped to withstand drought; in fact, those few who watered their lawns or gardens with hoses and sprinklers severely taxed the water supply of Oxford, and had to be asked to restrict their usage.

The air hummed with the traffic of bees and wasps. The latter invaded bakeries and fruit stalls, household marmalade jars and fruit bowls, their access simplified by the open windows and doors that the English prefer to effete American screens. "Mrs. Blount, I don't care if we stifle to death in here, I will *not* have wasps in my house!" I kept saying. Mrs. Blount would shake her head. It was bad enough that I insisted on drying our woollies indoors, without benefit of good English air, but to keep the windows closed in weather as fine as this. . . .

Finally, with a crash and a bang, the granddaddy of all electrical storms dumped a cloudburst and three weeks of showers on us; and England was green again.

Days had grown long. In May you could read a newspaper outdoors at nine, and then at ten in the evening, and by mid-June the sunset glow was lingering, silvery pink in the sky, until almost eleven at night. (No contrast was greater, on returning to California, than to have night fall as if someone had suddenly turned off the lights in a ballroom.) It was a time for seeing Greek plays at twilight in college gardens, for having tea on terraces, for idling through the woods or along the water walks; in short, for taking life easy.

Only the young were tense. Red was staying up until all hours cramming for the exams his housemaster had thought it would be sporting for him to take. These were called O-levels; "O" stands for "Ordinary." Had he been an English schoolboy, he would have taken them in the following year, eight of them instead of the three he was tackling now. They were a necessary

preamble to having a shot at the A (for Advanced) levels, at age seventeen or eighteen, which qualify a student for university admission.

At the top of the educational ladder, at the university itself, the Honour Schools were in session. Americans would say that "finals" were in progress. For some thirty-six hours of writing, undergraduates were pouring out what they'd learned in their three or four years of tutorials and reading; and the gutters outside the examination building on the High were nightly yielding a rich harvest of champagne corks. Friends who were currently being spared the woe that was going on inside the building would wait outside on the steps; and when the drained-dry undergraduates came shuffling out after writing their last paper, there would be a bottle of champagne awaiting them. To be drunk on the spot.

But for the rest of us, it was a relaxed time, a sit-back-in-your-chair-and-chat time. Lifting his brandy and sighting into its amber depths, someone at a dinner party would begin, "It seems to me the undergraduates are growing rather bolder in the matter of boutonnieres. Carnations weren't so bad . . . but *irises!*"

And then, to us, "They've got to wear proper *sub fusc*, not even colored stockings, you know, for Schools. The carnation boutonniere is a sort of harmless protest. Expression of independence, and all that. But *irises!*"

Someone else would chime in. "D'you think there's any truth to that tale about the tankard of ale?" Another voice would say, "No matter. As long as it makes a good story, Oxford likes it. Tell the Beadles."

"All right. It goes this way. An undergraduate is said to have come to Schools armed with a secret weapon from the Statutes. . . ."

316

Interruption from the chair in shadow across the room. "Ridiculous to think himself more clever than the dons, what?"

". . . and after he'd sat himself down, he demanded that the invigilator fetch him the tankard of ale to which the Statutes entitle him."

From the chair in shadow: "Rather clever of him at that, though."

"So the invigilator *did* fetch the ale. And then sent him out of the hall. Told him he couldn't return until he was wearing his sword. The Statutes require *that*, too."

General laughter. Puffing of pipes in a moment of serene silence. Then a new conversational tangent. "According to gossip . . ." someone would begin.

"Which is undoubtedly Oxford's second most durable commodity, ranking just after motorcars and just before marmalade," another voice would cut in.

"According to gossip, there were twenty-six thousand volumes of books in Canon Jenkins' lodgings, and no nightwear."

Someone would chuckle. "Do you recall the notice he once had inserted in the *Gazette,* offering to supply 'informal instruction and miracles'?"

"And his blazing pipes?" someone else would say. "Sometimes they shot blue flames. I was told that he carried his sleeping pills in his tobacco pouch, and occasionally tamped a few into his pipe along with the tobacco."

Canon Jenkins had died, at eighty-plus, shortly after we had come to Oxford. "He was unmarried," his obituary in *The Times* had concluded, "having an equal aversion to women and to cats." A much-loved old gentleman, his longer-lasting obituary was the fond regard of people who had known him; and these recollections in turn would lead to anecdotes about other Oxford eccentrics, a long and honorable line.

The Heads of colleges, especially in the nineteenth century, were a notable lot. They ranged in temperament all the way from the strong-willed Lindsay of Balliol to gentle Spooner of New College—Spooner of the twisted tongue, whose name lives on in spoonerism. Lindsay knew what he wanted, and usually got it. Once the Fellows turned down a proposal he favored, voting 8–1 against him. "Well, gentlemen," he said. "We seem to have reached an impasse"—and adjourned the meeting. Spooner, who couldn't have uttered half the spoonerisms attributed to him, probably *did* say, when advising an undergraduate to get a bicycle, "Young man, what you need in Oxford is a well-boiled icicle." And he *did* announce in college chapel that the congregation would now sing the hymn that begins with "conquering kings"—only Spooner switched it to "kinkering kongs." But it's probably libelous to credit him with a transposition of the "b" and "h" upon intending to remark that he liked nothing better than a fine boar's head on a cold winter night.

By June our university acquaintances had learned that we didn't react to critical comment about the United States as if the speaker were attacking motherhood and the Flag, and they began to swap anecdotes with us.

One evening we had been talking about national stereotypes, and I was telling a group about an experience of a friend of mine. She and her husband had saved for years in order to finance the trip and their sabbatical stay in England, and they had nothing left over for luxuries. "So you can imagine their pleasure," I said, "when they were invited to a grand orders-and-decorations banquet at the Dorchester. The only flaw in my friend's pleasure was that she had no evening wrap—just an old cloth coat.

"Fortunately, the people with whom they were going to the banquet were not only rich but approachable, so my friend

asked her hostess if she happened to have an extra wrap of some sort; and she was given her choice of two, both fur. On the night of the banquet, as the women were queued up to leave off their wraps, my friend noticed that another pair of guests were watching her intently as well as listening to her conversation with her hostess. And as she turned away to go to the banquet hall, she heard one of them say, 'Did you notice her fur? These rich Americans have everything!' "

Mrs. Evans-Hume chuckled. "That reminds me of how excited I was when we learned we were to have a year at Princeton. I could hardly wait to do my cooking in one of those splendid American kitchens full of appliances that do all the work while one stands off to the side and tends the buttons. But the house that was let for us there wasn't as up-to-date as mine here in Oxford."

"*I* had a fine kitchen, when we were in the States," Mary Rowlands said, "especially the fridge. I remember how thrilling it was, the day we arrived, to find that some thoughtful faculty lady had completely stocked it with food for us. This is an example of that wonderful American hospitality, I thought. Especially when I found a note, which had been slipped under the butter dish, on which there was a schedule of dates and the names of the ladies who would be coming to call on those days. I was *so* pleased, and I told Henry, 'Isn't that American efficiency, though?' " She giggled. "And then not one of the ladies ever showed up."

I drew in my breath. "Oh, Mary," I said. "I think that's shocking."

"They were terribly nice later," she said. "And we ended by having a most enjoyable stay. I must say I rather miss those supermarkets."

"They're coming, though," another lady remarked. "The self-

service stores are enormously successful. One can hardly get through the aisles."

"And the variety of frozen food increases all the time," someone else said. "There's nothing especially novel any more about presliced and packaged bread, and I've noted that the Co-ops are precutting their meat and putting it in plastic film, as is done in the States."

"The one near me on the London Road has installed a rotissomat," I remarked. "They're cooking young broilers on spits under infrared heat, and selling the whole bird for ten bob."

"But the innovations that are a great success in America don't always catch on here," Mrs. Evans-Hume said. "Remember when cakes mixes were introduced? In the early fifties, wasn't it? In America one sees dozens of different kinds, but I believe there are only one or two that have survived in England. And putting tea into paper packets has been a failure here too."

I disputed that. "I'm not sure tea bags have been such a failure," I said. "There are three different brands on display at the shop where I trade. Any time there's enough business to support three brands of anything, *somebody* buys it. I don't suppose any of you . . . ?"

They all looked shocked, and shook their heads.

While we had been making these comparisons, I'd been tempted to say that Britain is beginning to catch up with the United States in supplying well-designed, tasteful clothing and household goods for the masses, but I refrained. Imagine claiming that my young, raw country has better taste than the country that produced Wedgwood and Chippendale, Wren and Adam! But, of course, that's what has happened in the course of the past thirty years. The great leveling of society that has taken place in the United States has upgraded the taste of the middle and lower classes, who now buy good copies of Swedish modern

320

instead of massive two-color mohair "suites"; who are less frightened of abstract art and symphony orchestras than they used to be; and who have learned to prize simplicity in both dress and interior decoration. (A comparison of the modern Sears Roebuck catalogue with one published in the 1930's will prove the point.) Increasing knowledgeability and sophistication in popular taste are coming to England now—with such shrewd merchandisers as Marks and Spencer (a British equivalent of Penney's) and the mass-circulation women's magazines leading the way. But there is still an enormous gulf in England between the taste of the classes and the masses.

Meanwhile, over on the men's side of the room, George was saying, ". . . and of course if the chap hadn't had so much wine, he would never have been so outspoken. Apparently, they'd been informally 'dedicating' the lab all afternoon. I'd given my speech at four, not a very good one, I'm afraid; and then there'd been the official dedication, with quantities of sherry afterward. Finally, this young fellow—a pretty recent graduate, I'd say—came up to me, and grabbed the lapels of my suit jacket. . . ."

The men around George smiled. The fellow must have been quite drunk. Englishmen normally avoid all personal contact. They don't grab lapels to command attention; they clear their throats or point their pipes at each other.

". . . and then he said, 'Professor Beadle, that was a most enlightening lecture. Far better, if I may say so, than the series you gave at University College, London. Much less turgid.'"

George's Oxford audience laughed heartily. For a young graduate to speak so candidly to a professor meant that he had been *very* drunk.

"That's the only time since we've been in England that I've known for sure what someone thought of my efforts," George

concluded. "In fact, I could have done with some of that out-spokenness during my first series of lectures here. I'd stop every fifteen minutes and ask if anyone had questions, and nobody ever peeped a peep. Then, afterwards, when the hall had nearly emptied, someone would come up and ask a question that indicated I'd probably snowed the lot of them. Talked over their heads, I mean. It was very frustrating."

John Cavendish spoke up. "I had the same experience in reverse, when I did that year at Dartmouth. It was shattering to be halted during a lecture and asked to do a better job of it. Not that they put it quite that way. It was on the order of, 'Come again, Professor, if you don't mind?'

"Of course, I *did* mind, because the object of lecturing at Oxford isn't to instruct the young, but rather to show off one's own bag of tricks, and I considered the undergraduates at Dartmouth most impertinent. . . . They were really just frightfully keen, and nobody has ever told them that children should be seen but not heard. In the end, I came rather to like their insistence on getting the facts. Keeps one on one's toes."

"It's interesting," George said, "how the English and American schools operate in reverse. We give our youngsters much more freedom in secondary school than you do, but tighten the reins considerably when they go to college—more required courses, more frequent exams, lots more pressure all around. You give them no freedom to speak of until they get to university, and then you turn them completely loose."

A schoolmaster in the group—he'd just returned from an exchange year at a New York boys' school—said, "Perhaps that's because America keeps all of its youth, including the dull ones, in school until they are eighteen? And because you don't apply selective procedures until they reach university age? I should hazard a guess, in fact, that you use the university *itself*

as your selective device. Something on the order of half your youth now go to 'college,' I believe? Here, it's far less, as you know. At my school, only 11 per cent prepare for university— so, of course, we have to wind them up sooner."

"It's too bad they have to specialize so early. Yours," George said. "I don't know how it is in the humanities, but in the sciences a good many undergraduates here are weak outside their areas of specialty. One of the boys I've been tutoring, a very bright young fellow, has got interested in virology and would like to do his doctoral research at Caltech. But he's been trained as a classical botanist, and his background in math and physics is hopelessly inadequate. The only way we can take him at Caltech is to admit him on condition that he go back to school first and learn some calculus."

"Go back to school? An *Oxford* graduate?" (This from a non-scientist don.)

"I'm afraid so," George replied. "I must say it's been a surprise to me to find that some undergraduates here haven't been as well prepared by their secondary schools, particularly in math, as many of those who come into Caltech from American comprehensive high schools."

A chill suddenly descended; it was that word "comprehensive" that had done it. So George moved rapidly to dispel it. "Of course, I'm talking about only a limited number," he said. "Those few who've grown interested in one of the areas in modern science which have become a synthesis of several specialties. Biochemical genetics, for example, is a blending of chemistry, physics, and biology, with math as the foundation. . . . Incidentally, Mr. Cavendish, how did you like having all your Dartmouth boys present at *every* lecture, writing down every word you spoke?"

The tension eased in a general laugh, for Oxford under-

graduates aren't the inveterate lecture-goers and note-takers that American college students are. With good reason. Nobody is going to examine them on the content of any course—only on their over-all knowledge, when it comes time for Honour Schools. Which reminded someone else of a good story:

"Reynolds was telling me last week of how he averted a crisis in our relations with Latin America. Seems he had a man from Argentina—or perhaps it was Bolivia—anyway, he was scheduled to give a lecture that afternoon, and you know how fine the weather has been. Reynolds realized that the undergraduates would in all likelihood be punting on the river. But he also realized that the gentleman from Argentina—or Bolivia, or wherever it was—would consider an empty lecture hall as a personal insult.

"So Reynolds persuaded some of the staff and their wives to come by, and he telephoned a general invitation to the finishing schools roundabout—they're *full* of girls from South America, you know—and the fortunate result was that the assigned lecture room was found to be too small. The entire crowd had to move to a larger one, and the V.I.P. was very flattered. But Reynolds had been quite right in his initial assumption. The undergraduates were on the river."

The river was a good place to be on a warm June afternoon. The Thames Valley is cut by hundreds of streams, none of them deep or fast-flowing; and it was a never-ending source of delight to me—who have never, in my citified life, even *seen* an ole swimmin' hole—to watch people sunning themselves on grassy riverbanks or diving from half-submerged tree trunks into the green-brown water.

Southern California children know nothing but tiled pools and seashore sand, and Red reacted with horror to the idea of putting his bare feet into *mud*. But he learned to paddle a

kayak. He and his friend Francis Cooke spent one exhilarating Sunday afternoon swooping and turning—like terriers yapping at a St. Bernard—around the punt that George, with grunts and occasional profanity, was learning to pole. It looks so easy when an experienced punter goes gliding past, but the tyro must guard both against pushing with uneven force (which makes the boat veer) and thrusting his pole too deeply into the river bed (which can result in his being left dangling on the pole while the punt shoots out from under him).

One Sunday we took an all-day boat trip on the Thames. It was a bittersweet day. Lovely in its beginnings, with the brilliantly colorful, tidy gardens of the lockkeepers and the stately processes of opening and closing locks as counterpoint to the intervening green and quiet stretches of the river. The one flaw was that volume of traffic (a variable, of course, according to weather) affects the speed with which craft can pass through the locks—and our steamer spent so much time in watery queues that we didn't get to Marlow, the end of the run, until three in the afternoon, two hours behind schedule.

Stupidly, we had brought no lunch; nothing but orange squash had been sold aboard; and watching our more foresighted fellow passengers dig into their picnic hampers had further whetted our appetites. The boat would return, on schedule, thirty minutes hence—so, the minute it tied up at Marlow, we thundered down the landing stage in search of food. "Now, if you'll take whatever is ready and don't ask for anything special, we might have time for a whole meal," George warned, as he paced us through a park and up to the town.

One café was open. We studied the menu, making our choices on the basis of what would be quick. Then the manager approached us. He was most regretful. He had run out of food. "The boat is nearly always late," he reflected sadly and sym-

pathetically, "and Sunday after Sunday, there are people like yourselves whom I must disappoint."

We lunched on ice-cream bars, snatched at a stand in the park as the boat cast off for the return trip. George was as close to a black fury as he ever gets, and spent the journey back hatching schemes for making a pot of money out of opportunities the English ignore. The first of these schemes involved selling box lunches on the landing stage at Marlow.

"I just don't understand the English lack of enterprise," he said. "Look at Oxford. *One* Wimpy's. *One* Palm's. Why isn't anybody smart enough to imitate them?"

Wimpy's is a hamburger joint in the civic center; always jammed, and not just with Americans. Mrs. Palm's is the delicatessen that is the foreigners' home-away-from-home in Oxford, the only place where one can get rye bread and chili powder and avocados and spicy German sausage. She did a land-office business. And, as George said, neither place had any competition.

"Add launderettes to your list," I said. "I've started going again to the one on the London Road. With so little rain, our stuff has a pretty good chance of drying dry outdoors now.

"Well, the manager told me she'd missed seeing me, and I said I'd have been a regular customer all along if she'd had hot-air dryers. She said, 'Yes, many American ladies have praised the convenience of such dryers.' But she was only being polite; you know, as if I'd just told her how deep the Grand Canyon is. Then she went on to say that *English* ladies prefer their laundry ready for the iron.

"I'd like to test that. So, after you've made your first profits on selling box lunches at Marlow, *I'm* going to install hot-air dryers in a launderette somewhere. I have a feeling that English ladies might be good and ready to forgo the pleasures of

wrestling damp bed sheets back and forth across their ironing boards."

"Yes, but Mom"—Red insists on being fair, which is a great inconvenience on occasions like this one—"you've been saying all along how nice it's been to get away from American standardization and efficiency. You've been saying how much you like the slower pace here, and that there's no high-pressure selling, and that everything is more personal than at home."

It was a good point. I *did* like the lack of rush. The English don't look or act as harried as Americans. They don't frown as often, and smile more. The English storekeeper takes the time to say, "Good morning" before he asks if he may serve you; the American says, "What'll it be for you?" without preamble, or just, "Who's next?"

I also liked the flexibility of most English rules. Imagine any American librarian refusing to collect the fine on a book because it was "only one day past due." It had been entertaining to observe that temporary "No Parking" signs got shifted about quite openly by motorists hungry for parking places; and we never met a pubkeeper or wine merchant in England who refused to sell us cider or spirits a little before or a little after "hours."

I was enormously impressed, too, by the English system of magistrates, in which all breaches of the peace are first heard in a neighborhood court by a citizen-judge—someone appointed to the job because of intelligence and background, not because he or she possesses special expertise. The magistrate is free to dispose of those cases that need go to no higher court in most any way that seems sensible. (A legal adviser sits with the magistrate, but only to see that his disposition of the case doesn't *break* the law.) In America such a system would be too casual and would soon be codified, the magistrate either being forced to stand for

election or to qualify as an expert under Ordinance No. 1783, Section 2.45, Subsection (c) of some municipal code.

Musing on in this vein, as the launch cut slowly through the quiet waters of the Thames, I said to George, "Red's right, you know. Even if it isn't very fast or efficient, there's a lot to be said for muddling through. Think of the affair of the crossed check. At home, you'd still be waiting for your money."

George smiled. "That *was* a funny one, wasn't it?"

As a protective device, most English checks either come with two lines printed vertically across the face or the person who draws the check pens in two comparable lines. This "crossing" prevents the check's being cashed; it must be deposited, first, to the account of the person or firm to whom it is drawn. As for accounts, there are two kinds: internal and external. Ours was the latter; they exist for the convenience of foreigners like ourselves, who had brought dollars into Britain. (They make possible one's taking home an equivalent sum.) British law forbids the deposit of sterling into an external account—unless the person or institution issuing the check has been authorized to do so. Oxford *had* been, and the pounds it put into our account were what fed us. But other British institutions did not, naturally, have the proper authorization, since George came to them—to give a lecture, for example—only as a transient visitor.

The "affair of the crossed check" had come about this way: George had conducted a seminar at a Scottish university, and had been reimbursed by check for his travel expenses. When he got back to Oxford and took it into the bank, he discovered that it was a crossed check. So he couldn't cash it. But he couldn't deposit it, either, because its deposit into an external account hadn't been authorized.

He and the bank clerk had stood looking at the check as it

328

lay on the counter between them. It appeared to be no good to either of them.

"Well," George had finally remarked, "what'll we do with it?"

"Allow me to confer with the manager, sir," the clerk had said.

The manager had joined the two of them at the window. There had been the ghost of a smile on his lips.

"You'd be spending this money here in England, wouldn't you, sir?" he'd asked.

"Sure would," George had replied.

"Then . . . ah . . . perhaps the best solution to the problem might be to cash it for you?"

"That strikes me as an . . . ah . . . *admirable* solution," George had said, adopting a favorite English adjective for a uniquely English situation.

We *had* spent it, too. Right down the street, at Shergold's, for paraffin.

Still to come was our last day in Oxford, when we bundled our dirty clothes and other leftovers into two packages and took them to the Headington Post Office. One weighed 9¾ lbs. and was speedily dispatched. But the other, at 11 lbs. 1 oz., was just an ounce too heavy to qualify for the 8- to 11-lb. parcel-post rate. The clerk's face puckered into a familiar expression, and we knew what was coming. Whenever a package *barely* weighed into a given rate block—this one was just into the 11- to 15-lb. rate—the girls at the post office tried to persuade the customer to take the package home and rewrap it. (We never wanted to, and always did, not daring to behave like wasteful Americans in the face of that frugal British concern for our pocketbooks.)

On this particular day, however, the clerk happened to look at us before she voiced the customary suggestion. We'd been

packing and house-cleaning for a week, and it was obvious now, from our weary faces, that we were bone-tired. So, instead of advising us to take the package home, she looked George directly in the eye, and said, firmly, "I make it just on the line at eleven pounds, sir."

Wonderful people.

I'd still like to give those box lunches and hot-air dryers a try, though.

28

WE'D been in queue outside the Sheldonian Theatre for twenty minutes, Red and I, and my fashionably pointed shoes were starting to pinch. So I leaned back against the iron railings of the fence—just a little, not enough to risk dirtying my best print dress or my long white doeskin gloves. Red was wearing his best too: gray flannel suit (the trousers a bit high over the ankles now), the silk version of his school tie around his neck, and his pristine straw boater, its band in school colors, set square on his head.

"Pop will be having his second glass of champagne about now," I said. "Pretty high living, eh? Champagne and strawberries at eleven in the morning. Courtesy of the Right Honorable Nathaniel Lord Crewe, bishop of Durham, dead these more than two hundred years."

"Oh," said Red. "The Creweian Benefaction! You mean he left the money for *strawberries and champagne?*"

"Sure did. A whole five pounds per annum. That was probably a lot of money in the eighteenth century. But I doubt it even begins to pay for the refreshments that the bigwigs are lapping up over at Magdalen today."

The cheering cup of wine was a good idea for someone like George, since it would make his processional march through the streets of Oxford, in full academic regalia, a little more endurable. That's what I was thinking as our queue outside the

Sheldonian started to move; actually, as I realized when I set eyes on him thirty minutes later, I needn't have worried about his discomfort in the spotlight. He'd been with Dame* Margot Fonteyn the whole while, and he bounced into the Sheldonian looking as buoyant as if he'd just been elected president of her fan club.

The reason that George was eating strawberries and drinking champagne, and the reason that Red and I were queued up for seats at the Sheldonian, was that today was Oxford's Encaenia—the fanciest university ceremonial of the year, when honorary degrees are awarded. George was to get one. So was Dame Margot. And five others: Prime Minister Gordon Menzies of Australia; Sir William George Penney (head of Britain's atomic weapons research); Lord Somerville of Harrow (a lord of appeal, equivalent to a justice of the U. S. Supreme Court); historian Peter Geyl; and German scholar Eliza Butler.

Red and I were to sit above them, somewhere on the benches that ring the circular theater. The honorands were to stand in the pit, holding onto their poise as best they could, while hundreds of eyes focused on them, and the Public Orator extolled their virtues in a language that none of them understood. Even their names would be Latinized. Then the Chancellor would shake their hands and admit them to the rights and privileges of their new degrees.

Of the seven, Dame Margot and Prime Minister Menzies were the two in whom the public was most interested. A few years back, when Harry Truman had received a honorary degree

* Americans tend to choke a little when they say this title, doubtless because they've heard so often that there's nothing like a dame. A Dame, however, is a lady who's been knighted. She can't be a Lady because a Lady is the lady of a *man* who's been knighted.

at a ceremony like this, the undergraduates had lined the parade route up to the Sheldonian, yelling "Give 'em hell, Harricum!" But the American honorand at *this* June's Encaenia lacked Harricum's high position or fame and was just the guy lucky enough to have drawn the beautiful ballerina as his partner in the procession. ("Luck, nothing!" George says. "It was fast footwork.") It was she around whom the photographers swarmed.

The procession had started marching across town from Magdalen at just about the time we took our seats in the Sheldonian. I should have liked to see them, but had no fault to find with the spectacle in Technicolor and Vista Vision that was unfolding where I was. The dons were assembling. There was a bustle of activity on the floor, a shimmer of white shirt fronts and bow ties, a constant shifting of color as their hoods swung toward the viewer, or away: the lot of them looked like a cage full of parakeets.

At noon precisely they stopped twittering. The galleries hushed. The organist played the final chord of a Bach fugue. And we all sat silent, waiting.

Then the great center doors swung open. Outside, in the bright sunlight, we could see a blaze of scarlet and blue and a glint of gold. The procession marched in—not very smartly, but with the dignity of the ages. First, the university marshal and the verger. Then the mace-bearing beadles. Then the Chancellor: Lord Halifax, nearing eighty now, and bent beneath the weight of his years and his robe of office. (He died the following year.) He was wearing court dress, with black satin breeches, and a black brocaded gown with sleeves and hem encrusted with gold lace. An undergraduate page carried his train. Behind him came the Vice-Chancellor and the proctors, the snowy ecclesiastical "bands" under their chins starched to highest Puritan

333

standards. Then the Heads of House and other university officials. Finally the Doctors. Divinity, medicine, music, letters, science, civil law. They sat in two crimson lines on either side of the Chancellor's throne.

We sang "God Save the Queen."

The Chancellor declared the Convocation open. ("What funny-sounding Latin," I whispered to Red. "Old-style pronunciation," he whispered back.)

The beadles went out, returning with a bunched-up band of honorands; now there was a Beadle in the pit, too. They all sat demurely, on opposite sides of the little aisle, like children at dancing school.

First up was Menzies—a tall man, straight and vigorous, with a face that made one feel good just to look at it, and eyebrows like circumflexes. A ripple of laughter coursed through the Sheldonian when the Public Orator said something about *"Matildam ad chorum invitatum."* One doesn't have to be stuffy, just because one is speaking Latin, and apparently he had just alleged that the Prime Minister likes to explore the Australian outback while singing "Waltzing Matilda."

Menzies got a bigger hand than those lesser-known personages who followed him—Donaldum Baronem Somervell de Herga, Elizam Marian Butler, and Petrum Geyl—but the star of the show was clearly Dominam Margot Fonteyn de Arias. She was getting an honorary doctorate of music, a degree whose gown is a creamy brocade with facings of shocking-pink silk. It is a robe enormously becoming to a woman, and her skin was very nearly the same ivory as the brocade. Her carriage was superb, of course, and the fine black silk jersey dress and double strand of pearls one could glimpse when she moved did nothing to destroy the illusion of grace and elegance she projects from the stage. She was doubly in the news at that particular time because her

334

Panamanian diplomat husband had just been involved in an abortive revolution. Hence, when she rose to stand beside the Public Orator, the entire audience in the Sheldonian—as one person and with one rustle—leaned forward to get a good look. Had I been in her place, I should have felt like the last pickle in the jar, with tongs coming at me. She just lifted her chin a little, and smiled.

The Public Orator let her off easy—no jokes, just some flowery references to the fact that her "shapely physique is transfigured by genius." Or, at least, that's how the official translation of *"corpori venusto addit ingeni dotes"* read. Obviously a bachelor don—an *old* bachelor don—had done the translation.

Willelmum Georgium Penney came next; and then Georgium Wells Beadle. The Public Orator had had a flash of inspiration when he had been considering how to describe George's work with bread mold: *"Legimus in libro Iosue e Gabaonitis dissimulandi causa ostentatos esse panes mucore corruptos,"* he began, and everyone smiled. How clever of him to have remembered the reference in the Book of Joshua to the Gibeonites having "used moldy loaves to further their deceit." The Public Orator made it clear, however, that George had been interested in furthering scientific truth, using *"fungum illium qui appelatur Neurospora crassa."* George got a big grin on his face at that point, partly because it was comforting to recognize the familiar botanical name, and partly because it sounded so odd to hear *Neurospora crassa* restored to the company of its kinfolk in an entire Latin sentence. And he looked impressed, in spite of himself, when the Public Orator got to the grand finale; Latin *does* have a majestic rhythm to it: *"Presento vobis hospitem acceptissimum Georgium Wells Beadle, Artium Magistratum, Collegio de Balliolo ascriptum, Praemio Nobeliano donatum, ut admittatur honoris causa ad gradum Doctoris in Scientia."*

335

The rest of the Encaenia program included recitations—from high pulpits hung midway between the galleries and the pit—by undergraduates who had won prizes for their various compositions. Miss Stephanie Roberta Pickard of Somerville read a bit of her translation into Greek of a *Circassian Love Chaunt* by Coleridge; Mr. David Patrick Walley of Merton quoted a few verses from his Latin poem on space travel; and a Balliol man with a Scots burr and the lovely name of James Iain Wilson Brash gave us an inkling of Gladstone's views on education.

Finally, the spotlight swung back to the Public Orator, whose Creweian Oration was similar to an annual report. This time there were English translations in our hands, so *everyone* could appreciate the wit and wisdom of the speaker. His best laugh came when, in referring to that spring's great Latin debate, he recommended that the opposing factions take Vergil's advice: *"Claudite iam rivos, pueri, sat prata biberunt"* ("Dry up, my lads, the meadows are awash"). Finally he came to a graceful conclusion, and in the same sentence suggested that it was time for lunch. Then the Chancellor dissolved the Convocation, and off we all went.

University officials, the honorands, and other distinguished guests were to have lunch at All Souls College. So I sent Red off to whatever culinary treat the cooks at the Muni had prepared that day for their schoolboy trade, and followed in the wake of the official procession to All Souls. When I finally found George, in the quadrangle under the great Wren sundial, he was just relinquishing Dame Margot to the Vice-Chancellor. He acknowledged my congratulations on his new honor with a far more gracious and benevolent smile than husbands customarily bestow on wives. Dame Margot—and I mean no disrespect—must be quite a dame.

336

Among the notables who needed no introduction was Sir Anthony Eden, an elegant sight in his scarlet D.C.L. robe with squashy velvet bonnet. There, too, was Sir Alan Herbert, the lawyer-author whose *Holy Deadlock* played a major part in getting the English divorce laws modified. At the moment we strolled past him, he and Lord Halifax had their academic headgear point to point, and Sir Alan was saying, "Now, just the other day I was telling Winston . . ."

We lingered within earshot while Professor Geyl, a Dutchman, finished the anecdote he was telling the Master of Balliol and Lady Keir. "It *is* a difficult name for the English to pronounce," he was saying. "So I have become quite accustomed to being called 'Guile.' Except at any London club, of course. There, the porters mark my messages, 'For Mr. G-a-l-e.'" George and I smiled, too, and walked on. A very English story. The porters would be Cockneys; and "Guile" would be the Cockney pronunciation of a surname written "Gale."

The Mayor of Oxford was at the luncheon party too, his gold chain of office in a wide loop about his shoulders. The Dean of Christ Church, sweating a bit under his clerical collar and his heavy robe of red wool and black velvet, was talking to the Mayoress. (That's the mayor's wife. Once in a while, the mayor is a woman. But she is still addressed as "Mr. Mayor." And I suppose that her husband, poor thing, is the mayoress.) The Heads of House and the Doctors made a gaudy splash of color against the old stone walls of the college. By comparison the women at the party looked like wrens. The feminine honors seemed to be about equally divided between Dame Margot and the Right Honorable Robert Gordon Menzies' trim little Dame Patty.

We lunched in the library—a vast, two-storied room, its proportions and architectural detail an example of the eighteenth

337

century at its elegant best. A priceless collection of rare books is housed there, behind beautiful brass grilles. We ate turbot in shrimp sauce. Jellied chicken and asparagus. Coffee ice cream with overtones of rum. Strawberries as big as plums, with cream almost too heavy to pour. And coffee, afterwards, in the quadrangle.

"You could certainly get used to this life, couldn't you?" George said when he finally found me. I was leaning up against a doorway, sipping coffee, and blissfully watching all the pretty people.

They began to drift away by three. We went over to Balliol, to allow George to remove—for a bit—his weighty scarlet robe. Then we set out again; this time for the Vice-Chancellor's Garden Party, the university's "family party" of the year. (Gowns are worn but wives are brought.) George and I sat on a low wall and watched them arrive: it's a splendid show, in case prospective tourists who are reading this can arrange to be in the vicinity of the Vice-Chancellor's college at 4 P.M. on the Wednesday of the week following Trinity Full Term, and the weather's fine.

Behind those college gates, on this particular Wednesday of the week following Trinity Full Term, the dons wandered about sipping tea and admiring the plantings in the Magdalen College gardens, making mental notes that the gardeners at their own colleges ought to be gingered up a bit. The dons' wives wandered about sipping tea and appraising each other's hats; for an organdy mobcap of the type Mrs. Smathers has got, one *does* need a well-defined chin line, doesn't one? There was chitchat about the O.U.D.S. production of *The Birds;* and how nice it was to have all the examinations done with, only the *vivas* left; and what plans have you made for the Long Vac? Nobody

asked us if we were missing our steam heating, or if we were getting to see any of the *real* England. I was both elated and depressed. "George," I said, "we've finally made it. We're members of the family. And in just three weeks we've got to go home!"

We wandered down to that part of the garden that is bisected by a bit of the river. In the beds along the graveled paths the Canterbury bells were standing as tall and proud as any Head of House, the larkspur hazy blue beside them. Peppermint-striped phlox and rubrum lilies nodded in the breeze, with here and there a spike of yellow rue. There was meadow just over the river, and a line of noble trees beyond the meadow, and, high above, some languid puffs of cloud in a clear blue sky. It was too much. We were suddenly unbearably tired.

I said, "George, my feet are killing me" just as *he* said, "Honey, I'm sweltering to death." We smiled at each other. "Let's go home."

It was rush hour. Cyclists came swooping down the High like swarms of bees. The big red busses thundered past in series, and motorcyclists ranged along the fringes of each lane, like yapping dogs.

"I will not make a dash for it, dressed this way," George said.

He didn't have to. A bobby held the pack at bay, and George strode across the street with all the dignity and pride one would expect from a new D.Sc. (Oxon), his red gown belling out in the wind like a cavalier's cape. I pattered along behind him, like the Oxford wife I'd seen on that figurine so many months before.

On Magdalen Bridge there was a small party of American tourists sitting on a bench. One of them spotted the oncoming vision in red and jumped to her feet. But George was going too fast for her; he was gone before she'd even got her Box Brownie

out of its box. Such a pity, too: in addition to the gondolier in Venice and the guard on the horse at Whitehall, it would have been so *nice* to have shown the folks at home a snapshot of a Genuine Oxford Don.

29

IT promised to be a fine, hot Fourth of July. Whatever the millions of people at home were setting forth to do today—a trip to the beach, a parade in town, a picnic in the park—one thing was pretty sure: not many of them were going, as we were, to church.

"C'mon, Mom! Pop's got the car out. We've got to be there by nine-fifteen, or all the places will be taken. Cooke warned us, remember?"

We were there at 9:10 A.M., and the places were very nearly taken; the parents of Magdalen College School boys are an eager lot. The Commemoration Service wasn't due to start until ten, but I didn't mind waiting. St. Mary the Virgin church was cool and shadowy, and full of history.

Ahead of us a few pews was the pillar whose molding had been mutilated in 1556, in order to anchor the platform on which Archbishop Cranmer was to stand when he publicly recanted his Protestant opinions. Only he'd reaffirmed his heresy, instead. And had gone to the stake. That was during the reign of Bloody Mary, when Roman Catholicism had been restored as the state church. But only briefly. The reaction had been Puritanism.

Not that *it* lacked dissenters, either. My eyes strayed to the pulpit across from Cranmer's pillar. In 1606, a young Fellow of St. John's had stood in that pulpit and had preached a sermon

for which the church authorities had reproved him because it was "too popish." But he had persisted in his views. He was William Laud, later Chancellor of Oxford, Archbishop of Canterbury, churchman-turned-statesman. Americans should be grateful to him. It was his persecution that drove the Pilgrims to Cape Cod.

The organ had started to play a Handel overture. It was solemn music; a bit funereal.

Laud, of course, had gone the way of Cranmer. The skullcap he'd worn at his execution is on display at St. John's, and his bones lie under the altar of the college chapel. *Except*—I smiled at the thought—*when he and King Charles are bowling.* To dedicate the library he'd added to the college in the seventeenth century, Laud had given a party for Charles I and Queen Henrietta; and now (or so it's said) the ghosts of the two men play bowls there, using their own skulls for balls. One can't see much of the action nowadays, however; they play at the original level of the floor, which has since been raised.

There were the final chords of the introit. The Master was taking his place at the lectern. "Let us now praise men of renown. . . ." he began, reading from Ecclesiasticus.

Cranmer and Laud. Wesley and Newman. *Like a pendulum swinging across the centuries,* I thought. In the 1730's, John Wesley and his Holy Club had gone from services at St. Mary's to his rooms at Lincoln College, where they'd had long, argumentative discussions about Anglican doctrine. John Newman, too, almost a hundred years later, had fallen to wondering what the Established Church really stood for. He'd been Vicar of St. Mary's in the 1830's. But the two churchmen, in their separate centuries, had moved in opposite directions—one to found Methodism, the other to lead many of his fellow Anglicans back to Rome. Newman, of course, had died a cardinal.

The choir had sung the "Jubilate Deo," and now the vicar was beginning the commemoration prayers.

I made the responses abstractedly, reflecting meanwhile that it was an accident of location that had caused so much history to be written in St. Mary's. The significant fact was that men who made history had been at the university, and thus at St. Mary's. "Full of grace, and beauty, and scholarship; of reverend antiquity, and ever-young nature and hope": that's what Leigh Hunt had said about Oxford. It was still true, and I was going to miss it.

An English school commemoration is much like an American baccalaureate service. At the conclusion of this one we all streamed up to the Carfax and down St. Aldate's to Town Hall, for the second stage of the program—the Presentation of Prizes. This part was like an American school commencement. The Master made a few remarks, a guest speaker extolled the virtues of scholarship, and the two of them handed out the prizes.

Red had got three. One for General Progress. One for being first in his division on the General Knowledge Paper (not bad for a boy who, until the previous September, had never heard of B.S.T. or "taking silk," let alone been capable of identifying them as British Summer Time or being appointed Queen's Counsel). The third prize was for top score in his form's history exam. *A pure miracle, that,* I thought as he went up the aisle to get his prize book. *He couldn't have blown up worse on most of the others.*

He'd passed the O-levels, the three national-standard exams he'd taken a year early, but his head had turned fuzzy when he'd tackled the school's own end-of-course exams. His papers had come back with marks ranging from 77 down to a ghastly 26. Not that those course grades mattered much, except as a record of overextension. The O-levels were the necessary preamble to a

decent job, as well as to the later exams that would qualify him for a place at university. *If he were a bona fide British schoolboy, that is,* I thought.

As a transient American, none of the exams he'd taken would have any impact on his future. Officials of the high school to which he was returning at home would decide by guesswork alone how many "grade points" and "course credits" he had earned during his year abroad. A different set of national-standard exams, two years hence, would open to him—we hoped— the doors of an American university. So, what *really* mattered in the report book that Magdalen College School had sent to the parents of every boy was the comments of the masters. These Red would treasure, for they were the true record of his Oxford year. The word "admirable" kept cropping up, his housemaster had expressed the wish that he were staying on, and the Master himself had added a congratulatory note.

As my son returned to his seat with *The Selected Letters of Sidney Smith* in hand, I looked at him fondly. It had been a fine year for him. He knew his mind better, spoke with greater assurance, was more eager for new experiences, and could handle them better. What share of the credit should go to the school, how much to our wanderings during vacations, and how much to the natural processes of adolescent growth I couldn't say. But he'd bloomed.

"Another for Marriott," he murmured at my side. "He's up with Tinbergen now."

The two boys, both sixth-formers, were what Americans would call Big Men on Campus. Between them they captained the school teams, sustained the orchestra, various school societies and the Cadet Corps, and served as prefects. *He's the type to be a student-body president, all right,* I thought as Marriott accepted

the John Lyne Memorial Prize. *But I still prefer election to appointment.*

There is no student government, in the American sense, in English schools. The Head appoints older students as prefects, who serve as his lieutenants—responsible for school leadership and also for school discipline. I smiled now as I remembered Red's only tangle with a prefect; it had happened in January, when he had mislaid his gym shirt.

The notice on the bulletin board had read: "The following"—and Red's name led the list—"have lost personal belongings. They will call at the Prefect's Study by Thursday, 12 February." (Note: no "please.")

When Red had gone to get his shirt, the seventeen-year-old prefect—a lad who was a head shorter than Red and still had peach fuzz on his cheeks—had handed over the shirt, and had then said, "Standard punishment. Fifty lines. Best handwriting. I'll have them tomorrow in break."

Our independent, almost-grown-up son—I can't think how many years it's been since he's needed "disciplining"—had swung for a moment between outrage and amusement. He'd settled on the latter, and that night at home he'd meekly written out, fifty times, "My carelessness with my personal property will cease."

The next day during recess, as ordered, he had delivered the paper to the prefect, had seen his name checked off a list, and had watched his fifty lines of best handwriting torn in half and dumped in a wastebasket. What's more, his carelessness with his personal property *had* ceased. (At school, anyway.) *But the prefect system,* I thought now, *would never work in the States.*

What was it that our English schoolmaster acquaintance, the one who'd spent the year at the boys' school in New York, had said? Oh yes: "The boys were alert, friendly, well behaved—

and if good manners consist in putting one at ease they had it all over our English children—but nevertheless I found the democracy there a bit wearing. I'm still for a certain amount of benevolent despotism."

And what was it that Bud Robertson had told me? (The Robertsons were from Iowa.) "I like my school here fine. Except for one thing. I'll sure be glad to get back to the good discipline at home." His comment had rocked me back on my heels. It was the *English* schools that were supposed to have such good discipline. The Talbot children, Canadians with an American outlook, had reported that their schoolmates got hit over the knuckles with rulers if they talked out of turn. Red was always having to stay after school because the whole class was being punished for the misbehavior of one member. I knew that canings, though rare, occurred. So what did Bud Robertson mean by "good discipline"?

It turned out that he meant *self*-discipline. It made him uneasy to have a class go to pieces whenever the master left the room. He'd been brought up, as most American school children are, with the idea that the teacher and the class are in partnership. From the moment that an American first-grader gets elected Pet Chairman, and with the title acquires the high honor of being allowed to feed the goldfish for a week, his sense of responsibility to the class begins to build. His sense of individual worth builds through those early school years, too. It is a rare American schoolteacher who fails to accord equal, and patient, attention to each child. She wouldn't be human if she didn't have favorites, but I'd never been in an American elementary school classroom without being impressed by the attentiveness the average teacher accords both the fumbling questions of her dull or shy children and the snappy answers of her bright and articulate ones.

346

The result, by sixth grade, is that if a teacher has to leave the room she leaves a whole class full of ex-chairmen of something or other, each with a vested interest in the *status quo*, and none with a grudge against authority. By the final years in high school the students themseves are calling roll, running the clubs, policing the school, and punishing offenders against the common good. *It's a far less efficient way to run a school than the English system*, I thought now. *But much of the American zest for life, our willingness to take the initiative, our strong sense of responsibility for good works in the community must surely start with that first-grade goldfish bowl.*

The last prize had been given now, and we all arose to sing "Sicut Lilium." The schoolboy backs I was looking at weren't markedly different from those of a similar gathering at home, except for one thing: none of the skin was brown and none was yellow; none of the eyes was slanted, and none of the noses was broad and flat. None of the names was Watanabe, or Lopez, or Luzzati, or Sobieski. Not for reasons of prejudice; there just isn't much of anybody in England except the English. They've had no immigration to speak of for hundreds of years. So they don't need to use the schools to unify many and diverse strains of people. *We* still do.

As we eased through the crowd down the Town Hall staircase, George said to Redmond, "How'd you like to have lunch at the Mitre today? To celebrate your prizes, and the Glorious Fourth? Sure wish we could go to a ball game, too."

"We *are* going to one," Red replied, deadpan. "At least, it's a game that's played with a ball."

"Cricket's no game. Somebody has to *move* before you can call something a game."

"Now, Pop. Sometimes there's a lot of action. Anyway, *I* like it."

I couldn't understand Red's enthusiasm for cricket either. But I well remember the first real match he'd played in. He'd come home all fired up, half in glory because he'd been part of a team and half in agony because he'd made mistakes.

"We were playing against Maltby," he'd started off. "And I did O.K. I really did. Until Rogers started bowling to me. The first two were wides. The next was a no ball. The fourth looked good, and I was sure I'd connect real clean and maybe smash it over the boundary. That would have meant four runs for Wilkinson. Boy! But what'd I have to go and *do?*" He'd groaned. "I went out hit wicket! And later, when Maltby had their innings and I was square leg—no, I guess I was silly mid-on—well, *whatever* I was, here came this ball angling across the pitch. . . ."

"Hold on a minute. Would you mind saying it again, slowly—and in English?"

"In *English?* Oh. I get you. Sure. It's simple. Cricket's a little like baseball. There are two sides. First, one side bat, then the other. Two batsmen are up at a time, one at each end of the pitch. The pitch is the long, narrow strip of grass with the wicket at each end, only sometimes the whole field is called the pitch and the pitch is called the wicket.

"The bowler—that's the pitcher—bowls to one batsman, who hits the ball if he can. He tries not to knock down his own wicket, which is what I did—what a goof!—or he's out, which is what I was. Every time a batsman hits a ball, he and the other batsman can run, if they want to. They have to change ends to get a run. Unless one of them hits the ball so it rolls over the boundary; then his side get four runs. Understand?"

"I'm still with you. Go on."

"Well, properly, the first side are supposed to keep batting until all their men are out. Except those who are not out, of

348

course. Then they go out—the first side, that is—and the other side come in. Until all their men are out. Except for those *not* out. Same for both sides, of course. Then they change again, and again, and maybe twice more. But in our matches there isn't time to do all this, so each side have only one innings, and there are only sixteen overs to an innings."

I was getting a glassy look, but Red didn't notice.

"An over is when the bowler bowls six balls, including no balls and wides. A batsman can be up for quite a few overs. There's no limit; you're up until you're out. You're out, of course, if somebody catches your hit ball before it strikes the ground. Unless it's a boundary six. And you're out if you're stumped, bowled, or leg-before-wicket, too."

Red paused, looked off into the distance, and then said, "I think that's about it, Mom. There are still a few points I'm not clear on myself. But you get the general idea, don't you?"

"Sure," I said. "It's like baseball. Two sides."

He wasn't listening; he was too full of the game. "O.K., then. Now let me tell you what happened next. Maltby was in, and I was—well, whatever I was—and the batsman hit the ball with a terrific wallop, and . . ."

As time went on, he learned whether he was square leg or silly mid-on—and, for that matter, whether he was cover point, silly mid-off, or short extra cover: they're all fielding positions. But he never succeeded in making clear to either of his parents why he was so nuts about the game. All I managed to learn about it for sure was that nobody ever talks about sticky wickets while playing cricket. I dutifully watched a game—pardon, a *match*—or two, but I still think cricket is like eating a marshmallow sundae or knitting an afghan. Soothing to the people who are doing it, but not very stimulating to watch.

However, the third phase of Magdalen College School's

349

"Commem" featured a cricket match between the school team and the Old Boys—so over we went, at twoish in the afternoon. The day couldn't have been finer. The playing field lies on an island in the Cherwell, just below Magdalen Bridge, with the tower in the distance. The sky was flawlessly blue. Every chair in the school had been dragged out on the field so that Mums and Dads could watch the games in ease, and a tea tent had been set up. We could hear the chirpings of the Parents Association ladies as they arranged the little cakes on trays and checked the hardness of the ices. And, as a sort of extra blessing, the Magdalen bells were pealing. Change-ringers go from town to town, having competitions with the local champions; that's what we must have heard that afternoon, for the ringing was intermittent. The sound of bells came and went, muted by distance, as gently hypnotic as the little wavelets in the river at our feet.

It was a good afternoon, in short, for just sitting and *being*. We sat and watched the cricket for a bit, and chatted with the Master, and wandered off to the art exhibit, and strolled back to see if anyone had moved yet on the cricket field—having missed, of course, the afternoon's one flurry of activity. Then a sign went up: "Teas Now Being Served," and Red materialized from wherever boys go when they've done their initial duty by their parents at a school event.

"Would you like me to scrum around in there for you?" he said, nodding toward the tea tent.

"Sure," I said. "Bring me a pink cake."

The Schleichers wandered by. They were from Oregon. Twelve-year-old Alan was at M.C.S., and Susan, fourteen, was at a private girls' school. They stopped to chat.

"I hardly recognized you, Susie," I said. "You look like an American teen-ager today. Lipstick and high heels. Last time I saw you, you were all done up for St. Trinian's."

350

Susie giggled. "I'm out now," she said. "'No more classrooms, no more books, no more teachers' dirty looks.'" Then she turned serious. "Only I don't really mean it. I even think I'm going to miss the uniform—a little. And I sure hated it when I first got here. That *hat!* Ugh!"

Mrs. Schleicher spoke. "Well, I can tell you one thing. It's been wonderful for me to have a year off. No breakfasts gulped while running for the school bus because she's spent so much time deciding what to wear to school. No big scenes because 'everyone' is dyeing streaks in their hair, and why can't she? No 'May I go here?' 'May I go there?' In Oxford, there's no place to go but *home.*"

"Creepers," said Susan. "I've probably even forgotten how to dance. C'mon, Al. Let's go get some tea. May we bring you folks something?"

"Red's getting ours, thanks. You'll probably meet him on the way," I said. "Just bring something for your mom and dad."

Bill Schleicher watched his daughter's departing back. "It's been a particularly good year for her," he said. "She wasn't ready to be boy crazy when most of the girls her age were. But you know how it is, at home. You've got to keep up with the crowd. I knew all along she'd be happier wielding a hockey stick along with a lot of other screaming females."

His wife chimed in. "You make it sound so simple, Bill. Have you forgotten the stricken look on her face when she first saw that uniform? And those ghastly gray knickers? And how she wept when she didn't get invited to any of the Christmas parties?" Then, to us, "But Bill's right about it's having been a good year for her, over-all. She really *was* more child than teen-ager, and it was nice for her to get out of that awful, competitive, you-have-to-be-popular routine back home. I've decided we put

way too much pressure—social pressure, I mean—on our American kids."

We drank our tea in companionable silence, watching the statuesque figures in white on the cricket field, and listening to the Magdalen bells. Then the Schleichers strolled on. George looked at his watch. It was almost four. "Gosh," he said, "I suppose I ought to go to the lab sometime today."

"I think I'll stick around for a while," Red announced. "I'd sort of like to see how the match comes out. It's school forty-seven for three right now. You don't have to stay, either, Mom, unless you're especially keen to."

"I'll run along with Pop, then."

However, when we got in the car I said, "How about dropping me off at Longwall, and meeting me in an hour at Balliol? There are a couple of things I'd like to buy, with the packers coming in two days and all. O.K.?"

"O.K."

I walked up High Street toward the Turl. At the Queens bus stop, I had to veer to by-pass a lengthy queue. *A bad place to get on,* I thought as I cut past. *Just one queue for all those busses.* It was a transfer point, hence all the busses stopped there. You'd be standing tenth in line when a No. 2 came swooping in, and nobody up ahead would move. So you'd figure they were waiting for 3's or 5's and dart out of line to grab the 2. At which point a retired-colonel type with walrus mustaches would take a grave step forward, then turn and glare because you were being pushy. *Not for me,* I thought. *It's simpler to queue up for the 2 alone, at the Carfax stop.*

George wanted a Balliol tie, and I got it at Walter's. Mr. Morrissey knew us now, and I thought it might be decent to tell him good-by. He wished us a pleasant journey and thanked us for our custom.

Then I popped into The Market; not that there'd be much left this late in the day at Mrs. Palm's.

"I kept back a small loaf of the rye you like," the jolly little German said.

"That was awfully nice of you, Mrs. Palm," I replied. "We'll miss you. We're leaving next week."

"Have a good journey."

"We'll send you some more Americans."

"Good. Good." Big smiles on the other side of the counter. "*Auf Wiedersehen*. God bless."

The last stop was at the bookstore across from Trinity. They'd had a copy of that Penguin book on *Monumental Brasses;* at least, I was pretty sure that this was where I'd seen it. As I entered, the salesgirl was directing a couple of American tourists to the Shelley Memorial. Guidebook map spread out on the counter, she was saying, ". . . and straight down to the end. Not more than two minutes' walk. Then to your left at All Saints. Look lively after St. Mary's, and whenever there's a chance, cross. You'll find Univ where the street widens a bit and begins to curve."

It won't be nearly as interesting as if they were to cut between Lincoln and Exeter and come down to the High through Radcliffe Square. But I didn't say so aloud. I stood off to one side looking at magazines. And let them go.

How unfriendly of me, I thought, as I took my book and started up the Broad toward Balliol. They were countrymen of mine. They would probably have appreciated hearing an American voice, after the broad a's and dropped h's they'd been coping with. Then I had a flash of insight. *Why, that's the reason I didn't speak! My accent would have equated me with them—and they're TOURISTS. I'm not. I LIVE here.*

My husband was waiting in the car. I scrambled in. "George,"

353

I said, "I've just made a discovery. I don't want to go home."

He turned his head and looked at me, smiled a little, stepped on the starter, then took his hand off the gearshift and patted my knee. "Don't worry, honey," he said. "You'll like it when you get there."

Epilogue

NATURALLY, we had anticipated some breakage. If you're realistic, you don't rent your house to a family with five children and expect every last glass and saucer to be there on your return. Nor did we expect to find each piece of furniture exactly where we had left it. But when we stepped back across our own threshold after an absence of almost a year, it certainly never occurred to us, as we made our first swift survey, to look into the living-room fireplace. Of all our household belongings, a pair of heavy wrought-iron andirons would seem to be the least susceptible to removal, damage, or loss.

I didn't, in fact, miss them until that evening. It had been a happy home-coming: whatever had been broken had been replaced, the renters had even laid clean shelf paper in the kitchen cupboards, and I rather liked their rearrangement of furniture in one of the bedrooms. So I was feeling relaxed and cheerful when I finally sank down on a sofa in the living room and let my eyes roam lovingly over its familiar details. That's when I caught a glint of brass behind the fireplace screen.

Brass?

I got up and peered into the fireplace. Then I called George. "Look in there," I exclaimed. "The black wrought-iron andirons are gone. These are the brass ones that belong in the den."

We stood mutely, staring at the interlopers. Then, as one, we went into the den. The fireplace there was bare.

"Strange," George murmured.

"How could anyone misplace a pair of andirons?" I said. "They must weigh twenty pounds apiece."

"Oh, they'll turn up somewhere," George said, and we went to bed.

During the next few days, as we unpacked the boxes of household goods we had stored in the garage, and checked the other possible spots where the andirons might have got to, it became apparent that we were rapidly running out of somewhere. I even set Red to thrashing around in the shrubbery. Finally we were convinced that there were no wrought-iron andirons in or near the house.

It is to our credit that we never seriously suspected our ex-tenants, people named Crawford, of theft. But it *was* possible, we thought, that they might have lent our andirons to someone. A group of Caltech students, for example. And if they'd done anything as irresponsible as that, I was going to be pretty darned angry, I told George. So I sat down to write them a letter of inquiry.

"Be tactful," George cautioned. "Don't accuse them of anything."

"Yet!" I added darkly.

I penned a cheery little note, thanking them for their stewardship of house and property, and tucked the key question into the fourth paragraph. "By the way," I wrote, "do you recall what happened to the black wrought-iron andirons in the living-room fireplace? The entire set was made to order for the house by the people who had it before we did. And since they were dear friends, we particularly cherish these fireplace accessories."

I received a prompt reply. Mrs. Crawford wrote, with cheer equaling mine, that they had *loved* living in our house, were so happy we had found things in good condition, and, oh yes, about

356

the andirons—there weren't any andirons in the living-room fireplace when they had moved into our house. That's why they had brought in the brass ones from the den. Surely we had put them away somewhere ourselves and would come upon them any day now.

Our breakfast coffee cooled in the cups while we digested this information. Well, then, what had *we* done with the andirons? My original assessment was still valid. How could anyone misplace forty pounds of andirons?

That's when a speculative expression suddenly crossed George's face. He leaned across the table and grabbed my wrist. "Are you sure we *had* andirons in that fireplace?" he asked.

Astounded by his question, I rejoined, somewhat tartly, "Of course I'm sure. My goodness, I've been cleaning out the ashes in there for six years now."

"Red?"

"Gosh, I don't know. All I do is lug in the logs."

George was frowning. "It's very peculiar. I can see the outline of the andirons, all right, but I've been going through the fire-building routine in memory and I have no recollection at all of laying logs across metal."

His memory is generally so good that now I became doubtful. I telephoned my mother, who had helped us get the house ready for the renters. "Certainly there were andirons in that fireplace," she said. "I dusted them the day you left." Pause. "Well, I dusted *some* andirons. I can't swear that I dusted the iron ones." Then I called a friend who had known well the former owners of our house. "Why, of course, there were andirons in that fireplace," she said. Pause. "At any rate, there was often a fire burning there when I came to call. I'm sure of *that* much."

A research assistant at the lab finally provided the key to solving our mystery. She said to George, "You've taken dozens of pictures in and around that house. Surely you've taken some of the fireplace, too?"

Of course.

He dug out the box labeled "Slides" and found the pictures we'd taken during the Christmas holidays in 1956. Among them were some of the fireplace. One, in particular, was very sharp. The fire screen had been moved to one side. The tools showed clearly on the left. The woodbox showed clearly on the right. The logs blazed cheerily in the middle. Two cats dozed gracefully on the rug in the foreground. Nothing was missing from this cozy scene—except a pair of andirons.

We searched the depths of the picture. We studied the foreground detail. There were no andirons in the fireplace today. There had been no andirons in the fireplace in 1956. Obviously there never *had* been any andirons.

Red let out a great whoop of laughter. George and I sat staring blankly at each other. Then, tipping my head toward the fireplace, I said, "It was really all the Crawfords' fault. If I hadn't seen the brass andirons in there, I wouldn't have visualized the wrought-iron ones, and the silly business wouldn't have begun at all."

"Speaking of visualizing," George said, "what did *your* andirons look like? Mine had open rings on top, to match the tool stand."

"Oh no!" I exclaimed in instant and positive disagreement. "They had solid iron balls on top and spreading three-pronged feet. I can see them as clearly now as the day I first laid eyes on——"

I didn't finish the sentence. That's when *we* began to laugh.

358

The point is this. Readers who know England and the English well may wish to dispute the accuracy of the facts set forth, and the inferences drawn, in the chapters of this book. Go right ahead. Maybe we *didn't* see the real England, after all. Maybe we have generalized too broadly from unique experiences. As for our reliability as witnesses, you have just had evidence.